*50 Years
Down a
Country Road*

❖

ALSO BY RALPH EMERY

Memories

More Memories

The View from Nashville

50 Years
Down a
Country Road

◆—◇—◆

RALPH EMERY

with Patsi Bale Cox

William Morrow
An Imprint of HarperCollins*Publishers*

HarperCollins books may be purchased for educational, business, or sales promotional use. For information please write: Special Markets Department, HarperCollins Publishers Inc., 10 East 53rd Street, New York, NY 10022.

FIRST EDITION

Designed by Cassandra J. Pappas

Printed on acid-free paper

Library of Congress Cataloging-in-Publication Data
Emery, Ralph.
 50 years down a country road / by Ralph Emery with Patsi Bale Cox. — 1st ed.
 p. cm.
 Includes index.
 ISBN 0-688-17758-1 (alk. paper)
 1. Country music—History and criticism. 2. Country musicians—United States. I. Title: Fifty years down a country road. II. Cox, Patsi Bale.
ML3524.E44 2000
781.64'2—dc21 00-059449

00 01 02 03 04 RRD 10 9 8 7 6 5 4 3 2 1

To Eddy Arnold
Country music's first superstar

Contents

PART 6

THE NINETIES: COUNTRY EXPLODES

ACKNOWLEDGMENTS

PEOPLE ARE ALWAYS asking me how long it takes to write a book. This one took approximately fourteen months, give or take a few days, and from my standpoint it was the toughest of the four I've done. How do you pack fifty years into the pages of a normal-size book? I know some of you readers will find that your favorite stars are not included in this book, and by no means did we mean the omissions to signify a lack of respect. Simply a lack of space. We also tried to include artists that were not in *The View from Nashville*.

The sources of the information in *50 Years Down a Country Road* are interviews done on my syndicated radio show, which lasted more than twenty-four years, interviews done on television shows such as *Pop Goes the Country* and those for The Nashville Network, including *Nashville Now* and *On the Record*. One other radio source was my recollections from the all-night show on WSM. More recently, Bobby Bare and I hosted two televised series, *Ryman Country Homecoming* in 1999 and the *Ralph Emery Homecoming* in 2000. We had between twenty and twenty-four country legends on each show and their memories are included in various stories.

Another problem I faced at the outset is the fact that I wasn't involved in the music business in 1949 and 1950, when this book

begins. And while I wanted to start the story with Hank Williams, I never met the man. I had to seek out people who were working in the business at that time; specifically, people who'd known Hank and would share their thoughts with me. I'd like to tell you something about those people and thank them for their time and input.

I heard former record executive Murray Nash talking about the beginnings of Nashville as a show business center with deejay Eddie Stubbs on WSM radio around the time we were starting on the book and realized that Murray was just the guy I wanted to interview first. We got together on June 28, 1999, and his insights on Fred Rose and Hank Williams were invaluable. I had hoped to see him for a follow-up interview toward the end of the writing process, but sadly, in April 2000, Murray died at age eighty-two. I extend my deepest sympathy to his family. He made many contributions to this business, especially in the '40s, '50s, and '60s.

Another executive who was kind enough to share his time with us was Buddy Killen, former owner-president of Tree International Publishing. Back in the 1950s Buddy was a freelance bass player at the Opry. He was among those who were waiting for Hank Williams to arrive for his show in Canton, Ohio, on that fateful New Year's Day, 1953. I also want to thank Jimmy Dickens. He and his wife, Mona, brought their memories to an interview session at the Country Music Hall of Fame. A more pleasant man I've never met. I sought out Billy Robinson, an old schoolmate of mine from our days at East Junior High in Nashville. Billy played steel guitar for Red Foley and for a time in the Opry's house band. Billy provided us with a wealth of information that helped develop our story.

On August 21, 1999, I went to Carthage, Texas, and emceed a show for the Texas Country Music Hall of Fame, where Hank Thompson was being inducted. Hank shared his thoughts on his friend Hank Williams as well as on his own legendary career. As we continued to explore the beginnings of Nashville as a music center, we talked with former deejay-songwriter Joe Allison. Joe penned "He'll Have to Go," among other songs. It was Joe who gave us a good handle on Harry Stone's contribution to the Opry. My collab-

orator on this book, Patsi Bale Cox, thoroughly enjoyed talking with Johnny Wright and Kitty Wells and hearing more about how the two helped open doors for women artists. Also, when I asked Johnny to reflect on Hank Williams, he told us: "I know more about Hank than anyone!" In our last book, *The View from Nashville*, Patsi found herself charmed by my taped interviews with the late Carl Perkins. This time out, the Marty Robbins and Tex Ritter interviews especially captivated her.

I did not set up a formal interview with Eddy Arnold for this book. Eddy has two new books about his career on the shelves and he told me that he was "interviewed out." So I used hours of old taped interviews and also took him to lunch to confirm a few things.

In November 1999, I attended a ceremony at which a beautiful statue of producer-label executive and studio owner Owen Bradley was unveiled. Owen's brother Harold spoke about the days when he and Owen were getting started, and I later interviewed Harold about the beginnings of Music Row, called Record Row in the old days. Music Row, the area around 16th and 17th Avenues South, now houses most major record labels, publishing houses, management firms, and artists offices. Harold is now president of the Nashville Musicians Union, Local 257. Harold, I can't thank you enough for your acumen.

I suppose everyone who tries to explore the life of Hank Williams comes to Nashville to interview Don Helms, Hank's friend and steel guitarist. Thanks to Don, I now know much more about the humorous side of Hank Williams. And, thanks to both Don and Murray Nash, Hank the man emerged over Hank the myth. More help in developing the Hank Williams story came from Hank's daughter, Jett Williams, and her husband, Keith Adkinson. I learned much about her struggle to gain acceptance as Hank's daughter and about Hank's unfulfilled wish that she be cared for.

The Country Music Foundation, as always, was generous with time, facilities, and information. I'd like to plug *The Encyclopedia of Country Music* (Oxford University Press) edited by Paul Kingsbury, here. We turned to that excellent book over and over. I'd like to sin-

gle out Allen Stoker, who is the son of Jordanaires legend Gordon Stoker, for praise. I worried Allen to death about this and that and he never let me down. I'm also indebted to the foundation's record expert, Bob Pinson, who showed me the first country LP, a 1949 10-inch record by Gene Autry. Ronnie Pugh was a great help, as was the foundation's Fred Rose expert, John Rumble. Special thanks to Kyle Young and his executive assistant, Christina Fernandez, for their help. Additional thanks to Mark Medley.

There are many other people who contributed to this book, and I hope I don't exclude anyone. If I do, I thank you and apologize for the omission. We interviewed the great writer-artist Don Gibson early on. Don is a very quiet man, soft-spoken and not prone to reminisce. Therefore I doubly thank him for his recollections on his career and Nashville in the '50s and '60s. Bobby Bare, surely one of Nashville's greatest trailblazers, was a gold mine of information. Ronnie Milsap showed us that a blind man can often see far more clearly than a sighted one. Merle Kilgore has been in all my books. He worked with both Hank Williams and Hank Jr. and is a great storyteller. This time out he tells a funny tale about the wedding of Johnny Cash and June Carter.

I play golf with Tom T. Hall once or twice a week and it is one of the most enjoyable parts of my life. Tom is a good friend and was kind enough to write the introduction to *50 Years Down a Country Road*, as well as to share some of his personal stories. Tom is one of the most creative people I know.

I also interviewed writer-artist Johnny Russell for some thoughts on the early days of *Nashville Now*; songwriter Larry Henley on his song "The Wind Beneath My Wings"; Dickey Lee on his song "She Thinks I Still Care"; and my Oklahoma pal Jerene Gill, who always has a good story about her son, Vince. Patsy Cline's husband, Charlie Dick, and daughter, Julie Fudge, both talked with me about Patsy.

My thanks also to Vickie Cutrer, widow of my old friend and fellow WSM announcer T. Tommy Cutrer. It was Vickie who gave me the details of Marty Robbins being fired from the Opry and about the Opry's 1961 Carnegie Hall show. I obtained some of the photographs in this book from veteran Opry photographer Les Leverette.

When I went to get the pictures, Les also talked to me about that Carnegie Hall show that's mentioned in the Patsy Cline chapter. Lou Robin, who is Johnny Cash's manager; Marty Robbins's son, singer-songwriter Ronnie Robbins; Irving Waugh; and Acuff Rose's Peggy Lamb were a great help. I appreciated the assistance of Donna Hilley at Sony Tree and Kay Smith at Sony Music.

I've also included a number of pictures taken by Judy Mock. While Judy is not a professional, she had photographs equal to any I've seen. She is a super country fan who allowed me to choose from her entire collection, which spanned almost fifty years.

We have certainly enjoyed working again with our fine editor, Henry Ferris, as we did on *The View from Nashville*.

I've been lucky to travel down this country road over the past fifty years and would like to thank all the performers, writers, producers, crew members, and others with whom I have made the journey. I'd like to thank my wonderful wife, Joy, for her support and my sons, Steve, Kit, and Mike.

About the time this book was completed there was a death in our family. Joy and I lost our beloved cat, Mammy, who'd been with us since 1977. She truly was one of our children and I'm afraid that as I write this grief still permeates this house. Mammy slept with us, dined with us, and reigned supreme over the household. And as I worked on this book, Mammy contributed by making leisurely strolls past the kitchen table that had become my desk, asking only for everyone's utter admiration. She always got it, too. In an effort to bolster my spirits, my aforementioned cowriter, Patsi, sent me a tribute that Kinky Friedman once wrote about his cat, Cuddles.

Kinky is generally thought of as a cigar-chomping, irreverent, politically incorrect writer and singer. A great talent, but surely not a softie. Yet Kinky's writings about the death of fourteen-year-old Cuddles were deeply felt and helped Joy and me immensely. You can read the entire piece either in the epilogue of *Elvis, Jesus and Coca-Cola* (Simon & Schuster, 1993) or on the Utopia Animal Rescue Ranch website, www.utopiarescue.com.

In part, Kinky wrote this: "Dogs have a depth of loyalty that often we seem unworthy of. But the love of a cat is a blessing, a privilege in

this world. They say that when you die and go to heaven all the dogs and cats you've ever had in your life come running to meet you. Until that day, rest in peace, Cuddles."

Thanks for the thoughts, Kinky. And until that day when you come running to Joy and me, rest in peace, Mammy.

INTRODUCTION

IN KEEPING WITH the informal style of this book, I would like to employ the first-person voice and ramble along for a short time on the merits of the book's contents.

When I was a young disc jockey aspiring to be a country music songwriter, Ralph Emery was my hero. I listened to him all night and tried to imitate his style the next day on my own radio show. It was years later when we were friends that I found out that I was making more money than he was at the time I was idolizing him.

Although there is a considerable disclaimer at the start of this book stating that it is not history, I would like to disagree on the premise that Ralph Emery was there. He listened, he looked, he watched, he participated, he remembered, he read, and he cared. Although Ralph is not a historian, he would certainly qualify for the lineup if all the usual suspects were sought. Sitting behind a microphone or staring into a TV camera for the better part of his life, listening to thousands of performers, songwriters, publishers, musicians, producers, agents, publicists, and all other types of manipulators of public opinion throw their spin around his studio, Ralph has refined a natural-born bullshit detector.

This book will raise some eyebrows. The author is not a man without opinions.

For the country music fan, not only eyebrows will be lifted. The eyes themselves will be moistened as Ralph takes you down this sometimes tragic, sometimes sad, sometimes hilarious highway he calls a country road.

For years I have maintained that history is the most patient thing in the world. There is no changing it. There are revisionists afoot always. But we get our best information from the oral historians, people who were there, wanted to be there, loved being there, and are not afraid to return and face friend and foe alike with equanimity, understanding that we as human beings are imperfect, fallible, and not always well intentioned. Ralph Emery is such a historian. One day scholars doing research will go first to his books when they find no blood and guts in their country music statistics.

When Ralph asked me to read this manuscript and write this introduction, I showed up late for our regular golf. Ralph said, "You're late, T."

I said, "Yeah, I was reading your book."

Nuff said!

TOM T. HALL

PART I

Opening Act

Setting the Stage

I'VE ALWAYS WONDERED if maybe I passed Hank Williams on the street without knowing it. I worked down at Loews Theatre at the intersection of Church Street and Capitol Boulevard when Hank was at the Opry and when Hank and Audrey had a clothing store downtown. During the three years I worked there, I met hundreds of people, thousands of people. I rode the bus back then since I didn't have a car. If you came downtown, you'd probably cross that intersection of Church and Capitol Boulevard, and there in the heart of the city, not far from the Ryman Auditorium, you might pass anyone. Tex Ritter, Ernest Tubb, Red Foley—and, just maybe, Hank Williams. I did recognize Bashful Brother Oswald downtown one day down around Fifth and Church.

I might not have known who Hank was because I wasn't a big Opry follower in the late 1940s. I wasn't really a fan of anything except boogie-woogie. My grandparents loved the Opry, so I was grounded in it, but I thought there was a sameness to it. You tuned in and heard the same people singing the same songs. It took me a while to really start to love it. But I did.

I started listening to country music and the Grand Ole Opry because of my friend Jim Ralston, who was a big fan of Lazy Jim Day

and the Singing News. I lived at 812 Russell Street in East Nashville and I'd go across the street to Jim's house at 817 Russell. Jim had a bedroom down in the basement, and that's where we'd go to play records and sometimes listen to the radio. Every Saturday night we'd listen to the Opry, then tune in to WLAC's late-night boogie and blues show. Gene Nobles would play gut-bucket blues and boogie-woogie. Gene's trademark was when he supposedly poured beer into the microphone. He was sponsored by a beer company, and he'd say, "I'm gonna pour a beer through the mike—get ya a sponge and mop it up!" Then you'd hear a sound just like liquid being poured into the mike, a kind of fizzing sound. I got to know him after I started in radio and Gene told me he created the sound effect by dropping a seltzer tablet into a glass of water. But I never guessed it when I was listening to him as a kid.

Jim Ralston loved to hear Lazy Jim make up his funny little off-meter songs based on the news. Here's a bit of what a Lazy Jim sketch was like:

"Listen, everybody, here comes the singin' news with a little music to chase away the blues. This news is the truth, every line says I, and I'll betcha thirty cents you can't catch me in a lie. The longest line of the season—a boy down in Florida went to the woods with his father to help drag up some poles but one crawled away from the other. He saw a twelve-foot snake, but I couldn't a guessed how long 'cause I wouldn't a even stayed there till the other end come along. But I don't think that'll happen again in months and months and months. No, I don't think that'll happen again in months and months and months and months."

(I think it's safe to say that Lazy Jim never heard of iambic pen-tameter, but we didn't care. He was funny.)

If I ever heard Hank Williams on the Opry, it would have been because of Lazy Jim. I remember one night while I was working at Loews Theatre, a bunch of us high school boys all got off work around 10:00 P.M. and decided to head over to the Opry. Since we'd come late, it didn't cost anything to get in, and that was probably an inducement for us to stop by. We sat up in the balcony. I don't remember Hank Williams being on the show that night. The person

who stood out in my mind was George Morgan, who was wearing a bright checkerboard shirt. Now I treasure memories and stories from those early times.

One of my favorite stories from country music's old days comes from Uncle Art Satherley, the executive who almost single-handedly built Columbia Records into a country powerhouse. It's a story about how one of the biggest records in the industry's history almost didn't get cut. The tale begins at the Adolphus Hotel in Dallas, where Uncle Art was on one of his music-finding jaunts. Into the hotel walked Albert Poindexter, a housepainter from Troup, Texas, who wore chaps, boots, and a ten-gallon hat and thought he could speak in tongues. Art knew Poindexter and had already made a few records with him, none of which caught on. But among Poindexter's new tunes was a lovely song titled "Rosalita," which Art thought had potential. They picked eleven more songs and began recording in Art's hotel room, using Poindexter's band.

One of the compositions was about a woman who walks into a bar and finds her husband in the arms of another woman. Clearly not amused, she pulls a gun and shoots him. Art thought the lyrics were bizarre, but he liked the steady rhythm enough for the tune to make the cut. And it was enough of a contrast to "Rosalita" that Art put it on the B side of the single and sent it to radio in March 1943. Almost no one ever heard "Rosalita" because the minute the deejays listened to "Pistol Packin' Mama," they played it instead. By June it was one of country music's biggest-selling records and the darling of the jukebox crowd. By December it had sold 1,600,000 copies and the manufacturer had orders for an additional 500,000 that they couldn't fill because of the wartime shortage of manpower and shellac.

A big black-market operation soon followed with coin-machine phonograph operators offering copies ranging in price from $3 to $10 apiece, a hefty price back then! Poindexter changed his name to Al Dexter and was soon commanding up to $3,500 a night on the vaudeville circuit. The song got so big that Bing Crosby covered it.

Hit Parade ignored "Pistol Packin' Mama" because of an FCC ruling that did not allow songs to promote drinking; the first line of the

song went: "Drinkin' beer in a cabaret." The song publishers took
Hit Parade to court, and they finally resolved the issue by changing
the line to "Singing songs in a cabaret." Of course, millions of copies
of the original were already circulating, but at least the song could
claim its rightful place as *Hit Parade*'s top tune. And when anyone
questioned country music's ability to sell in large numbers, Uncle
Art need only utter three words: " 'Pistol Packin' Mama.' "

When I went into radio work here in Nashville, we didn't play
country music. We played gospel and pop. Many people in Nashville
hated country music. Nashville liked to be thought of as the Athens
of the South, not the home of what most still called hillbilly music.
Back in 1962, when I was announcing at the Grand Ole Opry, my
wife at the time, Skeeter Davis, and I built a house in Brentwood; I
got to know the contractor well. I didn't think he was a country
music fan so I was surprised to see him at the Opry one Saturday
night.

"John! What are you doing here?" I asked.

"Oh, we've got out-of-town guests who insisted on coming," he
answered.

That's how it was. Many Nashvillians would never have come at
all except to accommodate out-of-town visitors.

I remember Minnie Pearl talking about how Nashville's "blue-
bloods" viewed country music. And of course she was around them a
lot, since her husband, Henry Cannon, was a member of the city's
elite. "They make fun of people who paint their names on the sides
of their cars," she said slyly. Of course, she was talking about the days
when entertainers had touring cars instead of buses and put their
show names on the sides to advertise the fact that they were in town
for a show. Roy Acuff, Bill Monroe—all the entertainers painted
their names on the cars.

The King of Country Music was a title bestowed on Roy Acuff by
the great Dizzy Dean. Acuff liked that title, even though he liked to
tell people that there really wasn't any royalty in country music, just
in beehives. Of course I never heard of any king bees in a beehive,
and the King of Country Music wasn't even the original term Dizzy
coined. It started when Roy played a show with Gene Autry and

Dizzy Dean in Dallas. The audience rushed the doors trying to get in, and Roy tried unsuccessfully to calm the excited crowd. "You know how Texans are," Roy later joked. "They'll stampede just like a herd of cattle!" Finally Dizzy Dean came out and referred to Roy as the King of the Hillbillies.

There's a fascinating story about Acuff and Tennessee governor Prentice Cooper that is a perfect example of how some felt about country music in the mid-1940s. It was in October 1943, and Roy Acuff had just gone on the air with a coast-to-coast hookup of 129 stations. To celebrate the momentous event, Acuff planned a party to be held at the Ryman Auditorium, where around 3,500 people paid 75 cents every Saturday night to attend the Grand Ole Opry. Acuff thought it would be a fine idea to invite Governor Cooper to be a part of it all. The governor declined and behind Acuff's back criticized the event mightily. "I'll be part of no such circus," he reportedly said. "Acuff is a disgrace to the great state of Tennessee for trying to make Nashville the hillbilly capital of the United States."

The incident might have gone unnoticed, but it happened on a slow news day and a Tennessee reporter named Beazley Thompson decided to stir things up. He told Acuff what Cooper had said and suggested that Acuff run for governor. Acuff supposedly only nodded absently in response, but that was all it took for Beazley to jump in with both feet. He got up a petition and Acuff found himself as a candidate in the 1944 gubernatorial race. Acuff was a Republican, which made the chances of his being elected slim in the first place. Tennessee was a Democratic stronghold. The *Tennessean* was the pro-Democrat paper and the *Banner* supported Republicans. In fact they used to say that a possum could run against a Democrat in Tennessee and the *Banner* would support the possum.

Acuff eventually dropped out of the '44 race and ran again in 1948, but it was the 1944 run that caused the initial political furor. At issue was the fact that a "hillbilly" might govern Tennessee, and people still remembered how W. Lee O'Daniel campaigned for governor of Texas playing country music. The *Memphis Commercial Appeal* even ran a political cartoon depicting a Tennessee politician

standing outside a music store staring at a fiddle in the window. In the caption, the politico mused, "I wonder if you really can learn to play in ten easy lessons."

The irony here is that in '44 Acuff stood a better chance of becoming the governor of Tennessee because when he left his Prince Albert hosting job at the Opry in 1946, he reduced his visibility in the state.

So why did the city become country music's capital? I think several factors and people can share the credit. When I was in Louisville on my last book tour, a radio guy mentioned to me that Opry founder Judge Hay had come through Louisville before locating in Nashville. He said, "Who knows, if he'd stayed maybe we'd have become a music center." I thought about that comment not long ago when I was talking to Joe Allison, a Songwriters Hall of Fame writer and longtime disc jockey who started here in radio before me. Joe mentioned that it was Harry Stone who had gotten the stars coming to the Opry. When the Opry started, it was primarily an amateur show. The performers were farmers and teachers and doctors, people who worked other jobs, then sang and played as a hobby.

So the Opry's rolling along in 1925 and 1930 with an amateur cast. I remember once when Minnie mentioned to me that in the early days a star like Jimmie Rodgers, who was recording for RCA, wouldn't have given the Opry the time of day. And of course Jimmie died in 1933, so he never saw what the Opry was to become. I guess if you wanted to pick the first star, you'd have to say Uncle Dave Macon. Uncle Dave described himself as a "banjoist songster" with a repertoire of over two hundred tunes. Like me, he started his show business career in the Loews Theatre chain, only he was playing for the audiences, not ushering them to their seats. He became one of the Opry's first regulars, and one of its few professionals. I think WSM radio made Uncle Dave. But when Harry Stone came in, he started bringing in pros like Pee Wee King, Roy Acuff, Ernest Tubb, and Bill Monroe. My guess is that the way Harry would have approached the idea was to tell the National Life insurance company that they could make the Opry bigger and sell far more life insurance with a star-studded cast. That was the only way to talk to

that board of directors. The Opry grew because people could hear recording stars on the radio.

Then, of course, a great contributor came about when in 1939 Prince Albert bought that thirty-minute time spot and the Opry got NBC's coverage in addition to the 50,000-watt coverage they already had. There wasn't much man-made noise like television antennas and electric transmission lines back then, so the 50,000 meant even more than it does today.

The Opry and National Life, the owner of WSM, were the key factors in the initial development of Music City. When I went to work for WSM, old E. W. Craig was still there. His father was one of National Life's founders, and E. W. had started working for the company at an early age. Over the years the other national barn dances fell by the wayside, but National Life continued to put money into the Opry and kept it alive here in Nashville. Joe Allison says Harry Stone had to fight to keep the show on all the time. He says it was always on a precarious footing with National Life and that Stone kept it on the air on a week-to-week basis. I have to believe that the National Life field folks helped keep the company interested. When they went to sell someone insurance, they didn't knock on a person's door and say they represented National Life. They said: "Good morning, sir. I'm from the Grand Ole Opry."

And E. W. Craig was a big fan of the Opry and of WSM as long as they did nothing to embarrass him among his blueblood friends in town. A couple of times come to mind when E. W. was indeed embarrassed. One night he was listening to WSM when a deejay played a Julie London recording. You may remember that Julie had a breathy, sexy voice. E. W. jumped on the phone and called the deejay with instructions to "Get that crotch music off the air!" Another time, Jimmy Dickens put out a song called "Just a Bowl of Butter Beans," which he sang to the tune of "Just a Closer Walk with Me." When E. W.'s church friends complained, he ordered that song off the air for good, too.

Add to the Opry a fledgling recording industry, starting with Castle Studios, which was run by WSM engineers. When WSM management told the engineers they had to make a choice between the

studio and WSM, Castle went under. Then in 1955, when Decca executive Paul Cohen threatened to take his sessions to the Jim Beck studio in Dallas where he could get an echo chamber, Owen and Harold Bradley decided to open their own studio. That's when Owen said to Paul Cohen, "Okay, I'll get fifteen thousand dollars and you get fifteen thousand dollars and we'll open a studio. I'll throw in Harold's services for free."

Owen passed away while I was working on *The View from Nashville*, not many months after I'd interviewed him for a chapter on his legendary career. I thought it would be interesting here to add to Owen's thoughts by talking with his partner and brother, Harold Bradley. Harold is the man who was session leader on my own recording sessions, which come later in this story. When I spoke with Harold, I reminded him that I'd recently and wrongfully introduced him as the first man to play electric guitar on the Opry. He'd thanked me for the compliment and then told me the real story.

"Ernest Tubb's guitar player, Jimmy Short, was the first guy to play the electric guitar on the Opry," Harold said. "When Ernest had such a huge hit with 'Walkin' the Floor Over You,' the Opry was hot to get him to perform it on the show. But that song had 'electric guitar' all over it, and Ernest said he wouldn't perform without Jimmy playing his part. So finally the Opry caved in—the song was too strong to not include it."

Harold got started playing country music when he was seventeen years old, a year after Ernest had "electrified" the Opry. He was at somewhat loose ends that spring and Owen called him with an idea.

"Harold, why don't you go on the road with Ernest Tubb this summer?"

Harold, who studied classical music, was aghast.

"What!" he exclaimed. "You want me to play that corny country music?"

"It'll do you good," Owen answered.

Harold said that summer was wonderful and he came to think the world of Ernest Tubb.

"Ernest would come by around four A.M. and pick us all up to go play the early morning shows," Harold recalls. "We'd be on our way

in the building and Ernest would say, 'Somebody pass me a flask,' and sure enough, a band member would pull out a flask of whiskey and he'd take a big drink. I was still in school and thought it was just awful that he was drinking whiskey in the morning! But after a while I realized it was to clear his throat. You can't imagine how that gravel voice of his sounded right after he got up! A couple of pops from the flask was all it took to fix it."

Harold got the chance to play with Ernest because Jimmy Short decided to try and pursue a solo career. Short returned about the time Harold went back to college to study classical music. But by 1949 he realized it wasn't his calling and took a job as Slim Whitman's bandleader for his Mutual Network show. Harold was paid $150 a month.

"I couldn't spend that much money!" he said. "I was single and living at home, with no expenses." That was a princely wage in 1949. Harold played sessions, worked with Owen's dance band, and had made quite a name for himself by 1955, when Owen got the idea to build a studio.

On the advice of a friend, Owen and Harold looked at the area where Record Row is today. I didn't realize this at the time, even though I'd worked in that area, but Harold says the houses there were in such bad condition back then that you couldn't get a GI or an FHA loan on any of them. Owen ended up buying a place on 16th Avenue, and that conversation between Owen Bradley and Paul Cohen played a big role in Nashville ending up as Music City.

Interestingly, Harold tells me that Paul Cohen never did ante up his part of the money. Owen borrowed his $15,000 from his life insurance policy and never saw a dime from Paul. Yet Owen treated him as a full financial partner. When he sold the studio, Paul received a share of the profits. I think he understood that Paul's contribution came in another way: by directing his artists to record at Bradley's Studio.

Jim Beck, the studio owner in Dallas who almost got Decca's business, made quite a contribution to country music. He recorded Lefty Frizzell, Ray Price, and Billy Walker in addition to Fats Domino and classical pianist Gyorgy Sandor, as well as many others

in his legendary studio on Ross Avenue. Beck also engineered records for Columbia, Decca, Imperial, and Bullet. But in 1956 Beck was cleaning the heads of his recording machines with carbon tetrachloride and forgot to open a window to ventilate the room. The poison got into his system and he died within a few weeks. If Beck hadn't died when he did, he might have become a major threat to Owen. But Owen's studio was good for Paul and Decca, too. Paul didn't like having to take his acts to Cincinnati or Chicago because of the expense.

"Red Foley played a role in Paul's thinking," Harold explained. "When Red recorded he insisted on taking his entire band and that Paul pay them a per diem. Paul hated it! So when Owen and I opened our doors, Paul saved money."

In the meantime, old Fred Rose was building a publishing concern. Joe Lucus was the Acuff-Rose publicist and a great friend of mine back when Acuff-Rose was just a small company. It was so small back then that everyone wore many hats, but basically Joe publicized the company's artists and songs. When I got on the radio, I could always count on Joe to give me the records and bring his artists around. Back in the '50s I asked him how Acuff-Rose stacked up against Hill & Range. Joe said, "Oh, Hill and Range could buy us out of their stamp box."

But Fred's vision and Owen's vision got the industry started. Then you add Chet Atkins into the mix. Both he and Owen were musicians who could get things done. They made it easy for the New York and L.A. guys to do their jobs.

My story begins as the 1940s gave way to the 1950s, and of course, since Hank Williams set the tone for the '50s he occupies a hefty part of the front end of *50 Years Down a Country Road*. Before you start backtracking fifty years down these country roads with me, I want to mention a few things about the book. First, this is in no way meant to be a history of country music. While it is loosely divided into time periods and contains some historical data, it is primarily thoughts I have on various artists and trends over the years. It is certainly not meant to be definitive. I leave that to the historians. Most artists I've included could fit into many of the time periods.

Some may disagree on the placement of artists, and they might be right. For example, is Dolly Parton more likely to be found in the '60s, '70s, '80s, or '90s? I ended up including her in the '80s, when she had her huge crossover success and film career. But a good case could be made for the other decades.

There are some omissions, too. Some artists, like Conway Twitty, Faron Young, Vince Gill, Brooks and Dunn, and others were the subjects of lengthy chapters in *The View from Nashville,* and I didn't want to go over old ground. If I'd tried to do that, we'd have had 50 *Years Down a Country Road, Volumes 1–5.* What I've tried to do is show some of the personal side of country music through the years, at times set within the context of Nashville's music industry and at others within the overall society.

Finally, I leaned heavily on the earlier days of country music. I hear people say they never heard of this or that artist, this or that song, and it concerns me that our heritage may be slipping away. In 1999 Bobby Bare and I put together a Ryman Country Homecoming television special. At one of our taping sessions, Willie Nelson pulled me aside and said, "Let's do this again. If we don't, people may forget all those great days." That is what this book is about, remembering some of the people and events of the past half century in country music. I've started with this "stage-setting" chapter; then I begin the bulk of the book with Hank Williams and Nashville in the 1950s.

WHEN I GOT INTO the radio business, Record Row was just a glimmer in Owen Bradley's eye. George Morgan was the hottest act on Columbia Records in 1949, with six top-10 singles, including his signature, "Candy Kisses." Gene Autry and Jimmy Dickens were still charting on Columbia when 1950 rolled around, but Roy Acuff had his last chart hit on the label in 1948. Bill Monroe last charted on the label in 1949. Floyd Tillman had his last Columbia hit in 1949. Eddy Arnold and Pee Wee King were still going strong at RCA, and Red Foley and Ernest Tubb were Decca's flagship artists. Upstart Capitol Records was enjoying big records with Tennessee Ernie

Ford, Tex Ritter, Hank Thompson, Merle Travis, Tex Williams, and Jimmy Wakely. The Delmore Brothers and Moon Mullican were recording for King Records. Although Mercury's Patti Page was having success in the country charts, that label still hadn't seriously entered the country playing field. Yet it would be Mercury that, in 1952, opened the first permanent record-label offices in Nashville. MGM wasn't known as a strong contender in country, with just Arthur "Guitar Boogie" Smith charting for them in 1949, but with the signing of Hank Williams that was all about to change. When Hank first auditioned for the Opry in 1946, the biggest names in country music were Red Foley, Tex Ritter, and Eddy Arnold.

Red Foley, the Kentucky native who has sold over 25 million records, was probably the most beloved artist of the day, and the first country artist to have his own network radio show, *Avalon Time*, which costarred Red Skelton. He started out in 1931 at the WLS National Barn Dance in Chicago after a station talent scout heard him singing at Kentucky's Georgetown College. In an old interview, Red's father, Ben Foley, said Red was making $60 a week at WLS, which was a helluva lot of money back then. According to Ben, Red was just twenty years old and so homesick he stayed only a few weeks. But he must have missed the paycheck because he soon returned, only to have the Barn Dance management decide it had too many people on the show and cut him loose.

Red was married for a second time by then. After his first wife, Pauline, died in childbirth, Foley married Eva Overstake, known professionally as Judy Martin, one of the Three Little Maids singing group. When he told Eva he'd been fired from the show, she said, "Well, you may not have a job but you've still got a voice."

Red answered: "Yeah, but it's just an ol' hillbilly voice."

"It's the sincerity that matters," Eva retorted. "Not what kind of music you sing."

In 1937 Foley started headlining his own show on the new Renfro Valley Barn Dance, and he performed there for the next three years. Several stations, including Cincinnati's powerful WLW, carried the Renfro Valley Barn Dance, established by Kentuckian John Lair. Lair wore many hats in the music business. He was a talent

scout, producer, writer, and singer in addition to running Barn Dance. He started Barn Dance partly out of his worry over the movie-generated western influences he felt creeping into country music. And he picked Red Foley as his big draw.

In 1940 Foley went back to WLS and the Barn Dance before coming to the Grand Ole Opry in '46. But one of country music's most tragic incidents gave Hank Williams a shot at hosting the Opry, and it was an incident that centered on Red Foley's personal life. Foley and Eva had been married since 1933, but in 1951, while Foley was at his peak, he began seeing a woman named Sally Sweet. When Eva learned of the affair, she committed suicide. Foley went into seclusion and Hank Williams ably stepped into his shoes on the Grand Ole Opry's Prince Albert Show. Foley would later marry Sally and return to music, hosting the *Ozark Jubilee*, where he helped launch the career of a young Brenda Lee among others, and where I would appear on his last show. Foley came back to Nashville in the early 1960s.

Tex Ritter was a Texas boy who got his start in New York in a college theater company. After making some waves on Broadway, he made a name for himself hosting a radio show called *Tex Ritter's Roundup*, where he sang many of the old folk ballads. Art Satherley started recording him on the American Recording Company label in 1932. During his 1932 and 1933 sessions, he cut "The Cowboy's Christmas Ball," "A-Ridin' Old Paint," "Every Day in the Saddle," and "Goodbye, Old Paint." "Rye Whiskey, Rye Whiskey" would become a 1948 standard. Ultimately, Tex would be inducted into the Country Music Hall of Fame, the Cowboy Hall of Fame, and the Songwriters Hall of Fame.

Hollywood was looking for a singing cowboy, and Ritter fit the bill perfectly, making films with Wild Bill Elliott at Columbia Studios, with Johnny Mack Brown at Universal, and with Dave O'Brien and Guy Wilkerson at PRC. Tex told me that the films he made were considered series westerns, because the stars were cowboy stars who seldom ventured from that category of film. The westerns might star people like Gary Cooper, who would move to other kinds of movies the next time out. Tex became the first country act signed to

the newly formed Capitol Records in 1942, and he had a string of hits, including his signature songs "Rye Whiskey," "Daddy's Last Letter," and "High Noon."

Signature songs are very important to an artist, and they have to figure on singing them as long as they have a career. I remember Tex telling me once about a rodeo he played in Montgomery, Alabama. It had rained all day and I guess the promoter decided to skip the concert that was supposed to follow the final event, the bull riding. Tex was sitting to the side, his guitar under his coat in the evening drizzle. The promoter simply said, "Good night, folks," and started turning off the big lights. Tex not only didn't perform, he didn't get paid, and he had to face at least one very unhappy fan. A fellow and his wife approached him and the guy snapped, "Tex, we drove fifty miles to hear you sing 'Rye Whiskey'!" Tex didn't miss a beat. "Sir, I flew two thousand miles to sing it!"

"High Noon," of course, was the theme of the movie by the same name. It took home the Academy Award for Best Song in 1953, and Tex said he wasn't sure he was going to remember the words because he hadn't been singing it that long. "I was as nervous that night as any night in my career," he recalled. "And Bob Hope didn't help any when he introduced me, saying, 'Here's Tex Ritter, who insists he remembers the words to 'High Noon.' " But Tex got through it fine, and it took its place in film history as well as in music.

Before he ever made a movie, Tex got the idea that there was one thing wrong with the series westerns. The cowboy never got to kiss the girl! So while making his first picture, *Song of the Gringo*, with Joan Woodbury, he insisted they kiss at the end. He called it "the big clinch." The critics loved the movie. *Film Curb* called it "a right smart western" and *Film Daily* said it was "above average drama." But Tex's idea proved to be a wrong one, because young boys wrote in by the thousands complaining about the mushy ending. That, said Tex, was his first and last screen kiss.

It was a kiss to remember, though, because it was through Joan Woodbury that a young actress named Dorothy Fay Southworth first heard of Tex. Dorothy was still a drama student in 1936, nearly two years from making her screen debut. Dorothy was lunching with her

friend Joan at a small café on the corner of Sunset Boulevard and Highland Avenue when Joan mentioned that she was getting ready to star in a picture called *Song of the Gringo* with a new actor whose name she couldn't remember. Dorothy said she couldn't wait to see the movie starring Joan and "Mr. What's-His-Name." Two years later, after Dorothy had acted in several pictures in quick succession, she took a bit part in a film called *Song of the Buckaroo*. By that time Dorothy was important enough that she probably shouldn't have accepted such a small role. But she was promised a starring role in another picture in return for the smaller role in *Buckaroo*, which required a woman with some riding skills. Dorothy was from Arizona, and while she wasn't a highly accomplished horsewoman, she could indeed ride.

Now the story gets a little convoluted here. Some sources say that Dorothy had already met Tex and was smitten with him by the time she took that role. But Tex told me a different story, one that may have simply been more interesting than the real version. Here's what Tex told me:

"The first time I saw Dorothy she was flying through the air," Tex said with a chuckle. "She had a small part, and was actually just going to be shooting with us a few days. One of her scenes called for a wild ride, where she led a posse. Of course, she had a stunt double—a man named Chick Hannon—who was supposed to put on a wig and go on that wild ride. But Chick was late, and since Dorothy had said she was a rider, they had her saddle up. When I got there, all I saw was the posse go one way and Dorothy fly off the horse in a different direction. She landed in a sitting-down position behind some bushes, then skidded so that it burned her. She was able to walk back to her trailer, but that burn was bad enough that she had to be taken to the hospital later. I always tell people the first time I met my wife I had to apply medicine to her backside. I didn't, of course, but it makes a good story anyway."

Dorothy continued to make films, including *The Philadelphia Story*, until she married Tex in 1941. This wedding was a new one on me, because they had two preachers. Dorothy wanted her Congregational minister, but Tex wanted his sister's husband, a Methodist

preacher in Texas. So both preachers read the vows. Maybe that's why Tex and Dorothy had such a strong marriage: They were double married.

I loved the cowboy movies. I even took my cap pistol to the theater just in case the cowboy star ran into any trouble. And I well remember standing in line as a ten-year-old boy to get Tex Ritter's autograph, so you can imagine how awed I was years later, in 1966, when I ended up as his cohost on the mighty WSM's all-night show.

I always liked talking movies with Tex, especially finding out how things worked on the set. For example, I once asked him why cowboys never seemed to have to reload their guns. "Now, Ralph, you are the only person who cares about that," Tex jibed. "It's called 'dramatic license.' The movie people figured the audience didn't want to sit there and watch a cowboy reload. They want action." Tex also explained that those beer bottles they break over each other's heads are made from plastic, and the chairs are made of balsa wood or yucca. "You've got to be careful swinging a yucca chair," he said, laughing. "Because you don't want it to break before it even hits the bad guy's head!"

Tex was capable of standing in awe of people, even if he was larger than life. He once told me about being a newcomer to Hollywood and spying Gary Cooper in a parking lot. "I think it was the only time I approached a public figure and introduced myself," Tex said. "But we were the only two people in the lot and it seemed like it would be all right. He'd heard about me coming out to Hollywood to make westerns, and he wished me well. It is one of my finest memories."

Another person he admired a lot was Jean Shepard. He'd almost been the one who discovered Jean, but as it turned out, one of his other discoveries found her first! Tex had been introduced to the music of Hank Thompson by his show emcee, Joe Allison, at a concert in Waco. He told his label, Capitol, about Hank, and as they say, the rest is history. Some time later Tex heard Jean Shepard sing with what he called a "voice as pure as honest dirt under your fingernails." He told her to make a tape and he'd send it to Capitol. Jean

said Hank Thompson had already done it and she had a deal in the works! I once kidded Tex and mentioned that Hank Thompson called him America's Fattest Cowboy, instead of his usual tag, America's Most Beloved Cowboy. Tex laughed and said, "Well, Hank ought to look at his friend Roy Clark!" Tex was also a big fan of Wynn Stewart, who sometimes gets overlooked as one of country music's great influences. Tex always said Wynn made a big impact on a generation of singers, and he certainly did.

Tex told me a strange story one time, and I still don't know if it's true but I'll pass it along. He had at one time worked in the production of *Green Grow the Lilacs,* which was later put to music and became *Oklahoma.* According to Tex, the south-of-the-border term "gringo," used disparagingly for Anglos, was actually a garbling of "Green Grow the Lilacs." Tex said that during the Mexican conflict of 1845 the American soldiers guarding Mexican prisoners sang the song. After the war the returning prisoners referred to Americans as "gringos."

Perhaps the best Tex Ritter story is about the IRS. It's a tale worthy of the wild and woolly westerns Tex starred in, and his reputation as a man who said what he thought no matter what. Keep in mind: Tex Ritter was an American patriot. But he hated the IRS. And the IRS had it in for Tex because he didn't keep good records and counted deductions they disallowed. Tex had a theory about the IRS. The first letter they write is nice. Throw it away. The second is mean. Throw that away, too. The third time they contact you is with a visit. One time the IRS guy came to visit Tex and kept asking him, "Are you stupid?" So after it was all over, they walked out to the guy's rented car and Tex asked, "Are you finished being a representative of the government?"

"Yes," the IRS agent said.

"Good," Tex answered. And he punched him in the face.

Tex was in trouble with the IRS from that day on.

But he remained America's Most Beloved Cowboy. And maybe that side of him was part of the reason.

◆ ◆ ◆

IN 1950 only one man cast a longer shadow than Ritter and Foley, and that man was Eddy Arnold. And if the troubled genius of Hank Williams eclipsed the straight-arrow image of Eddy Arnold, the reality is that their spheres of influence were probably equal. A few people have truly changed the face of country music: the Carter Family, Jimmie Rodgers, Roy Acuff, Hank Williams, Kitty Wells. And Eddy Arnold.

It is important to remember that many middle-class listeners were familiar with Hank Williams because of artists like Jo Stafford and Tony Bennett recording his songs. Hank's songs may have crossed over, but Hank did not. Eddy broke down virtually every barrier and made country music respectable. Consider this: In 1948 only six songs reached #1 on *Billboard*'s country chart. Five of those songs were by Eddy Arnold: "Anytime" stayed at #1 for nine weeks, "Bouquet of Roses" for nineteen weeks, "Texarkana Baby" for three weeks, "Just a Little Lovin' (Will Go a Long, Long Way)" for eight weeks, and "A Heart Full of Love" for one week. The only other artist to hit #1 that year was Jimmy Wakely with "One Has My Name (the Other Has My Heart)," which was at the top spot for eleven weeks. I think it's safe to say no one before or since has so completely dominated the charts.

Don Cusic put Eddy's influence into good perspective in his 1996 biography *I'll Hold You in My Heart* (Rutledge Hill): "In many ways the story of country music is a fight for respect. For a number of years country music and its performers were subject to stereotypical images of poor white trash. The most important thing Eddy Arnold did for country music was give it respect."

Eddy is a good friend of mine, and two stories always come to mind when I think about his long and overwhelmingly successful career. The stories have little to do with his hits or his record sales. The first story is about Eddy Arnold, champion laugher. When Eddy gets to laughing at something he considers really funny, he sometimes can't stop. It's one of those rare joys to hear his laughter, too. Chet Atkins told me this story: It seems that back in the early '50s Eddy went to see country entertainer Shorty Long in *The Most Happy Fellow* on Broadway. The show was written by Frank Loesser

and included some songs that went on to be big—"Big D" and "Standing on the Corner Watching All the Girls Go By." Well, there was a part in the show that was funny and Eddy started laughing. He kept right on laughing, too. In fact, Eddy was laughing so hard and so loud that they stopped the show for a minute. Of course most people in the audience had no idea that one of the biggest show business legends in the world was sitting in that darkened theater and creating an uproar. One person in the audience that night was Frank Loesser. Later a very irate stage manager started raising cane to Loesser about it and Loesser said, "Bring that guy back every night." Well, "that guy" was Eddy Arnold. Chet also told me that he specifically invited Eddy and Jerry Reed to Homer and Jethro's recording sessions because his laughter was so loud and so infectious. It created a domino effect.

George Morgan once reminded me of how Eddy could laugh: "I had only met Eddy once before I was scheduled to take his place when he was leaving the Grand Ole Opry," George recalled. "I'd just arrived in Nashville and was living downtown at the YMCA. The night I was scheduled to go on, I started out walking early because I didn't know my way around Nashville and only knew that the Opry was in the downtown area. I wandered all over and finally approached a couple of guys standing with their backs to me and asked if they knew where the Opry was located. Well, they turned around and it was Eddy Arnold and Gabe Tucker. Eddy thought I was joking, so he said, 'Hello there, I'm Gene Autry and this is Hoot Gibson.' Then Eddy and Gabe started telling jokes, and Eddy would laugh so loud I figured you could hear him all over downtown Nashville. I couldn't get a word in. Finally I stopped them and said, 'Look, I'm serious! I've got to be onstage in less than thirty minutes and I don't know how to find the Opry!' Eddy laughed again and pointed to the building we stood behind. 'That's the Opry, George! You're right behind it!' Every time Eddy Arnold sees my mother he tells that story, Ralph. And then he throws his head back and laughs that big laugh."

The other story I am always reminded of is the one about Eddy being refused a room at a swank Philadelphia hotel when the man-

ager realized he was a "hillbilly" singer. I told that story in detail in *The View from Nashville*. But I think it bears repeating when you consider just what this man has meant to this industry.

Eddy grew up on a farm near Madisonville, Tennessee, and started playing for square dances while he was a teenager. He made his radio debut in Jackson, Tennessee, then moved to station WMPS in Memphis. Eddy was singing in St. Louis in 1938 when he met the Grand Ole Opry's Pee Wee King, who was impressed enough to introduce him on his show at Kiel Auditorium. Pee Wee then hired Eddy for the princely sum of three dollars a day and five on the weekend. During World War II Eddy joined the WSM Camel Caravan traveling show, sponsored by R. J. Reynolds and featuring Pee Wee King and Minnie Pearl. After the war Eddy stayed as the featured vocalist with Pee Wee's Golden West Cowboys until going solo in 1943.

While Pee Wee hated to see Eddy go, taking two of the Golden West Cowboys (Roy Wiggins and Speedy McNatt) with him, Pee Wee later said it was the smartest thing Eddy could have done. He wrote in his 1996 autobiography, *Hell Bent for Music* (with Wade Hall for the University Press of Kentucky): "Leaving me was a smart professional move for Eddy. Sometimes a person has to grit his teeth, close his eyes and plunge right in. Unless he does he'll never know whether he'll sink or swim. It was soon obvious that Eddy was going to swim."

Another key element fell into place in 1943 when Colonel Tom Parker read an article in a 1943 issue of *Radio Mirror*. The article pointed out that although Eddy was a newcomer to the Opry, he was an experienced entertainer. Then, in 1944, Opry backstage comedy act Jam Up and Honey hired Parker to promote some of their shows. Eddy told me that it was on those outings that the Colonel went from interested to impressed. In the fall of 1945, Colonel Parker became Eddy's manager.

Eddy was impressed with the Colonel, too, understanding that Parker was a shrewd businessman. Eddy handled the songs and the song selection and recording. The Colonel saw to it that Eddy was out in front of crowds and that he got paid well. Even after Eddy and

the Colonel parted ways, they remained great friends. Eddy said they spoke on the telephone on a weekly basis, and when the Colonel died, Eddy spoke at the funeral. Whatever else people may think of Colonel Tom Parker, he inspired loyalty in two of music's biggest stars: Eddy Arnold and Elvis Presley.

By 1945 Eddy had his first Victor Records chart single, "Each Minute Seems a Million Years," which went to #5. And in 1946 his climb to the top was evident to all. Eddy says his real career boost was the 1946 hit "That's How Much I Love You," a song he initially heard as a novelty tune he didn't like. But as Eddy noted in his 1969 memoir, *It's a Long Way from Chester County* (Hewitt House), RCA's Steve Sholes couldn't have been more right when he told Eddy, "They always sound so much better after they become hits."

Eddy kept right on having hits, and the bigger his career became the bigger his frustrations with the Grand Ole Opry. At that time the Opry ruled country music. It took Eddy Arnold to break that viselike hold and prove that artists could go their own way and remain on top. The Opry managers always said they "made" country stars. But Eddy knew what had made him: his recordings. And with his daily national radio show on Mutual Networks, Eddy certainly didn't need the Opry to keep him in people's living rooms. Colonel Tom Parker agreed that Eddy should leave. After all, the Opry demanded 15 percent of the artists' bookings in addition to the required Saturday-night performances. With Eddy's stature through-out the country, he could make far more money and never miss a step in the visibility department. Other artists had tried to separate from the Opry. Roy Acuff had left in 1946 but returned as soon as his bookings started to slack off. Back then, it was a confined world that centered around the Opry. Publishing hadn't really entered the pic-ture. Record labels were in New York or Los Angeles. In Nashville, it was the Opry.

"How can you leave the Opry, Eddy?" an Opry official asked in 1948, when Eddy told them of his plans. "After all, the Opry made you!"

"If that were true, the Fruit Jar Drinkers would be the biggest act in America," Eddy answered.

Steve Sholes and Eddy were among the few who prepared for the musicians' strike of 1948, too. They stockpiled sessions, and while many artists were cooling their heels with nothing to release to radio or the public, Eddy Arnold never missed a beat. Even though Eddy knew very well that he was a star, he was still a little scared when Frank Folsom, the head man at RCA, asked to see him one day. Eddy feared Frank might drop him. The man said, "Eddy, every week I get pages of sales figures across my desk. And every week you outsell every other artist RCA has." Eddy said to me, "Well, Ralph, I figured out right then that they weren't going to drop me."

Eddy Arnold became a separate and equal entity in country music. On the one hand, you had the Opry, and on the other, you had Eddy. Pop singers as well as country singers watched Eddy to see what songs he made successful and then often covered them, taking full advantage of Eddy's track record. For example, Eddy had a big hit with "That's How Much I Love You" in 1946 and Foley covered it the next year. Bing Crosby and Frank Sinatra also covered it. Eddy appreciated Bing Crosby a lot. Crosby had quite a few releases with country songs, and as Eddy says, "Bing never sang down to them."

I fear that the country music industry takes Eddy for granted now, possibly because of the Hank mythology that started right after Hank Williams's death. And you have to wonder whether Hank could have sustained his momentum if he'd lived. His records were still holding up, but he was rapidly losing the will and the ability to back them up with a tour. But the drinking and the early death became as much a part of the legend as the songs and performances. It's a fact that back in those days a lot of performers were hell-raisers. A lot of the entertainers were big drinkers. The difference had to do with whether it affected their work. In Hank's case it did. The Opry worried about the public's view of country music, just as the Country Music Association did later. In fact, once, when legendary Texas hell-raiser George Jones was coming to town to record, the CMA sent representatives to warn George to stay sober. Unfortunately, they picked the wrong two men to show up at George's hotel room. They picked Tex Ritter and Johnny Bond. The three men sat around

praising sobriety for so long they started toasting it by passing around a bottle. Soon all three were drunk. But for the most part, they got by with their drinking because they made more shows than not.

I fear that if Hank had lived, the younger generations might have forgotten him. A lot of legendary talent has been forgotten or ignored. For a time even Patsy Cline was largely forgotten by much of America. When Barbara Mandrell was doing her weekly television show, she suggested to the producers and writers that they do a show about Patsy Cline. Their answer: "Who is Patsy Cline?"

But Eddy himself became as big as the Opry; once he got his career rolling, Eddy was selling between 600,000 and a million records with each release. He was the biggest thing on RCA, bigger than Perry Como and Vaughn Monroe, bigger than the whole pop division. Those are astronomical figures for the time. So astronomical that RCA's president, Frank Folsom, used to stop by Nashville in the company plane and take Eddy on some of his business trips. That was big respect for a country boy back then.

And it was in 1950 that another man who gave country music a lot of class and dignity first appeared on the Grand Ole Opry—Tennessee Ernie Ford. Ernie was a wildly popular West Coast deejay on Pasadena's KXLA when Cliffie Stone discovered him and helped him sign on as a regular at Los Angeles's *Hometown Jamboree* television and radio shows. As a matter of fact, Joe Allison replaced Ernie and says he spent the first few weeks taking nonstop "Where's Ernie?" calls. And while Ernie used lines like "Bless your little pea-pickin' heart," he never held the music or country people up to ridicule in any way. No doubt his huge 1949 hit, "Mule Train," spurred the Opry to invite him to perform, and there's also no doubt that his television shows in the 1950s and 1960s helped promote and expand country music throughout the nation. One of my favorite Ernie Ford stories is about his signature song, "Sixteen Tons." Ernie was on my radio show one night and I mentioned that I still remembered the day a friend of mine ran in with a copy of "Sixteen Tons."

"You gotta hear this!" he exclaimed.

I listened to the song and literally got a cold chill. It was that

good. Some years later I told the song's writer, Merle Travis, about the incident and he shrugged it off: "Oh, that ole song?"

In some ways "that ole song" had been Ernie's first opinion, too. "I first got that song when I was doing my television show five days a week. You have to really hunt for material when you have that much time to fill, and somehow I got hold of 'Sixteen Tons.' I performed it on the show, and later at the Indiana State Fair. Well, the show caused some other complications. I was working so hard on it that I hadn't been in for any of my Capitol recording sessions. In fact, I was almost in breach of contract! So I went in and brought the first two songs I could think of—'Sixteen Tons' and 'You Don't Have to Be a Baby to Cry'—convinced that 'You Don't Have to Be a Baby' was the A side."

There's an old music business saying that goes: "If I could always pick the hits, I'd open an office." Nobody could have dreamed what would happen when "Sixteen Tons" was released. The song sold a million copies in just twenty-one days, which was unheard of.

A lot of people asked Ernie if he hated having to sing that song every time he stepped on a stage, and his answer was always "No way!" Every artist wants and needs that one huge signature song, the one they will be remembered for and for which they will always be in demand.

I'd always heard that there was some negative response to the song, that some people objected to what they considered a bad portrayal of poor people. Ernie said when anyone asked him about that, he said his father and grandfather had worked the mines, and until John L. Lewis came along, the man who owned the mine owned the company store. "Men were paid in script, and they stayed in debt to the company store," Ernie said. "That's just the way it was."

But, he added, one time he was told a tale along those lines that took him aback. "I was in Hawaii standing on the beach looking out at the ocean," he explained. "There was one other man on the beach that day and he kept looking my way. Finally he approached me and asked me if I was Ernie Ford. I said I was, and he introduced himself as a vacationing electrical engineer who had homes both in New

York and in Israel. Since he spoke fluent Russian in addition to English and Hebrew, when he was at his home in Israel he always tuned his radio to *Music of the World,* on a Moscow radio station. The announcer played 'Sixteen Tons' and commented: 'It's a wonderful song and it shows you what life is like in America. Everybody works and they never get paid!' "

Tennessee Ernie remains one of my favorites of all the country music stars I have met through these fifty years. He was a simple, seemingly accessible man with talent and class—just what country music needed to get America's attention.

It was a simple time all around back then as the decade of the '40s waned. Harry Truman was in the White House. Mail was still delivered twice a day in Nashville. You could rent a five-room house near Vanderbilt University on Highland Avenue for $65 a month and buy a used Chevrolet Fleetline for $695. You could even pick up a 1947 Cadillac for $1,995. Food was cheap. A 25-pound bag of flour sold for $1.38 and corn was a dime a can.

A new comic strip called *Peanuts* made its debut to rival favorites like *Blondie* and *L'il Abner. The Jack Benny Show, What's My Line,* and *You Bet Your Life* debuted on television. New products in the stores included Minute Rice and hair-color kits from Miss Clairol. A company named Xerox started selling copy machines.

If Marilyn Monroe and Marlon Brando were the sex symbols of the generation, a kid named James Dean was quickly becoming the icon of troubled youth. Nashvillians could see their favorite stars at first-run theaters like the Paramount on Church or the Knickerbocker Theater on Capitol Boulevard or Loews at the intersection of Church and Capitol Boulevard. They could buy a copy of the just-released Betty Crocker's picture cookbook or pick up a copy of Henry Morton's runaway best-seller *The Cardinal,* at Ziebart's Book Store on Church Street. The New York Yankees, counted out by most as a contender in 1949, went on to become America's team, winning eight out of ten pennants in the '50s and six World Series.

On the surface it was a simple time. Yet Americans feared a dis-

ease called polio far more than drugs or schoolhouse violence, and they were not only staring at the Cold War era, President Truman had committed troops to Korea. Several young men who aspired to music careers put them on hold to fight the Communist peril. Johnny Cash joined the air force, Sonny James joined the army, and Mel Tillis tried in vain to convince the military that his stuttering wouldn't be a problem if they allowed him to train as a pilot. The air force decided it might be safer to allow him to work for the war effort on the ground. Faron Young was drafted into the service and replaced Eddie Fisher on the Special Services circuit.

Pop stars like Frank Sinatra, Jo Stafford, Rosemary Clooney, Frankie Laine, Nat King Cole, and the Andrews Sisters dominated music. Country entertainers were still called hillbillies. Eddy Arnold might have been selling more records than his company's pop artists, but the trade publications still catered to the pop side of the business. *Hit Parade*'s top-10 songs of 1950 were: "Goodnight Irene," Gordon Jenkins and the Weavers; "It Isn't Fair," Sammy Kaye; "Third Man These," Anton Karas; "Mule Train," Frankie Laine; "Mona Lisa," Nat King Cole; "Music, Music, Music," Teresa Brewer; "I Wanna Be Loved," the Andrews Sisters; "If I Knew You Were Comin' I'd Have Baked a Cake," Eileen Barton; "I Can Dream, Can't I?," the Andrews Sisters; and "That Lucky Old Sun," Frankie Laine.

Country music, or as *Billboard* then termed it, folk, country & western, was, in fact, small news in that trade publication. *Billboard* spent far more time on articles about movie stars like Joan Crawford and Jimmy Stewart vying for radio shows and Danny Thomas's negotiations for a television show than on Nashville doings. Then again, with the exception of Acuff-Rose, Nashville advertising dollars weren't contributing much to the magazine's coffers. Ads for roller-rink opportunities, mechanical pecking chickens, and fortune-telling machines and slot machines filled out where pop music left off.

But by the late '40s, thanks to Eddy Arnold, Red Foley, Tex Ritter, and Tennessee Ernie Ford, country music was starting to gain a

wider acceptance and a wider audience. And if you look back at the massive success of a song like "Pistol Packin' Mama" you'll see that Americans liked music with some grit. All country music would need to take center stage was the right person at the right time. And that man was Hank Williams.

PART 2

Hank Sets the
Standard as an
Industry Takes Shape
in the 1950s

—◇—

Hank Williams:

Elusive Legend

*H*ANK WILLIAMS PACED the floor. He could hear the
crowds out front clapping for first one act and then
another. Roy Acuff. Cowboy Copas. George Morgan. It was a formi-
dable lineup. And never mind that he was known to brag about his
ability to wow a crowd, this one show meant the world to him. This
crowd in particular had to love him. Hank was closeted backstage in
the Opry manager's office and he knew damn well why. They still
didn't trust him to stay sober, and even if he hadn't snapped to the
reason for his seclusion, Audrey would remind him easily enough.
He stared down at his guitar case, thinking back to when he'd first
begun to learn to play on the streets of Montgomery with old Tee-
Tot. He'd come a long way since then, since the days when he'd
been fired from radio jobs for drinking, from when he'd stop people
on the street and offer to sing them a song for a quarter. He'd hooked
up with Roy Acuff and Fred Rose, two of the most powerful men in
Nashville, and Hank knew it had been a lucky day for him when
Audrey dragged him into Fred Rose's office and told him to sing.

Still, nothing that had happened in the past meant anything now. This was the moment he had to grab; his music had to hypnotize the audience.

Hank had something to prove. After a year of playing the *Louisiana Hayride*, he'd finally gotten a guest spot on the June 11, 1949, Grand Ole Opry, during the 9:30 to 10:00 P.M. Warren Paint–sponsored segment hosted by Ernest Tubb. He planned on making it count. And as he always did, he had to work himself into a moment of supreme confidence. As he always told the Drifting Cowboys when they followed an act: "Boys, we'll kill 'em."

The Opry kicked off that night with Roy Acuff's 7:30 P.M. American Ace Coffee Show featuring Acuff and Uncle Dave Macon among others. Acuff and Macon were longtime Opry veterans and crowd favorites. Next up was the 8:00 to 8:30 Purina Show with Cowboy Copas and George Morgan. Copas was riding high with hits like "Filipino Baby," "Signed, Sealed and Delivered," and "Tennessee Waltz." Copas and George Morgan had dueling versions of "Candy Kisses" out that year. Copas had released his version a week before George's version back in February '49. They were both hits, but of course, while Copas hit the top-5 with his, George had the definitive version and stayed at the #1 spot for three weeks. George was on a real roll right then. In 1949, the year he debuted on the charts, he had six top-5 singles! Lazy Jim Day followed George and Copas.

The Opry's flagship show was next, the 8:30 to 9:00 P.M. Prince Albert Show, emceed by one of the two biggest stars in country music at the time, the great Red Foley. As I mentioned earlier, the other biggest star, Eddy Arnold, had left the Opry when he figured out that he was losing money hand over fist by committing his Saturday nights to Nashville and WSM. Jimmy Wakely was on with Red and he would end up with one of the biggest hits that year when he and Margaret Whiting took the Floyd Tillman song "Slipping Around" to #1 for seventeen weeks on the country charts and three weeks on the pop charts. Still, I don't believe even the across-the-board drawing power of Foley and Wakely posed a threat to Hank. He knew what "Lovesick Blues" did to audiences. It drove them wild.

At 9:00 P.M. Acuff was back with the Royal Crown Cola Show and Jam Up and Honey, another Opry audience favorite. Then, at 9:30, Ernest Tubb took center stage with the Warren Paint Show. Hank was fourth on the roster, following Lew Childre singing "My Mammy" and Ernest Tubb with "Biting My Fingernails Thinking of You." Bill Monroe followed Ernest, but the program doesn't list what he sang.

Through it all, Hank waited. Finally they came for him. "You're up, Hank." His time had come. The minute he began to sing, to sway and moan "Lovesick Blues," his fears evaporated. He had the Opry crowd in the palm of his hand.

Opry officials Harry Stone, Jack Stapp, and Jim Denny stood backstage and watched as the tall, skinny Williams sang "Lovesick Blues" and brought the house down. He received six encores and might have had more if Ernest Tubb hadn't come onstage and quieted the crowd. You have to feel sorry for the next act, the Crook Brothers, with their rendition of "Old Joe Clark." It was hard even for Hank to follow himself that night. He was back on the 11:00 P.M. Allen Manufacturing Show with emcee George Morgan. Hank sang "Mind Your Own Business," and while the crowd again whooped and hollered, they weren't as far over the top as they'd been with "Lovesick Blues."

Little Jimmy Dickens was also standing backstage. Like many of the Opry stars, he'd heard about Hank, but Jimmy hadn't seen him perform until that night in June 1949. "The crowd wouldn't let him off the stage," Jimmy recalls. "I'd never seen anything like it. Still haven't."

I've asked many performers who knew Hank about that magic, and no one seems to be able to explain what it was that he had. Jimmy said that over the years he'd tried to figure it out. "I never could decide if it was the way he moved, or his voice, or the songs—or all of them together. But what he did was electrify an audience. He'd get right down into a song. He'd bend his knees, hump over the microphone a little and sway with it." Minnie Pearl compared Hank's appeal to that of Elvis Presley, with one big difference: Elvis's biggest fans were women. Hank grabbed everybody's attention. Men loved him, women loved him, and kids did, too.

One of Hank's close friends, Buddy Killen, was playing at the Opry back then, and he thinks a key element was Hank's rawness. "Hank was country to the core, backwoods country, and it gave him an honesty of both words and emotion. He didn't just sing songs to those audiences, he explored their lives and let them know they weren't alone. Back then there weren't that many people doing what they call 'confessional' songs."

Hank Thompson was another close friend. In fact, back when they played dates together, the two Hanks flipped coins to see who closed the show, and Hank Thompson says he always prayed he'd lose. Nobody wanted to follow Hank Williams. Hank Thompson once described what he saw as the Williams magic: "His projection was dynamic, with that clean, crisp voice. He sang songs with meaning to them—meaning that people could grasp, could take home with them. They could hear it, feel it, and touch it. He sang with such authority, and a sort of abandon—like he was saying, 'I'll do this my way, and if you don't like it, that's fine, because I do.' And of course, people loved that attitude and respected him for it."

Mitch Miller, who called Hank one of music's two best writers, Stephen Foster being the other, also summed up Hank's appeal. "Hank had a way of reaching your guts and your head all at the same time. No matter who you were, a country person or a sophisticate, the language hit home."

Hank was referred to by many critics as "the hillbilly Hammerstein" or the "hillbilly Shakespeare." He would probably have preferred the Hammerstein comparison to Shakespeare because his most pointed insult about another songwriter was to say: "He's no good a' tall. He writes just like Shakespeare." His best compliment was: "Say, that's really good. It's really maudlin!" What he meant by that was that it was heartfelt. As Hank often said, "I can't read a note except in my heart."

He missed subtlety in conversation. For example, he was asked why he wrote so many sad songs and he remarked in all seriousness, "I guess I'm just a sadist." When I first read that Hank used a word like "maudlin," I wondered if it was a mistake because it didn't sound

like a word he'd have used. But when you think about it, he was around people like Fred Rose, more sophisticated people who probably had wide-ranging vocabularies. Hank seemed as if he always wanted to better himself, and he probably picked up and used words whether he quite understood the meaning or not.

I can identify with that because I was ignorant as hell when I came out of high school. I learned more at work than I ever did in school. I'd hear a word and try to use it properly. I'm sure that many times I made a fool of myself doing just that, too! Like all of us, maybe Hank wanted people to perceive him as a little smarter than he really was. In a way, it's a very endearing trait of Hank's, that wanting to make himself better, to expand and upgrade his vocabulary. Still, the lack of some language skills didn't stop him from writing some of country music's classic compositions.

The Opry's management knew about his appeal long before Hank ever graced their stage. He auditioned for them in 1946, but nothing came of it. And by the following year, Stone, Stapp, and Denny knew about Hank's drinking. After all, Hank Williams started drinking when he was only eleven years old, and by the time he was thirteen he was a full-blown alcoholic. Even though Hank had scored a 1947 top-5 hit with "Move It on Over," the Opry didn't think they could take a chance with him. So in 1948 Fred Rose decided to get Hank a spot on the *Louisiana Hayride* to prove himself. Back then people thought it was like starting out in the minor leagues, even though the *Hayride* was certainly a top-notch show. The Opry folks were keeping their ears to the ground to see if Hank could stay sober.

The recently founded *Hayride* was only too happy to get Hank Williams. Broadcast from Shreveport's Municipal Auditorium over KWKH's 50,000-watt clear channel, the *Hayride* was often referred to as the "Cradle of the Stars." When Hank got to Shreveport on August 7, 1948, the mainstay acts were the Bailes Brothers and Johnnie and Jack, Johnnie Wright and Jack Anglin. Johnnie Wright's wife, Kitty Wells, appeared with the duo, but in 1948 she was four years from a Decca recording contract and her signature hit, "It Wasn't God Who Made Honky Tonk Angels." By the time Hank

did come to the Opry, he had several hits under his belt; 1948 was a breakthrough year. "Honky Tonkin' " peaked at #14 in *Billboard*, and "I'm a Long Gone Daddy" made it to #6. In 1949, when Hank played the Opry, "Lovesick Blues" was firmly entrenched at #1, where it stayed for sixteen weeks. It made no difference; Hank Williams still made the Opry nervous.

Hank certainly wouldn't have been the first or the last hard drinker to grace the stage of the Grand Ole Opry, and I'll give you a personal example, even though it's a little out of our time frame. During my first three or four years at WSM, I wasn't on the Opry. I was the all-night disc jockey and general utility man. I didn't get to be on the Opry until 1961. One night I had Roy Acuff's segment and I knew Roy had been drinking. He wasn't falling-down drunk, but he was high as a kite and he knew it. I wondered just how he planned on singing without the audience knowing it, too. Well, they played the theme song and I introduced the star, Roy Acuff.

"Well, all right," Roy said. "It's nice to be with you folks. Now let's hear Jimmy Riddle play one."

So Jimmy Riddle played a tune on the piano and I went to a commercial. Acuff came back out.

"All right," he said. "Let's get June Webb to sing one for us."

June sang her song, and Acuff again stepped forward.

"All right, let's get Big Howdy Forrester to fiddle one for us."

And Big Howdy played his fiddle.

Acuff didn't sing one song during the whole thirty-minute show.

The Opry officials knew very well that Acuff was drunk, but they correctly surmised he wouldn't embarrass himself. Hank Williams was a different story.

Hank was a binge drinker. He'd stay sober for weeks and months at a time, then something—Don Helms, his friend and steel guitar player, says he never figured out all the triggers—would set him off. Hank explained it by saying there was "a busting out" inside him. And who knows, maybe that "busting out" helped write those songs. Don didn't realize Hank had a problem when he first started playing with him in 1944, but Hank's mother, Lillie, told him Hank had fought the battle since he was very young. Don and the band ran

interference for Hank as much as they could. They'd haul him off to a drying-out place in Madison, Tennessee, if he got too bad, and try to keep him sober before shows. Hank hid liquor everywhere. He'd put little miniatures in his boots, his guitar case, once even in an atomizer in a hotel bathroom. Once, Don had to bail him out of jail in Andalusia, Alabama, where he and Audrey got into a fight that went public when Hank threw all her clothes out of the motel room. Don says he went in the jail and stood there looking at Hank, who was disheveled, unshaven, and bleary-eyed. Hank looked up and said, "Well, what do you want me to do? Stand on my head? Let's get out of here."

"When Hank was drunk, he was like most drunks—aggravating," Don says. "But when he was sober, you couldn't find a better man. And he really was sober more often than he was drunk. There were those long dry spells when he wanted to talk baseball or go fishing or talk music. He loved to analyze people's lyrics. He was good at it, too. He could tell you where a song hit the mark and where it missed."

Hank Thompson never saw Hank Williams drunk in the years he knew him. "It was odd. I went over to Hank's house one day and he offered me a drink of whiskey. I accepted one, but Hank stayed with his soda. He told me he didn't dare touch even one drop or he'd be off and running. Hank understood what he was up against."

Johnny Wright, who played the *Hayride* with Hank, didn't see him take a drink until about a year after Hank and Audrey arrived in Shreveport. Johnny told me Hank was sober as a judge from the time he arrived in September 1948 until one afternoon in April 1949.

"We decided to have a picnic at the lake near Shreveport on Easter that year," Johnny recalled. "It was Kitty and me, the Bailes Brothers and their families, and Audrey and Hank. We had these picnics every year and we always brought along a big tub of cold drinks and beer. We hid Easter eggs for the children, and they had their egg hunt, and when things started winding down, Hank went over and picked a beer out of the tub of ice. Nobody thought anything about it. Then we moved on over to Johnny Bailes's house, which wasn't too far away, and ended up having a cookout that

night. Audrey was pregnant with Hank Jr. then, and she might have been mad about the beer drinking Hank had been doing and knew what was coming. But she didn't stay at the Baileses' for long. Hank did, though. Johnny had some whiskey in the house and Hank got started on hard stuff. When Kitty and I left the cookout, Hank was pretty stewed. Several hours later Audrey called, very upset, and wanted Kitty to come over. We went and couldn't believe our eyes when Audrey opened the door. Hank had torn up the entire house. Lamps were broken all over the living room and Audrey told Kitty that Hank had thrown them at her. Hank was passed out on the bed, and it didn't look like he was going to wake up anytime soon. Audrey was afraid, though, so Kitty and I said we'd stay the night. Even then I didn't grasp the severity of Hank's problem. Then Kitty went to the medicine cabinet to get Audrey her nerve pills. When Audrey looked in the bottle, there were only a couple of pills. She said there should have been ten or fifteen. Hank had arrived home raging drunk and swallowed them. We got a doctor over to the house and he kept trying to shake Hank awake. Finally Hank opened his eyes.

" 'How many of those pills did you take, Hank?' the doctor asked.

" 'You know, too damn much,' Hank answered.

"The doctor didn't think Hank was in danger of an overdose, so he left and told us to stay close to him just in case. Audrey was still scared so I slept in the bed with him. I lay there next to the wall listening to him breathe and I finally understood just how sick Hank was. But he pulled himself back together and the Opry never got wind of anything."

Hank stayed in Shreveport with the *Louisiana Hayride* for a year to prove he could stay sober and show up for his performances. Luckily for Hank, only Audrey, Johnny and Kitty, and the Baileses knew about his Easter binge. Two things probably figured into the Opry's finally asking him to appear. First, Fred Rose let Jack Stapp and Harry Stone put their names on a very valuable copyright, "Chattanoogie Shoe Shine Boy." I always wondered about that song and whether it was an inducement to let Hank on the Opry, because I never knew Jack or Harry to write a song. Buddy Killen recently told me that the two really did come up with the idea and told Fred he

should write it. Jack and Harry were standing out in the hall at the Opry one night and noticed the shoe-shine man flip his rag to a beat. They ran into Fred later and told him about the incident and suggested he write a tune about a shoe-shine boy, and even said "Chattanooga Shoe Shine Boy" would be a good title. Fred changed "Chattanooga" to "Chattanoogie," wrote the song, and gave it to them. I don't think there's any question that Hank's debut on the Opry was part of his motivation.

I had an odd and interesting experience with that song back when I was working at Lowes Theatre. In '47 and '48 I was working as an usher, then in '49 I got a raise from ten dollars a week to twelve, and got promoted to doorman. I didn't know a thing about the music business back then, so when a guy walked in carrying an acetate I didn't even know what it was. He didn't introduce himself and I never did know who he was, but he was very excited, explaining that he was holding a surefire hit—Red Foley's "Chattanoogie Shoe Shine Boy." Little did I know that within a couple of years I'd be spinning that record on the radio myself, or that a song Red Foley recorded would have been bartered for Hank Williams to play the Opry.

Of course, there was another reason Stapp, Denny, and Stone had to cave in to Fred Rose's demands that his top writer get a shot. Hank was making a lot of noise on the *Hayride* and it could easily have pulled attention away from the Opry. WSM was trying hard to establish Nashville as the country music capital. They needed the Opry's supremacy to be unquestioned, and to do that, they needed Hank Williams. When Hank stepped out onstage that night and drove the audience wild, there was no turning back. Within a year Hank was not only a member of the Opry, he was occasionally emceeing the Prince Albert Show and Nashville was on its way to becoming Music City USA. It was still officially Foley's show, but Hank was there often and it was high praise. The Prince Albert was the bellwether show, heard nationally on NBC.

The Opry kept right on using Hank. When the officials wanted to interest NBC in televising the show in 1952 and found they were up against a lot of competition nationwide, the star they dangled in

front of network executives was Hank Williams. And that was when he was already on a downhill slide. Even so, he had star power and they knew it. He had changed the face of country music and Nashville.

Hank showed singer/songwriters there was money in country music, and that Nashville was the place to find their piece of the pie. He also proved that country writers could get cuts from pop stars and make more money than they'd ever dreamed of. Fred Rose, by open-ing a publishing concern here and nourishing country writers, also led them to Nashville as surely as the Pied Piper. People have said that Hank was country's first superstar, but I question the validity of that statement. Country music had Eddy Arnold, who was a huge star before and after Hank. Country also had Red Foley and Tex Rit-ter. Looking back on it, I realize that I never thought of Ritter as a music star. It's odd how we pigeonhole people. I thought the same of Gene Autry. To me, Autry and Ritter were movie stars, and I suspect a lot of people felt that way about them. I know that years later, when Lorrie Morgan came to the Opry with her father, George, she was excited about the fact that a real movie star was there and asked Ritter for his autograph. That was the famous time when Ritter turned and said, referring to Lorrie and a friend, "Tell them kids to shut up!" And Lorrie promptly tore up his signature!

It's easy to lose sight of just what a superstar Eddy was because he just went out and did his job. He didn't have flamboyant stories told about him. I asked him once if he'd known Hank well, and he said no, just in passing. Eddy would have found little in common with Hank.

But Eddy was at the top in those days, no question about it. No one in country history spent more time at the top of the charts than Eddy Arnold. Not even Hank Snow who, with "I'm Movin' On," stayed at #1 for twenty-one weeks in 1950 and still holds the record for the biggest chart hit ever. Of course, today's entertainers don't have much of a chance to match him because songs aren't allowed to hang in at the top for very long. Certainly not twenty-one weeks. But in 1948, when Hank was in Shreveport proving himself, Eddy Arnold was at the top of the music charts all but two weeks that year.

But even though Eddy and Tex and Red were huge stars, Hank

Williams was the most *country* of any of these people. Moreover, he was succeeding with songs he'd written himself. Hank brought Nashville to the attention of the entire country, and when *Variety* made the pronouncement that Nashville was the hottest music town in the nation, I think it was due to Hank Williams and Fred Rose.

By the time the second half of the century rolled around, record companies were signing more and more acts. Hank Snow made his debut on RCA and Lefty Frizzell on Columbia. Another new Columbia artist, George Morgan, had debuted the year before with six top-10 singles! Faron Young followed Hank's example and joined the *Hayride* in 1952, and signed with Capitol in 1953. Webb Pierce, another *Hayride* veteran, signed with Decca in 1952. Hank didn't live long enough to see the excitement of country music in the 1950s, but he had led the charge.

THE SAD THING IS, Hank Williams has somehow been lost in his own legend, a legend that started immediately after his death, with sixteen tribute songs in 1953 and 1954 alone and an Audrey-led campaign to have him made the patron saint of country music. Somewhere in the deification process we lost Hank Williams the man.

One of the people who knew the man best was Ray Price, who roomed with Hank for about six months after he and Audrey split up. Hank had taken a liking to Ray and his music the first time he heard him, and invited him to guest on the Friday-night portion of the Opry, the Duckhead Overalls spot. Hank even talked Jim Denny into making Ray a regular, though he had no hit record yet. Of course, Ray proved that Hank could pick talent by debuting in 1952 with a top-5 hit, "Talk to Your Heart," and later by knocking Elvis Presley's "Heartbreak Hotel" out of the #1 spot with "Crazy Arms."

I especially wanted to ask Ray about one side of Hank. I'd always heard that he was intensely competitive and that he could be particularly ugly about it when he was drinking. I wondered if he was a little like Ernest Tubb, the most Jekyll and Hyde person I ever met. When Ernest was sober, he was the nicest man you'd ever meet.

When he was drunk, he was capable of making Mr. Hyde look like a librarian.

Ray said he thought Hank was a troubled soul who hid behind a facade of gruffness, of a hard-nosed attitude. Ray also thinks more people should have gotten tough with Hank, stood up to him and insisted he get help. "He was really a gentle man," Ray said. "He tried very hard to hide his feelings except through his music."

A lot of entertainers witnessed the competitive side of Hank. Hank would watch an act like Jimmy Dickens or the Bailes Brothers, then turn to his band and say, "We can eat them alive." Some saw it as arrogance, but Don Helms says it wasn't that as much as the fact that he understood his abilities and wanted to keep the band pepped up. "Hank was never haughty," Don reflects. "He just liked to remind us that we were as good as the next guys. And I don't remember a show where he didn't tell us we'd done great. 'Boys,' he'd say, 'we killed 'em.' "

Another insight is offered by songwriter Vic McAlpin. He was a frequent fishing pal and sometimes Hank's cowriter, who collaborated with him on "Long Gone Lonesome Blues." Vic once said that when you came up the way Hank did, you got kind of like a whipped dog and you didn't trust just anybody.

Minnie Pearl once said she thought it was too bad that remembering Hank later brought to mind the tragic figure of an emaciated and ghostly man, of heartbreak and hopelessness. Minnie didn't think that blaming his drinking on his marriage difficulties with Audrey was fair, either. She believed the problem was fairly simple: Hank suffered from severe depression. If it had been diagnosed and properly treated, maybe he could have pulled through. Minnie said that Hank was a paradox to her, on the one hand depressive and on the other a very funny guy, with a quick, sardonic wit. But as she said, a lot of unhappy people hide behind humor. She said she believed that's why her husband, Henry Cannon, warmed up to Hank so quickly. Henry had a great sense of humor, too.

Hank could come up with a good comeback line pretty fast, even if some of them might be considered politically incorrect these days. Don Helms tells this story: "One night Hank was onstage when a big

drunk guy walked up and said, 'If my wife ever turns the radio on again and I hear you singin' I'm gonna knock her brains out.' Hank shook his head and replied, 'I don't blame you. A lot of women waste time like that.' Of course, the joke fell on deaf—or drunk—ears and Hank ended up having to fight his way out of the place. But it was a good comeback anyway." Don also talked about Fred Rose not liking "Lovesick Blues." When he told Hank the song was out of meter, Hank said, "Well, Fred, when I get hold of a note I like, I'm gonna hold on to it."

Hank loved practical jokes, even when he was the butt of them. Don says Hank used to bum cigarettes off him all the time. One afternoon Hank was in a hotel in Hollywood, waiting for Nudie Cohn to phone him about a fitting for some new stage clothes. As usual, Hank reached over and grabbed a cigarette out of Don's pocket. But Don had removed all the smokes except three, and those three were the exploding kind. The phone rang just as Hank was lighting up, and about the time Nudie said hello, that cigarette exploded. Don said all that was left of it was a tiny bit of the butt sticking out of Hank's face. Hank laughed so hard he could barely carry on a conversation.

Then, as they left to go to the designer's office, Hank pulled the same trick on bass player Cedric Rainwater, whose real name was Howard Watts. He'd taken Hillous Butrum's place in the band in July 1950. But Cedric didn't think the joke was funny. In fact, Cedric nearly exploded. He got so mad and was raising so much cane that finally Hank handed him a wad of bills and told him to take another cab. "You ain't no fun and you ain't ridin' with us," he said.

I've always heard that George Morgan didn't really like Hank much and Don says that rumor may have been started because of yet another Hank joke. Once, when Hank was picked up for public drunkenness in some little Southern town, he told the police he was George Morgan. Then he sang "Candy Kisses" to prove it. It's possible that the reason Hank did that was because George Morgan wasn't a fan of Hank's singing voice and Hank didn't like this fact a bit.

People also use Hank as an example of anticommercialism. The thing is, though, while Hank's music was the most important thing

to him, he was also very aware of the commercial side of the business. He was quick to demand his fair share and quick to spend what he earned. Don told me that once, at the same time MGM was pushing for another album, Hank was negotiating for a new recording contract and decided to hold out for more money. They were offering something like three cents a record, and Hank wanted more. Fred Rose was sitting with Hank in the Acuff-Rose office, talking to New York by telephone.

"Sorry, Hank, they say they'll only go for the three cents," Fred said.

Hank leaned back in his chair and said, "Well, I don't believe I'm feeling like making any records right now."

Fred relayed Hank's response to the label executive, then turned back to Hank. "How would you feel if they upped it to three and a half cents?"

"I'm feeling better already," Hank said. "Let's cut."

Hank started selling products on radio shows—he knew it took sales to keep companies and careers going. He was a good pitchman, too, having learned the art at a very young age. In a letter to the *Montgomery Advertiser* on January 11, 1953, Hank's mother, Lillie Stone, explained, noting that Hank had gotten his first job at the age of six. By this time his father Lon's health was failing and he was hospitalized at the Veterans Administration Hospital in Pensacola, Florida.

Hank came up with a solution to the family's desperate situation. He was going into the vending business. Hiram, as he was called then, asked his older sister, Irene, to roast some peanuts at a friend's house and put them in some small bags. He took them to town and offered passersby a choice between a bag of peanuts or a shoe shine. Hank Williams made his first cash money that day: thirty cents. Lillie recalled that he went to the store and bought a dime's worth of stew meat, a dime's worth of rice, a nickel's worth of potatoes, and another nickel's worth of tomatoes.

"Mama, fix us some gumbo. We eat tonight," he proudly announced.

Of course, biographer Colin Escott, in his biography, *Hank*

Williams (Little, Brown), says that Lillie's recollections fail to include the fact that it was she who sent him out with the peanuts and she who counted his earnings carefully to make sure she wasn't shortchanged.

Hank's second day on the job resulted in another thirty cents, but this time he arrived home with firecrackers, caps, and a cap gun. Lillie said she spanked him until the matches in his back pocket caught fire. I doubt it was the last time Lillie lit a fire under Hank Williams.

"Little White Boss"

*W*HEN HANK WAS BORN, his parents, Lillie and Lon, were living in a rented log house that doubled as a little country store in Mount Olive, Alabama. In addition to the usual groceries and dry goods, Lillie sold the strawberries Lon grew. Lillie also played organ at the Mount Olive West Baptist Church and Hank loved nothing more than to sing the hymns while his mother played. The influence church music had on Hank can't be underestimated. He loved to praise the Lord and, even more, to sing the mournful, dirgelike tunes about death and damnation.

Fate has always played fast and loose with small farmers, and one early frost put the Williamses out of business. In 1924 Lon had to go to work for a lumber company. For a while the family lived in a box-car near Chapman, then moved to the place near Georgiana, and finally, in 1927, when Hank was four years old, Lon somehow scraped together the down payment for a house and ten acres in the lumber town of McWilliams.

It was there that Hank got his first musical instrument, a mouth harp given to him as a Christmas present by the grandmother of one of his friends, Edna Curry. Edna was an only child and very lonely

when she met Hiram and Irene Williams. They befriended her and, she said, brightened her world considerably. After Hank's death, Edna (now using her married name, Lamkin) explained that all three children, Hiram, Irene, and Edna, received ten-cent harps the year Hiram was five. Hank took to it immediately, and according to Edna, she and Irene kept trying to steal his. It seemed to be able to play "Home Sweet Home" with ease, while theirs held nothing but squeaks and squawks.

Hank's next instrument was a $3.50 guitar from Lillie. The day she brought it home Hank got so excited he ran out into the yard and hopped on the back of a calf. The calf promptly threw him off and Hank ended up with a broken arm. It didn't dampen his enthusiasm, though, and, cast or not, he was soon strumming away, determined to learn to play as well as the people he'd heard on the radio and at local shows.

The man who taught him and taught him well was Rufus Payne, a black street musician everyone called Tee-Tot. (The name stood for Rufus's habit of mixing liquor into his tea for a toddy while he played.) Tee-Tot took a liking to young Hank and spent a considerable amount of time with him, teaching him the bluesy, driving rhythm that became Hank's trademark. Lillie later said she paid Tee-Tot for the lessons by feeding him a meal from time to time. Tee-Tot got a kick out of Hank's brashness and desire to learn his craft, and nicknamed him "Little White Boss." Some believe that it was Tee-Tot who first played Hank the song that would bring down the house at the Grand Ole Opry: "Lovesick Blues." It wasn't long before Hank had added a little music to his street-corner peanut store and shoeshine business.

That Tee-Tot gave Hank musical inspiration is a given, but he gave him something far more important: a complete lack of racial prejudice. After Hank's death several people wrote to the *Montgomery Advertiser* about that side of Hank Williams's character. Jay Boddie of Prattville wrote: "Hank would just as soon speak to a colored man, woman or child as a white man." And Dollie Bee Anderson of Montgomery remembered her mother washing clothes for

Lillie's boardinghouse. She said she remembered two things about Hank: the fact that he was always singing and that both "colored and white respected him."

By July 1937, when Lillie packed up Irene and Hank and established a boardinghouse at 114 South Perry in Montgomery, Hank was ready to make his move into a country music career. He'd completely dropped Hiram and was calling himself Hank because of his admiration for singer Hank Penny, who recorded for ARC, King, RCA, and Decca. Hank always loved the western persona, and Hank Penny could certainly deliver a western swing tune.

I don't think it was any accident that the first place he set up shop was in front of WSFA Radio. The station's piano player, E. Caldwell Stewart, soon heard Hank singing and convinced WSFA to let him sing once in a while, billing him as "The Singing Kid." At the time Hank was singing a lot of material already released by Roy Acuff, a partner in Acuff-Rose, the company that would be key to his later success. And the thing Hank admired most about Roy Acuff was his sincerity, which would also be crucial to Hank's success. He once made the comment that when a hillbilly sang about his mother's death, he could see the coffin right in front of his eyes. It's odd that he used the word "hillbilly" in the first place because Hank is said to have disliked it very much. But it's possible he didn't mind the term until he got out in the world and realized it was often used derisively. WSFA immediately started to get phone calls about this new performer, although some of the staff had the sneaking suspicion that Lillie Stone was behind some of the calls. It brings to mind Colonel Tom Parker bringing in hoards of teenage girls to scream in front of RCA's studios when Elvis came to town. Then, of course, he'd turn right around and notify the press. Lillie was a strong woman and a shrewd one.

Lillie was by then firmly convinced that Hank was a star in the making and in 1937 she bought him a new Gibson guitar for Christmas. But if she was proud of her son's talent, she despised the way he handled money. He entered talent shows, then spent the prize money on liquor, which he was quick to share with his friends. Don Helms says Hank was that way all his life. Although he wanted to be

paid well, he was never miserly with his earnings; if a band member mentioned that he was hungry, Hank would grab a wad of money from his pocket, never counting it or wanting an accounting of it.

Hank started playing in bands around 1938, touring with Juan Lobo (Jack Wolf), a western singer and sometime actor who wore the full western getup and used cowboy jokes in his repertoire. Hank's love of western movies and his admiration for Lobo probably account for his adopting a cowboy image for his shows, though he would have had very little experience in that realm. Every band he put together was named the Drifting Cowboys. He also put together a band with his sister, Irene, and played the Alabama/Florida Ritz Theater circuit. The list of Hank's strongest influences up to that time would no doubt read: Lillie and the Mount Olive West Baptist Church; Tee-Tot; Acuff; and Pappy McCormick, an Indian who played steel guitar and was known as a master showman. When you put together his love of darkly religious songs, blues guitar, tear-jerking emotion, and showmanship, added to Hank's natural way with words and his high, lonesome voice, you start to see Hank Williams emerge.

Hank got his first taste of real success at a club called Thigpen's Log Cabin on Highway 31 in Georgiana. For the two years he played there, 1940 to 1942, Hank was the top draw. Hank didn't have any kind of sound system, so he learned to sing loud enough to overcome it. Years later, even though he loved, respected, and helped promote Lefty Frizzell, Hank sometimes shook his head in disbelief because Lefty had to sing into a microphone to be heard by the entire audience. Hank was a very confident entertainer, and I think that confidence started building right there at Thigpen's. He saw how easy it was to quickly move into center ring. The other acts booked just couldn't grab an audience the way he could.

Don Helms says Hank became even more dependent on Lillie during this time. He lived with her, she gave him money, drove him to shows or loaned him her car to get there, often booked his dates, took tickets, and handled the receipts. A lot of people have portrayed Lillie as overbearing and domineering, but Don says Hank needed that, and that she's gotten a bad rap she didn't deserve. And

Merle Kilgore agrees: "Like a lot of geniuses, Hank was lazy and he needed someone pushing him. And he loved his mother. He may have resented her bossiness at times, but under it all, he adored her. Lillie is where he got that affection for women who told him what to do, women like Audrey."

Hank needed Lillie to take care of business. After one short venture to Mobile to work in the shipyards, Hank returned home broke and uncertain of his future. Lillie had already taken care of it. She'd traveled all around Montgomery and the small towns surrounding the city putting together club dates. By the time her son walked in the door, his dance card was full. His confidence restored, Hank negotiated for and got a show on WSFA in Montgomery.

One out-of-town gig in late 1943 was a medicine show in Banks, Alabama, and it was there that Hank Williams met his muse. Audrey Sheppard and her aunt Ethel were driving through Banks on their way to a show in Troy. Audrey's daughter Lycretia wrote in her 1989 memoir, *Still in Love with You* (Rutledge Hill), that Ethel noticed people gathered around a stage on top of an old trailer, and suggested she and Audrey see what was up. The way Audrey told it to Lycretia was that she and Ethel left after Hank sang, when the announcer began selling his bottles of herbs. They were sitting in the car when Hank—never one to miss a sale—sidled up and asked Audrey if she didn't need some medicine.

When she looked up at him, he smiled and said, "No, I guess you don't."

They made some small talk, and Aunt Ethel invited Hank to come along with them to the show in Troy. He agreed, but only if the two women would stay around for his next show and pick him up the following day in time to get to Troy. Audrey showed up around noon and Hank staggered out of the old trailer, still drunk from the night before. She said he looked like a tramp, the complete opposite of the charming man she'd met the previous day. But Hank wanted to talk, and Audrey says he was so pitiful she decided to see what he had to say. After some coffee and tomato juice, Hank admitted he'd lost his radio job for being drunk. The following day, after being together twice, Hank proposed to Audrey.

The two married on December 15, 1944, and there was conflict between Audrey and Lillie from the start. Part of Lillie's unwillingness to accept Audrey was just the overprotective mother wanting to keep her son tied to her apron strings. But in Hank's case, there was also the business situation. Lillie was his acting manager, and Audrey started horning in on that role right away. She wanted to be included in everything from booking dates to being onstage. Don Helms says Hank hated conflict and that his way of handling the problem was to go out and get drunk in any one of a number of his favorite Montgomery bars. But both Audrey and Lillie were soon to be replaced as the pivotal figure in Hank's career, and it would be a man who understood alcoholism firsthand.

Fred Rose:

The Beginnings of

an Empire

\mathcal{E}ARLY ONE MORNING IN 1935, film-score writer Hy
Heath was on his way to New York's songwriting central,
the Brill Building, when he saw a filthy drunk shuffling along, head
down, stumbling in and out of the gutter. Just as he started to turn
and go into the building, the derelict looked up, bleary-eyed. *Good
Lord*, Hy thought. *That's Fred Rose.*

"Hello, Fred," Hy said, and started over to shake his old friend's
hand. Fred looked straight at Hy with no sign of recognition and
kept walking. Hy followed Fred around the corner and stopped him.

"Fred, I said hello to you," Hy said.

"Well, hello to you if it's any of your damn business," Fred
responded.

"Don't you know who I am?" Hy asked.

"No, and I don't care," Fred said angrily.

Fred tried to pull away, but Hy wouldn't let him. Hy, a Christian
Scientist, knew there was a Reading Room a couple of blocks away,
and he took Fred by the arm and led him there. Fred was too drunk to

put up much resistance. They sat down at the Christian Science cen-
ter and Hy tried to get Fred to open up. The last time he'd seen Fred
Rose, Fred was a successful songwriter and piano player. He drank too
much, but he didn't seem to be a candidate for the gutter. What Fred
told Hy frankly scared the devil out of him. He was living in a flop-
house. He couldn't even go to work because all he had were the filthy
clothes on his back. He hadn't eaten in days. Finally he confessed to
Hy what his intention had been that morning. Fred Rose was trying
to get to the George Washington Bridge so he could kill himself.

Hy was chilled at that news, and decided to try and salvage some
of Fred's pride.

"Fred, I know some people who owe you money," Hy said. "Let
me collect it and get you back on your feet." Hy convinced Fred to
stay at the Reading Room while he supposedly went to collect the
money. When Fred later told this story to his friend, A&R executive
Murray Nash, he said he remembered that a kindly little gray-haired
lady kept bringing him pamphlets and booklets until there was quite
a collection on the table next to him. He remembered looking
through a few things, but being too drunk to read much.

Hy went to the bank and withdrew some money from his
account, then stopped by a café and bought some coffee and sand-
wiches. After Fred wolfed down the food, Hy gave him the money
he'd withdrawn.

"Fred, I want you to pay up your rent and buy some clothes and
food. But I also want you to buy a Christian Science book. I'm not
going to give it to you. It'll be more meaningful if you pay for it. I
want you to go back to your room now. Stop drinking and start read-
ing. Call me in a week. Not before." Hy wrote down his phone num-
ber and put the piece of paper in Fred's jacket pocket.

The following Thursday Hy received a call. It was a day early and
Hy reminded Fred of their deal.

"No, Hy, I'm ready now," Fred declared. "I've read this book cover
to cover, over and over. I want to become a Christian Scientist."

I met Hy in 1953 when he came to Nashville to write with Fred.
The song they completed on that trip was "Take These Chains from
My Heart." Fred's name is on that song because, like Fred, Hy was an

ASCAP writer. I've often thought that Fred probably made sure he collaborated with Hy because of their old friendship. But until Murray Nash told me the story of Fred's gutter dive and Hy's role in saving him, I didn't realize just how much Fred owed the man.

Hy was the man who wrote "Mule Train." I was not only impressed by his credentials but by the fact that he was a very nice man. In 1953 I was a fledgling disc jockey who used to hang out at Acuff-Rose to get free records. They'd also send me their stars, people like Marty Robbins, who was one of the shyest stars I interviewed back then. For some reason Fred took a liking to me, and even sent a letter to the station congratulating us on the good job we did.

COMPARED TO Fred Rose's childhood, Hank Williams had it easy. Fred's parents split up when he was just a baby, but there was no strong-willed woman like Lillie to guide Fred. He was farmed out to relatives in St. Louis who treated him like a servant even as a small child. He started playing piano in some of the city's roughest bars for tips, bringing home every penny he'd made to pay for his food and lodging. Fred told one reporter that he'd been on his own since he was seven years old.

In 1917 Fred headed to Chicago and soon established himself as a mainstay at clubs on the city's South Side. He had some success as a composer, penning songs like "Sweet Mama (Papa's Gettin' Mad)," "Red Hot Mama" (for Sophie Tucker), and "Deed I Do." But Fred often lost jobs because of his drinking, which escalated throughout the 1920s; by 1933 he was traveling between Nashville, New York, and Chicago. By the time he came to Nashville, he was on his third marriage.

Some people have speculated that Fred didn't have much use for country music at first. And there's another aspect to Fred that sometimes gets overlooked. He had a contract with Columbia and recorded as the Rambling Rogue. He also had *Freddie Rose's Song Shop* on WSM. I understand that at one time Fred got a post office box where people could order his songbooks. He probably didn't

want WSM knowing how much he was making off the show! Back then, WSM didn't monitor things very closely. People had all kinds of side deals going. Today you'd never get away with any of it. It was pretty obvious to me that they ran a loose operation when they hired me, a twenty-four-year-old guy with six years of experience with various stations. They turned me loose on the all-night show and we didn't even sell any advertising. It was a way to promote the Opry. They handed me a handful of public service announcements and said *if* I had the time, I could read some of them, and if I did read one, to write it in the log. I rarely read any of the things because they were boring. I didn't think anything of it at the time, but they were turning me loose with a lot of clout. As Eddie Hill, the guy who preceded me, used to say: "There may not be anything to what I say, but it sure goes a fer piece!" He was right. Here's how far WSM went—we made it into the Cincinnati ratings books!

FRED ROSE MET three acts in Nashville that initially intrigued him: the Delmore Brothers, the Vagabonds, and Roy Acuff. The Delmores were a country act from Alabama, but one with a bit more sophistication due to their masterful guitar work and love of blues. Columbia recording artists Alton and Rabon Delmore had been signed to the Opry by Harry Stone in 1933 in an attempt to broaden the show's appeal to people on the East Coast. The Vagabonds—Curt Poulton, Dean Upson, and Herald Goodman—were very progressive and industrious businessmen in addition to having one of the most polished acts at the Opry. The trio not only formed their own production company and record label, but were among the first to start selling songbooks of their compositions. Harry Stone had signed the Vagabonds to the Opry in 1931, no doubt with the same intent as he later had when he signed the Delmore Brothers. There's a lot of talk about diluting country music, but the truth is, the business has always been looking for ways to broaden its appeal, whether by adding strings or bringing in acts such as the Vagabonds.

If Fred thought he'd be a fish out of water in Nashville, the Del-

more Brothers and the Vagabonds quickly assuaged his fears. But according to Hank Williams, it was Roy Acuff who caused Fred to gain great respect for the genre. Hank told an interviewer in 1952 that he believed Fred came to Nashville just to laugh at the music, but when he heard the sincerity with which Acuff sang, he began to see it in a whole new light. Like the Vagabonds, Roy Acuff was interested in the business side of music, or at least in making a profit. He tried from time to time to administer his own publishing, and he sold songbooks, saving every cent he made from the sales. That fact would play a decisive role in Fred Rose's future. By 1936 Fred had written a country hit for Tex Ritter, "We'll Rest at the End of the Trail," and he was soon writing for both Roy Rogers and Gene Autry.

Roy Acuff had been around Fred Rose enough to know that he had a head for business. He instinctively trusted the man, and moreover, so did Acuff's wife, Mildred. By 1942 Acuff had decided to invest $25,000 to launch a publishing business that would protect his copyrights and help sell his song folios. He approached Fred, the two went into business, and thanks to hits by Bob Wills (who Fred had met during a short stint at station KVOO in Tulsa) and Roy Acuff, Fred never had to touch a cent of Acuff's $25,000. KVOO was where Bob Wills based his act, and it's still rocking right along. Billy Parker's still there, and the station is a power in country music.

Acuff reminded me several times of that story of Fred taking the $25,000 and never using it. He was really proud of that fact, proud, I think, that his trust was so obviously well placed. I was proud to be a friend of Acuff's, and proud to say that I am on the very last recording he ever made of "Wabash Cannonball." It's not a big deal in the history of country music, but it's a big deal to me. *Nashville Now*'s puppet, Shotgun Red, and I did an album called *For Children of All Ages* during my *Nashville Now* years. Acuff loved that puppet. So when we decided to do it, I called Roy and said, "Mr. Roy, would you like to come sing with Red and me?" Now you wouldn't think that Roy Acuff would jump at the chance to sing one of his biggest hits with me and a puppet, but he did!

When Hank Williams came to Nashville in 1946, it was not the country music capital. To be sure, Nashville had WSM and the

Grand Ole Opry, but there were several cities, most notably Chicago, with the WLS *National Barn Dance*, or Cincinnati, with the WLW *Midwestern Hayride*, that could easily have become Music City, USA. In fact, Chicago's *Barn Dance* was a year older than the Opry. But it would be 1952 when *Variety* magazine called Nashville ". . . the hottest music town in the country," and that would be due in large part to Fred Rose and Hank Williams.

Not much recording was done in Nashville back then; the majors simply sent A&R (artists and repertoire) men through the country finding and recording artists. No national label had a permanent Nashville address. Columbia, Decca, RCA Victor, Capitol, and Mercury had country, or hillbilly, folk and western, as it was usually called, but truly country music was the stepchild of the industry.

For Acuff and Rose to start a publishing concern and actively seek out writers was a daring move. Until then most songs had been published through Northern companies. But Acuff and Rose had the Opry ace up their sleeves. By being close to these artists and writers, Acuff-Rose could often get songs under contract before companies like New York's Hill & Range even knew they existed. Hill & Range was founded in 1945 by Julian and Jean Aberback, two Austrian veterans of the European music market. The company liked to sign the already famous, and had Eddy Arnold, Ernest Tubb, and Red Foley in their stable. When Hank Williams broke wide open, his catalog alone put Acuff-Rose in the big leagues.

The Fred Rose–Hank Williams catalyst was Columbia's Art Satherley. Uncle Art, as he was known, was an interesting man and one of the most crucial to country music's development. He came to America from Bristol, England, in 1913 at the age of twenty-three. He loved America, especially the idea of the Old West, and called his new home the "Garden of Eden." His first job was with a company called the Wisconsin Chair Company. "My first job there was to pack chairs, grade lumber, and just generally make myself useful," Art once said. "They told me if I stayed with them, I'd see America. I had no idea how true those words would be!" When the Wisconsin Chair Company sold Thomas Edison one of their plants, the inventor met Art and hired him as his assistant. Since Edison was in the

business of making phonographs and records, that brought Art to his first experience with the recording industry.

It was only natural, then, that when his old bosses at the Wisconsin Chair Company decided to start Paramount Records, they hired Art back, away from Edison. Art took the job and learned the business from the ground up, doing everything from working the presses to managing the plant. Finally the owners asked him to go out and find some music. Art's British background came into play here, because he loved the old Celtic music, and knew it was being played in the South. He traveled throughout the Southern states, recording anywhere he could—hotel rooms, bars, churches. Once he recorded in a funeral parlor. He recorded Bob Wills on a night in Texas that was so hot the band stripped down to their shorts! And once when he recorded Roy Acuff in a hotel room, he cut a hole through the wall to install speakers in the bathroom.

Art met with problems, though, when he tried to get New York record distributors to handle his product. "They thought it was trash," he later said. "They told me I had a lot of nerve trying to sell them backwoods music." Then Art hit on an idea that probably did as much as anything to popularize country music. He cut a deal with Sears Roebuck and the company's catalogs got the music straight to the heartland. Cutting that deal for country music was a landmark act in our business. Young people today don't have any idea what outcasts we were even in the '50s and '60s. We were considered white trash, hicks, hillbillies—dolts. Today we are so widely accepted, people don't know what people had to face to get this music played or sold.

In 1927 Art was working for Plaza Music, owned by Consolidated Film Industries. The chairman and president of Consolidated, Herbert Yates, orchestrated the purchase of the American Record Corporation, which included the Columbia Gramophone Company. Art Satherley was named Columbia's vice president of country, dance and folk music. Over the next thirty years, Art traveled an estimated 1 million miles, and according to Columbia, made some 80,000 recordings. A few of the standards Art produced were Acuff's "Great Speckled Bird," Floyd Tillman's "I Love You So Much It

Hurts," Patsy Montana's "I Want to Be a Cowboy's Sweetheart," Tex Ritter's "Rye Whiskey, Rye Whiskey," and George Morgan's "Candy Kisses." He used to say that while he was rarely in the New York headquarters, he was blessed by bosses who understood how he worked and why. "Nobody at Columbia ever said, 'Where the devil is Art,' " Uncle Art once said, laughing.

Molly O'Day and her husband, Lynn Davis, had been touring Alabama in 1943 and heard Hank sing "Tramp on the Street," a Grady and Hazel Cole song Hank had reworked. Molly watched as Hank got four encores and decided she needed to record "Tramp on the Street." It's not surprising that Molly liked Hank's material and his delivery. Writer/artist Mac Wiseman once called her the female Hank Williams because of her intertwining of the high lonesome Appalachian-style music and honky-tonk. In 1946 Fred and Art happened to hear Molly on a Gatlinburg, Tennessee, radio station singing the song and Fred convinced Art to sign her to Columbia and let him produce her. When they started looking for songs, Lynn Davis told Fred about Hank Williams. Fred wrote him and asked for songs. Fred liked what he heard when Hank sent him an acetate and invited him to come see him in Nashville. Murray Nash was there the day Hank and Audrey arrived.

"I was sitting in Fred's office when they walked in, this tall, skinny guy with an impressive-looking blonde beside him. Hank didn't say a word but let Audrey do all the talking. Hank played some songs, and Fred sent someone to prepare publishing contracts on a couple of them. Then, after they'd signed everything, Fred asked Hank to sing him some more songs. Audrey said, 'No, we have to catch the bus back to Montgomery for a show.' That interested Fred even more, so he told Hank he'd send them some money to come back when he had a few days off. They did, and stayed four or five days out at Fred's house on Rainbow Trail."

At that time there wasn't any question of Hank's being an artist. Murray says Fred never considered it, nor did Hank. Hank wanted to be a songwriter. Don Helms agrees with this. He says Hank always saw himself as a songwriter first. Sure, he wanted to be heard on the radio, and play shows, but the idea of standing in the national spot-

light with the likes of Red Foley and Ernest Tubb wasn't what he sought.

Hank didn't sign an exclusive Acuff-Rose contract until April 12, 1948, the same month that Audrey first filed for divorce. Fred Rose learned about the couple's reconciliation when Hank sent him a postcard with a photo of a woman riding a mule. On it was the caption: "I'm not the first jackass to support a woman."

Once back together, Hank and Audrey neglected to do anything to stop the divorce proceedings, so when Hank Jr. was born on May 26, 1949, he was almost declared illegitimate. Audrey had to file papers to get the divorce annulled, which the circuit court of Montgomery didn't make official until August 9, 1949.

Murray also told me that it was Fred's secretary, Eleanor Shea, who loved Hank's voice and suggested Fred take him to Sterling Records when they inquired about a country act in 1946.

"I was in and out of Acuff-Rose all the time when I was with Victor and Mercury," Murray recalled. "When Sterling called Fred he didn't immediately think about Hank. But one day Eleanor said, 'You know, that Hank Williams has a nice voice. Why don't you record him on Sterling?' Fred took her advice and got the Willis Brothers to back him up. They released a couple of records but nothing much happened."

The Willis Brothers weren't impressed with Hank at all after the sessions. They thought his songs were rough and didn't care for his delivery. Vic Willis later said he guessed they just hadn't heard a country singer quite *that* country! Vic said Hank couldn't pronounce the word "poor," and finally Fred Rose insisted the Willis Brothers pronounce it Hank's way: "purr." Of course, the Willis Brothers had worked a great deal with Eddy Arnold, whose style was so sophisticated and smooth compared to Hank's raw energy. I'm sure that affected their thinking. Hank was also dressed poorly and was so skinny that, as Vic McAlpin said, they called him "Gimly-ass." Bass player Bobby Moore said he was so skinny he could sit back in a chair, cross his legs, and still put both feet on the floor.

Vic McAlpin used to come visit me at my all-night show all the

time, so I'd hear lots of Hank stories from him. He loved to talk about how much Hank loved fishing. It makes you wonder if a lake was one of the few places where Hank could really find some solitude.

Fred was making regular trips to New York to deal with ASCAP back then, so he took the sessions to Paul Cohen at Decca. Paul said he liked Hank's voice but he already had Ernest Tubb and Red Foley and didn't have room for any more country artists on the label. What Fred didn't know was that Paul Cohen was going to try to deal with Hank directly and ease Acuff-Rose out of the picture.

"Paul Cohen was a big gambler," Murray said. "And he was always in trouble over gambling debts at the Plantation Club in Nashville. So he had to try and get a cut of whatever he was recording. He'd call an artist in for a recording session in a hotel room or somewhere, get them to do fifteen or twenty sides and sign a contract. Most of these artists were unsophisticated people and had no idea they were signing away everything, publishing and all.

"Fred must have made the mistake of telling Paul he hadn't signed Hank to an exclusive yet because the minute Fred left Decca, Paul picked up the phone and called Montgomery information and asked for a guy named Hank Williams. Hank didn't have a telephone, so Paul got the idea to call some of Montgomery's cab companies. I guess he figured an entertainer probably took cabs a lot. Sure enough, a guy at one taxi company knew Hank and said they'd get a message to him. Hank called Paul back that same day and Paul started talking about a recording contract right off.

"Hank said, 'Well, you'll have to talk to Fred Rose, because he handles me.'

" 'Fred's small-time,' Paul said. 'I'm in New York and I can do everything for you. I can publish your songs, record you, book your dates.'

" 'You'll have to talk to Fred,' Hank repeated.

" 'That's what I'm trying to tell you, Hank. Fred can't do anything for you. I can."

" 'Well, Fred's not doing too bad so far. He's got you callin' me, hasn't he?'

"And with that, Hank hung up. Hank Williams was nobody's fool."

Paul's call to Hank was too late, anyway. Fred had gone directly from Decca to Frank Walker at MGM, who agreed to sign him on the spot.

What Paul couldn't have known, of course, was that in addition to being a basically local person, Hank loved and trusted Fred Rose, maybe, with the exception of Lillie, more than anyone on earth. Ray Price says that Hank believed Fred was the master when it came to songs and songwriting. When Ray had questions about his own material, Hank sent him to Fred, believing Fred could articulate his evaluations better than he. Which of course brings up the question of exactly how much Fred had to do with Hank's writing. Some people say he was more of a song doctor than anything, changing a word here or there or streamlining a melody. But it's possible that Fred's pop expertise contributed a great deal to Hank's writing songs that could easily be covered by pop singers.

Texas songwriter/radio personality Joe Allison came to Nashville in the fall of 1949, after Eddy Arnold landed him a local radio gig on WMAK. He says Hank used to stop by the station once in a while, but that it was obvious it was Audrey who'd pushed him into making the visits. Joe was close to Fred Rose, and says that Fred played a big role in Hank's melodies. "Hank would hang a lyric on any old melody," Joe recalls. "When I was a disc jockey in San Antonio I played a record by T. Texas Tyler called 'You'll Still Be in My Heart,' and it is note for note 'Cold, Cold Heart,' written much later. They sued over it and settled only when T. Texas Tyler got to record four sides for MGM. So Fred had to stay on top of it to try and keep the lawsuits at bay. Hank didn't mean to out and out steal a melody. I think he'd just heard the Milo discs and thought it was okay to use them. And a lot of those Luke the Drifter spoken-word records were straight out of Edgar Guest columns in the newspapers." Joe also recalls that Fred Rose knew exactly what he had with Hank Williams, a product.

"Fred told me once that he thought of Hank as a commodity," Joe says. "His exact words were, 'I think of him like Coca-Cola or General Motors. I want to build the name Hank Williams so that every-

one all over the world will be recording his songs.' And Fred did a masterful job of building him."

Joe thinks that Hank's singing was his strong suit. "I don't think there's been a singer before or after who could match Hank's delivery," Joe explains. "Once he'd sung a song nobody else could do it—he made them sound like amateurs."

Murray Nash told me how Fred changed the song "Kaw-Liga." "Every time Hank came to town I'd give him a tape and he'd put down new songs," Murray recalled. "This one day he came in and sang "Kaw-Liga," about this tribe of Indians living south of Montgomery, and a train song dedicated to his father. I was getting ready to run down to the post office and Fred asked Hank to go along with me. When we got back, Fred had turned it into a story about a wooden Indian and a mannequin. Fred didn't like the train song and didn't even mention it."

But Jimmy Dickens saw firsthand how quickly Hank Williams could pen a hit. The two were on their way to a show, flying with Minnie Pearl and her husband, Henry Cannon, in a small plane. Hank loved Jimmy and had already given him the nickname "Tater" after "Take an Old Cold Tater and Wait." Jimmy says Hank knew he was in need of a big chart record about then. "Tater," Hank said, "I'm gonna write you the hit you need." Minnie got a piece of paper from the glove box and handed it to Hank. In about fifteen minutes he wrote "Hey, Good Lookin'."

"There you go," Hank said. "That's your next hit."

The kicker was that Hank recorded it himself before Jimmy could even call Art Satherley at Columbia and book studio time!

ONE PROBLEM MGM had to contend with was a musician's strike set to begin on December 31, 1947, the day the American Federation of Musicians contract with all record companies expired. That meant MGM needed as many songs recorded before that time as possible. Hank came to town on November 6 and 7 and cut eight sides at Castle Studio, including "I'm a Long Gone Daddy," "Honky Tonkin'," and "Mansion on the Hill." It would be a year before the

recording ban was lifted and he recorded his breakthrough "Lovesick Blues" in Cincinnati, Ohio, in December 1948. It was a song Fred Rose hated so much he left the studio while it was being recorded. "The song's a mess," he said.

Hank didn't worry about that, because he'd played it live and the audiences had loved it. He told Fred the song was so hot that when he walked offstage and threw his hat down, even the hat encored. Hank studied his own show and others carefully. Merle Kilgore says Hank would sit and listen to other people's acts every day, critiquing them, learning from them. And Hank's band members told Jimmy Dickens that Hank studied him every time he went onstage. He knew "Lovesick Blues" was a hit, and he believed it so much he told several people that if it didn't make any noise he might even quit the business. Of course, he also told Fred Rose that he owned the song, that he'd bought it from Aulsie Griffin. Irving Mills and Cliff Friend had actually written it a year before Hank was born. Fred found that out when Irving Mills filed a lawsuit after the song was a hit. "Lovesick Blues" stayed at the top of *Billboard*'s charts for sixteen weeks.

Once "Lovesick Blues" got Hank on the Opry, he called up his old friend and steel player, Don Helms. Don had played with Hank early in his career but hadn't made the Shreveport sojourn. "I couldn't afford to make that move," Don says. "But Hank always said he'd call me when he finally made it to the Opry. I said, 'Okay, you got a deal.' So when they booked him for the third show and he knew it was permanent, he called me up and said, 'I start next Saturday night as a regular. I expect you to be there. I even got you a room booked at the Hermitage Hotel.' The Opry and the Hermitage were a big step up from the days when we played dives so tough Hank had to pass around blackjacks to the band members."

The band Hank put together for the Opry was Helms on steel, Jerry Rivers on fiddle, Hillous Butrum on bass, and Bob McNett on guitar. Don Helms is too modest to say it, but his steel provided the key to Hank Williams's sound. He reflected Hank's persona with every note: lean and blue.

Between 1947 and 1953 Hank had twenty-seven top-10 records.

And his star grew even brighter when Fred and Wesley Rose cut a deal with Mitch Miller to record, starting in 1949, some of his songs with pop artists singing them. Wesley later said it was he who convinced Mitch to pitch the songs to his artists. "They say 'Cold, Cold Heart' is nothing but a hillbilly song," he told Miller. "But I don't buy that because I like it and I'm not a hillbilly." Mitch cut the song with Tony Bennett, who enjoyed his first real chart success with it, and after that, Mitch started looking at Hank's catalog even more closely. He cut "Hey, Good Lookin' " with Frankie Laine and Jo Stafford, "Jambalaya" (which Hank pronounced "Jumbalaya") with Jo Stafford. Then Wesley bet someone $20 he could get Mitch Miller to cut any song in the Acuff-Rose catalog with a pop star. How about Bill Carlisle's "Too Old to Cut the Mustard?" his curious friend asked. This time Jo Stafford turned the song down, but Mitch pitched the idea to Rosemary Clooney and Marlene Dietrich, and the two went for it. That had to be a shocker for people in New York to hear Marlene Dietrich singing a country song. I can see Rosemary Clooney because she's an old Kentucky girl. But Marlene Dietrich?

Hank loved getting the pop cuts. He loved having the royalty checks and he loved the renown the pop cuts brought. He especially loved Tony Bennett's cut on "Cold, Cold Heart." Don says every time they'd eat in a café with a jukebox, he'd sneak over and play it, then act surprised when it came on. Hank Williams was high-rolling. But then, as the '50s began, country music was high-rolling.

An All-Star Lineup

I ENROLLED AT the Tennessee School of Broadcasting in 1951, and spent a considerable amount of time trying to drop my Southern drawl. I made my broadcasting debut at WTPR in Paris, Tennessee, as a fill-in for a vacationing staff member, working at a real radio job for a week before returning to my job at the Kroger food store. I returned to WTPR after I graduated and stayed four months before moving on to WNAH in Nashville in 1952. In '51 the hottest record in the country was Hank's "Hey, Good Lookin'," but the version we played at WTPR had a little problem. Somebody had dropped a cigarette ash on the 78 and left a glitch in the song. So we'd have to watch carefully and when the song got to that point, we'd turn the volume off and move the needle ahead as quickly as we could. When I went to WNAH as an announcer and deejay, we weren't allowed to play "hillbilly music." Still, as a Nashville radio professional, you always knew about the important players in country music.

As I mentioned earlier, Eddy Arnold was the biggest star, Ritter and Foley the most beloved singing movie stars, and Hank the most notorious. But standing beside them in country's colorful roster was an amazing talent lineup by 1951: George Morgan, Hank Snow, Carl

Smith, Hawkshaw Hawkins, Cowboy Copas, Johnnie and Jack, Kitty Wells, Hank Thompson, and Lefty Frizzell. The fact that I'm concentrating on Hank's life and death in this section of the book is in no way suggesting that these individuals were not huge stars and of vital importance to the industry.

As far as influencing the genre, it might be argued that Lefty Frizzell was the most significant of these artists. Among the artists citing Lefty as a primary influence are Merle Haggard, Willie Nelson, Keith Whitley, Randy Travis, and George Jones. Lefty, whose given name was William Orville, born in Texas and raised in Arkansas, had much the same bad-boy image as Hank. He was always a brawler. As Buddy Killen told me, when Lefty played the Opry the Nashville police force was often waiting at the back door of the Ryman to pick him up for one fight or another. In fact, a teenage schoolyard fight is where he picked up the nickname Lefty. The man who inspired Lefty to make music his life was Jimmie Rodgers, the Singing Brakeman. Lefty learned to yodel and to love the gritty hard-luck stories found in honky-tonk music. He played bars throughout the Midwest while still a teen, and by 1950 he was playing at a place called the Ace of Clubs in Big Springs, Texas.

It was Dallas studio owner Jim Beck who heard Lefty Frizzell's "If You've Got the Money I've Got the Time" and decided to cut a demo tape to pitch to Little Jimmy Dickens. Jimmy was on Columbia Records and when Columbia executive Don Law heard Lefty sing, he fell in love with the voice. The label released "If You've Got the Money" backed by "I Love You a Thousand Ways," and Lefty Frizzell was launched with back-to-back #1 records.

In April 1951 promoter A. V. Bamford put Hank and Lefty on tour together. A. V. was a powerful man in those days. Born in Havana, Cuba, in 1909, A. V. came to the United States in 1923. Nothing in his early years suggested that he'd one day be a promoter of country music. He attended military school in Pennsylvania, then both the University of Alabama and New York University. He ended up on the West Coast selling radio advertising and ultimately managing several stations before moving into the concert promotion business in 1933. After working with big bands including Benny

Goodman's and Tommy Dorsey's he met Bob Wills in the 1940s and made the switch to country. By the time Hank Williams hit, there was no bigger fan than A. V. Bamford.

Lefty and Hank had met earlier, and Hank knew he had a serious rival in the man. According to historian Charles Wolfe, Hank asked Lefty why he didn't stay down in Texas and leave Nashville to him. Lefty charmed Hank on the spot by saying, "Hank, the whole damn country is the backyard of both of us." Hank said, "It's good to have a little competition . . . and boy, you're the best competition I ever had!"

Hank pushed Lefty to join the Grand Ole Opry, and in fact he did for a time. But as had happened with Roy Acuff, when Lefty broke with Opry management, his career suffered.

The man who had the biggest single hit record at the time was Hank Snow, whose 1951 smash "I'm Moving On" stayed at #1 for twenty-one weeks and became the biggest single release in country's history.

Hank Snow was a great friend and fan of Hank Williams. In fact, Hank Williams had befriended Snow even before either man got a shot at the Opry. Hank told of their first meeting in his 1994 memoir, *The Hank Snow Story*. Snow had been approached by a KRLD deejay named Fred Edwards, who was in contact with a Texas club owner who needed an extra act for a show he was putting on in Corpus Christi. Hank Williams was the headliner.

Snow said he liked Hank Williams immediately. He said Ole Hank wasn't drinking, though Snow had heard all the rumors and didn't know what to expect. It was the spring of 1949. "Lovesick Blues" was climbing the charts and Hank Williams had only a few months to wait until his Opry debut. Snow reported that the two had long talks between shows, and became friendly enough that Hank invited him to his home. On the way, Hank Williams stopped to buy a ring for Audrey, who was home, pregnant with Hank Jr.

Like so many of Williams's friends and associates, Snow soon learned that all was not right in the Williams household. When the two men arrived, Audrey refused to come out of the bedroom. Snow explained: "Hank went into the bedroom and came out suddenly. At

the time, I didn't know what was taking place, but he told me later he was having problems with Audrey. When he gave her the ring she looked at it and then threw it across the floor, saying, 'If you can't do any better than that for me, then just forget it.' I felt sorry for Hank that day."

Hank Snow said a very telling thing about Hank Williams one time. He was on the radio show, and as I always did with people who'd been close to "Ole Hank," I asked Snow to talk about his personality. Hank paused a bit, then he said: "Hank Williams was a quiet man, a thoughtful—preoccupied kind of man." Then Snow fell silent again. Finally he said, "Hank was a studyin' kind of man." I thought that said worlds.

THE MAN WHO would ultimately take Hank Williams's place on the Opry also debuted during this time: Carl Smith, another Ernest Tubb protégé. Carl's music stood, at the time, right in the center between traditional and contemporary. Carl came to the Opry and Columbia Records in 1950, one of the few who didn't get too caught up in the catch-22 between a record label and the Opry. Usually the Opry demanded you have a hit single to join, and the record labels wanted Opry stars. But Carl was able to get both the show and the label simultaneously. The road hadn't always been smooth, though.

A native of Maynardsville, Tennessee, when he was sixteen, Carl traveled the twenty-five miles to Knoxville and auditioned for and got a summer gig on Cas Walker's WROL radio show. He once told me he could never remember wanting to do anything except be a country music singer. As a kid he mowed lawns to pay for his guitar lessons. And of course, the fact that Roy Acuff was a Maynardsville native made the dream seem possible.

After graduation, a year and a half in the military, and another short stint at WROL, Carl went to both WWNC in Asheville, North Carolina, and WGAC in Augusta, Georgia, with little success. Finally, in 1948, Carl returned to WROL to play bass with Skeets Williamson's band, featuring Skeets's sister, Molly O'Day, the same folks who'd played a role in the Hank Williams/Fred Rose

meeting. When Skeets and Molly left WROL, Carl stayed as Archie Campbell's bassist.

Peer International Publishing, originally founded by Ralph Peer (the man who first recorded the Carter Family and Jimmie Rodgers), had a talent scout named Troy Martin who discovered Carl and brought him to Nashville and Jack Stapp at the Opry. Carl's first Opry performance was on Hank Williams's Duckhead Overalls Show in March 1950. For the first few weeks, Stapp and Columbia Records's Don Law went back and forth about who should sign Carl first. Finally Stapp made the first move and signed Carl to the Opry, followed quickly by Law and Columbia. Hank took an immediate liking to Carl and even gave him two songs to record. Neither took off, which shouldn't have come as a complete surprise. When Hank had a sure hit, Hank recorded it.

Maybe that's why Carl later told me he was always suspicious of a writer/artist who pitched him a song. He said he always knew what they'd say: "It's just not my style." Carl figured if it was a potential hit for him, it was a potential hit for the guy who wrote it.

Once when Carl visited my show in the '70s he reflected back on those days. "I had 'I Overlooked an Orchid' out and it sold over a hundred thousand copies but didn't make the charts. It was very hard back then."

Of course the big difference was that in the '50s, the country music chart had ten spots. When Carl did hit, he ended up having four of those top-10 spots at once. Lefty had five, and that left one for Hank Williams. Another big difference was that the record companies kept on working all the singles. By the '70s, if they released something when one record seemed to peak, they dropped the top one. But not so back then. They worked everything!

I remember that on that particular radio show, Carl had just been honored by his record label for twenty years and millions in record sales. Columbia brought him to New York and threw a splashy event at the 21 Club. It must have seemed a long time since those first hundred thousand in sales couldn't even get him in the charts.

Finally, in 1951, "Let's Live a Little" made it to #2. He followed that with two more strong showings: "Mr. Moon" and "If Teardrops

Were Pennies." Then, in October 1951, Columbia released "Let Old Mother Nature Have Her Way" and it stayed at #1 for two months. Those were the four that Carl had in the charts at once, which kind of made up for the lack of chart action on "I Overlooked an Orchid." He followed "Mother Nature" with another chart-topper, "Don't Just Stand There," and that song stayed at #1 for two more months. By 1952, as Hank's career was heading downhill, Carl Smith's was soaring.

Carl was a lot like a guy who came along a little later: Conway Twitty. Both men could be considered a song's best friend. Carl paid strict attention to his songs, never leaving song selection to the whims of others or believing he could put out anything and make it a hit. Carl was one of the first in Nashville to recognize the brilliance of Boudleaux Bryant and his wife, Felice. Carl told Chet Flippo in 1991 that in the '50s finding good songs was a hit-or-miss situation: "Boudleaux was the first full-time songwriter I ever met. Most of the other people would write one song. You'd find a hit from one part of the country and then one from one publisher and then another." But once he met Boudleaux, Carl realized he'd found a hit-song gold mine. Boudleaux contributed three of Carl's biggest: "Back Up Buddy," "It's a Lovely, Lovely World," and "Hey Joe."

Carl once told me that when he started cutting a lot of Fred Rose songs, people began asking him if he'd cut some kind of deal with Fred and Acuff-Rose. Carl said, "No, but Fred writes great songs. Eight lines long and you get the whole message in the first four!"

Carl was married to June Carter from 1952 to 1956 and is the father of Carlene Carter. In 1957 Carl married Goldie Hill, who was in many ways the main competition to Kitty Wells on Decca. Goldie was considered a glamour girl, Decca's "Golden Hillbilly," and got her start with Webb Pierce's band in Shreveport in '52. It took Decca's Paul Cohen only one listen to sign her to a recording contract, and, like Kitty Wells had done, she debuted with an answer song: "Why Talk to My Heart," a response to Ray Price's "Talk to Your Heart." That was such a huge success, staying at #1 for three weeks, that Decca had Goldie cut "I Let the Stars Get in My Eyes," "I'm Yvonne," and "I'm Yesterday's Girl." None of the three charted.

Goldie had moved to Nashville and the Grand Ole Opry in 1953. She became a regular on *Country Tune Parade* for a time and recorded with Justin Tubb, including the 1954 top-5 hit "Looking Back to See." Goldie was on tour with the Philip Morris Country Music Show when she decided to leave and marry Carl in '57. She seemed to prefer marriage and motherhood to being a music star, and dropped out of the business except for a brief stint with Epic Records in 1968. In the '70s I asked Carl if Goldie was retired from show business. "Well, I guess so," he said. "Nobody's shown up at the farm with a check lately."

Carl likes to kid about his last name, which has caused some confusion for him and for a few others over the years. He told me a funny story about a deejay who had him on his show the day Carl played a concert in that particular town. The guy kept naming songs and saying, "I've sure been playing this a lot all week!" Then he'd play another tune and say, "That's another one I played for you all week." Carl finally had to tell the guy: "Well, I guess you've been promoting my show by playing every record *Cal* Smith has ever made!"

The government got them confused, too. It seems the IRS showed up one day, demanding to know what Carl had done with all the money he'd earned when he was a Texas Troubadour! He had to explain that it was Cal who'd played in Ernest Tubb's band, not him.

Carl also said he ended up having a lot of family he had never heard about. He had uncles and aunts and cousins writing him. Nobody else in Carl's family had ever heard of these people, either. Most of the so-called relatives wanted money. Of course, a lot of stars get hit up for money. One letter didn't make any pretense of being from a relative. This ploy was strictly because Carl owned a farm.

"The letter writer started out by talking about the farm they'd sold to move to the city," Carl said, laughing. "Then the guy says they got to the city, spent all the money, and hated it anyway. Now they want to move back and buy up their old farm. They figured that since I was a farmer I'd understand and give them the money!"

The worst part of the name Smith turned out to be all the people who swore he was their long-lost son, uncle, brother, or cousin. Carl

got all kinds of grief about that, including from one woman in
Louisiana who wrote and chewed him out for never visiting his poor
old mother and father, who happened to be her neighbors. "Mrs.
Smith says she guesses you got to be a big star and just abandoned
them! How could you do that!" she ranted. Carl didn't respond, but
if he had written her back he said he'd have told her that his mother
was a very sprightly and independent eighty-four-year-old woman
living in Maynardsville, Tennessee, in the same house where he and
his five older sisters were raised!

My favorite Carl Smith story involves Jimmy Dean. Dean once
called Carl and asked him to pick him up in the middle of the night
at the Nashville airport. Carl said that day he got to thinking about
how Jimmy always claimed to be such a cowboy. So he loaded up two
saddle horses in a trailer and Goldie dropped Carl and his horses off
at the airport. When Jimmy got off the plane carrying his bag, there
stood Carl Smith, with two horses, right in the middle of the termi-
nal. Jimmy asked him if he was serious, and Carl said, "Dean, it's
either ride or walk. Goldie's gone to the farm."

Well, the two got on the horses and rode all the way from the air-
port, down Thompson Lane, over to Franklin Road and into Brent-
wood. By that time it had started to rain, so Carl said he was more
than a little happy when he saw Goldie waiting for them with the
horse trailer. "She took pity on us and came out looking," Carl said,
laughing.

I bet Dean thought twice before he asked Carl to pick him up
again!

The airport is a little inside joke at the Smith farm. One of Carl's
boys was almost seven years old before he realized that his daddy was
a singer. "We never talked much about my shows at home," Carl
said, laughing. "And every time I said I had to go to work, the family
would pile in the car and drop me off at the airport. He assumed I
worked there."

I remember asking Carl about his dog Blue, who was a Great
Dane. "What does a Great Dane do?" I asked, wondering if they were
hunting dogs, guard dogs, or just what category.

"Oh, Blue eats, roams through the house, and chews up furniture," he deadpanned. "It's like the guy said when someone asked him where his tiger slept: 'Anywhere he wants to.' "

Carl had another Great Dane named Thurber, and he took him out to the Opry once. When Porter Wagoner, always bone skinny, gave him and the dog a funny look, Carl said, "Well, look there, Thurber. I been promising you a bone all day. There goes one." Porter didn't have any comeback. I asked Carl if he was considered a man who spoke what was on his mind, and he said he didn't know if he was thought to be such a man but he knew one who was: Jerry Lee Lewis. "That Jerry Lee always will tell you what he's thinking," Carl said. "I guess if you're tough enough, you can say anything, chief!"

His wife, Goldie, is a funny lady, too. One day a fan showed up at the farm, recognized her, and said, "Why, Goldie Hill! I thought you married Justin Tubb! You used to sing with him!" Goldie didn't miss a beat. "Well, I'm sleeping with Carl Smith," she quipped.

Carl says Cal Smith used to get asked about Goldie all the time: "Where's Goldie?" Cal would have to say, "Well, I hope she's home with Carl!"

THERE ARE several other favorites of the time that I want to mention here. Hawkshaw Hawkins had his biggest year in 1951. Hawkshaw, wed to the Opry's Jean Shepard, had three top-10 songs that year: "I Love You a Thousand Ways," "I'm Waiting Just for You," and "Slow Poke." He started on the Wheeling Jamboree, and had made his name on the tour circuit and CBA radio by the time he came to the Opry. When he moved from King Records to RCA in 1953, Hawkshaw's career slowed down, and, of course, was tragically cut short in 1963 when he died in the plane crash that killed Patsy Cline and Cowboy Copas. But in 1951 Hawkshaw was a contender. And Hawkshaw again was a contender at the time he died in 1963. "Lonesome 7-7203" was a top-10 record. Copas, too, had considerable tour success in the heartland before coming to the Opry. An Ohio native, Copas was also on King Records, and between 1946 and 1949 had a string of hits including the trademark "Filipino

Baby" and covers of "Tennessee Waltz" and "Candy Kisses." In 1951 Copas was an Opry favorite with a hit in "The Strange Little Girl." He, too, had a comeback in 1960 with "Alabam."

Johnnie and Jack, who'd been close friends with Hank at the *Hayride*, signed with RCA in 1949 and by 1951 had a hit with "Poison Love." Like Hank Williams, they owed their break to Fred Rose. Johnnie and Jack had been recording for an independent label, Apollo. When RCA came calling they found they were locked up tight, even though Apollo hadn't done much for the duo. When Fred learned of their predicament, he simply picked up the phone and told a confidant of the Apollo owner, Sid Prosen, that Sid didn't ". . . need Johnnie and Jack. He ought to cut them loose." Sure enough, that was all it took, a little shove from Fred. Johnnie and Jack were back in Nashville and on their way. The career of this great duo got sidetracked a little, and that story is yet to come.

On January 5, 1952, the *Louisiana Hayride* introduced another new star to country music's ever-enlarging stable of top entertainers. Webb Pierce had more chart-toppers than anyone during the 1950s. Webb seems a strange case in some ways. I always thought he had a big people problem. He was very uncomfortable in crowds and appeared to have a continual case of stage fright. I remember once when we were on a package show, with a lot of entertainers, Webb was so stiff and uncomfortable he barely made it through his set. Then I guess he decided a few drinks would loosen him up. But he went out and had so much to drink in such a short amount of time that he couldn't go on for his second show. Webb's "day job" in Shreveport had been as a men's clothing salesman at Sears Roebuck, and I've always wondered how in the world he managed to sell anything given his unease in personal situations.

But if Webb had a hard time with one-to-one encounters, he sure knew how to market stardom. He went out and bought a silver-dollar-studded car from Nudie and drove around town in it. He built a guitar-shaped swimming pool and invited tour buses to stop by his home. Sometimes on a package show trip, instead of waiting in his room for showtime, Webb would get dressed up in full star regalia and just stand around the hotel lobby.

Another area Webb understood was the job of putting together a band. The musicians he surrounded himself with at the *Hayride* were phenomenal: Floyd Cramer on piano, Tillman Franks on bass, Jimmy Day on steel guitar, and Tex Grimsley on fiddle. Add to that mix vocalists Teddy and Doyle Wilburn and newcomer Faron Young and you've got some kind of a show band. The *Hayride*'s producer, Horace Logan, was impressed with Webb's business acumen; together the men launched a record label, Pacemaker, to record *Hayride* acts. Webb recorded first for Four Star and then for Decca. In January 1952, Decca released "Wondering," and it went straight to the top of the charts and stayed there a month. Webb was clearly a contender with two more #1 releases that year: "That Heart Belongs to Me" and "Back Street Affair." In total, he spent two and a half months of 1952 at the top of the charts. I have more to say about Webb at the end of this book, because he was on my mind throughout the writing of 50 *Years Down a Country Road*.

The Wild Side of Life

CAPITOL'S HANK THOMPSON WAS also making a lot of noise, and would help pave the way for some of Hank Williams's *Hayride* friends to step to the '50s forefront. Hank Thompson had six hit records in 1949, all leading to his smash "Wild Side of Life," which stayed at #1 for fifteen weeks in 1952. A Waco, Texas, native, Hank started out on station WACO as Hank the Hired Hand. After serving in the navy during World War II, Hank attended Princeton University for a year, followed by stints at Southern Methodist University and the University of Texas. But music called, and Hank returned to Waco and a radio show at station KWTX. In 1947 he signed with Ken Nelson at Capitol. His debut, "Humpty Dumpty Heart," was kept out of the #1 spot only by the formidable Eddy Arnold and "Anytime," which stayed at #1 for nine weeks. Hank had been to Nashville and checked out both the Opry and the music being recorded at Castle Studios. But he knew it wasn't his style, nor his direction. Wisely, he chose to stay in Texas, where he made the Hank Thompson and the Brazos Valley Boys one of the hottest tickets in the business.

"I came to Nashville and played the Opry," Hank told me recently. "I hadn't put together the Brazos Valley Boys when I first

came here, so I had to use what the Opry offered. And at that time they didn't want drums or horns or electric instruments, and that was a big part of my sound. It's not a reflection on Nashville or the Opry pickers—that's just the way they did things in the late 1940s. You didn't have the chance to develop like you could now, when you can try just about anything. So I was living in Nashville in a little apartment—I couldn't afford a house—and one day I realized that not only was Nashville not my bag, I was never going to get anywhere by staying there. I said to myself, 'I'm going back where I know what I can do. Where I know the musicians and the kind of music I can make.' And the good thing was this: After being in Nashville a while and understanding what I didn't want to do, I had a clear picture of what my sound should be. So I went back to Texas and that's where I stayed."

Because, in retrospect, Hank Williams looms so large, I think it might be interesting to show some statistics about the career of Hank Thompson, for he has sold over 60 million records internationally and has had a career of firsts. Hank headlined the first country music show to play Las Vegas. Hank's *Live at the Golden Nugget* was the first live country music album ever recorded. Hank was the first music act to receive corporate tour sponsorship. Hank and his band, the Brazos Valley Boys, were the first to do a musical show on color television. "I was already doing a television show on WKY in Oklahoma City," Hank explained. "And when they looked around for something to do in color they saw the Brazos Valley Boys in Nudie suits and decided we were about the most colorful bunch in town!"

Hank and his band were the first to tour with a sound and lighting system. Hank put the system together using his electronics training and experience at Princeton and later in the navy. The Brazos Valley Boys were voted #1 country & western band for fourteen years in a row by *Billboard*. Hank and the band still perform over 120 dates a year throughout the world. Hank is still a top singer, too, as his 1999 release, *Hank Thompson and Friends*, proves.

If Hank Williams lived and died on the wild side of life, Hank

Thompson made the concept a hit record, and when Kitty Wells answered him in song, a new day dawned for what were then referred to as "girl singers." Until "The Wild Side of Life" came along, Hank's biggest hits—all on Capitol—were 1948's "Humpty Dumpty Heart" and "Green Light" and 1949's "Whoa Sailor." His sound was evolving in the late '40s, and around 1950 he put together his big Texas swing band and really caught fire.

"I decided if I was going to do it, I'd do it right," Hank told me. "I decided to find the best musicians possible. It was a little harder back then than now. Now there are so many brilliant musicians that it scares me! But back then the pros were a little scarce and they circulated among a few bands. Sometimes a guy would get tired of living on the West Coast and he'd come back and work with Bob Wills. Sometimes it was the reverse. They'd get tired of Tulsa and go to Dallas or back to California." But Hank found the musicians anyway and developed a sound incorporating twin fiddles, steel guitar, Merle Travis–style guitar, and sometimes the muted trumpet of Dubert Dobson. And according to Hank, Dubert was a vibrant addition to the group.

"Dubert was one of those guys whose enthusiasm rubbed off on everyone else," Hank reflects. "He was a spark plug. You've seen it on a football field, when one guy walks out and things begin to happen. Dubert would come onstage and within minutes the whole band was jumping."

So by the time "The Wild Side of Life" came along, Hank had one of the top bands in the entire nation and was on the road continually. He was ready and able to handle a monster hit, which is just what he got. Ironically, Hank didn't think much of "The Wild Side of Life" when he heard it.

"That song had been out for a good year when I recorded it," Hank reflects. "Jimmy Heap and the Melody Makers from Tyler, Texas, had released it on Imperial—Jimmy's piano player, Arlie Carter, was one of the writers. The band's vocalist, Perk Williams, did a great job singing it. But the quality of the recording was terrible. If you heard it on a jukebox, it would sound like sandpaper and

gravel, so it wasn't being picked up by those guys. And since Imperial didn't seem to have much distribution anyway, nothing was happening with the record. But the song itself was working. You could go into any honky-tonk in Texas and hear 'The Wild Side of Life' by the house band.

"I was getting ready to go to the West Coast for a recording session and went to Pappy Sellers's studio to try out some material. My wife at the time, Dorothy, asked me if I'd considered cutting 'Wild Side.' I told her the tune was just that same old 'Great Speckled Bird' melody with some new words. Dorothy said: 'That's not the point, Hank. The point is, it's got the phrase 'honky-tonk angel' in it, and that's a catchphrase if I ever heard one. Every band in Texas is playing the song, but the record that's out can't get any radio airplay or jukebox play.'

"So at Dorothy's insistence I got a copy of Jimmy Heap's record and listened to it. The song was too long for the kind of records we were making so I reworked it, shortened it, and put a fiddle turnaround in the middle. When I got to California and played all the songs I'd done for Ken Nelson, he liked everything but 'Wild Side.' 'That's just that same old melody that's been done a hundred times,' he said. Then I told him Dorothy's theory and we decided to record it as the B side of the next single, which was going to be 'Crying in the Deep Blue Sea.' It was released in March 1952 and the A side never even charted nationally. It was doing all right until people started turning the record over and playing the B side. Then the jukebox people caught on to it and all of a sudden I had a number one record. It stayed there for fifteen weeks, then when Kitty came out with her answer song it propelled our song back up the charts, too. I think it stayed in the charts thirty or so weeks. Of course, I'd almost missed it because of that melody throwing me off. I believe Rich Kenzle researched that melody and traced it back to an old British folk tune. The fact is, every time someone uses it, the song turns out to be a hit!"

It took a homespun, married female singer known for her gingham dresses and quiet ways to fire right back at the man in the song

and open the doors for women in this business. And it took the innovative business sense of Kitty's country star husband, Johnny Wright, to change the industry's perception of what was possible.

Kitty's real name was Muriel Deason. The stage name came from an old song titled "Sweet Kitty Wells." Kitty had been performing on the Johnnie and Jack show since the early 1940s and Johnnie was determined that she secure a recording contract. She cut a few sides on RCA, where Johnnie and Jack were signed, but they came to nothing. Johnnie decided to try another label, and sent Decca's Paul Cohen a demo.

"We hadn't heard anything from Paul by the time we moved from Shreveport back to Nashville," Johnnie said. "And Kitty wasn't torn up with star ambitions anyway, even though I knew she could be big on radio with that beautiful voice. Jack and I were recording for RCA and were playing a show at the Ernest Tubb Record Shop when Paul Cohen came in with a tape recording of a song he wanted me to listen to for Kitty. I didn't know he'd even given us a second thought after he got my tape, so it surprised me. Well, I took 'It Wasn't God Who Made Honky Tonk Angels' home to Kitty and she listened. Her first reaction was that she wasn't sure 'The Wild Side of Life' needed an answer. But then she said we could use the money and she'd do it just so we could get the union-scale payment for the session!"

Kitty picks up the story here: "When we came back from Shreveport, I decided to quit the music business. I war happy being a wife and mother and didn't mind staying home at all. I only sang the song because Johnny wanted me to and for the money."

Kitty recorded "Honky Tonk Angels" with Owen Bradley at the Castle Studio at the old Tulane Hotel on May 3, 1952. Johnnie Wright played bass on the session, Jack Anglin played rhythm guitar, Shot Jackson played steel, and Paul Warren played fiddle.

"Honky Tonk Angels" hit #1 in *Billboard* on August 9, 1952, and stayed there for six weeks. "I didn't even realize I had a hit until Audrey Williams called and told me," Kitty says, laughing. "She said, 'Girl, that record is being played everywhere!'" It also sold an

initial 800,000, and in addition to the union scale Kitty'd been paid for her efforts, she received her first royalty check and it was for $5,000! A king's ransom in those days.

Here's where Johnnie Wright's business acumen comes into play. While many in the industry saw women artists as far less important than their male counterparts, hit records or not, Johnnie Wright was not among them. When Kitty's career started to take off, Johnnie approached Jack Anglin and suggested they change their advertising, change the entire name of their show, in fact, with Johnnie and Jack taking a bit of a backseat.

"It was obvious to me," Johnnie said. "She was outselling us and 'It Wasn't God Who Made Honky Tonk Angels' was the biggest song in the country. I told Jack I thought we should change our name from 'Johnnie and Jack with Kitty Wells' to 'Kitty Wells with Johnnie and Jack.' Jack went along with the idea, so I approached Roy Acuff about us being billed that way at the Opry. Roy said, 'Johnnie, a woman can never headline a country music show. The American public wouldn't stand for it.'

"I didn't agree with that at all. She had the hit and she should be the featured star. As far as I could see, the American public is what had made her deserving of the spotlight. It was as simple as that. So against Acuff's wishes, I changed the show name."

So it was a simple move for Johnnie. But what he did with that name change was to begin to change perceptions about women's place in country music.

MAYBE PART OF the saddest side of the Hank Williams story is in the comparison of the two Hanks and their "wild side of life." Hank Thompson would be the first to tell you he liked to sample some whiskey through the years. In fact, you may remember that Hank Williams once offered Hank a drink, adding that he didn't dare get started. Hank Thompson explained the difference recently. "I drank my share back then. Most of us did. But I guess I just paced myself more than Hank Williams and a few others. They'd start and never

stop. They'd be passing out and I'd already had a night's sleep and some rest and could start again if I felt like it."

It had never been like that for Ole Hank. And when life got more complicated, Hank Williams turned increasingly to the bottle. The strength of his competition had to prey on his mind as he felt his grasp on things slipping away.

Let's Turn Back the Years:
Hank's Final Decline

*T*HE HADACOL CARAVAN TOUR of 1951 started out looking like a high point for Hank Williams. That Caravan was spectacular, with top performers, circus acts, and fireworks displays. Hank took the Drifting Cowboys and Big Bill Lister with him and joined the show in Lafayette, Louisiana. Bob Hope was the man signed to close the show, but when he tried to follow Hank, the applause was so loud no one even heard Bob's name. Bob had to introduce himself, and he did so by saying, "Hello, I'm Hank Hope."

The Caravan was an expensive show to move around the country. They traveled in Pullman cars, dined on steak, and had more perks provided to the acts than today's rock stars. But trouble was brewing underneath it all. For one thing, Bob Hope had been paid $10,000 for his appearance, Hank Williams only $7,500, and the check was bad, to boot. So what should have been a high point, with a star of Bob Hope's magnitude tipping his hat to Hank, ended up with Hank taking two hits. The first was when he learned he wasn't getting paid on Bob Hope's level, and the second was when the checks he did get started bouncing. Injury piled on top of insult.

There were other setbacks for Hank during that time. Hank played Las Vegas in May 1951 and Don Helms said they bombed big there. "Hank was nervous about the Vegas run," Don said. "He asked me, 'What in the world are we gonna do for those people?' I think he was afraid of his ability to cope with those kinds of shows. I told him to just go out there and do what it was that made him so popular. He did, but it didn't work with the gamblers. Pretty soon the casino people noticed that the crowd had changed. We were drawing all the locals, and they weren't there to gamble! So that run ended pretty quick."

According to Jim Denny's wife, Dollie, there was an additional problem in Las Vegas—Hank's drinking. Audrey's daughter Lycretia believes his nerves were on edge because of an upcoming trip to Hollywood where he was to meet with producer Joe Pasternak about a movie script written especially for him, *Small Town Girl*. Whatever the reason, whether it was the Las Vegas audience or the pending film meetings, Hank was drinking heavily in Vegas. Denny even sent an ex-policeman named Charlie Sanders to watchdog Hank, but Hank was too slippery.

Don says if Hank didn't understand a situation, he feared it. For example, if someone told him he was going to play Boston and he didn't know what Bostonians were all about, it bothered him. He liked to know his crowd. Lycretia pointed out in her book that Hank always seemed more at ease around children, and I think it's because he knew children are nonjudgmental. He didn't have to worry about how they'd take him or if they liked his music or his songs. He didn't feel like he had to put up any kind of front.

As it turned out, Hank was right to be nervous about the film meeting with Joe Pasternak. He got treated like a piece of meat and didn't like it. The writers and directors were all in the meeting, and first one and then another would tell him to stand up, sit down, turn around. Finally someone told him to take his hat off, and asked, "Hank, do you have any hair?"

"Hell, yes," Hank said. "I got a dresser drawer full of it." And he did. Don said Hank had a drawer full of wigs. When he left the meeting, Hank said, "They're slicing me up and selling me like baloney."

He didn't do the movie. Chill Wills took over the roll. Clearly, Hollywood was out of Hank's comfort zone.

Hank could always find ways to spend his money, and if he couldn't, Audrey could. On June 16, 1951, they held the grand opening of Hank & Audrey's Corral, a western wear store, at 724 Commerce Street, two doors down from Ernest Tubb's Record Shop. The opening was broadcast over WSM from 5:00 to 5:30 that evening and it turned out to be so successful that they tried to keep on having the shows. Unfortunately, the crowds got so big the logistics became impossible. (Audrey later claimed that she and Hank introduced Nudie suits to Nashville, but in fact, Jimmy Dickens had introduced them to Hank.) The importance of Hank & Audrey's Corral may lie in the fact that, according to Lycretia, a lot of hangers-on and troublemakers hung out there and carried tales back and forth between Hank and Audrey, whose fighting seemed to worsen daily. The problem with the store's location was that it was surrounded by dives. It made it all too easy for people to get half drunk and stagger on over to Hank's store.

Like Merle Kilgore, Don Helms believes Audrey was the love of Hank's life. He just couldn't understand the fights, which he says could come on instantaneously, and were intense and loud. "I never saw Hank hit Audrey," Don says. "But I sure heard him cuss and her scream. Somebody once asked Jerry Rivers if Hank and Audrey fought like cats and dogs and Jerry said, "Nah. Cats and dogs don't cuss and throw rocks."

Would there have been a Hank Williams without an Audrey Williams? Joe Allison thinks that there would have been a Hank Williams, singer/songwriter, but not the Hank-as-legend. "Hank would have always made music, but I don't think we'd have heard about him without Audrey in the mix. She worked twenty-five hours a day pushing him, dressing him, telling people about him, collecting his royalties, his paychecks, and making deals. I believe Audrey Williams was the most ambitious person I ever met."

Her ambition contributed to the fights more often than not. Joe told a story about going to Hank and Audrey's place for dinner, at

Audrey's invitation. Much like Hank Snow's dinner experience with the Williams family, it was a less than pleasant evening.

"When I got to the house, Hank answered the door in his undershirt. He had a cowboy hat on a little crooked and he was about half drunk. Audrey was furious because she thought Hank ought to act 'right' in front of a disc jockey. When we sat down to eat, Hank started reaching across the table for things and she'd slap his hands and tell him to mind his manners. He'd want more liquor and she'd say, 'No, you don't need one.' Finally she made another comment about his manners and he glared at her, then grabbed a handful of salad right out of the bowl and stuffed it in his mouth. He started chewing it and half-eaten salad started spilling out of his mouth and down his undershirt. 'How do you like that for manners,' Hank asked her. Well, the fight was on."

Joe told about another time, when Hank was holed up in a hotel room shooting his gun. The hotel manager phoned the Opry office and said if Hank didn't leave he was going to have him arrested. Jim Denny and Henry Cannon, Minnie Pearl's husband, went to go get him in Henry's plane. They took Audrey along and throughout the flight Jim kept cautioning Audrey to not start anything. "Don't worry," she said. "I know how to handle Hank Williams." All through the drive from the airport to the hotel Jim warned her. "Don't worry," she'd repeat. "I know how to handle Hank Williams." And on the way up in the elevator Jim warned her again. "I know how to handle Hank Williams," Audrey said firmly. Then, Joe says, Audrey knocked on the door and shouted, "It's me, you son of a bitch!" And the next round of the fight was on.

Hank recorded "Let's Turn Back the Years" in 1951. It's a song steeped in regrets, and no doubt it reflected Hank's mood at the time. It seemed like beneath every success there was a failure. Events like the Hadacol Tour, the Las Vegas shows, and the ill-fated movie deal had to have haunted Hank that year.

In September 1951 Hank and Jerry Rivers were hunting on some property Hank owned, and Hank fell, injuring his back. By December the injury required surgery. Hank wanted to be home for Christ-

mas, so the hospital released him early after the December 13 sur-
gery. This move upset Audrey, who yelled at Hank, who responded
by throwing a chair at her, reinjuring his repaired back and being
readmitted! Hank was forced to cancel Connie B. Gay's New Year's
Eve shows in Washington and Baltimore and it scared him. Rumors
about his escalating drinking and unreliability were spreading far
past Nashville's music circles. Bookers, press, and fans were talking
openly about Hank's "problem."

Hank decided to face the matter as personally as possible and he
recorded a warm and genuine apology, explaining the back problem,
omitting the chair-throwing incident, and asking for the audience's
forgiveness. Then he sent Audrey to Washington to play the record-
ing in person for the crowd. The exact text of his statement went:

"Howdy, folks. This is Hank Williams. Hope ya'll are havin' a
great big time at the show. I'd like to say thanks to my good friend
Jimmie Davis for coming up here to Washington and pinch-hittin'
for me. Also my wife and my boys.

"I'd been looking forward to visitin' with you folks in Washing-
ton today, but on the thirteenth of December I had to have an oper-
ation I'd been putting off for a long time. Got to where I couldn't
even walk. When I had the operation I was told that I'd be down
about ten days if everything went fine. So at the time I had the oper-
ation I knew about the date here and thought I'd get to make it. But
after the doctor started the operation he—it was called a spine
fusion—he got into my back and found a lot of stuff wrong that he
hadn't anticipated before. So after he did this he went ahead and
had to fix it all. I had two ruptured disks and the first and second
joints in my back was bad. So he had to do quite an operation. I
stayed on the table over three hours. So I was brought home Christ-
mas Eve morning in the ambulance. I'm in bed at home here now. I
haven't been able to get up yet.

"Me and Mr. Denny at the station, we tried to talk the man—the
doctor—into letting me take an airplane up to Washington—an
ambulance airplane. Then have an ambulance meet me at the air-
port, carry me to the armory and roll me out on stage and let me sing

or say hello to you or something. But we couldn't talk him into it. He said it might tear down all he'd accomplished.

"So I hope you folks—I know you will, in fact—you have a good show. Jimmie Davis and all my boys. Audrey's gonna say hello to you for me. I'd like to say thanks to you for buyin' my records and I'd like to promise you that just as soon as I get up out of this bed I'm gonna try to get up there to Washington and make an appearance.

"So until I see you, thanks a lot and I know you're gonna have a great big time at this show. Thank ya a lot."

LIKE HIS SHOWS, Hank's spoken word here was brilliant. He did not grovel, he did not whine. He delivered the lines with plain-spoken honesty and just the right amount of regret. Of course, he didn't mention that part of the reason he was still laid up was because he'd arrived home on a stretcher and almost immediately thrown a chair at Audrey!

From what everyone says, he needn't have worried because once Audrey rolled the tape, the audience absolved Hank of any culpability. Not so with Audrey, who must have become madder by the minute as she traveled north to play the tape. She phoned Hank from Washington, D.C., on her way to the date, and told Hank she was filing for divorce and wanted him out of the house. On January 3, 1951, Hank Williams moved to the Andrew Jackson Hotel, then to his mother's Montgomery boardinghouse to finish recuperating. According to Ray Price, Hank said he wanted to give Audrey half of everything he owned. He didn't care about any of it.

It seemed like Hank was snakebit. His first show after the separation from Audrey was at the Mosque in Richmond, Virginia, and it was a disaster. He got so drunk that Ray Price, with whom he was sharing a house on Nashville's Natchez Trace, finally had to step in and cover for him. Edith Lindeman, a writer for the *Richmond Times-Dispatch*, wrote such a scathing review of the first night's show that on the second night Hank dedicated "Mind Your Own Business" to her.

Like Minnie Pearl said, it's hard to lay all the blame for Hank's downhill slide on his marriage to Audrey. He had a lot of strikes against him, starting with spina bifida. Then there was the hunting-trip accident. Add depression and a weakness for liquor into the mix and you've got a potentially lethal combination. Finally, even Ray Price couldn't take it and he joined forces with Don Helms to have Hank committed to a sanitarium to dry out. Hank was furious and ordered Ray out of the house they'd been sharing. Even though Hank had an orderly from the sanitarium drive him to the house to apologize, Ray moved. Ray has said he thinks more people should have stood up to Hank and confronted him with his problem instead of letting him slide. Ray stood up to him and Hank obviously respected him for it. He proved it with the apology.

There are two more aspects to Hank's final decline that bear mentioning. For one thing, Hank went straight from his mother to Audrey—two strong and controlling women who treated him like a child. He never grew up—he didn't have to. He was used to living up—or down—to other people's expectations. And he did something else that could have contributed to that last round of binges. He started to believe his own press. I recently spoke with Joe Allison about it, and Joe says that in Nashville at that time, Hank's behavior was so notorious that it was almost expected, almost a badge of honor in some circles. Ole Hank was country's bad boy. And Ole Hank decided to live up to his bad reputation.

Not long after Joe and I had that talk I played golf with Tom T. Hall and mentioned that idea to him. "It's not just Hank, Ralph," he said. "We all have to be careful not to believe our own press."

Hank started dating a Nashville secretary named Bobbie Jett before the divorce was final. It would be a relationship that would have long-lasting consequences because Bobbie became pregnant with Hank's child. When Hank's daughter Cathy, aka Jett Williams, tried to piece together the exact story of how Hank and Bobbie met and the nature of their relationship, she came up short. Those were the days when Hank was going downhill fast, and it's thought that Bobbie stayed at the house on Natchez Trace and helped nurse him

to health after his back surgery. That story may have been started by Hank himself, because he often introduced Bobbie as his "nurse."

Looking back after all these years, it almost looks like Bobbie didn't want to marry Hank. A week after Hank's leaving the Grand Ole Opry and just two months before his very public weddings to Billie Jean, the then-pregnant Bobbie and Hank Williams spent two weeks together in a cabin at Lake Martin, near Kowaliga, Alabama, where he ended up writing his initial version of "Kaw-Liga." Bobbie also spent time in Montgomery with Lillie, and she easily turned custody of the baby over to Hank and his mother. When Hank married Billie Jean, Bobbie appears to have been unaffected by the turn of events. One thing seems clear—Bobbie Jett wasn't angling for any payoff from Hank Williams.

If, in fact, Bobbie Jett didn't want to marry Hank, it may have been a result of the lake trip. Hank stayed drunk, got arrested, and was a mess most of the time. To Bobbie, Lillie's boardinghouse might have looked like a good place to wait for the baby to be born. Thinking about Hank's trip out to the lake reminds me of something that Don Helms told me. He said that when Hank would get on one of those drunks he'd end up with no place to go. Nobody wanted him when he was in that condition. Not Audrey, not Fred Rose, not anyone. That's a sad commentary, especially considering how the industry lionized him in death. It's like the song on the *Old Dogs* CD, "Nashville Is Hard on the Living, but She Sure Speaks Well of the Dead."

FRED ROSE KNEW Hank had to get back to the *Hayride* and prove himself once more, so he parlayed Hank's recent success with "Jambalaya" into an invitation to return. It probably wasn't a tough sell, because the *Hayride* had just lost Webb Pierce and Faron Young to Nashville and the Opry.

On October 15, 1952, Hank and Bobbie signed an agreement whereby Hank and his mother would be responsible for Bobbie's unborn baby. Bobbie died in 1974, so it's unlikely we'll ever know

how she felt about giving up her baby. But she seemed to do it easily. Three days later Hank married Billie Jean, and a day later, on October 19, 1952, they remarried twice in New Orleans. Supposedly, the reason for the very public weddings was to spite Audrey.

Hank was back in Shreveport, but he was a shell of the man he'd been the first time around. For one thing, he was starting to have chest pains and he had problems breathing. For another, he became incontinent whether he was drinking or not. And his behavior became more boorish as time went by. He even ended up offending his friend and supporter Kitty Wells when he drunkenly sang incredibly filthy lyrics on a bus trip to a show in Texas. Kitty is too much of a lady to talk about that trip, but others confirm Hank's actions.

Ole Hank had come a long way down. He'd sold everything he had left after the divorce from Audrey, the farm and the Corral, for about half their value. It was a time of contrasts. He had five of the top jukebox records for 1952: "Jambalaya," "Half as Much," "Honky Tonk Blues," "Baby We're Really in Love," and "Crazy Heart." In terms of national popularity, Hank was second in country music only to Eddy Arnold. Yet by the holiday season in '52, he was sick, broke, and often reduced to playing high school gymnasiums. And during a show in Beaumont, Texas, he was so drunk the crowd booed him off the stage.

The final nail in Hank's coffin was probably when he met "Dr." Toby Marshall in the fall of 1952. Hank was introduced to Marshall when the *Hayride* did a package show at the Trianon Ballroom in Oklahoma City. Suffering from pain in both his back and his chest, Hank started drinking heavily. Thinking they were doing him a favor, someone from the *Hayride* called Toby Marshall. Marshall claimed to be a specialist in treating alcohol-related problems, and used his own supposed triumph over demon rum as part of his credentials. In reality, Marshall never even finished high school and was an ex-convict. When all was said and done, Marshall was nothing more than a drug dealer who supplied Hank with amphetamines, Seconal, chloral hydrate (knock-out drops), and morphine. Between the four big Ds of 1952—drinking, divorce, drugs, and depression—Hank didn't have long to go.

Merle Kilgore, who'd carried Hank's guitar case and idolized him in 1948, ran into him during the Thanksgiving holiday in 1952. "I was back home in Shreveport for Thanksgiving and decided to stop down at Murrell's Café on Market Street. That's the same Murrell who'd loaned Hank the money to get Hank Jr. out of the hospital when he was born. I walked in to Murrell's and passed what appeared to be a very old man sitting slouched in one of the booths. I'd barely glanced at the man until he called my name out. When I turned and looked I saw it was Hank. He looked awful. He was skinny but bloated at the same time. His eyes seemed to have sunk way back into his head. He wasn't drunk or drinking, but he smelled like whiskey all the same. And his clothes were awful—dirty and tattered. Hank was always proud of his clothes and it scared me to see him like that. But that night when I went to the *Hayride* to see his show, he walked out and gave an incredible performance. It's hard to know how he could have transformed himself like that. But Hank's stage charisma can't be underestimated. Up close he may have appeared wasted, but from the audience, it looked like the old Hank."

Hank's ability to pull himself together was not the biggest shocker that night, although neither Merle Kilgore nor Billie Jean knew it at the time. Hank saw Johnny Horton backstage, and he pulled Billie Jean aside and said, "Honey, one of these days you are going to marry this man." Merle said it was chilling. Hank Williams would never have suggested that a woman would leave him for another man, unless he was long past caring whether he lived or died.

In mid-December, Lillie came to Shreveport and insisted Hank return to Montgomery with her. She told the *Hayride*'s Horace Logan that Hank had such a severe case of the flu he'd need round-the-clock treatment. Once home and feeling better, Hank tried unsuccessfully to live a somewhat normal life. He and Billie Jean attended church, but he couldn't stand long enough to sing. He attended a ball game and the wind chilled him.

It must have been a nightmarish time for Hank. Billie Jean and Lillie were at each other's throats. Bobbie Jett was ready to give birth. His career was nearly dead. When he performed at a musi-

cian's union benefit, the papers kindly described him as looking "tired."

Hank had burned most of his bridges. But one promoter who still believed in him was A. V. Bamford, and A.V. booked Hank for a show on New Year's Eve in Charleston, West Virginia, and another on New Year's Day in Canton, Ohio. This time there would be no recorded message of apology. Hank was determined to put 1952 behind him and start 1953 on the right foot. He was not going to let A. V. Bamford down.

The Man, the Myth,
the Mystery

*C*OME AT ONCE, Hank is dead. Mother."

That was the simple yet chilling text of the Western Union telegram Lillie Stone sent to her daughter, Hank's sister, Irene Williams Smith, on January 1, 1953. What led to that telegram is a story shrouded in mystery, the truth of which may never be known.

Back when I was still hosting *Nashville Now*, TNN approached Tom T. Hall about a special on Hank's last days. The idea was for Tom to get on his bus in Montgomery and follow the route of that final journey all the way to Oak Hill, West Virginia, where Hank was pronounced dead. The plan was for Tom to stop at various significant places—hotels, gas stations, certain towns, and so on—to film and discuss the events as they had unfolded. The irony of this project is that it was shot down because Hank Jr. got into some sort of mess and got some bad publicity. Even though the network had a lot of money already invested in the research, they got cold feet and backed off. To my mind, Hank Jr.'s latest escapade wouldn't have made any difference. I thought it was a great idea and didn't think

the image problem would have made a bit of difference. You can't blame the sins of the father on the son or vice versa.

Tom and I talked it over and decided to pursue it as a made-for-television movie, with Tom writing the screenplay. I think the Hank Williams story ought to be told, the real story, not some glossed-over Hollywood version. That kind of thinking is what caused the myth to grow in the first place. We got some interest from some Hollywood people because of the fact that Barbara Mandrell's made-for-TV movie got such good ratings. Well, by this time, Tom was running hot and cold on the project. Still, he found and interviewed Charles Carr, the kid who was with Hank those last days. In the end, though, Tom came to me and said the whole story was so depressing he wished he wasn't working on it. So while we ended up with a lot of research and no television movie, I wound up with some good material to begin a book on country music starting in about 1950! I'd still like to make a movie about Hank Williams, the real man, not a sugar-coated portrayal like George Hamilton did in *Your Cheatin' Heart.*

Here is what we learned. Some of it is well known, but at almost every turn the facts ask more questions than they answer.

On December 29, a day after he played the musician's union benefit, Hank phoned his friend Daniel Carr, the owner of the Lee Street Taxi Company, and requested a driver to take him to the West Virginia and Ohio shows. Carr didn't have a regular driver available and suggested he send his son Charles, a student home on vacation from Auburn University. Sure, Hank said. How about paying him $400 to make the trip? That sounded fine to Daniel Carr. Four hundred dollars was a good chunk of change for a college kid back in 1952.

What all Hank did that week before he left is unknown. We do know that on the same day he hired Charles Carr he paid Dr. Stokes in advance to deliver Bobbie Jett's baby and left money to take care of any other expenses. But something else happened that last week. Hank Williams received a beating and nobody seems to know where or from whom. Hank biographer Colin Escott speculated that it might have happened in a Montgomery bar brawl. Yet if that's true, people in Montgomery were quiet about the incident. Is that why,

when Hank saw Dr. Stokes that last time, he asked for a shot of morphine? Stokes, for his part, wouldn't hear of it once he smelled whiskey on Hank's breath.

Still, Hank felt strong enough to help load the car before he and Carr left Montgomery on December 30. They packed Hank's guitar and stage costumes, as well as his merchandise to sell—songbooks, records, and photos—in the trunk of the blue Cadillac. According to most sources, Hank was usually able to lie down in a hollowed-out space between the trunk and the backseat, but on this trip he took so much merchandise he had no place to stretch out. Charles Carr told Tom this was not so. He said Hank took very little luggage and it all fit easily in the trunk.

On their way out of town, Hank had Carr make several stops. They dropped by a local radio station, then went to a contractor's convention at a hotel, where Hank started drinking. The next stop was at the office of Dr. Stokes, where Hank tried to get a morphine injection. But as I mentioned, Stokes smelled bourbon on his breath and refused. Hank simply went to another doctor for the morphine. The next stop was for a six-pack of beer. Then they stopped at the Hollywood Drive-In on Bell Street, where Hank ran into an old friend, saxophone player Leo Hudson. Hank stood outside talking to Leo while Carr went inside. Finally Hank was ready to start his trip. So it was late on a cold, rainy afternoon by the time they got out of Montgomery, taking Bell Street to head north on old Highway 31.

Lillie was worried about Hank, and about 4:30 P.M. she phoned Toby Marshall and asked him to meet Hank in Charleston, West Virginia, and accompany him to Canton. "Take care of Hank," she said. Unfortunately, Toby Marshall's "care" accounted for a big share of the problem.

Charles told Tom that they tried to get a room at the Tutweiler Hotel, which was considered the city's finest accommodations. But when Carr started to park the Cadillac, a police officer flagged him down. "We were parked in front of what was supposed to be a loading zone," Carr explained. "But I couldn't tell if we were actually blocking anyone or not. When the policeman told me to move, Hank rolled down the window and said, 'Do you know who I am?'

The policeman said, 'I'll tell you one thing, if you don't move that car I'm gonna give you a ticket.' So we went on down the street to another place."

Hank and Charles ended up staying at the Redmont Hotel in Birmingham that night, and according to Charles three female fans somehow learned that Hank was at the hotel and showed up at his door. Charles Carr has always seemed evasive about that trip with Hank. I think he knows a lot more than he's ever said; he's probably fearful of being criticized or getting into trouble in some way. One of the things I think he's hedging on is this story about these three women. I believe Hank knew the women and probably phoned them as soon as he got to Birmingham. I think Hank invited them to come to his room.

The next morning Carr and Hank left Birmingham and headed for Chattanooga. By the time they got to Fort Payne, Hank wanted breakfast and a shave. After he ate a bite and got his shave, Hank bought a small bottle of whiskey and the two were back on the road. The weather worsened, and by the time the two arrived in Knoxville, it was snowing. Hank realized that the only way he could make the show in Charleston was to fly, so the two got on a plane at 3:30 in the afternoon. Carr says Hank was relaxed and in a good mood during the flight. The policeman back in Birmingham might not have been impressed that he was in the presence of Hank Williams, but according to Carr, the flight crew out of Knoxville most definitely was.

"The stewardess was very nice to Hank," he explained. "He had his muddy, wet boots propped up in the seat in front of him, and she never even mentioned it. She just lifted up his boots and put a towel underneath them. Once he got settled, Hank slept for most of the flight." The plane either couldn't land or turned back at some point because Carr and Hank returned to Knoxville at 5:57 P.M. The two checked into the Andrew Johnson Hotel, room 417, a little after 7:00 P.M. (That hotel is now an office building, and room 417 is a law office.)

Carr says he called A. V. Bamford and told him they couldn't get to Charleston. Bamford told him to make sure they made it to Can-

ton. The Charleston show was canceled because of the weather.
Buddy Killen was on that tour because the Webb Sisters, Buddy's
wife, June, and her sister Shirley, were to open the show. He said the
roads were treacherous. "When the Charleston show was canceled
we drove straight to Canton to spend the night. Or, I should say, we
slid all the way over there. I am telling you, it was a miserable night.
It was wet glass. But we got there all right, and waited for Hank."

Back in room 417 at the Andrew Johnson Hotel, Carr ordered a
couple of steak dinners, although Hank left his plate untouched.
Hank was in no condition to eat anything. He was either very drunk
or knocked out by chloral hydrate. He was in such bad shape by this
time that Carr says he fell out of bed and banged up his face.

Carr asked to see the hotel doctor because by this time Hank had
a severe case of hiccups. Dr. P. H. Cardwell arrived and gave Hank
two shots of morphine with vitamin B_{12}. Cardwell said he tried to
talk to Hank, but he was very drunk. In all honesty, I don't see how
anyone could live through all those drug injections, added to liquor
consumption, especially a man as frail as Hank was by that time.

I think Hank was worried about that Canton show. I think it was
important that he impress the Nashville contingent appearing with
him, and he felt the pressure mightily. I think that played a big role
in his taking more and more drugs and even in his case of hiccups.

At 10:45 P.M. Carr checked out of the hotel to once more get
started on the trip to Canton. By this time Hank was so out of it that
the hotel porters had to carry him, as if he was dead, to the car.
Hank's coat was draped around his shoulders, and when the porters
got him situated in the backseat, Carr covered him with a blanket.

And here begins another of the Hank discrepancies. At the time,
it was reported that Charles Carr hired relief driver Donald Surface
in Bluefield, West Virginia. If that's so, then Surface could not have
been with Carr when he was stopped for reckless driving in Ten-
nessee. Years later, Carr told Tom he found Surface in Bristol, not
Bluefield. "I stopped for gas in Bristol and noticed a diner across the
street. Next to the diner was a cab stand. Since I was familiar with
cabdrivers, I decided to ask if there was anyone who'd help me drive
the rest of the way. That's how Donald Surface was hired. I paid him

twenty dollars as I recall." Carr told Sean Gannon of the *Charleston Gazette* that the last time Hank Williams spoke to him was in Bristol. According to Charles Carr, Hank's last words were: "I'm gonna get some sleep."

WHAT HAPPENED NEXT is one of the oddest segments in the last hours of Hank Williams's life. Around midnight a policeman stopped Carr near a drive-in theater about six miles past the Grainger-Knox county line, near Blaine, Tennessee. Supposedly, Carr had narrowly missed hitting the policeman's car as he passed another vehicle on Route 11W.

As Carr explained to Tom: "It was a bit hilarious. There was a truck or a bus that I was starting to pass. But there was a car coming down the road from the opposite direction and since the road was icy, I dropped back behind. Another car came right up behind me. It turned out that the car coming toward me was a trooper. He turned around and stopped me and the guy in back jumps out of his car yelling, 'Give him a ticket! He almost made me wreck!' So even though the trooper couldn't possibly have known how fast I was going, he told me I'd have to follow him and go before a magistrate."

The patrolman, Swann Kitts, said he looked in back and asked Carr what was the matter with that man lying there. Carr, said Kitts, said Hank had had a few beers and been given a sedative. Kitts said he then asked Carr if Hank was dead and Carr said no, just sleeping.

When he was stopped, Carr was in Knox County, but he was instructed to go to the Rutledge courthouse in Grainger County to pay his fine. Swann Kitts claimed that he wrote Carr a $25 ticket for reckless driving, which he paid, plus court costs, amounting to a total of $33.50. Carr later said he gave the magistrate, O. H. Marshall, $65 and that there was no ticket. Since there was no record of the ticket, the arrest, or the time Carr spent in court, it is a fairly safe guess that the whole thing was a "small-town speed trap" scam and that someone was pocketing the money in cash.

"When I got in front of the magistrate, the first thing he does is

ask me how much money I had on me," Carr explained to Tom. "Well, I had about $700 because Hank had given me my pay plus the cash for the trip expenses. I had a feeling I shouldn't say how much, though, and I answered, 'Seventy-five dollars.' They asked me if Hank had some more money I could get and I said no."

Swann Kitts's account of the night is open to question. He said that there was a soldier in the car with Hank and Charles Carr, and that when Carr went in the courthouse to pay the fine, the soldier stayed in the car and read a newspaper, even though it was freezing cold and in the middle of the night. The "soldier" must have been Donald Surface. But I'm sure Kitts stopped a lot of people out on that stretch of road, and it's possible he just got confused. You have to wonder whether the Cadillac's engine was left running during the whole time Carr was in the courthouse, too. If not, I don't see how Hank—if he was still alive—could have withstood the cold.

Carr took Route 11 to Abingdon, then continued on Route 19 to Bluefield. He said he checked on Hank at Bluefield and that he was still breathing. There is a discrepancy in how and when Carr discovered Hank was dead. Dr. Leo Killorn, an intern at the hospital in Beckley (some fifteen miles from Oak Hill), says Carr stopped there and asked the doctor to check on Hank. Dr. Killorn said he told Carr that Hank was dead, but there was no coroner on duty, and Carr headed on for Oak Hill. Carr denies the entire incident.

Carr told it this way: At Hilltop, West Virginia, about three miles from Oak Hill on Route 21, Carr and Donald Surface stopped to stretch their legs. It was about 5:30 A.M. Hank's blanket had slipped off him, and when Carr reached back to adjust it, he noticed that Hank's arm seemed abnormally still. Carr drove straight to the Pure Oil station on Main Street in Oak Hill and asked directions to the nearest hospital.

"It was an all-night, cut-rate station," he told Tom. "There was a gentleman there and I remember thinking he was ancient even though he was only around fifty. He was sitting in a straight chair next to a radiant heater."

Deputy Sheriff Howard Janney and a patrolman happened to be

at the gas station and the two accompanied Carr to the Oak Hill Hospital. Dr. Diego Nunnari pronounced Hank dead, citing "acute ventricular dilation," or heart failure, as the cause.

Carr then called his father in Montgomery. "It's a good thing I called him when I did," Carr told Tom. "Because it wasn't thirty minutes later that someone called him and said they heard Hank and I had been killed in an automobile accident. Dad called Mrs. Stone, and she called me back at the hospital. As soon as I said it was true, that Hank was dead, she said, 'Don't let anything happen to that automobile.' Then about fifteen minutes later I was called to the phone again. This time it was Billie Jean. She said: 'Don't let anything happen to that Cadillac.' So I went up to the deputy sheriff and handed him the car keys. He asked me what I wanted him to do with them and I said, 'I don't want to be responsible for that car.' They drove the car back to the Pure Oil station and left it inside."

Several things were soon missing, most notably Donald Surface and one of Hank's hats. No one knows what happened to Surface, but some people say they saw him on the streets of Bluefield wearing one of Hank's suits. Charles Carr never heard from Surface again. Why he dropped from sight is anybody's guess and another part of the mystery of Hank's last day. Then there's Hank's missing hat, which most folks think was removed from the Cadillac by the man who ran the gas station.

Carr stayed at the Tyree Funeral Home to wait for his father and Lillie Stone to arrive in Oak Hill. He wasn't officially detained, but because the circumstances were so unusual, Carr was told to stay in town until a coroner's jury could be assembled. Since January 1, 1953, was Howard Janney's last day as deputy sheriff, he didn't write the official report of the day's events. But when he was contacted later, he did say that he remembered Surface being with Carr that day, and that he was told he could leave even though Carr was asked to stay in town.

Dr. Ivan Malinin, a Russian emigrant and a pathologist from the Beckley Hospital, performed an autopsy at the funeral home. The preliminary autopsy report shows that Hank suffered hemorrhages around the heart and neck. It supposedly showed that alcohol was

present but not drugs, although it's not known if they even tested for drugs. However, C. P. Miller, a member of the coroner's jury, recalled that a lengthy autopsy report was read to the six-man panel. He says both alcohol and drugs were mentioned. He also said that one of the reasons for a coroner's jury was the fact that Hank had a suspicious-looking mark on his forehead. Charles Carr assured the panel that it had happened in Knoxville when Hank fell out of bed. Carr seemed to have two stories about Hank's drinking and drugging on that trip. He told some that Hank didn't even finish the small bottle of whiskey and that he only had a few beers. That account was reported in the *Knoxville Journal* on January 3, 1953. But Miller remembers Carr telling the panel that Hank drank and took pills from the minute they left Montgomery. Miller also noted that the one thing he said he'd never forget from viewing the body was that Hank had an unusually large Adam's apple.

Other jurors had varying and interesting recollections. Hobart Booth said he remembered that in one report the word "suffocation" was used, yet there was no sign of foul play connected with it.

All those connected to the autopsy were very closemouthed. Janney didn't see anything sinister in the fact that no written records of the autopsy could be found at the time. He wrote it all off to the county's bad record keeping back in the '50s. However, juror Eugene Duncan explained it another way: "Back in those days they could make things be whatever they wanted them to be."

And what the jurors all agreed on was that what Hank's people— Lillie, Billie Jean, and a team of eight lawyers—all seemed to want was a speedy, painless, and non-finger-pointing decision. One juror said he believed it was proven that "Hank was killed off by his doctors." And another said that most of the family members were more concerned with what they would get from Hank's estate than with what had killed him. They remember joking that Billie Jean ". . . must have had an onion in her handkerchief to help her wring out a couple of tears."

Here again, we're dealing with people's recollections and you never know if they actually thought Billie Jean was crying crocodile tears back then, or if that thought was a result of later newspaper sto-

ries. The thing that interests me most is that eight lawyers showed up. They represented MGM Records and Acuff-Rose and my guess is that they were there to try and hush up any talk of Hank's death being drug related.

BUDDY KILLEN THOUGHT they were joking backstage at the Canton Auditorium when A. V. Bamford announced that Hank was dead. Hawkshaw Hawkins was there, the Webb Sisters, Homer and Jethro. They were milling around backstage waiting to play the matinee.

"I was such a naïve kid, and was used to people like George Morgan playing jokes on everyone," Buddy reflects. "I walked down the hall to get a Coke from the machine, and when I got back everyone was standing there looking like they were in a daze. I thought it was another trick somebody had come up with. 'What's the matter?' I asked. 'Is everybody mad at me?'

"Bam [A. V. Bamford] shook his head and said, 'Buddy, I was just telling everybody that Hank died on the way up here.' I said, 'Come on, that's not a very funny joke.' Bam shook his head again and said, 'I'm not trying to be funny.' I started talking louder, almost in shock. 'Come on, Bam!' I said. Then I saw tears in people's eyes and I knew it was true. I just couldn't believe it. Hank was only twenty-nine years old."

At Hank's request, Don Helms had driven the band members up from Nashville in Hank's big seven-passenger touring Cadillac. A. V. found the men in their dressing rooms and said, "Brace yourselves, boys. Hank is dead."

The crowd thought it was a joke, too. When WHKK/Akron deejay Cliff Rodgers stepped in front of the microphone and said he had a difficult announcement to make, a scattered snickering emanated from the audience. "This morning on his way to Canton to do this show, Hank Williams died in his car." A few people continued to laugh.

"Ladies and gentlemen, this is no joke. Hank Williams is dead."

WCKY's Nelson King, known as the King of Hillbilly Disc Jockeys, announced it this way:

"Friends and neighbors, today the world of folk music lost one of its greatest performers, one of its greatest writers. At 1:10 P.M. Eastern Standard Time, a teletype machine here in our newsroom at WCKY began typing out a dispatch from Oak Hill, West Virginia. It said, 'Hillbilly singer and composer Hank Williams died today, apparently of a heart attack while being driven to a show in Canton, Ohio. His driver, Charles Carr, said he discovered Williams was dead in the backseat of the car a few miles outside of Oak Hill. Carr said he thought his employer was asleep and he'd gone back to make sure he was warm enough. The two men had left Knoxville last night. The driver said that Williams, who was in his late twenties, was not feeling well and had seen a Knoxville doctor who had given the singing star a sedative. The exact cause of death will be determined at a postmortem to be conducted by the Oak Hill Justice of the Peace. The hillbilly singer's home was in Montgomery, Alabama, and his mother left there today for Oak Hill.' "

When Nelson finished reading the teletype, he continued with his own commentary: "Just a few moments ago I was talking to our good friend Murray Nash, a great friend of Hank's in Nashville. He tells me that Hank's mother and wife, Billie Jean Jones Williams, are both on their way to West Virginia. Hank's body will not leave Oak Hill until tomorrow afternoon, after two o'clock P.M.

"I can first remember meeting Hank Williams back in 1947, back in the early part of the year. Hank was working at a radio station in Montgomery, Alabama, and he'd formed the habit of giving me a call about twice a week and we'd pass the time of day or the time of night, since the *Jamboree* was on the air. He was always telling me, 'Someday I'll be up to see you. Someday, I'll be up to see you.' "

BUT HANK RAN OUT of "somedays" on that long, cold trip. And if Hank in life had shown Nashville what a superstar could do for

the business, Hank in death showed them what a legend could accomplish.

WHEN THEY TRANSPORTED Hank's body back to Alabama, people showed up along the highway, at gas stations where the hearse stopped. They waved from front porches. All were saying good-bye to Hank. On January 4, 1953, over 20,000 people showed up at the Montgomery funeral, jamming Perry Street, where the city auditorium was located. As the *Montgomery Advertiser* reported: "They came from everywhere, dressed in their Sunday best, babies in their arms, hobbling on crutches and canes, Negroes, Jews, Catholics, Protestants, small children, wrinkled old men and women. Some brought their lunch."

The service started at 2:30 P.M. with Ernest Tubb singing "Beyond the Sunset." By the time Ernest reached the line ". . . autumn leaves turning brown," the church was in complete silence. Ernest did a recitation during the song, a powerful one that went:

> "If you go first and I remain, one thing I'd have you do. Walk slowly down that long, long path. For I'll soon follow you. I want to know each step you take, so I may walk the same. For someday down that lonely road you'll hear me call your name."

The Drifting Cowboys played their last gig with Hank that day. Jerry Rivers was on fiddle, Don Helms on steel, Sammy Pruett and Hillous Butrum on guitar. The Southwind Singers, a black gospel group, sang a spiritual. Hank had drawn a black audience of about two hundred to this last show. Of course it was 1953 and in the South, so they sat in the balcony. Stars who came to say good-bye included Ray Price, Webb Pierce, Carl Smith, June Carter, Bill Monroe, Jimmy Dickens, Red Foley, Ernest Tubb, and Roy Acuff. The pallbearers were Jim Denny, A. V. Bamford, Jack Anglin, Johnny Wright, Bill Smith, W. Lewis King, Bob Helton, and Braxton Schuffet. Honorary pallbearers were Fred and Wesley Rose and Jerry Rivers, along with the staffs of WSM, WSFA, and KWKH.

Dr. Henry Lyons, pastor of the Highland Avenue Baptist Church, noted in his opening statement: "When he played on his guitar he played the heartstrings of millions of Americans." The preacher must have thought he'd try to save some souls during the service, because he gave it his all. Hank's mourners heard prime country preaching that cold day in January. Reverend Lyons read the 23rd Psalm, 1 Corinthians 15:50–58, and John 14:1–7. As he read, the sobbing in the audience got louder.

Roy Acuff attempted to introduce around twelve singers and musicians, but finally quit. "I'm too moved to remember the names," Roy said. Then he added, "Hank was one of the finest young men that we ever knew." When Red Foley sang "Peace in the Valley," Jimmy Dickens burst into tears backstage.

Dr. Lyons not only preached his full-service funeral that day, he did a good job of explaining Hank's greatness: "I cannot preach the funeral of Hank Williams. It has already been preached in music and song on radio, listened to by millions of admiring Americans, since the sad message of his death was announced Thursday. The preacher of the message was Hank Williams. The congregation was made up of the American people. Deep down in the citadel of his inner being there was desire, burden, ambition, reverse after reverse, bitter disappointment, joy, success, sympathy, love for people. What was his message? It was the message of the things everyone feels—of life itself."

Just before the final benediction, the Statesmen Quartet sang "Precious Memories." As Roy Acuff passed by the casket, he leaned down and whispered, "Good-bye, Hank." But it was Fred Rose who got the last word just after the service when he explained that Hank had recorded a wealth of material that hadn't been released yet.

"You'll be hearing Hank right along for some time," he pronounced. Fred was right. On January 7 the Canton *Repository* announced that Hank's music had sold out in every area music store. His record company was quick to react. Sales were astonishing in other parts of the country, too. More records were promised to the stores within two to three days. Hank had ushered in a new era and his memory and influence would be felt for a very long time.

◆ ◆ ◆

As IT GOES with all royalty, we pay homage to a passing, then cele-brate the next in line for power. And in Nashville, the next five men who assumed royal personas were definitely destined to be industry powerhouses. Of course, the new king wasn't to be found in Nash-ville. He was just a few miles down the road in Memphis. But Nash-ville's successors to Hank were royalty all the same.

Marty Robbins had debuted on Columbia in December 1952 with "I'll Go on Alone," a song that was heading to #1 when Hank died. Capitol introduced their new star-bound act, Faron Young, with "Goin' Steady" just days after Hank's death. In March 1953 Abbott Records released one of 1953's biggest successes, Jim Reeves singing "Mexican Joe," which stayed at #1 for over two months. Then, in October of 1954, Porter Wagoner signed with RCA and released "Company's Comin'," a top-10 hit that paved the way for his #1 signature song, "A Satisfied Mind," the next year. And of course there was a guy in Texas named George Jones who was mak-ing some noise regionally before hitting the national airwaves in '55 with "Why Baby Why."

This lineup, along with stars like Eddy Arnold, Hank Snow, Carl Smith, Ray Price, Webb Pierce, Hank Thompson, and Lefty Frizzell, was to be country's front line when rock 'n' roll took the world by storm. As the '50s drew to a close, stars including Sonny James, Johnny Horton, Patsy Cline, and Don Gibson played major roles in keeping country popular. And so country branched out to try and keep its core audience and gain a larger one even in the midst of rock 'n' roll mania. On the one hand you had Lefty Frizzell and George Jones with their stone country and honky-tonk. You had Hank Snow and Porter Wagoner with traditional country that at times tipped its hat to the early mountain sound. There were smooth crooners like Jim Reeves and Ray Price. Western swing, in the per-sona of Hank Thompson, never wavered and stayed as strong as ever in Texas, and of course, the rockabilly acts like Johnny Cash, Carl Perkins, and the Everly Brothers stood strongly between the two camps.

In April I went to work at a new station, WAGG in Franklin, Tennessee. Bill Ormes was the owner of the station and he had come over to WNAH one day to purchase all the country records that the station refused to play and had stored. I hit Bill up for a job and got hired for an early-morning show at $60 a week. In November of that year, WSIX announced it was expanding to include a television station. When many of the radio personnel left to work on the television side, the station found itself looking for broadcasters. The minute I heard there would be openings, I applied. I was very tired of the early-morning drive to Franklin, and only too happy to try for a new opportunity. WSIX was one of Nashville's top three stations, along with WSM and WLAC. It was a 5,000-watt station on the air full-time, and a network affiliate. In my terms it was my first shot at "the real thing." It's ironic that I finally got back to country music the same year that Hank the King died.

As I move on to some other great talents of the industry, I'd like to start with one of my favorite people, Marty Robbins.

Marty Robbins:
Country & Western
Crossover Giant

J CAN'T THINK OF anyone I've known in the music business who did more to hold country's flag high during the '50s than Arizona-born Marty Robbins. He was good at everything he did, from his signature pop-flavored ballads, to Hawaiian-type music, to western songs, gospel, rockabilly, and straight-ahead country. And Marty was one of the reasons country withstood rock mania. I always told Marty it was hard to put together a radio show about him because there were so many hits we'd miss just because of the time element. It turned out that way in this book, too. Like Hank Williams, Marty Robbins is a favorite of mine, and I found myself hating to part with his portion of the story!

Like so many country stars, Marty had an impoverished and troubled childhood. His mother took in laundry to support her nine children and Marty did odd jobs. In fact, many people thought the song "You Gave Me a Mountain" was about his wife, Marizona, but it was about the struggle Marty's mother went through raising him. They were dirt poor with a seemingly hopeless future, but the seeds of success were being planted then and there. "I cleaned out ditches and

picked cotton for about a quarter a day," he said. "On Saturday I'd pay a dime to go to a Gene Autry movie, a nickel for a bottle of pop and another nickel for a bag of popcorn, and have a nickel left over. I watched those movies over and over."

Marty's grandfather was another big influence on his love of westerns, cowboys, and story songs. Texas Bob Heckle, rumored to have been a Texas Ranger, though no one knew for sure, was the subject of great family tales, and Marty grew to love the legend and the mythical West. And so young Martin Robinson sat all day every Saturday, watching Gene Autry and thinking about his own family's cowboy. The dream took form right there.

Dreams were about all Marty had. He once told me that after he got to be a star he shopped all year for his family's Christmas presents, stopping in stores all over the country for interesting and unusual gifts. I asked him why he didn't have his secretary go shopping for him, and he acted surprised that I'd even brought it up. "I'm not that rich! My secretary wouldn't dream of running around shopping for me!" So I asked him why he shopped year-round. "I just try to avoid the crowds," he joked. But I knew there was more to it. "What was Christmas like when you were a boy, Marty?" I asked.

Marty got a faraway look on his face. "Well, we didn't get any new toys, of course." Then he was again his wisecracking self. "But all that means is that we didn't have anything to fight over!"

"Do you remember ever getting toys?" I asked.

"Let me tell you the story of Christmas, poor people style," he said, sadly shaking his head. "This is how it was for everyone without money, and I'm sure it's still this way. About three weeks before Christmas, you start to notice that you can't find what few toys you have. Then on Christmas Day, you open a little sack with your name on it and find your old toy painted a different color. I had one little metal car I got for Christmas about six years running! But it was all right because the paint made it seem new to me even if I knew it wasn't. I remember another thing about Christmas at our house. Mother loved to send people Christmas cards, but she couldn't afford to buy them. Luckily, back then, people signed the cards in pencil,

not pen. Mother would carefully erase the signature, add her own, and send it to someone the following year."

As hard as Marty's mother tried, though, she couldn't keep him on the straight-and-narrow path, and he got into quite a bit of trouble as a kid. He told me once that he'd spent some time in a Phoenix jail, suspected of robbing a liquor store where his car had supposedly been spotted. Thankfully, Marty was able to prove that his car had been in the repair shop during the time of the robbery. But trouble wasn't anything new to him. An unhappy childhood and a father who—Marty said—simply didn't care about him or even like him much left a mark. Marty talked some about it in an interview with Bob Allen, reprinted in Barbara J. Pruett's excellent and comprehensive source book, *Marty Robbins: Fast Cars and Country Music* (Scarecrow Press, 1990). Marty admitted that he and his friends used to use ice picks to break into the payoff pinball machines in town, and that the police kept a close eye on them all. He added that they only stole a dollar a night to try and keep from drawing attention to the scheme!

Marty told Bob Allen many interesting stories, including one about Jim Denny. Marty didn't name names, but the man booking the Opry when Marty came to town would have been Denny. Marty said he couldn't seem to break into the clique who constantly got good bookings. Try as he did, he wasn't able to make any headway. Marty got the dates that required the most driving for the least money. Finally he got mad and told the "booker" that when he got a hit song, he was going to make it rough on him for holding him back. The man, who had to be Jim, said, "You're never going to have a hit."

About six weeks later "Singing the Blues" hit and it was Marty who held all the cards. He played 'em, too. Marty told Bob: "He'd offer me jobs and I'd tell him where to stick it!"

But until the late 1940s, Marty Robbins held very few cards. While many of his fellow artists spent their military years in Korea, Marty enlisted in the navy in 1943, at age eighteen, and served in the Pacific during World War II. He had one of the roughest assign-

ments believable: driving the landing craft when U.S. Navy troops stormed beaches. I asked him one time if he'd gotten any medals for such dangerous work and he grinned, saying, "Yeah—an honorable discharge!" Years later Marty hired a Japanese guitar player and said he liked to kid him, reminding him that "me and your uncle mixed it up some years back." The kid—a tremendous and original musician—always laughed. There were never any ugly old feelings between them about the war.

Marty had another pretty dangerous gig in the navy. He was an amateur boxer, fighting thirty-six fights while in the service and winning over half even though he often fought army boxers who had been professionals before they were drafted. "I don't know why the army did it, but they let their boxers spend most of their time training," Marty said, laughing. "The navy made us work and train when we could fit it in!"

Upon returning to the United States, Marty worked odd jobs, driving a brick truck, assisting an electrician, working on a well rigging—anything to make a few dollars.

Marty met the love of his life, Marizona Baldwin, one afternoon when he stopped by a malt shop where she worked. She flirted with him and he flirted with her. Marty kept stopping in until one afternoon when Marizona let it slip that she was fifteen years old, almost ready to turn sixteen. That took Marty aback because he'd thought she must be at least nineteen. Marizona once told me that Marty stopped coming in for a few days but finally the attraction was too strong and he returned. They were married on September 27, 1948.

He had started singing around town while he was dating Marizona, but he used the name Jack Robinson because he believed his family wouldn't approve of a show business connection. He didn't tell Marizona for a while, either. When he did he must have been stunned by her reaction. Marizona told me she thought a prayer had been answered:

"We were very poor when I was a child," she said. "Almost as poor as Marty and his family. I would sometimes sit and daydream that I'd meet one of those heroic singing cowboys like in the movies.

Then I'd never have to worry about money again! Sure enough, the man I fell in love with wanted to be a singing cowboy and he was finding work doing it!"

In the beginning, Marty was more interested in pop music and only knew the country songs of the very biggest stars. It was after listening to Eddy Arnold that Marty's love of country songs came into full bloom. "I think the first time I heard a country song I really loved was in about 1946 when I heard Eddy Arnold sing 'Many Tears Ago,' " Marty recalled. "It was the first song I'd ever heard with such emotion, and yet so pretty." Marty remained one of Eddy's biggest fans throughout his life, counting as other favorites Merle Haggard, Hank Snow, and Gene Autry. Although, as he once told me, "nobody can sing a ballad any better than Jimmy Dickens!"

In 1947 Marty went to work for KPHO in Phoenix and it was there that Opry star Jimmy Dickens first heard him. "I started out doing a radio show," Marty once said. "And when I was asked to take over the television show I balked. It just didn't seem like something I'd be good at. But the station manager told me I had two choices— do television or lose my job. So I did television."

Marty came to Nashville in 1953, after Jimmy Dickens helped him secure a contract with his own label, Columbia. Marty never forgot who had helped him when he needed that career boost, either. Marty often dropped this line in his shows: "If you don't like my singing, don't blame me. Blame Jimmy Dickens!"

Roy Acuff told a story once about Marty's early days on the Opry. Marty didn't get the same wild reaction from the crowd that the established stars got, and it bothered him. So he started ending every song by throwing his hands up in the air and applauding, or running down to the edge of the stage and interacting with people in the front rows. He soon got as big or better applause as the regular lineup! Marty used that technique throughout his career. If the audience doesn't seem to "get" you, run out there and get *them*.

Another thing Marty did was use a song to change the subject during a show, just like he did in his movies. If he saw the need for a change from, say, stone country to pop country or cowboy music, Marty could change his show midstream. He always said that the

old-time cowboy stars often got out of tight spots by bursting into song—and Marty did it over and over in his films. Marty's stamp is all over his films. Faron Young said that Marty spent half his time on the set rewriting the scripts to make them more realistic. It seems like he split the rest of his time on the set acting and playing tricks. Faron also told about one time when he was supposed to be carrying Marty's body out of the line of fire, and Marty was goosing him all the way!

He had ninety-four charted records in his lifetime, including sixteen #1s, recorded seventy-one albums, and made twenty movies. In 1955, when some were scratching their heads and asking what to do about Elvis, Marty jumped out and covered "That's All Right, Mama" and hit the top-10. He followed it with a cover of Chuck Berry's "Maybelline" and racked up another top-10.

In 1956 he really hit his stride when in September he released "Singing the Blues." It was such an immediate smash that pop singer and fellow Columbia labelmate Guy Mitchell released it to pop radio two months later. Marty's version stayed at #1 in country for thirteen weeks and Guy's perched on top of the pop charts for ten.

Marty signed with Acuff-Rose Publishing, and his copyrights became part of the publishing base Wesley Rose developed following the loss of Hank Williams. Among Marty's biggest are: "A White Sport Coat (and a Pink Carnation)," "El Paso," "You Gave Me a Mountain," "My Woman, My Woman, My Wife," and two that were penned on the same day: "Big Iron" and "Devil Woman."

Marty was one of the first people to utilize the songwriting talents of Burt Bacharach and Hal David when he recorded "The Story of My Life" back in 1957. Mitch Miller was producing him in New York then, and I asked Marty once if he ever felt out of place recording there with New York musicians. "No," Marty said. "I actually think the Nashville Sound grew out of what those guys were doing. It wasn't as different as you might think."

No, except that I think the Nashville Sound was more open to innovation. I covered the Nashville Sound, Owen Bradley, Chet Atkins, Ken Nelson, and Don Law extensively in *The View from Nashville*. The addition of strings and background voices in an effort

to sell to urban audiences has taken some undeserved hits over the years. For one thing, hard-edged honky-tonk and other stone country music coexisted with the smoother sounds. And the Nashville Sound is part of what built Music City. Marty Robbins is a perfect example of how it worked without killing the genre.

Marty proved that Nashville could produce a wealth of musical styles and all under the wide umbrella of country. His Hawaiian albums with Jerry Byrd on steel can stand beside any in the field, and his western genre albums are matchless. No one could deliver a soulful ballad any better than Marty, either. There was a good reason early on that he was dubbed "Mr. Teardrop." Of course I always used to like to kid him about another nickname he picked up along the way: Mighty Marty. The promoters in Texas used to co-bill Marty and Willie Nelson shows as Mighty Marty and Wonderful Willie.

He also proved that taking risks with your music might well be the best move you make. Back in the '50s it was unheard of to record a long country song and expect it to be a single release. It was more a problem with the powerful jukebox operators than with radio. Those guys wanted two-and-a-half-minute songs because anything longer ended up costing them money. More song for the dime, if you will. "El Paso" was four minutes and thirty-seven seconds long, and when it first came out we deejays didn't know what to say! It took Marty several years to even get Columbia's Don Law to allow him to record the song. As he told me: "The main reason Don finally allowed it is that I dropped one verse that would have made it even longer and I kept after him every time we were in the studio. Back then we were making about four albums a year, so he finally ran out of ideas to keep 'El Paso' off!"

All it took was for listeners to hear it and "El Paso" was a hit.

It had been written in just a few hours, but had been in the works for three years before Marty started pitching it to Don. Here's the way Marty once told me "El Paso" happened: "We went through El Paso every year when we drove from Nashville to Phoenix for Christmas. It was about 1955 when I got the idea for a song about El Paso right when we were coming into the city limits. I didn't have a title, just a vague idea about El Paso and West Texas, which I see as

the start of the West. I started thinking about a song called 'The West Texas Waltz,' since waltzes were big then. And when I couldn't come up with anything along those lines I thought about 'West Texas Moon.' Then the wind came up and I thought about 'West Texas Wind.'

"But by the time I got through the city, the whole West Texas idea had vanished. So then the next Christmas rolled around and the same thing happened when I saw the El Paso city limits sign. And once again, when we got through town I'd forgotten about it. Finally, the third year I saw that sign and said, 'You were going to write about El Paso!' And we stopped at a gas station and the words started to come to me: 'Out in the West Texas town of El Paso I fell in love with a Mexican girl . . .' I wrote it in my head all the way to Phoenix—didn't write down a word until we were there. It was like a movie that I didn't know the ending of and couldn't wait to see what happened."

I'll bet Don Law was waiting to see what happened with "El Paso" when the deejays heard it, too. It was finally released in November 1959 and became the first country song to win a Grammy.

I'D FIRST MET Marty in 1953, when I was working in Franklin, Tennessee, at WAGG. As he did with so many of the acts he was excited about, Fred Rose sent Marty over to the station. Marty was painfully shy when he first appeared on my show, but he soon overcame it and we became fast friends. After I moved to WSM, Marty loved to stop by and play the piano on my show—sometimes we even played a record or two on those nights! And Marty was a guy with a quick and offbeat wit. You never knew what he might do or what he might think funny. One night when he came to the show and I announced that he was in the studio, he didn't say a word. I kept trying to get him to talk, so the audience wouldn't think I'd just made it up, but Marty just sat there. Finally he spoke up, but for a while there I feared I was going to sound like an idiot to the listeners!

Marty pulled a trick like that on Johnny Cash once. He went to New York and took a front-row seat at Cash's show at Madison

Square Garden. The stage revolved and each time the band came around to where Marty sat, they nodded and grinned. Marty sat there stone-faced and looking at them like they'd lost their minds. Finally one guy looked at another and Marty knew he was whispering something to the effect of: "Is that Marty or not?" When Carl Perkins came onstage, Marty did the same and he said Carl almost fell off the stage trying to get a better look through the spotlights. The only downside to the joke, as far as Marty was concerned, was that somehow Cash had been tipped off Marty was in the crowd, so the gag fell flat with the Man in Black. You have to get up pretty early in the morning to run one by Johnny Cash.

Another gag Marty played was on Roy Rogers, but it, too, fell flat. Marty once got on an elevator and was standing in the back when Roy and Dale got on. They didn't see him, so he started talking loudly, doing his best Gabby Hayes impression. Roy never turned around. Who knows what kind of a nut they might have thought was standing back there!

In 1955, when I was working at WSIX, I ran a contest asking listeners to vote for their favorite entertainer. I didn't ask about group or gender, just "favorite." Marty won that poll then, and he won again in a 1969 poll. Back when he was getting started, Marty appreciated the fact that WSIX played his records long before WSM did. In those early days he'd shake his fist toward WSM, which was down Union Street from WSIX, saying: "Ralph, those sons a bitches won't play my records!" He was especially mad at WSM's Eddie Hill, since Eddie was the most influential country deejay on the air at the time.

Marty wasn't the kind of guy who had a lot of rowdy buddies among the country music stars. He loved his home life, wasn't a carouser, and kept his home and family separate from his stardom. (Although he would provide entertainment for the tour buses that caught him in his Brentwood swimming pool by doing a few back flips off the diving board.)

Marty did like to pal around with Hawkshaw Hawkins. Hawkshaw was a great softball player, able to hit the ball completely out of the field. It was almost impossible to get an out on Hawk. So on one occasion at Shelby Park, when the Opry All-Stars, captained by

George Morgan, played the Acuff-Rose All-Stars, captained by Wesley Rose, Marty decided to change Hawk's luck. Hawk hit one over the centerfield light tower, and Marty, who had run into the next field and was standing on the pitcher's mound, reached up and caught it.

After Hawkshaw died, Marty wrote "Two Little Boys" for Hawk's widow, Jean Shepard, and the couple's sons.

One song I always loved was Marty's "The Master's Call." It's another great story song, and one with the most visual lyrics I've ever heard. The song starts out: "When I was a young man I was wild and full of fire, a youth in my years but full of challenge and desire." The story continues with the boy leaving home and taking up with a gang of outlaws. They end up rustling a herd of cattle and heading for Mexico. But along the way a thunderstorm brews. The young boy is surprised when a lightning bolt turns a tree into a burning cross and he doesn't realize the herd has started to stampede. At the same moment he turns away from the burning cross to face the hundreds of cattle headed for him, his horse stumbles and he is thrown to the ground. Knowing he is doomed, the wayward boy prays for forgiveness. Suddenly another bolt of lightning cuts through the sky and drops the cattle headed toward him, leaving the rest of the herd forced to run around him. As Marty sang, he heard the Master's Call that night when that final lightning bolt turned into the face of Jesus: ". . . a miracle performed that night, I wasn't meant to die."

I loved that song and always wished it had been a single. So when Marty stopped out at the show one night for one of his frequent visits, I asked him why he never released it. Marty appeared chagrined.

"I mispronounced a word," he admitted.

"What word?" I asked. "I never heard you mispronounce a word."

"Listen to it again," he said.

I listened and still I couldn't hear a thing wrong.

So Marty had me play it again and pointed out that in those final lines he pronounced the word "performed" as "preformed." Marty couldn't have stood hearing that word mispronounced over and over on the airwaves. Of course, I'm sure that it wasn't so much a case of his mispronouncing a word, as a case of the individual who typed the

lyrics for the session making a typographical error and transposing the r and the e. Marty probably sang what was written and never thought about it until the record was pressed and it was too late to change it.

The irony in Marty's life was that while he had a very laid-back personality, everything in his public life was high energy. His shows were always energizing, and of course, there was his car racing, which he loved as much or more than music. He used to tell people that music was what he did to pay for his racing habit. Then he'd laugh and say he just went out on the track and found a car that seemed about his speed and chased it around the track. But he was competitive, make no mistake.

Barbara Mandrell tells a story about the All-American Games at Fan Fair. Marty played the games as hard or harder than anyone, even though he had a heart condition and had undergone bypass surgery. One night Marty was on my show and mentioned how great the event was going to be the following year. Unfortunately, he didn't live to see it. Barbara says she realized that day, in the sweltering heat, that competitiveness was a trait they shared.

I think that most great artists are highly competitive. You don't get to be a Marty Robbins or a Hank Williams or a Barbara Mandrell or a Reba McEntire by shying away from a contest!

Marty was good behind the wheel in his racing. His car was named "Devil Woman" and he drove the devil out of her. Bobby Allison once said that when Marty first started racing cars he was a singer who liked racing, but as time went by he became a race car driver who also sang. Even a heart attack didn't stop him from climbing right back in a race car, and he ended up in a terrible crash that left him with four cracked ribs, a cracked tailbone, and in need of thirty-seven stitches. True to Marty's style, he was right back on the stage within thirty-six hours! At least he let Bobby Sykes take the lead singing "You Gave Me a Mountain" that night.

Marty wrote his song "Twentieth-Century Drifter" about car racing and the life of the driver trying to break into the business. "It's very much like the music business," he once told me. "The young guys knock on doors, try to get someone to pay attention to them—

to give them a chance to show what they can do. A lot of dreams crash just as hard as the cars. But then you can suddenly find yourself crossing that finish line ahead of the pack."

I WANT TO MENTION some other artists who found themselves leading that pack Marty spoke about by the mid-1950s. Missouri's Porter Wagoner signed with RCA in '52, but he couldn't come up with a hit until 1954's top-10 "Company's Comin,' " followed by 1955's career-making release, "A Satisfied Mind." Since then Porter has chalked up eighty-one releases and become a mainstay on the Grand Ole Opry. By 1960 Porter moved to television, hosting his own syndicated show that would last two decades and in 1967 would introduce America to a young lady named Dolly Parton, a mountain girl who ended up redefining women's roles in Music City.

Faron Young got his start with a little help from Webb Pierce, a fact Webb seldom let Faron forget. Many years later, Faron jokingly asked Webb, "Webb, how long do I have to be grateful?" Like Marty Robbins, Faron was incredibly versatile despite being tagged a honky-tonker because of songs like "Live Fast, Love Hard, Die Young." Pop music was his first love, but a stint with his high school football coach's band and then in Webb's convinced him to change direction. He signed with Capitol Records soon after Webb cut his deal with Decca, and after a short leave of absence when Uncle Sam called him to the service between 1952 and 1954. Faron stepped into pop star Eddie Fisher's post on the Special Services circuit, and the tour of duty probably helped his career as much as it hurt it. Throughout the '50s and early '60s Faron stuck with his hard-edged sound. It wasn't until after he signed with Mercury in 1963 that he recorded some ill-fated, watered-down material in what appeared to be an attempt to stay current with the Nashville Sound. By the '70s, he was back to honky-tonk, and he continued to record into the '90s.

One of the nicest and most mild-mannered guys in the business had to be Johnny Horton, a man who really couldn't have cared less about stardom. His '50s recordings on Mercury went nowhere, and it wasn't until after he'd married Billie Jean Williams, hired Tillman

Franks as his manager, and signed with Columbia that he caught fire in '59 and '60 with "When It's Springtime in Alaska" and "The Battle of New Orleans." These story songs became his trademark, and he subsequently hit with "Johnny Reb," "Sink the Bismark," "Johnny Freedom," and "North to Alaska." Those songs did much to keep country's fire hot for two short years back then, and it's hard to know what additional contributions Johnny Horton might have made to country music had he lived. But in the early morning hours of November 5, 1960, he was killed in an automobile accident after playing a show in Austin, Texas.

The
"Heartbreak Hotel"
Factor

\mathcal{B}OOKS AND MORE BOOKS have been written about Elvis's rise to glory and his place at the forefront of rock 'n' roll. But Elvis Presley, the King of Rock 'n' Roll, was in 1998 inducted into the Country Music Hall of Fame, and while some country purists criticized the move, I think it was appropriate. Elvis was aware of the new sound he was creating, but he first considered himself a country singer. He was the Hillbilly Cat long before he was the King of Rock, and throughout his career he frequently recorded country songs as well as gospel and bluegrass. I've always thought of "Heartbreak Hotel" as the first country-to-pop crossover song. And while in reality that title might belong to Jimmy Wakely's 1948 version of the Floyd Tillman–penned "I Love You So Much It Hurts," Elvis took crossover to unknown heights when he hit with "Heartbreak Hotel." And that song played a role in the commercial development of Nashville.

Elvis Presley had been hanging around Sun Records since 1953, when he paid Marion Keisker four dollars and recorded two songs for his mother, "My Happiness" and "That's When Your Heartaches

Begin." Marion, the former Miss Memphis Radio who served as Sun's office manager and Sam Phillip's right hand, kept his address: 462 Alabama Street, Memphis. Elvis cut more sides for Sam Phillips, and while Sam liked him well enough, nothing happened. Then one day Sam got a recording of "Without You" in the mail, recorded by an unknown black singer. He first phoned Nashville for suggestions about who he could get to record the song but came up dry. That's when Marion Keisker made her famous offhand comment:

"What about that kid with the sideburns?"

Still, Elvis wasn't immediately magic in the studio. "Without You" didn't come off, nor did his run at "Rag Mop." That's when Sam asked Elvis what he liked to sing and Elvis said, "Oh, anything." "Do it," Sam answered. And Elvis Presley did. He sang what Phillips later said was one of the most versatile and on-the-money collections of country, gospel, and R&B songs the record exec had ever heard. They ended up releasing Bill Monroe's "Blue Moon of Kentucky" and "That's All Right" in 1954, and you could argue that rockabilly was born right then and there.

I wasn't a friend of Elvis, so I can't speak from personal experience. But Harold Bradley, who played on so many sessions with Presley, says he was one of the nicest artists he ever worked with. Most others who worked with him say the same thing. The first two Sun releases didn't chart nationally, but in 1955 "Baby, Let's Play House" hit #5, followed by "I Forgot to Remember to Forget." When he signed with RCA and released "Heartbreak Hotel" it went to #1 country and stayed there an impressive seventeen weeks as well as at the top pop spot, where it stayed for two months.

Elvis was but a part of the Memphis legacy to Nashville's music. And for long-term power and influence on country music, Johnny Cash stands taller than any of the Sun Records acts. His story, in detail, will come later, as he becomes the biggest icon country music has ever known. But it was in the mid-1950s that Cash began a career that broadened country's acceptance as only Eddy Arnold had previously accomplished.

Johnny Cash auditioned for Sun and had a 1955 hit with "Cry, Cry, Cry," released a month prior to the July '55 release of Elvis's first

national hit, "Baby Let's Play House." Between 1955 and 1958 Cash broke through in the pop charts only slightly less impressively than did Elvis. And in 1958 his "Guess Things Happen That Way" became nearly as big a pop hit as it did country. And it was during that year Cash left Sun for Columbia, where it is said he later pulled off the same sales feat Eddy Arnold had done at RCA when he outsold every act on the label during the 1960s.

Carl Perkins's "Blue Suede Shoes" did as much as Elvis's "Heartbreak Hotel" to establish rockabilly as a bridge between country and the rapidly emerging rock genre. And like Elvis and Johnny Cash, Carl's background was perfect for the new sounds. His early influences were divided between the Grand Ole Opry and the blues songs he heard black field hands singing in rural Tennessee. Most of the Sun artists kept a foot in rock and another in country. Jerry Lee Lewis, who rocked hard at Sun, soon turned to more traditional country and had chart success in our genre as well.

The importance of Kentucky's Everly Brothers to country music is sometimes overlooked among Memphis-based artists such as Presley, Cash, and Perkins. But Don and Phil's country harmonies, combined with a rock 'n' roll edge and teenage attitude, brought Nashville as a recording center to the attention of New York and Los Angeles as much as anything had done. Further, the Felice and Boudleaux Bryant songs they recorded reinforced the concept of Nashville as a songwriters' haven, since the Bryants were among the first to make songwriting a full-time profession in the '50s and early '60s.

The thing to remember about these years, to my mind, is that these styles—country and rock—coexisted, intermingled, cross-influenced, and in the long run, helped each other. In Nashville, the fear that rock might cause a schism could have been common, but in the end it was all in the family. Elvis, Cash, the Everlys, Carl Perkins, and Jerry Lee—they were all as much a part of us as we were of them.

AS FOR ME, I made some real progress when WSIX asked me to announce and do spot ads on its ABC radio network in-depth news program, *America's Town Meeting of the Air*, broadcast from David

Lipscomb College. The spot ads were an unpaid job that went along with my regular duties. I was also asked to announce for a local high school student who had a music show on Saturday mornings. The show was called *Youth on Parade* and the young student was Pat Boone. It wouldn't be long before he was, if not an actual threat to Elvis, at least the entertainer considered his clean-cut competition.

My Pat Boone connection would help me land my first out-of-state job a few years later. In 1956, when Pat was one of the hottest acts in music, WLCS in Baton Rouge, Louisiana, offered me a job. I went down there for about a month, but couldn't stand the loneliness. My wife at that time, Betty, stayed behind with our son, Steve, and even though we were having marital troubles, I hated being away from them and from Nashville. Since I didn't have anywhere to go or anyone to see, I became a total workaholic for the three weeks I stayed in Baton Rouge. Luckily, Nashville soon called and I accepted a job with WMAK, a new rock 'n' roll station. I got to come home and they upped my salary to $125 a week. I also made some extra income making the taped programming announcements used in drive-in theaters.

Ultimately the job at WMAK turned sour. I learned that a colleague of mine, Wayne "the Brain" Hannah, was about to be fired and warned him about the impending move. Unfortunately for me, a guy in the control booth overheard me talking to Wayne and turned me in. I ended up getting the boot even before Wayne! It gets better. Wayne then called the program director an SOB for firing me and they gave him *his* walking papers on the spot. But the whole incident had the benefit of leaving me feeling like I had nothing to lose by applying for a job at the mighty WSM. I took a cut in pay, but in October 1957, I had landed at the station I would call home for many decades. As country struggled to retain its audience in the '50s, I struggled to keep working at what I loved best! We both experienced some highs and some lows. For Nashville, the would-be music center, "Heartbreak Hotel" was a high.

"HEARTBREAK HOTEL" HAS a strong Nashville connection as the song that helped launch one of our biggest and most powerful pub-

lishing houses. The march toward Nashville's claim to the title Music City started with the Opry, the success Acuff-Rose had with Hank Williams, and Owen and Harold Bradley's studio. That's what kick-started the mass migration of songwriters entering Nashville and prompted more publishing concerns, record labels, and other organizations to open their doors in town. And for Music City to work, songs and songwriters had to find a safe haven here in town.

Broadcast Music Inc. (BMI) played a role here, too, when the organization began to change the way songwriters got paid. The organization, which had been started in 1939 by radio broadcasters unhappy with ASCAP's rising rates, is crucial to the development of country music and Nashville as a music center. ASCAP had virtually ignored the country songwriting efforts, leaving many a country tunesmith in the dust financially. BMI sought out publishers of country music, including Acuff-Rose, and when, in 1941, broadcasters banned the use of ASCAP songs, the organization was forced to lower rates as well as get on country's bandwagon. Country publishers tended to affiliate with BMI because of ASCAP's lingering elitist attitude, and the fact that BMI paid for recordings as well as live performances. For years ASCAP writers were not allowed to cowrite with BMI-affiliated writers, so Fred Rose often wrote for BMI under the name Floyd Jenkins. Fred never cared about the credit as long as Acuff-Rose got the money. Although BMI didn't open an office in Nashville until 1958, when Frances Preston opened up shop in her home, the organization added greatly to Nashville's attractiveness and ability to draw talent.

Tree International was founded in 1951 by Jack Stapp, who enlisted the aid of the young musician I mentioned earlier, Buddy Killen. Some in Nashville didn't understand why a wet-behind-the-ears picker got the gig.

"Jack hired me for thirty-five dollars a week," Buddy recalls. "Even though the word was already out, I couldn't wait to hit the streets and tell everyone what a big publisher I was. So I went down to the Clarkston Hotel and there were some guys sitting with their backs to me. I heard one of them say, 'Yeah, who does that hillbilly bass player from Alabama think he is? I'll give him two weeks.'

There I was, around nineteen years old, and even though I wanted to brag to someone about my new job, I was scared to death. I know I must have turned white as a sheet when I heard that comment. But I made myself walk over to them anyway. I said, 'Boys, would you give me three weeks? I'll need the first two to get rid of fellows like you.' Then I walked out. I knew I didn't know anything about publishing, but I had to make a living. I had to do something and I was determined to succeed."

Equally determined to succeed was Jim Denny, who founded Cedarwood Publishing with Webb Pierce in 1953. Denny tried to stay on at the Opry, but he was soon enmeshed in controversy and conflict-of-interest accusations. Since Denny controlled the Opry's artist service, he stood accused of using Opry time to promote his own company and to favor artists who cut his songs. In December 1956 Denny left, forming his own booking agency, the Moeller Talent Agency, with Lucky Moeller, which he ran from Cedarwood's Record Row offices.

MEANWHILE, Buddy Killen is over at Tree trying to build that company into a force to be reckoned with. And as it turned out, hiring Buddy proved to be the smartest thing Jack Stapp ever did. For one thing, Buddy worked sessions and that gave him an inside track on pitching songs to artists. But even if his career had rested on one song instead of thousands, Buddy's hot debut as a hit-spotter literally *made* Tree back then. Buddy found "Heartbreak Hotel" indirectly through a musician friend, Billy Robinson, who'd played steel on the Opry staff band during Hank Williams's days. This story not only shows Buddy's enthusiasm for his new job, it shows just how tough the boys in New York could be when they saw that a little Nashville company had something they wanted. (Guess what? It's still that way.)

Billy Robinson called Buddy in the summer of 1955 and told him about a job with a guy who owned the Mellow Club in Daytona Beach. The guy needed a band for two or three weeks. He couldn't pay anything but he'd offer food and lodging.

"I was married to June Webb at the time and we'd just had our

second daughter, Robin," Buddy recalls. "I thought it would be a good way we could all get a vacation by the beach, so Billy and I put together a little four-piece band and down we went. One night when we were playing I looked up and there was Mae Axton in the crowd. I knew Mae from her public relations work over the years, and she'd always been great to me. Even when I was nobody, Mae treated me like I was somebody. Mae invited us over to the Municipal Auditorium to hear Elvis Presley and Hank Snow. Andy Griffith was on the show. And Homer and Jethro. Later, when we had to go back and play our second show, Mae came back to the Mellow Club. Elvis and his crowd were with her, but they stayed out in the car. Maybe they weren't interested in the show, or maybe they thought Elvis would be mobbed. He was selling about 50,000 to 60,000 records every time he released anything, and even though he wasn't a huge international star yet, he was still tearing up every place he played.

"I told Mae about my new job and since she had written a few songs I asked her if she had anything for me.

" 'I've got this one song I wrote with Tommy Durden, the steel guitar player,' she said.

" 'Really? What's the title?'

" 'Heartbreak Hotel.'

" 'Who do you think it would be good for?'

" 'Elvis.'

"I told her I'd love to hear it, and several weeks later I received a five-minute reel at my little office in the old Hill Building on Church Street. We were in the same building with Dee Kilpatrick and Mercury Records, right next to Nashville Gas. I pitched the song to Dee in case he had any artists who'd be right for it and Dee immediately told me Mae would have to rewrite the second verse. I knew Mae wanted it for Elvis, so I also sent it to Elvis's manager, Bob Neal. The next thing I knew Bob Neal had sold Elvis's contract to the Colonel, and Sun had sold his recording contract to RCA. So to cover all the bases, I quickly got a copy to Steve Sholes at RCA, who said he'd put it on the session. Mae was way ahead of me. She'd run into Elvis at the Andrew Jackson Hotel and played him the song. Elvis liked it and cut it.

"The funny thing is, the demo was sung by a guy named Glen Reeves, who specifically sang it the way he thought Elvis would. That's how Mae intended the demo be performed. Then, when Elvis cut it, he sang it exactly like Glen. So 'Heartbreak Hotel' is actually Elvis emulating Glen Reeves emulating Elvis."

Buddy told me that here's where the story turned sticky—or could have if Mae Axton wasn't such an ethical person. Hill & Range publishers, who had an exclusive with Elvis, came to Mae and offered to buy the song for $10,000—a lot of money in those days! Buddy didn't have anything on paper—he admits he was the worst about business dealings then: "I didn't know what a file cabinet was, let alone ironclad contracts and heavy-handed tactics." But contract or not, Mae turned them down flat, even though she needed the money. She even insisted that Elvis take a part of the song. Hill & Range didn't want the song to be a single if they didn't own it, but RCA knew it was too good to pass up.

Hill & Range wasn't finished. They approached Jack Stapp and offered him $40,000 for the song. Stapp wanted to take the deal, but Buddy insisted they hang tough. "I told Jack we'd never build a song catalog if we started selling off our songs the minute they hit," Buddy says.

Jack threatened to do it anyway and Buddy threatened to walk out. Tree kept the song and it became one of their biggest copyrights, along with "Crazy," "Green Green Grass of Home," "King of the Road," and "I Fall to Pieces." Tree became the biggest country music publisher (after the purchase of Pamper Music's catalog, which included Willie Nelson and Hank Cochran's songs), and Buddy became one of the most important figures in Nashville's history. I guess he proved the two fellows at the Clarkston Hotel wrong after all.

It's interesting to note that in the year 2000, Buddy Killen, having sold Tree to Sony Music nearly ten years ago, is releasing *Mixed Emotions*, his first solo album, a collection of pop standards like "Mack the Knife" and "New York, New York," as well as his self-penned hits like "Forever." Like a lot of fellows from those days, Buddy was always more about the music than the business of it.

Nashville was still a long way from being Music City, and as we bade good-bye to the 1950s and welcomed the '60s, there were few businesses on the Row: the Bradleys' studio, the Atlas booking agency, Jim Denny's Cedarwood Publishing, and the RCA offices. As Buddy Killen mentioned, Tree's offices were downtown on Church Street. The '50s had seen amazing performing talent infused into Nashville; the '60s would see Nashville become a songwriters' mecca.

More and more publishing concerns opened their doors in Nashville: Southern Music, Moss Rose, Silver Star Music, Starday, Pete Drake's Window Music, Bill Hall and Memphis transplant Jack Clement's Hall-Clement, Combine, and Al Gallico Music were all up and running by 1963. Opry stars like the Wilburns, Jimmy C. Newman, the Glaser Brothers, Mel Tillis, and Bill Anderson saw publishing as a moneymaking enterprise as well as a major contributor to building a solid foundation for Nashville's music community.

PART 3

Country's Golden Age—
the 1960s

Country Becomes a
Fighting Force,
Led by the Man in Black

J CALL THE 1960s the Golden Age of Country Music. The fledgling industry became a legitimate force during the 1960s, and Nashville could honestly call itself Music City USA, as WSM announcer David Cobb had dubbed it in the 1950s. Obviously the town didn't grow strictly within a decade-by-decade time frame. RCA had opened its doors in 1957, the same year a guy named Roger Dean Miller hit town. Chet Atkins and Owen Bradley were smoothing out the music with what was called the Nashville Sound to compete with pop recordings and, as Owen once told me, to keep their jobs. Nashville was competitive and diverse.

Consider the top-10 songs of 1960, not country songs, but all-inclusive: "El Paso," Marty Robbins; "Running Bear," Johnny Preston; "Teen Angel," Mark Dinning; "Stuck on You," Elvis Presley; "Cathy's Clown," the Everly Brothers; "I'm Sorry," Brenda Lee; "Only the Lonely," Roy Orbison; and "The Twist," Chubby Checker.

At the end of the decade of the '50s, another rock-inspired innovation happened in country music: the "big" show concept. Bill Anderson is the man responsible for making the move to bigger and more sophisticated lighting techniques and flashing backdrop images, which would peak in the '90s with shows like the Garth Brooks extravaganza.

John Lomax III writes in the Country Music Foundation's exhaustive *Encyclopedia of Country Music* that, by 1961, Nashville had over a hundred song publishers doing business. Professional musicians vying for studio work numbered over 1,200 and there were fifteen recording studios. Over 200 songwriters had gathered in Music City and there were in excess of 1,600 professional singers and sidemen. By 1962 Columbia Records had bought the Bradleys' famous Quonset Hut and opened offices. Capitol Records came to town. Mercury-Smash opened for business.

The United States Senate proclaimed a week in November as Country Music Week, and network television aired four specials during the newly declared country tribute week. And the Country Music Association opened its permanent offices in that same week. Mayor Ben West had signs erected welcoming tourists to Music City USA.

One important event that happened in '62 was all but overlooked. A red-headed guy from Abbott, Texas, named Willie Hugh Nelson made his chart debut. His buzz was to come some years down the road, but what a buzz it would be by the '80s, when people all across America sported "Willie for President" bumper stickers. Another buzz-to-be was born in '62, when, on February 7, a former Capitol Records recording artist named Colleen Carroll and her husband, Troyal Brooks, became the parents of a baby boy named Garth.

The number and quality of artists who were becoming stars during this period of time is overwhelming. In addition to Willie, you had great writer/artists like Bill Anderson, Bobby Bare, George Jones, and Buck Owens. By the end of the '60s, Merle Haggard would be a major force in country music, and ultimately as influential for future artists as Hank Williams.

The year 1960 had marked the end of the Eisenhower era and the

beginning of Kennedy's Camelot. And although on the surface there were remnants of the complacent '50s, societal changes were in the air. The first birth control pill was approved by the Food and Drug Administration. The first Playboy Club opened its doors in Chicago. And in Greensboro, North Carolina, four African Americans staged a sit-in at a Woolworth's lunch counter.

Freedom of a less serious nature than the growing civil rights movement was becoming an all-important concept in country music. In 1960 Patsy Cline broke free of her strangling contract with Four Star Music, which allowed her to record only that company's songs. Patsy and Owen Bradley tapped into the ever-deepening well of Music City songs and found "I Fall to Pieces" and "Crazy." By 1963, when she died in that terrible plane crash, she was a superstar.

There was one writer-artist who brought more attention to Nashville than any other. That man was Johnny Cash, who ushered country music into the '60s with fierce determination. Johnny Cash left Sun Records and moved to the Nashville-based Columbia Records in 1958. By that time there was no doubt that he was a country/rockabilly genius for whom boundaries meant nothing. His third Sun release, "I Walk the Line," had spent six weeks at country's #1 spot and made it to pop's top-20. Then, in January 1958, "Ballad of a Teenage Queen" was released and stayed at country's top chart position for ten weeks and hit pop's #14. The song was written by Sun engineer Jack Clement, who later moved to Nashville and played a major role in the careers of Cash, Charley Pride, and Waylon Jennings. In fact, Jack wrote the song Johnny still says is his favorite to perform: "I Still Miss Someone."

Sun also released "I Guess Things Happen That Way" in '58 and it, too, hit #1 in country, staying there for two months and hitting #11 pop. Cash's sound was very different from Marty Robbins's, yet the two had some things in common. They were fearless when it came to taking musical chances; they were brilliant songwriters and spellbinding performers. Those two men are the only two stars who ever intimidated me when I first met them. I grew to love them as close friends, and over the years my admiration did nothing but grow.

Cash, on Columbia, seemed to slow a little. His first release, "Don't Take Your Guns to Town" (backed by "I Still Miss Someone"), did well: #1 in country for six weeks and a top-40 pop hit. But Columbia followed that with less-well-received singles. In 1959, after six releases, "I Got Stripes" became his next single to crack the top-5 in country. Of course, Sun was continuing to release his material, so Johnny was competing with himself for chart space during that time. Sam Phillips continued to release Cash singles until 1970, and you can't blame him for that business decision. Johnny hit his stride at Columbia in 1963 when the label released "Ring of Fire." The song was written by June Carter, who would marry John in 1968, and Merle Kilgore, who would serve as his best man at the wedding.

June and Merle had both been on tour with John, and the two found they made a pretty strong songwriting team. They'd penned a long list of songs, including "Promise to John" for Hank Snow and June's sister Anita Carter. They met frequently to kick around ideas when they weren't on the road. Finally June decided to kick the writing into high gear. She called Merle and said, "Listen, let's meet every day we aren't on tour and write as much as possible. I know we can get some songs recorded if we just work harder at it." Merle agreed.

One day June arrived at the meeting and told Merle she'd had a letter from a friend who was going through a terrible divorce. The woman had referred to love as a "burning ring of fire."

Before we go on with this story, I need to tell non-music-business people that songwriters they know are listening to their words all the time for great ideas! And they listen to each other, too. Songwriters used to want to hang out with Roger Miller just to hear what he said as throwaway lines. I've heard that if people really knew how many songs got written because of a line Roger said and forgot about, it would be an enormous list.

But June had this letter containing a great line, and she wanted "Ring of Fire" to be the title. Merle hesitated. "June, Duane Eddy has an instrumental titled 'Ring of Fire.' Maybe we should title this 'Love's Burning Ring of Fire.' His is in a movie, and I'd hate to be

accused of taking his title." The "Burning" part never made it to the Columbia release, although Anita Carter recorded it under the complete and correct title.

The two started working on it and then they got stuck on a word to rhyme with "fire." The line they had to follow was "I went down in a burning ring of fire."

"What next?" Merle asked. "Then what did love do?"

June offered, "It mired."

Merle said, "What in the world does 'mired' mean?"

June was surprised he didn't know: "Well, it means when you get stuck in the mud. Haven't you ever heard that?"

Merle told her he was a city boy and had never once heard the word.

June liked it.

" 'Mired' is not an affectionate word, whatever it means," Kilgore said.

"Well, it doesn't bother me and I can't think of anything else," she replied.

And as Merle explained, things like that can throw a whole writing session off. "The rhyming just fell apart then," he said, laughing.

They tried to come up with an alternative, but remained "mired" on "Burning Ring of Fire." Then, as with many songwriting efforts, necessity bred creativity.

"Kilgore, get over here!" June exclaimed one day. "Anita is in the studio and she needs another song! We've got to finish 'Ring of Fire'!"

Merle was living on Kemper Drive in Nashville, which was not far from the Carter house on Due West, where the Mother Maybelle Carter Retirement Home is now located. He ran right over, and with the pressure on, they nailed the song in fifteen minutes, headed to the studio, and got it cut. The line that replaced "mired"?

"I went down in a burning ring of fire. I went down, down, down and the flames went higher."

Seems like such a natural, after the fact, doesn't it?

The truth is, both June and Merle had specific people in mind when they wrote that song. June was thinking about Johnny Cash,

the man with whom she was in love and the man who made it a hit. Merle was thinking about an old high school girlfriend. Merle wrote all his lost-love songs for her, including "More and More," which both Webb Pierce and Charley Pride released. "More and More" proved to be a song that withstood the test of time, too. Webb's version stayed at #1 for ten weeks in '54 and Charley's hit top-10 nearly thirty years later in '83.

Merle confessed to me that he had a thing for his first sweetheart for years, and although he never tried to make a move on her, they corresponded after they both married. In fact, Merle says the worst thing he did was having a simple lunch with her after all those years had passed. They realized they had no real romantic feelings for each other anymore, and Merle realized he'd gained a great friend and lost a great writing inspiration.

One day in 1968 June called Merle about another get-together. This one didn't involve songwriting. It involved a wedding.

"Kilgore," June began, "what are you doing on March the first?"

Merle looked at his calendar and said he appeared to be doing nothing on that day.

"Oh yes you are," June retorted. "You are going to be the best man at the wedding of June Carter and Johnny Cash!"

Merle says his first reaction was disbelief at being chosen out of all Johnny's friends to be the man who stood up with him at the wedding.

"Everybody else must be out of town," he said. Then he added. "June, Waylon's in town."

"Merle, we want you."

Merle named several other Cash pals.

"We want this to be a private wedding," June said. "We're going to sneak off to Franklin, Kentucky, and get married and Johnny and I want you to be best man. You're our old war buddy, Merle."

Merle said he was still almost speechless. "This is the greatest honor of my life," he finally stammered.

And that's what they did. They went to a small chapel in Franklin, Kentucky, and Merle stood as best man with Johnny Cash.

But he still must have been a nervous wreck over the whole situation, because Merle told me he messed up big that day.

"Johnny pulled me aside before the ceremony and handed me a fifty-dollar bill and June's wedding ring," Merle recalled. "He said, 'Keep the ring for me and be sure and pay the preacher after the ceremony, Merle.' I said I would and put the money in one pocket and the ring in another. I was wearing one of those Italian silk suits from Levy's—a gorgeous suit I'd bought just for the occasion. I got awful nervous during the ceremony and I started to sweat. Well, that silk suit started to shrink up tight against my body, and when the preacher nodded to me to produce the ring, I couldn't get the ring box out of the bottom of my pocket! Plus, the pocket I'd put it in was partially sewed up, to make the suit fit smoother, I guess. I fumbled around and Johnny nudged me and whispered, 'Merle, where's the ring?' I should have just put the ring in my pocket instead of leaving it in the box, but it's always easier in hindsight. I was there digging down in my pocket and Johnny was elbowing me. By then Johnny was doing a lot of coughing. Finally I just tore my pocket open. So in this quiet chapel during Johnny and June's wedding, the only sound is 'RIIIPPPP!' and 'Harruumph!' I got the top off the box and shoved the ring at Johnny and the preacher finished up the ceremony. I was so embarrassed about the sweaty suit with the torn pocket and me not being able to produce the ring fast enough that I hurried out of the church right behind the bride and groom. As soon as I got back to Nashville, I sent the suit out to get it cleaned and repaired. When I picked it up there was that fifty-dollar bill pinned on the front."

I had to laugh, sitting there trying to picture it all. "So Johnny Cash's wedding still isn't paid for?" I asked.

"No, I'm sorry to say it isn't. That preacher probably thinks Cash is the cheapest star in Nashville!"

I don't remember Merle showing up at the reception with a torn suit. The jacket must have hidden the pants pocket. I wasn't at the wedding, but Johnny had invited Joy and me, along with the wedding party, to the reception at the Cash house. I remember that Mother Maybelle and June's sisters, Helen and Anita, were there.

Johnny's band was there. And of course, Merle Kilgore was there, and unbeknownst to him, he was fifty dollars richer than he'd been before the ceremony!

JOHNNY CASH HAD and has star quality like almost no other. When I started writing about him, I recalled a moment at the old Andrew Jackson Hotel around 1958. It was a deejay convention and we were all milling around there in the lobby. All of a sudden into the hotel walks Johnny Cash, his then-wife, Vivian, Johnny Horton, and his wife, Billie Jean Williams Horton. The four walked slowly to the grand staircase and began to ascend. Like everyone else, I watched in silence. It was like royalty was making an appearance. It was one of those stunning moments that you never forget, a sight frozen in time.

After achieving country and rockabilly legend status in the '50s and early '60s, Cash branched out even more. He appeared at the Newport Folk Festival where he forged a fast friendship with Bob Dylan. I mentioned earlier in the book that Carl Smith said Jerry Lee Lewis was one who was always tough enough to speak his mind. Well, you don't have to look far to know what's on Cash's mind, either. In 1964 he released his piercing record "The Ballad of Ira Hayes," about the Native American World War II hero, and radio didn't seem interested. Cash took out a full-page ad in *Billboard*, asking: "Where are your guts?" The song made its way to top-5 and stayed in the charts for twenty weeks.

In 1969, about the time Cash was selling as many records as all other Columbia acts put together, *Life* magazine put him on its cover: "Johnny Cash—The Rough-Cut King of Country Music." Inside the magazine, the story title read: "Johnny Cash Makes Everyone Like Country Music." The writer, John Frook, noted: "He sings of bygone days many of his listeners can't even remember: railroads, hobos on the open road, Depression, hard times he knew growing up poor in an Arkansas cotton patch. These are curiously old-fashioned themes, but Johnny Cash makes them fresh."

Frook speculated that Cash appealed to Americans who were

"increasingly fed up with the pressure and confusions of city life and who yearn to get back to the land. That's why Johnny works. He's got soil." And he pointed to the "musicales" Johnny hosted in Nashville during those days, citing one night when Bob Dylan sang "Lay Lady Lay," followed by Judy Collins introducing "Both Sides Now" and David Crosby playing his group's new "Marrakesh Express."

Cash told *Life* that in his youth he did his best singing while he was plowing. "I had a very high voice, a high tenor, and I'd yodel. I never sang at public functions except for a few things like the senior prom, where I sang 'Trees' and 'Drink to Me Only with Thine Eyes.' " Then John's voice began to change. He was singing along one day at home and his mother stopped and asked who was hitting those low notes. "That's me, Mama," John answered. He said he was so proud he kept singing for days on end.

In the end, the writer speculates that Cash's insistence on reality is part of the key to his overwhelming success. During the breakthrough *Johnny Cash at Folsom Prison*, the listener hears the clang of prison doors, guards on loudspeakers, and Cash talking to the prisoners in the audience. On Cash's television show, viewers could hear babies and police sirens squalling in the background. Said John: "I *want* folks to hear those things. That's life."

That's Johnny Cash. And it was how he was on the television special we did in 1970. We had recently been at the White House for a special concert featuring country music. I have to say that my pride swelled that night. Country music had come so far. Johnny Cash was the star that night. I asked him if he felt extraordinary pressure and he said he had not, that in fact he'd never felt more confident. That is especially interesting, since Cash had turned down the White House request to sing "Welfare Cadillac." That was a song released by a Kentucky singer/comedian named Guy Drake in January 1970. Cash hadn't even heard the song, and when he did, he refused to perform it.

He was so confident, in fact, that when June left their passes at the hotel, Johnny didn't have the driver turn around to go get them. They arrived at the White House and when a guard asked to see their passes, Johnny spoke from the back and said they'd forgotten to

bring them. The guard leaned in the window, took one look at Johnny, and said, "Go right in, Mr. Cash."

I laughed at that story and told him he was lucky he was recognized, because Tex Ritter had said he wasn't going to vouch for him. Cash said, "Tex better, or I won't vouch for *him* next time."

Johnny is a man who has strong beliefs, and while he was no fan of the Vietnam War, he'd mentioned on his television show that he stood behind the president of the United States. "The president is elected by the people," John explained to me. "And we have to stand by him, even though we question some of his decisions." One decision President Nixon had made between the time of the White House show and the television show Johnny and I were doing was the invasion of Cambodia. Johnny just shook his head over that. "I don't know about that decision," he said. "I hope he is doing the right thing."

That night at the White House Johnny spoke up, not for the war, but for people supporting their president. "If you don't want to stand behind the man the people of the United States elected, then get the hell out of the way so I can," he said.

Johnny said the thing that impressed him about Richard Nixon was the fact that he seemed very real. He and Mrs. Nixon invited Johnny and June to their private quarters after the show and John said that the president was like anyone showing a visitor their home.

"You have to see this room!" the president would exclaim.

Johnny started to worry that he was taking up too much of the First Family's time.

"Mr. President, surely you've got better things to do than give June and me the dollar-ninety-eight tour of the White House," John said.

Nixon seemed surprised. "Well, if Pat and I came to visit you, wouldn't you show us around the house?"

Johnny admitted that he certainly would and they continued the tour. Nixon told him that he was a great fan of Merle Haggard, and Cash agreed that Merle was one of country's best. Keep in mind that Merle had just had hits with "The Fighting Side of Me" and "Okie from Muskogee."

"What I like about Merle Haggard is his attitude," Nixon said. "Look at how hard he had it growing up, and then his time in prison—and still he sings positive songs about America. He's a real patriot. You know, John, a man's real character is fashioned during hard times."

For John, hard times included his battle with drugs. I complimented him for holding a news conference to encourage the youth of 1970 to get out of the drug lifestyle. He'd told them that they were playing with death, and that no one understood that better than Johnny Cash. John also said those things on his television show. "I've learned that whether I want to or not, I influence people," John said. "I'm always getting questions from reporters about social issues and I know they are trying to use me in some agenda of their own. I used to avoid those questions, but more and more I realize that public figures have some responsibility along those lines. I'm a performer first, but second, if I can help someone with an idea or a viewpoint, I should do that. Television is so powerful. I think I realized that more than ever when I met this elderly man in Florida recently. He told me he and his wife were retired, living on a very small pension in a little four-room house. But, he said, they had a television and they looked forward to my show every week. That makes my responsibility to entertain and provide something of substance very great."

One of the people lost to drugs was the Native American folk singer Peter LaFarge, who wrote "The Ballad of Ira Hayes." That death and Johnny's concern for Native American issues prompted me to give him a gift that night. An elderly Native American woman, an invalid, had given me a handmade doll for my kids, and we thought it would be appropriate to give it to Johnny. I was impressed that he wanted the woman's name so he could correspond with her.

I gave John another gift that night, an 1851 Astin single-shot pistol that was used in the Civil War. John collects guns, and I knew he had a special interest in Civil War relics. "Now, John," I said, "I have to tell you that this gun is a Yankee gun, so unless it was captured by one of our boys, it fought on the wrong side." Johnny laughed and said he'd pretend that story was the real one behind the gun. Then

he mentioned that he was looking for a Texas Patterson Colt, the first revolver ever made and a very rare gun. I said I hoped that some viewer would contact him with information about one of those pistols. "What would one cost?" I asked.

"In good condition it would be about ten thousand dollars," John said.

"I don't believe this one is quite that expensive," I said, laughing.

We talked at length about the tabloids and what an invasion of privacy they are. John said he even saw an article in one magazine that contained lyrics he'd supposedly written about the recent birth of his son, John Carter Cash. "One line in this lyric I supposedly wrote was '. . . there's angel wings flapping over Nashville tonight.' Now do you think I'd write that?"

No, I didn't think that was a Johnny Cash line.

But Johnny knows there's a fine line between fan interaction and invasion of privacy. Johnny said he had called a friend, another entertainer, and suggested they meet for dinner. The fellow said he didn't want to go because his fans wouldn't let him eat in peace. Johnny said every time he heard something like that he was reminded of a time when he was fourteen years old and the Louvin Brothers came to Dyes, Arkansas, to play a show. Johnny was a big Louvin Brothers fan, having spent hours listening to them on WMPS, out of Memphis. After the show, Johnny approached Charlie Louvin, who happened to be eating a cracker.

"Are crackers good for your voice?" John asked, always hoping for some tidbit that would help him in his dream of becoming a singer.

"Not that I know of," Charlie said with a smile. "But they're good for your belly if you're hungry!" Then Charlie asked Johnny for directions to the rest room, and Johnny stood there while Ira waited for Charlie to get back so they could leave. John didn't say another word for fear he'd say something stupid. He said he always remembered Charlie talking to him, and how bad he'd have felt if Charlie had ignored him or made him feel like he shouldn't have spoken.

But the biggest lesson John said he ever learned about fans and the invasion-of-privacy issue had happened in 1974, just four years

after we'd had that talk on my Cash special. John Carter was four years old, and riding in a jeep with some family members. The jeep flipped over, and John Carter was trapped beneath it.

"The wheels on that jeep hadn't even stopped spinning when a Grand Ole Opry tour bus pulled up and twelve men jumped out and set it upright. John Carter was saved by those men, and every time I see a bus go by the entrance to my property, I remember that and thank the Lord for those twelve men who happened to be taking a tour of the Stars' Homes."

Johnny had recently had his own lifesaving situation, his visit with Waylon, who had just had a heart bypass operation. The story is well known, how a doctor took one look at John and ordered tests that showed John's arteries to be 90 percent blocked. John went straight in for bypass surgery.

After the surgery, Johnny said he changed many things, not the least of which was his junk-food habit. I reminded him of a trip we'd once taken where he almost bought the entire supply of Cokes, peanuts, and other junk-food items at one convenience store. He said he did much better these days except for Cokes, which he hated to give up. And his morning cup of coffee.

"My doctor prescribed a cup of real coffee for me every morning," Johnny said. "He told me he knew I'd have it anyway, so he might as well go along! He also said he knew I needed that bit of caffeine to get me started every day. I was dependent on it."

I asked him how long it had been now since he'd been dependent on the hard stuff, how long since he'd kicked drugs.

"Oh, I haven't kicked drugs," Johnny said. "I'll never truly kick them. I don't take them, but like any addict, I think about them. The gnawing will start, the craving. Sometimes it lasts a few minutes. Sometimes an hour or more."

"What do you do to ease that gnawing?" I asked.

John hesitated. "I have to make a daily commitment to God," he said. "I don't think about what I'll do tomorrow or the next day. And during the time I find myself wanting drugs I pray or call someone I know is straight. Maybe Waylon. I may not even talk about the drug

problem. I may ask him about his new record or his family. What I have to always remember is that even though I despise drugs and what they do, I crave them."

The ease with which an addict can slip back into the pattern was demonstrated to John in 1983 after stomach surgery. John was put on morphine and other pain medication and was soon addicted. He checked himself into Betty Ford and stayed for forty-three days. One of the things he especially liked at Betty Ford was the regimen.

"I was in the military and I actually liked having a regimen, making my own bed and keeping my clothes clean," John explained. "One problem with being an entertainer is that you wind up having all that being done by other people. You get used to people doing everything for you. At Betty Ford I had various jobs, menial tasks, to perform. I vacuumed, cleaned, made my bed. It was a good feeling. It gives you back part of yourself."

I asked John if people still offered him drugs.

"When you clean up your life, you have to start by cleaning up your playground," he said. "I don't go places where that's likely to happen, and my friends know better than to offer. There are times I hear about a show I'd like to attend, but I know there will be drugs, so I don't go."

I told Johnny that it always bothered me that when I went on shows where George Jones was on the bill, I saw so many people hanging around backstage offering him a drink. People would literally shove bottles at him. It's as if they needed to be able to say they got drunk with old George.

Johnny shook his head, and said something I think very profound.

"Ralph, that is probably the only way they feel they can share something with George, but the reality is that they aren't sharing anything. They are taking away a piece of his life."

Part of Johnny's character was forged in childhood as a direct result of his close relationship with his older brother Jack. Jack was two years older than John, and died as a result of a table-saw accident at school. When I was on the road with John's brother Tommy Cash, he often spoke of that close bond the two shared.

"Jack was the 'cleanest' boy I knew," Johnny told me. "By that I

mean he would never smoke or swear or do anything to bring any shame to the family. He believed he was called to preach and I think that's what he would have done had he lived."

We talked about the tragedy of losing a family member, especially one so young, and Johnny said that the one thing that had held the family together was what Jack had said before he died.

"Jack saw heaven, Ralph," John said. "He said he was going down a river. He could see fire in the distance but knew he wasn't going there, that he was going to heaven. Right before he died he said, 'Mother, can't you hear the angels sing?'"

John still dreams of Jack, and interestingly, through the years Jack has aged with John. Usually, if you think about it, you dream of people as they were when you last saw them or as they were during favorite times. But John's dreams of Jack, the brother who died at fourteen, are of a gray-haired man, face somewhat wrinkled, and still two years older than John.

John, too, had a brush with heaven. It was when he had his heart bypass surgery, and although it was a lifesaving operation, Johnny confided that for a time he felt violated. "It's hard to describe the feeling or the experience," he told me. "But I went to a place where I felt absolute beauty and peace. It wasn't some morphine dream, either. I've had those and I know the difference. I wanted to stay there. I don't mean that I understood that meant I had to die. I didn't want to die. But that place was so perfect that when they brought me back, I felt violated. I was angry they'd taken me away from where I'd been."

I asked him if Waylon had had a similar experience, and while John said the two hadn't really delved into the subject, Waylon also said he'd felt violated when he awakened. "Maybe that's why I'm mad all the time!" Waylon joked.

Tex Ritter used to laugh and say that if he played a show where someone didn't know a thing about country music, he could always count on that person yelling: "Where's Johnny Cash?"

"I don't know where John is," Tex would say. "But until he shows up, would you sit down and let me sing?"

Big John Cash. Almost impossible to follow.

The Long Good-bye

*H*ANK THOMPSON WAS the first to play downtown Las Vegas, but it was Marty Robbins who in 1969 first made it to the Vegas strip. A year later, again playing on the strip in Vegas, Marty collapsed after the show. He lay on the floor and stared up at his excited, fearful band members and wondered why their mouths were opening and closing yet they said no words. What they were saying, indeed, crying out, was "My God, Marty's turning gray. He looks like he's having a heart attack." Marty didn't get the word until later, when he awakened in a hospital bed and a doctor was standing over him. Marty struggled to sit up.

"Stay quiet, Mr. Robbins," the doctor instructed. "You've had a heart attack. You're in the hospital and stable. But we're going to keep an eye on you for some time."

"No, that's impossible," Marty answered. "I've got a show to play in Cleveland."

"Sorry," the doctor said. "There's not going to be any Cleveland show."

Marty may have been very ill, but his mind was working fast. "All right," he said. "I've got a ticket to Cleveland. I'll just change planes and go directly to Nashville to my own doctor."

The doctor, having no idea how serious Marty Robbins was about fulfilling his commitments, agreed. Marty checked out of the hospital and caught a plane to Cleveland. Then he took a cab to the venue. His band was in shock at the sight of Marty attempting to make it through the show. For one thing, "El Paso" is a grueling song to sing, and Don Winters says Marty began turning that gray ghost color again. Finally, Marty strolled over to Bobby Sykes and whispered, "Have security ready when I finish this last number. I have to get to a hospital."

Marty had played the show with half his heart working.

This time the doctors didn't mess around. They told Marty he had between three to six months to live. Marty was just forty-five years old.

"Unless you want to try something that's still in the experimental stages," the doctor continued. "Something called bypass surgery."

Marty Robbins feared nothing, certainly not experimental heart surgery! And so he became only the fifteenth person to ever have a heart bypass operation. And he also became one of many individuals who died on the operating table and lived to tell about it.

"I'm a believer, not a preacher," Marty once told me. "But that heart attack and what happened on the operating table was a positive experience because it was a spiritual experience. I'd always believed in God, but on the table, when I was clinically dead for a period of time, my beliefs proved to be very real. I knew I was no longer in my body, and that didn't seem to matter to me. I walked along and came to a river. Across that river, standing under a tree, dressed in a purple robe that seemed to have a second, white robe underneath, stood Jesus Christ. I wanted to cross that river and be with Him. I don't think I ever wanted anything more in my life. But as I started across, Jesus put His hand up and shook His head no.

"I stood there on the bank and understood that the time wasn't right. I had to come back. I don't like to talk about this much, because it was so personal. But maybe it will help someone to hear what happened."

There was another way that this experience changed Marty. He decided he would live every moment to its fullest. Four weeks after

the surgery he was back out on a tractor on his farm. He made an appearance on the Opry and joked that he owed too much money to die right then. What he didn't say was that the doctors had told him the surgery would probably give him twelve more years.

In March 1970 I welcomed Marty back with a simulcast special on WSM television and radio. I feared it wasn't going to happen, because Marty got lost on Hillsboro Road and arrived just in time for the start of the broadcast. Marty showed he still had that sense of humor when he started joking about his piano playing.

"You know the difference between Floyd Cramer and me is that Floyd plays on both the black keys and the white keys," he deadpanned. "He's still trying to find a style and I've got it figured out. Don't mess with those black keys!"

He told me he had been stunned at the amount of mail he'd received while he was in the hospital in Cleveland. Over 20,000 pieces. When I asked him if he was planning on getting right back to his career, he said, "Well, Ralph, it's either that or go to work."

He again addressed the spiritual experience of his surgery, and told a story I'll never forget. It's about what prayer really does for people.

"I was in so much pain I didn't think I could stand it right after the operation," Marty said. "I prayed for the pain to go away and it didn't. I prayed some more for it to go away and it didn't. Finally I prayed to God that if he wouldn't take the pain away, to take me. The minute I prayed that, I realized how wrong it was to pray to die. And the minute I realized *that*, the pain went away."

Soon Marty was back to wise-cracking, talking about the old days when he used to drive over to Murfreesboro so it would be a long-distance call, and call me on the all-night show. He'd fool me with this a lot of times. On one occasion it went like this:

"Ralph, I'm driving this truck across country and thought I might get you to play a song for me," said a gravelly voice that sounded nothing like Marty Robbins.

"Who's your favorite singer?" I asked.

"Well, I sure like that Marty Robbins," the voice would say.

"I just played a Marty Robbins song a few minutes ago," I often said, because in truth, I had. "How about a Faron Young song?"

"Now you know that even Faron Young's mother says Marty Robbins is her favorite singer, Ralph," Marty would say. Then I knew who it was and that I'd been had again.

That March 1970 show went over so well we followed it up with a kind of "Battle of the Bands" show during the deejay convention that October. I knew how much Marty loved Merle Haggard's singing, and with Merle the feeling was mutual. Marty showed up wearing a loud checkered jacket.

"Well, Marty," I said, "you may not outsing Merle tonight, but you've sure outdressed him!" Merle came out and borrowed Marty's jacket to sing "Devil Woman." Merle was unbelievable, as he always is when he does impressions. And the look on Marty's face was priceless. You'd have thought, given the way he mugged at the crowd, that he was hearing Merle's impression of him for the first time, which was far from the truth.

At one point in the show, Marty got started on public affairs. I asked him if he was still interested in politics, because at one time he was very heavily involved in the Republican Party. "Ralph, I've decided things aren't gonna get any better, so I'm retired from politics," he said. I was ready to move on, but Marty wasn't. He started talking about the environment, and how much damage the automotive industry was doing to the air. "You know, Ralph," he said, "this country needs to limit people to two cars per family! There's no reason for families to have four or five cars!" I told him I was already limited to being a two-car family.

He sailed right on, taking shots at politicians and unions and anyone else who might be responsible for the mess the environment was in. Tex Ritter and Roy Rogers were in the audience that night, and at one point Marty looked up in the crowd and said, "Right, Tex?" Of course, Tex Ritter was also involved in conservative politics.

Merle Haggard looked like he wished he could fade into the stage backdrop as he stood there watching Marty carry on.

"I probably shouldn't be talking about politics," Marty said. "I'll

get into trouble. You know what that's all about, don't you, Merle?" Merle looked slightly pale and nodded. Of course, Merle has just come off two big hits that had caused an uproar in those hot political times: 1969's "The Fighting Side of Me" and 1970's "Okie from Muskogee." It didn't seem like a subject he wanted to get started on during a deejay convention!

Then we went on break, and to my knowledge, no one mentioned Marty's political lecture to him. But maybe he started thinking about the time he endorsed Barry Goldwater and people started writing letters threatening to boycott his records. He came back out and offered an apology, saying that he hadn't meant to offend anyone. I just brushed it aside. But later, on one of my radio shows, we got to talking about politics and I reminded Marty that I have a theory about arguments. There are three topics nobody will ever agree on so you might as well not argue about them: religion, politics, and the question "What is country music?"

As it turned out, that conversation took place in June 1982, the last show of mine that Marty ever visited. In October 1982 Marty would be named to the Country Music Hall of Fame, where he accepted with a prophetic statement. He told the audience that he believed there were many people who deserved the award far more than he did. But then he added: "But I don't know if it would ever happen again, so I'll take it!"

On what would be our last show together, I again reminded the audience that night that it was almost impossible to prepare for a Marty Robbins show because you were always going to leave out some of his hits. We talked about his new album, which included five of his favorite pop songs: "Harbor Lights," "Return to Me," "Among My Souvenirs," "Don't Let Me Touch You," and "I Don't Know Why." Once, when I asked Marty to introduce a song, he joked: "I don't know why I can't talk like you, Ralph! I want to introduce records in a big voice, too." I laughed and said, "Well, Marty, I don't know why I can't sing like you!" Marty sang one of his own songs that night, and I believe it could stand as a final statement from Marty Robbins the man. It's a poignant, reflective, no-regrets song titled "Life":

"After all is said and done I've lived each moment one by one. Life's been good to me. When it comes time for the end, I'd like to live it all again. 'Cause life, you've been my friend."

Marty died on December 8, 1982. It had been twelve years since his heart bypass surgery.

Ginny's Heart:
Patsy Cline

*Y*OU'LL HEAR Patsy Cline's persona described many ways in books, documentaries, and magazine interviews: a tough-talking good old girl with a heart of gold, a straight shooter, the life of the party, a homebody, a teller of bawdy jokes, a pretty good wife, and damn good mother. Nobody questions the talent or the influence. She changed the expectations and possibilities for women in country music. She remains the yardstick by which female vocalists measure themselves. She proved women could sell tickets and close the show. She is still one of the top-selling females in country music, nearly forty years after her death. But, as with Hank Williams, the person behind all the hoopla seems to be somewhat elusive.

I think Patsy could truthfully be characterized using any of the above descriptions. She was a complex woman. She could cry herself to sleep from missing her children when she was on the road and still be one of the boys who could and would drink a beer with the guys and keep right up with Faron Young when he got to cussing. The combination of vulnerability and tough street smarts made her both interesting and convincing. She could sing about heartbreak with conviction, but underneath it all, you knew she'd pull through.

There wasn't a hint of weakness in her soulful performances of sorrowful lyrics.

When I think about Patsy, I always think about the nights she arrived with an entourage at the all-night radio show. They had often been out drinking and always seemed to have little inside jokes and asides neither I nor the listeners quite understood. That was the good-time girl in her. She loved hanging out at Tootsie's with songwriters such as Harlan Howard, Hank Cochran, Justin Tubb, and Willie Nelson and topping some good old boy's slightly off-color joke with one of her own and never blinking. Hank Cochran will tell you that when he called her with news of the latest "surefire" hit he'd penned, she'd say, "Cut the B.S., hoss. Get over here and let's hear it." And Hank and the other industry folks she knew loved her for it. No matter what you may hear about Patsy, you seldom hear anyone say he didn't like her.

I will say that I knew one person who didn't hit it off with Patsy. That was my wife at the time, Skeeter Davis. Skeeter and Patsy were contemporaries. Patsy first charted in 1957, with "Walking After Midnight," and Skeeter charted in 1958 with "Lost to a Geisha Girl." Patsy, due to her well-documented contract with Four Star, which kept her from looking for songs from anyone outside that company, waited until 1961 to have another hit. That year she had two monsters: "I Fall to Pieces" and "Crazy." In 1962 she stayed at the top of the country charts for five weeks with "She's Got You." Skeeter crossed to pop with 1960's "(I Can't Help You) I'm Falling Too," the answer song to Hank Locklin's "Please Help Me, I'm Falling." She crossed to pop again in 1960 with "My Last Date (with You)," a version of Floyd Cramer's "Last Date" with lyrics added. In 1963 Skeeter had the big country and pop hit that became her signature song, "The End of the World." Skeeter and Patsy were the only females making real inroads when it came to pop crossover releases.

Still, the friction between Skeeter and Patsy was more about lifestyles than professional jealousies. Skeeter hated drinking and wouldn't play bars or clubs where cocktails were being served. Patsy felt an underlying disapproval from Skeeter, and the relationship was

never close, certainly not like Patsy's friendships with many other female artists, most notably Jan Howard, Del Wood, Loretta Lynn, and Dottie West.

This is as good a time as any to address a well-publicized story. That is the one about Opry singers "ganging up" on Loretta when she first came to town. It's the story about an "anti-Loretta" meeting held at some artist's home, where Patsy not only showed up but brought Loretta along. I don't remember any anti–Loretta Lynn sentiment when Loretta and her husband, Mooney "Doolittle" Lynn, hit town. I think if it had been rampant, I'd have heard it, certainly from Skeeter and probably from the Record Row wags who stopped by WSM. Just recently, Skeeter told me she never went to any such meeting and never heard of anyone being against Loretta. Jan Howard says the same thing. Skeeter may have disapproved of Patsy's hanging out at Tootsie's and playing bars, but Loretta wasn't an issue.

This all came to a head at one show Skeeter played with Patsy, Webb Pierce, Ferlin Husky, and Grandpa Jones. When Patsy brought out a bottle of whiskey and passed it around, Webb said, "Patsy, I'll take your Jim Beam, but I don't want any old yellers." Old yellers were the amphetamines so many took back then. I don't know if Patsy thought Skeeter was looking at her in reproach, but she said, "Well, I know little Miss God All-Mighty here doesn't want any Jim Beam. She probably does her drinking behind closed doors." That cut Skeeter deeply.

The crazy thing about all this is that in some of the British versions of the *Always, Patsy Cline* stage shows, which spotlight a friendship Patsy had with a fan, Skeeter shows up as a pal of sorts! Patsy suggests going over to a club to hear Skeeter Davis sing "The End of the World." They evidently wrote this in because someone in the show wanted to sing the song. But I seriously doubt that Patsy would have suggested a Skeeter Davis show, and I know Skeeter wouldn't have been playing in a nightclub!

Patsy did get irritated when she thought someone was looking down his nose at her. Maybe that came from the days when her father ran off and fifteen-year-old Ginny Hensley, as her family called her, had to quit school and go to work to help support the

family. The lack of money, even after she was a star, played heavily in her life.

Sometimes the slight was real and sometimes perceived. In all honesty, I have to say that when Skeeter saw Patsy pass around the Jim Beam, she did pass judgment on some level. But here's one slight that Patsy imagined: George Hamilton IV tells about a time when he was traveling in Canada with Patsy and Jimmy Dean. The three were riding in the backseat of a car with a hired driver, George in the middle trying to sleep. "Patsy and Jimmy got to passing a bottle back and forth between them," George recalled. "At first they were laughing and reminiscing about the good old days around Washington, D.C. Then, as they got more liquor under their belts, they got to the crying stage. Finally Patsy turned to me and asked, 'You think you're too good to drink with us?' I decided to take a drink rather than argue, and by the time we got to the show, a Sunday matinee, we were pretty loose."

Another time the slight was very real. It happened when a group of Opry stars played New York's Carnegie Hall in 1961. It was quite a group: Jim Reeves (who closed the show), Marty Robbins, Patsy Cline, Minnie Pearl (who was the official spokeswoman, probably because she had a finishing school background), Faron Young (who was definitely *not* the spokesperson), Bill Monroe, the Jordanaires, Grandpa Jones, and the Stoney Mountain Cloggers. T. Tommy Cutret was the show's emcee.

Ironically, in light of some of the press's anticountry bias, the show was a symphony fund-raiser. New York columnist Dorothy Kilgallen, never one to miss a barb, called the performers coming to the Big Apple "hicks from the sticks." She also wrote: "You hipsters who have been planning a fall vacation might want to leave earlier. 'Grand Ole Opry' does a gig at Carnegie Hall this month. (Remember when Carnegie Hall was associated with MUSIC?)"

That fired Patsy up. A few days before the New York show she played a date in Winston-Salem, North Carolina, and referred to Dorothy as "the Wicked Witch of the East." Then Patsy said: "At least we ain't standing on some street corner with itty-bitty cans in our hands, collecting coins to keep up the opera and symphonies."

Patsy received ovations throughout her show. The *New York Times* reviewer raved about the show, yet couldn't quite keep from talking down to the music a bit. He noted: "Patsy Cline, a modern popular singer, had a convincing way with 'heart songs,' the country cousin of the torch song."

Patsy had the final word at a later concert, when she smiled sweetly and said, "We were awfully proud of being that 'fur' up in high cotton." I don't know how the conversation might have gone if Patsy had actually met Dorothy Kilgallen. It probably would have depended on Patsy's mood and if she'd had a beer or two. But she had a saying she loved, and I could picture her looking Ms. Kilgallen in the eye and saying, "Hoss, why don't you let your hair down so we can see what you *really* look like?"

I want to talk a little about Patsy and Loretta. First, I think the movie *Coal Miner's Daughter* made it appear that Patsy had few female friends aside from Loretta. She had many, many women friends. She did like Loretta a lot, and I know she helped her, as she had helped others. I think what Patsy loved about Loretta Lynn was that you always know what Loretta "looks like." With Loretta there is no pretense, no B.S. I love to listen to some of the old radio interviews with Loretta. Her demeanor has never changed. I remember her telling me about a time when both Doo and the housekeeper at Loretta's farm, Hurricane Mills, were ready to walk out. Here's how the 1974 conversation went:

"Why do you think your housekeeper wants to quit and Doo is ready to run off?" I asked Loretta.

"It's them animals," she said. "I got turkeys a gobble-gobbling, guinea hens a screamin' and a hollerin', pigs a rootin' around. And I'll tell you the truth, Ralph, that housekeeper and Doo can just go on if they want to. I'm a keeping my pigs whether they root or not! And I ain't lettin' Doo take 'em to market, neither. I like my animals to die of old age."

A no-bull person like Patsy couldn't help but be completely charmed with Loretta's equally straight-shooting character.

I believed a bond was formed that first night when the hospital-

ized Patsy heard Loretta sing "I Fall to Pieces" on Ernest Tubb's *Mid-Nite Jamboree*. Indeed, the two met under trying times for both. Patsy was slowly healing from her near-fatal car crash. She not only feared for her future, she was in a philosophical state of mind. She'd told her neighbor of a spiritual experience she had right after the wreck. Jesus, she said, had come to her and said, "Not yet." Loretta Lynn was a new girl in town, full of fear and confidence all rolled into one. When Patsy sent her husband, Charlie Dick, to find Loretta and bring her to the hospital room, it was almost as if it was providence, as if the planets had lined up right. They were instantly fast friends.

I once asked Loretta how she felt when Patsy went in the Country Music Hall of Fame in 1973. Loretta paused. "Well, I thought it was about time," she finally said. "I guess I was overwhelmed 'cause of what all she did for me. You gotta remember that when I met her she was red hot and ten years ahead of her time. And I'd just blowed into town."

Loretta said that Patsy was quick to give advice, support, money, clothes, anything a friend needed. Nashville is a town where advice is often cheap, but Patsy's was always specific to the situation and well thought out. Loretta told me that when Patsy talked to her about stage presence, she didn't generalize. Her advice was tailored to Loretta's show.

"The smartest thing she told me about my show was that I had to start hittin' that stage hard with a fast song. Then I had to stop leavin' with a ballad or a sad song. 'Don't you ever leave an audience on a sad note,' she said."

Part of Patsy's legacy is wrapped up in Loretta Lynn's legacy. Patsy had guts. Loretta says she usually has guts as well, but she admits that Patsy's strength has always been a part of her risk-taking personality. Remember, Loretta was the first woman to have a song, "The Pill," banned. She took a lot of criticism for her take-no-prisoners tunes and her honesty, too. Yet since her chart debut with "I'm a Honky Tonk Girl" in 1960 she has become one of the most important artists, male or female, of the genre.

Earlier in this book I asked the question: What would Hank Williams's legacy have been had he lived? Would he be the mythical figure he is now? Or would he have been pushed aside as a drunk who'd once had the world by the tail? I honestly don't know the answers to those questions. But I'll venture to say that had Patsy Cline lived, she would have been an even bigger legend than she is now. Patsy and her producer, Decca's Owen Bradley, were making brilliant records, and nothing in her personal life seemed to be standing in the way of much more success. People have speculated that her marriage was in trouble, but no one knows that for sure except Charlie Dick. And even if it was, careers have survived divorce. She liked a beer with the guys, but she wasn't a problem drinker. It's been reported that she sometimes took diet pills/uppers, but there appears to be no signs she abused them. The single biggest and most long-lasting problem Patsy ever faced seemed to be over, and that problem was lack of money.

She faced poverty from the time her father abandoned the family when she was fifteen. Those were the days when she worked at a poultry shop, at a drugstore, and at any club where she could make a few dollars by singing. Those were the days when announcers at WINC radio in Winchester, Virginia, saw her with her nose pressed against the glass windows, hoping to see a bit of the show business world she hoped one day to conquer.

Even after she had a hit song, 1957's "Walking After Midnight," and had married Charlie Dick, she had no real security. When Charlie was released from the military in 1957, they knew they should move to Nashville, yet to do so meant a little case of fraud against the United States government. The government mistakenly sent seven additional allotment checks of $138 to Patsy after Charlie was no longer serving his country. Charlie recalls that they spent the first one, then put six in a drawer, knowing the money wasn't theirs to keep. When the time came to move, the two threw caution to the wind and cashed all six checks. That's how Patsy Cline made it to Music City.

In her letters to a young woman named Treva Miller, Patsy

revealed a great deal about her life prior to 1960. Treva had approached Patsy in 1955 about starting a fan club, and Patsy was enthusiastic about it. By that time she was a regular on Connie B. Gay's *Town and Country* regional television broadcasts and had signed the contract with Four Star Records.

Two things stood out when I read those letters, now on display at the Country Music Hall of Fame Museum in Nashville (also available in *Love Always, Patsy* by Cindy Hazen and Mike Freeman, Berkley, 1999). The first thing that will cause fans to shake their heads is how broke Patsy remained until "I Fall to Pieces" was released on April 3, 1961. I'd known about her financial situation, though perhaps not how heavily it weighed on her mind. But there was one story I found astonishing. On January 16, 1956, Patsy wrote Treva that she was just back from a trip to Nashville, where she'd been at the Opry and accompanied some people to the Plantation Club after the show. The Plantation Club was our one big nightclub back then. Patsy sang two songs and the audience insisted she come back out for a third. And who accompanied this relatively unknown artist to the Plantation Club that night? Eddy Arnold, Bill Morgan (a deejay and the brother of Opry star George Morgan), Audrey Williams, Ray Price, and Tony Bennett! That's pretty heavy company for a girl from Winchester, Virginia, signed to a small label and with no charted records. I think everyone who heard her sing knew she was destined for greatness.

That included Four Star's Bill McCall, who was key to Patsy's financial problems between September 1954 and April 1961. By signing with Four Star and agreeing to record only Four Star material, Patsy was shut out of Nashville's vital songwriting community. The company had "Walking After Midnight," but little more. Even though Four Star had a leasing agreement with Decca, the larger label had no real control over her career. Owen told me Patsy sometimes broke down crying over her money problems. She told him she felt backed against a wall. That's why, the minute "I Fall to Pieces" hit the charts, Owen insisted on an advance for his artist.

By that time the Four Star arrangement was over and Patsy had

signed with Decca, a surprise move. In one letter to Treva, Patsy said she planned on signing with either RCA or Dot when the Four Star contract expired in May 1959. "I didn't think she'd stay," Owen Bradley told me. "By all rights she should have been angry at Decca."

Indeed. In 1957, when she was almost destitute, Decca informed her that "Walking After Midnight" was outselling both Bill Haley and the Platters. Another person at the label even told Patsy that the single was selling 40,000 copies a day! Yet no checks arrived in Patsy's mailbox. She was left to fend for herself, trying to tour enough to pay the bills. But big billings didn't always pay the bills. For example, she got top billing over both Johnny Cash and Jean Shepard at one 1957 show, yet her electricity was always in danger of being turned off. Touring expenses ran high, and sometimes promoters left the artists holding the bag. Patsy's letters to Treva during this time are warm and wonderful, but they are also heartbreaking. Over and over Patsy goes into great detail about her money problems. She was having trouble reimbursing Treva for the fan-club mailings. In April 1958, she apologized, "I'm down to my last ten dollars. I owe everybody, including you."

I think it's telling that during the few years of solvency Patsy Cline had, between 1961 and 1963, she spread her money around among friends. Dottie West told of a time when she was behind on the rent and Patsy slipped her a check for the $75 payment. Loretta and other friends of Patsy's have similar stories.

What a short time she had to enjoy the financial rewards of superstardom. On March 5, 1963 she died in a plane crash with her manager Randy Hughes, who was piloting the plane, and Opry stars Hawkshaw Hawkins and Cowboy Copas. It was a crash that never should have happened. The four were returning to Nashville from a benefit show in Kansas City. The weather was bad and showed no signs of clearing despite Randy's assurances to Patsy when they set down in Dyersburg, Tennessee. Bill Braese, the airport manager, even pulled Randy aside and warned him not to take off. But Randy was a daredevil at heart. I can remember his bragging to me on numerous occasions about how quickly he'd made a drive from Texas to Tennessee. I'd try to figure out how fast he must have been

driving and I was always taken aback. It was a bad call, and country music lost some great talents that day.

Later in this book, especially as we get to the 1980s and 1990s, we see women become very important as headline acts and trendsetters. I know most of them remember Patsy's opening the door, and I hope they remember the advice she often gave new entertainers: "Hoss, if you can't do it with feeling, don't."

Don Gibson:

The Acuff-Rose Heir Apparent

On December 2, 1965, a housekeeper at Nashville's Biltmore Motel frantically phoned Wesley Rose at his office. "You don't know me, Mr. Rose, but I know you're a friend of Don Gibson and I'm afraid he's dying." She went on to say that she'd discovered him unconscious on the motel bed, surrounded by pill vials and vodka bottles. In his hand he held a nearly illegible note that started "Dear Rosalene." The only other words that could be made out were "I love you" and "take care of yourself."

Wesley feared the worst. Rosalene Gibson, Don's third wife, was at that moment lying in Vanderbilt Hospital with an eye injury that doctors said could leave her blind in one eye. She'd been there for several days following a knock-down drag-out fight with Don, who had been arrested on assault-and-battery charges because of the incident. Free on bail, Don had checked into the Biltmore. He had been ducking Wesley's calls, and the executive feared that one of his biggest artists, the heir to Hank Williams's songwriting crown, had decided to take his own life.

By the time Wesley got to the Biltmore, the police were there and an ambulance crew was working on Don.

"We were able to rouse him for a minute before he slipped into a coma and he told us he wanted to kill himself because he was having problems with his wife and his record label," an officer told Wesley. "We found over twenty-five bottles of prescription-type drugs, including Deprol and Diolabol in his luggage. They don't appear to have been obtained through a legitimate prescription."

When the authorities contacted Chet Atkins at RCA, he said, "Don has trouble with us because he's been unable to record for quite a while. He's not in shape for recording sessions and hasn't been for some time."

Like Hank Williams, Don Gibson came very close to being an early casualty to his demons. Unlike Hank, someone checked on him in time.

WHILE MANY ARTISTS who started in the late '50s and '60s pointed to Ernest Tubb or Roy Acuff as influences, one of the biggest names to emerge from those years claimed Red Foley as his chief motivator. Don Gibson explained it this way: "Red Foley was always my idol when I was growing up, and I think some of my style came from him. When I began recording, maybe I thought the mike wouldn't pick me up, so I got as close to the mike as I could, and getting that close, it picked up a lot of my breathing between words. Maybe that's how my style happened."

Other influences Don cites are Eddy Arnold and George Morgan, two more crooners with decidedly pop leanings. And eventually (after a brief foray into a bit of Webb Pierce imitation) Don's smooth vocals, combined with his formidable writing, made him a superstar. But like Hank Williams, his was a light that frequently flickered and threatened to burn out early.

Don was always a big drinker, but his real problem started in 1959 when he consulted a doctor about his weight. The doctor gave him a prescription for Obetrol to help curb his appetite, and one of the first

things Don learned was that Obetrol cured hangovers. That was the beginning of almost three decades of drug and alcohol problems. It is astonishing that he lived through it. As Don once said, he spent the better part of his career "running, running, trying to get out of trouble." He went through messy divorces, brushes with the law, terrible problems with his manager, Wesley Rose, and his record label, RCA. Chet Atkins once told me, "If Don Gibson had died young, he would have been as big a legend as Hank Williams."

Born on April 3, 1932, in Shelby, North Carolina, Don Gibson was the fifth child of Solon and Mary Magdalene Gibson. When Don was only two years old, his father died, and his mother's remarriage seemed to affect Don deeply. His stepfather was so critical of the young boy that Don started stammering out of nervousness. He hated school and didn't attend much after the second grade; he hated work, and used to pray for rain so he could stay out of the fields. For some time it looked like Don's main interest in life would be shooting pool, and he was good at it. Then he turned to music and was even better at that.

"I think I wanted to sing because I grew up thinking that no one ever heard what I was saying," Don told me in 1999. "No one ever listened to me at home."

Finally Don said to his mother: "Mom, someday I am going to be on the radio."

"Oh, you mean fix radios?" she asked.

"No," Don said. "Someday I'm going to sing on the radio."

Don's mother just smiled.

At the age of fourteen he got a guitar and began to hang out with a group of older musicians who "gathered on back porches to teach licks and runs to younger guys." The lessons took, and it wasn't long before a local fiddler named Ned Costner asked Don to join him on some jam sessions. From those gatherings emerged Don's first band, the Sons of the Soil, a popular local group that played the Kiwanis Club and other clubs in Shelby while Don supported himself with day jobs driving trucks, working in the local textile mill, restocking jukeboxes, and collecting money from slot machines.

When he was seventeen Don's music caught the interest of Mer-

cury A&R executive Murray Nash. The first Mercury recording session took place in early 1949 at WBBO in Forest City, North Carolina, with Howard "Curly" Sisk on guitar, Jim Barber on fiddle, Milton Scarborough on accordion, and Don playing bass. There was a problem when it came time to sign a contract, according to Murray. "I loved Don's voice," Murray told me during a 1999 interview. "But I didn't like the band and wanted to sign Don as a solo act. He wouldn't budge. It was either sign the Sons of the Soil or nothing. So we never could strike a deal."

In many ways, that's not surprising. Don is an artist who loved and respected the musicians in his band so much he refused to even refer to them as "sidemen."

In 1950 the Sons of the Soil broke up and Don put together a new band called the King Cotton Kinfolks. On October 17, 1950, the group recorded its first sessions for RCA at WSOC radio station in Charlotte, North Carolina. In '51 Don moved to Knoxville and went to work for Lowell Blanchard at WNOX radio's *Mid-Day Merry-Go-Round* show. He had another recording session for RCA before signing with Don Law at Columbia. Still, nothing came of any of these early sessions. Then, in 1955, Wesley Rose and Mel Foree happened to stop by a club where Don was playing in Knoxville.

"I had just written 'Sweet Dreams,'" Don recalled. "I played it and Mel came up and told me Wesley wanted to hear it again. After I played the song a second time, Wesley came up and told me he wanted to publish it. I told him he could if he'd take me with it. Wesley hedged a little at first but ended up signing me and getting me on MGM."

The MGM recording of "Sweet Dreams" became a top-10 single in 1956. Faron Young covered the song and had a #2 hit with it in '57, and Don told me that Webb Pierce was planning to cut it when he learned that Faron already had. Of course, people remember Patsy Cline's 1963 hit of "Sweet Dreams," but the most powerful performance I ever heard was by Reba McEntire. After Reba's band members were killed in that 1991 plane crash, I emceed a fund-raising benefit show for the surviving families at the Nashville Municipal

Auditorium. We didn't know if Reba would feel up to coming or not. But she somehow pulled herself together and came for the sole purpose of singing "Sweet Dreams," which had been the last song she performed with her band before they took off in that plane. Reba sang it a cappella that night and you could feel the chill all over the auditorium.

The song has been recorded hundreds of times, but it isn't Don's most recorded copyright. He told me that he stopped counting when "I Can't Stop Loving You" had been recorded 1,500 times. Another of his big copyrights is "Oh Lonesome Me," which was originally written as "Ole Lonesome Me." Don says the song title somehow got changed between Knoxville and Nashville, probably by Wesley Rose or Chet Atkins. And it was those two songs that resurrected Don's career in 1958, after MGM had dropped him. Don signed with the newly formed Nashville branch of RCA, and Chet Atkins believed he saw a potential superstar, if Don would just change his style a bit, capitalizing on his smooth vocals.

"Chet told me he didn't see that he could do much with me unless we made my sound more modern," Don said. "So on 'Blue Blue Day' we took out the steel completely, added backup vocals, and that is the sound that clicked." But "Blue Blue Day" wasn't destined to be Don's breakthrough single.

His breakthrough songs came with a music legend attached. The story has always gone that Don wrote both "Oh Lonesome Me" and "I Can't Stop Loving You" one day when he was broke and living in a trailer north of Knoxville. His television set was repossessed that day, and it's interesting to note that today Don could probably buy an entire television station with the royalties from "I Can't Stop Loving You" alone.

Don didn't think "Oh Lonesome Me" was a particularly good song at first. He certainly didn't think it was good for him, and hoped that someone like George Jones could put a honky-tonk spin on it and make it fly. The song he wanted to record was "I Can't Stop Loving You." Don was trying to get "Oh Lonesome Me" to George Jones when Chet heard the demos of both and insisted Don record "Oh Lonesome Me" for RCA. Don was upset that neither Chet nor

Wesley was impressed with "I Can't Stop Loving You." Chet told Don he considered it "just another ballad." Don was in a bad place that day. He was hung over, broke, and feeling at the end of his rope. But he finally convinced Chet that "I Can't Stop Loving You" deserved to at least be on the back side of "Oh Lonesome Me." Chet acquiesced, thinking the big songs from the session would be "Too Soon to Know," "Blue Blue Day," and "Oh Lonesome Me."

Chet admits that the main thing he recalls from the "Oh Lonesome Me" and "I Can't Stop Loving You" demo was a killer drum track. Chet was familiar with the man who played drums on the songs, a Knoxville guy named Troy Hatcher, and decided to try and bring him in for the session to duplicate the "boom-ba-boom, boom-ba-boom" sound he'd heard on the demo. As far as Chet can recall, that became the first Nashville session where the bass drum was also miked. As he explained in Don's box set: "Up until that time, people just picked up the drums with one mike—whatever happened to be playing the loudest was the loudest on the record."

RCA released "Too Soon to Know," backed with "Blue Blue Day," first, and they were reviewed in *Billboard* in August 1957. When no one paid those much attention, Chet sent out "Oh Lonesome Me" and "I Can't Stop Loving You." Both caught fire. "Oh Lonesome Me" stayed at #1 for two months and "I Can't Stop Loving You" peaked at #7. Then, because of the excitement those cuts generated, deejays started paying attention to "Blue Blue Day" and it, too, rose to #1.

In addition to Don's success with the two songs he wrote that day in his trailer, he hit a big lick when the legendary Ray Charles decided to record a country album in 1963. Ray told me his label was aghast at the whole idea, fearing he'd lose his fan base. But Ray loved country music and he loved to sing country songs. Now, in any song, the thing that will make it memorable is what they call the hook, a line or a phrase that is repeated over and over. I'm always reminded of Mac Davis's song, "Baby Don't Get Hooked on Me" when I think of great hooks. Mac wrote the chorus of the song as a joke when his producer, Rick Hall, complained that Mac always gave his hook songs to Kenny Rogers or Elvis. Mac brought the chorus back to the

session and sang it and Rick almost dropped his jaw. "It's a smash!" Rick pronounced. Since the musicians were already set up, and there were no verses to the song, Mac just had them play chord progressions leading to the chorus, then went to his motel room and put verses to the rhythm tracks. That song was a huge success, and it was because of one line, "Baby, don't get hooked on me."

In the case of Ray Charles, it was Don Gibson's first two lines. As Ray explained to me: "My record label put out the word that I was looking for country songs and they started coming in. I must have listened to over two hundred fifty songs when I heard the lines, 'I can't stop loving you, I've made up my mind.' Those two lines did it. You know, a lot of people feel that way. A lot of people." And a lot of people wanted to hear Ray Charles sing that song. It took on a whole new life in the pop and country charts, becoming one of the biggest records of the year and introducing pop listeners to country lyrics in a whole new way.

Clearly, Don Gibson's luck had taken a turn for the better. Or maybe not.

Don says that his huge song royalties spelled huge trouble. "It's an old cliché, but you take a country boy with no formal schooling and all of a sudden he has more money than he knows what to do with— that's going to cause problems. With me it meant pills, which I used as a crutch."

I think there are a couple of additional reasons Don relied on pills, and they are reasons many entertainers understand: shyness and loneliness. Don used to call me from the road on my all-night show a lot, and he called his fellow entertainers in the middle of the night, too. It was loneliness, the loneliness of the road. "I lived on the road," Don reflects. "I stayed out there because I had no domestic life. There was no reason to go home so I stayed in one motel after another, one gig to another. And I'd call old friends."

And make no mistake, Don is a private and shy person. He is so painfully shy, I once asked him why in the world he chose entertainment as a profession.

"I loved to sing," he said. "It's the only thing I knew how to do."

Once Don discovered Obetrol, his pill use shot straight up and

his personal life shot straight down. His divorce from his second wife, Polly Bratcher, turned very ugly, with allegations that she tried to extort money from him. When that failed, she claimed she wrote the lyrics to many of his hit songs. Supposedly she told that tale to Wesley Rose, who answered: "Madame, if you've been writing all these hits, you just continue to write them and bring them to me. We'll make the same deal with you we made with Don."

And she never contacted Wesley again, but I think her public accusations hurt Don. There remained rumors that Don bought "I Can't Stop Loving You" from a Knoxville songwriter named Arthur Q. Smith. Arthur did sell a lot of songs to people in Nashville, at the whopping price of $10 a song, just enough to keep him in whiskey until he finished another tune. Murray Nash told me Arthur Q. Smith had no interest whatsoever in becoming famous or rich, just in his next drink. And, Murray laments, Arthur didn't seem to be able to write a song unless he was drunk.

I know it hurts Don that anyone questions who wrote the song, and he doesn't help himself by admitting he doesn't even remember writing it. In fact, unlike most songwriters, Don doesn't have many stories about what he was doing when he wrote a particular song. The drugs and alcohol obviously hurt his memory. So I asked him point-blank one day if he'd ever bought a song from Arthur Q. Smith.

"No, I didn't," Don said straightforwardly. "He hung around all the time. He hung out in taverns and wrote songs. He never played at clubs or sang on the radio. Just drank and wrote. I wanted to cut one of his songs, although I can't even remember the name of it now. But I carried it around a long time. He told me he'd sell it to me for ten bucks. I turned him down. I just couldn't do that."

And that is a good enough explanation for me. He couldn't have the catalog of songs he has and need Arthur Q. Smith to help him out.

Don remarried a third time within a year of his divorce from Polly, but that didn't work, either. This wife, Rosalene, had as big a pill and booze problem as Don. She caused so much trouble for Chet at one session that singer Maxine Brown threatened to beat the hell out of her. A couple of years after Don's suicide attempt, Rosalene

even tried to shoot him. So Don stayed on the road, as he said, "running, running."

The pills caused Don problems in his career, but according to him, Wesley Rose was the biggest obstacle he faced. "If it hadn't been for Wesley, I'd have gone about the career a lot more professionally," Don says. "I'd have got a real manager and a bus and hired some publicity people—the things you have to do if you want to really have a big career. But Wesley stood in the way of that. Wesley wanted me to stay right here in Nashville and write songs. I was worth more to him as a writer than as an artist."

Chet Atkins agreed. In a conversation with Dale Vinicur about the liner notes of Don's 1992 box set, Chet used strong words about Wesley: "Wesley Rose was playing me against Don all the time and was denying that Don had problems. Don would go to Wesley and tell him things that were untrue, and Wesley would act like he believed it because he resented the fact that I was making hits with Don. It was terrible. I liked him [Wesley] out of the office, but I refused to do business with him after the problems with Don. I found out that he was dishonest, he was not on my side. He was using me to try and turn Don against me. But I always knew that Don loved me, I never doubted that for a minute. I knew it was the drugs. I knew Don had a terrible, terrible problem and that he was wasting his talent. I just loved him and hoped he would get over it."

In 1967 Don married the woman who would ultimately help pull him through. That was the year that Rosalene tried to shoot him and he crushed his kneecap while running from her. Don was so stoned he didn't feel the pain for days, and by the time he went to a doctor he was on the verge of losing the leg. He went back to his home in Shelby to recover, and there he met Curly Sisk's niece, Bobbi Patterson. After Don and Rosalene divorced, he and Bobbi married. You couldn't even say Don's life was like a country song, because few are that bizarre.

Still, even with Bobbie's help, Don couldn't kick pills and booze. He parted company with RCA in 1969 and moved to Acuff-Rose's Hickory Records. I think Chet would have liked to have been in the loop as far as Don and his problems went. Chet genuinely loved Don

Gibson, and it's possible he could have helped him through some of the rough times. For one thing, if Chet had been aware of all the problems, he might have been less irritated when Don dropped out of sight from time to time. And who knows, if Don had been able to pick up the phone and call Chet instead of having to go through Wesley, maybe he'd have shown up for a few more sessions.

As he'd always done, Don stayed on the road, still running from his demons. He had some hits on Hickory through the years, most notably the #1 "Woman (Sensuous Woman)" in 1972. And while his enormous royalty checks kept him more than solvent, Don never did regain the momentum he'd had early on. As Chet said, if Don had died early, we'd be talking about him as if he were another Hank. Thank the Lord and Bobbi Gibson that didn't happen. It makes you think, though. If Hank had found a woman who could have pulled him through, he might have been Don Gibson. It was well known among musicians that Hank had a thing for Anita Carter. Maybe Anita Carter could have saved Hank like June Carter saved Johnny Cash.

After talking to Don, I got to thinking about Wesley Rose. Wesley was certainly not the creative company president that his father had been. Wesley had been brought onboard as an accountant, and somehow he started believing he could fill Fred's creative shoes when Fred was no longer around. He couldn't. Wesley was a tough, aggressive, and controlling man. I liked him, though, and considered him a friend. If you were a friend of Wesley's, he used his power for you. Like his father before him, Wesley always saw to it I got the new Acuff-Rose records to play and had their artists on my show as guests. In fact, Wesley's aggression and controlling personality once saved my record deal with Liberty, or at least postponed the end of it.

It happened back in 1962, when I'd had the one hit with "Hello Fool." I'd cut a couple of Christmas songs and I was hoping that they'd get released for the holiday season. Unfortunately, Liberty Records had figured out I wasn't going to be a big star, because they notified me that the songs had been shelved. I was hurt and embarrassed, but I knew I couldn't do anything to convince them to do otherwise. One day I was talking to Wesley and he asked about the

status of the songs. I had to admit that they were history. Wesley, with a tight-jawed expression, said, "We'll see about that." Sure enough, they were released shortly thereafter.

There's one incident I always think about when anyone talks about Wesley's personality. It not only shows how puffed up he could get, but how he sometimes didn't even realize he was full of it. Wesley had gone to New York to meet with some important people in the music industry and when he got back he told me they'd kept him waiting for a very long time. This infuriated Wesley. After all, *he* was a very important person in the music industry! Finally, according to Wesley, he jumped out of his chair and shouted: "I won't be treated like this! Gene Autry and I will *buy* this place!"

I listened to Wesley rant on and finally had to explain one thing to him. "Wesley, Gene Autry and *anybody* could buy that place," I suggested. "Hell, with Gene Autry's money behind me, *I* could buy it!"

With Bobbi standing beside him, Don finally cleaned up his life. Don says it was at a concert in the '70s, when he'd "made an ass of himself" in front of his audience, that he decided to get off pills. He ultimately went to Alcoholics Anonymous and kicked his last addiction in 1986. When I met with Don in '99, he told me he suffered from a great many health problems stemming directly back to his drinking years. He walks slowly, afflicted with nerve damage in the feet, which he says is from the drinking. His health keeps him at home most days. He tried golf once before his feet gave out. I always heard that he bought himself a set of clubs and Bobbi a set of clubs, then joined a country club. They played the first hole, couldn't find the second, and went home. I asked him if the story was true and he admitted it was.

"I sold the clubs," he said, grinning.

You will never see Don and Bobbi at an industry event. He even refused to attend the ceremony when he was named to the Songwriters Hall of Fame. Part of that is his health and part of it is because he still smarts at some industry slights also connected to his drinking years. Don said one of the worst slights was when the Country Music Association once hosted an event in Washington,

and stars including Ray Charles and Ronnie Milsap performed his songs. Don was not invited. He phoned Jo Walker-Meador, then executive director of the CMA, and said:

"Jo, elephants will be nesting in trees before I ever do anything for the Country Music Association."

And that story again reminded me of the Hank Williams connection. Would the industry that now holds Hank up as the standard have held an event in honor of his songs and neglected to invite him? Would the legend be welcome but not the man? Like Hank, Don's writing has influenced untold numbers of country writers. Just look at some of his BMI award-winning catalog, in addition to the songs already mentioned: "A Legend in My Time," "A Stranger to Me," "Bring Back Your Love to Me," "Don't Tell Me Your Troubles," "Give Myself a Party," "I Can Mend Your Broken Heart," "Just One Time," "Lonesome Number One," "There's a Big Wheel," "Wasted Words," "Who Cares for Me," and many more.

The happy ending in this story is that Don and Bobbi are as much in love today as they were when they married. He credits her with saving his life. He loves his wife, loves to watch movies and read, especially authors like Edgar Cayce and others who write about reincarnation. Don believes he'll be back, that we'll all be back. Maybe next time the early years will be smoother. He's quite close friends with Chet Atkins; no one stands between them anymore. But he doesn't write songs. And he never sings around the house. That part of Don Gibson's life is simply one for the history books.

Bakersfield Buck

WHILE NASHVILLE WAS becoming Music City in the 1960s, an important musical phenomenon was developing on the West Coast. It came to be known as the Bakersfield Sound, and was defined by Buck Owens and Don Rich.

Buck was born on August 12, 1929, in Sherman, Texas. His family made the trek West in 1937, as did so many poor Texas, Oklahoma, and Kansas sharecroppers during the Dust Bowl days. On their way to California, the Promised Land, the trailer hitch broke and the family was stranded in Phoenix, Arizona. They settled in nearby Mesa, and by the time Buck was thirteen he was picking cotton and hauling potatoes in an effort to help the family's meager finances.

Buck developed an early interest in music, learning to play the mandolin, steel guitar, sax, and harmonica. At sixteen he started picking guitar in clubs around the area. His music contained influences ranging from TexMex to western swing to stone country.

I once asked him if he'd run into Marty Robbins during his years in Arizona.

"Well, I was about eighteen or nineteen," Buck said. "Marty was a few years older. It was pretty tough to get into certain joints if you

weren't twenty-one. They watched it close back then. But I remember one time we got into this one club where Marty was performing with an acoustic guitar. He had another guy singing with him and Jimmy Farmer on lap guitar. Marty did a whole set of Eddy Arnold songs. Now back then I didn't sing, I just played the guitar. And as I listened to Marty sing those Eddy Arnold songs it was inspiring! I thought 'Who in the world is this guy?' His voice was amazing. So I started going back to the club, and every so often they would run me off for being underage. In the meantime, I got to know Marty a little so he went to bat for me with the club owner. He told them I was a friend of his and that I didn't drink.

" 'He just wants to listen to the music,' Marty said.

"The owner said, 'Well, Marty, that's fine, but if I get caught with a minor in here I could lose my license.'

"Not long after that the club changed owners and the new guy didn't think Marty was right for the job, so he was out anyway. By then I was playing for five dollars a night at a club called the Roundup, and Marty got a job singing with a western swing band. Unfortunately, the band didn't really have that swing thing down and Marty was real unhappy with it. Marty soon went back to his solo work, and I ended up moving to Bakersfield. We were all trying to find our place."

It wasn't music, but hauling produce, that landed him in Bakersfield.

"I drove a produce truck all over the area," Buck says. "And Bakersfield, California, seemed like a perfect place. It had honky-tonks where musicians could find work, and the people around there seemed to genuinely love going to hear live music."

Buck got some work as a deejay around Bakersfield and he also got a job picking at a place called the Blackboard, where he stayed until after he was signed to Capitol Records in 1957. The Blackboard was like music school for Buck—he played everything from tangos to polkas, honky-tonk to rock 'n' roll. And he started getting interested in the sound of a Fender Telecaster guitar, an electric instrument that played hard and loud. Buck Owens soon owned the patent on the Telecaster twang.

During his Blackboard days, Buck used to commute to Los Angeles to get session work. He played on records by Stan Freeburg, Sonny James, Faron Young, Wynn Stewart, Tommy Collins, and a very young David Frizzell. He didn't feel comfortable moving there for good, though, because session work wasn't always reliable. "You might work for four or five days, or you might even get a job every day for a couple of weeks," he recalled. "But then it all might go dry. I had to keep my job at the Blackboard because I had a family to support." Capitol's Ken Nelson was impressed with Buck's guitar work when he heard him playing on a Tommy Collins session, but it took considerable convincing for Ken to sign him as an artist.

"I didn't take Buck seriously for a long time," Ken told me a couple of years ago. "But he finally convinced me to take him in the studio as a vocalist. That was all the convincing I needed. I learned that it is always a mistake to underestimate Buck Owens."

Capitol didn't seem to be a match for Buck at first, and his singles went nowhere. Disgusted and depressed, Buck moved to Washington state and bought into a radio station in Puyallup. There, he met a teenage fiddle player named Don Rich. It wasn't long before Don was Buck's right hand—playing guitar, singing harmony, cowriting songs, and arranging.

That meeting must go down in country history right along with the day Hank Williams met Fred Rose and the day Bobby Bare hooked up with Shel Silverstein. Buck and Don fused raw Texas honky-tonk with rock instrumentation and came up with a sound that remains as fresh today as it was forty years ago. Buck used his pickers on his records, which not only meant he sounded live, but— and this is probably more important—he sounded on records like he did live.

Meanwhile, back in Hollywood, Ken Nelson wasn't giving up on his new artist, and he continued to record Buck and release singles.

Buck's first charted release was a song called "Second Fiddle," which went to #24 in 1959. But it was his second release, "Under Your Spell Again," that grabbed me, sitting at my WSM all-night show, always listening for that "something special" to come across my desk. I loved "Under Your Spell Again" the minute I heard it and

I thought it was a hit. In fact, I believe it is one of my favorite songs that Buck ever recorded. I'll go a step farther. I think "Under Your Spell Again," which made it to #4 in *Billboard,* is one of the greatest country records ever made. I played hell out of it on my show, and Buck has never forgotten that.

"I've told many interviewers who asked me who helped me along in this business that it was Ralph Emery who hung in there with 'Under Your Spell Again' through some pretty stiff circumstances," Buck recounted to me back in the late 1980s. "Your playing the song is what prompted all those stations under the WSM umbrella to play it. It meant a lot for you to get behind a song, especially from an unknown artist. In fact, I used that to my advantage. I'd run into a deejay who wasn't playing it and I'd say, 'Oh yeah, Ralph's playing that a lot.' "

Buck had more hits that followed, including "Above and Beyond," "Excuse Me (I Think I've Got a Heartache)," and "Under the Influence of Love." Then in 1963 his music took on a more distinct sound, upbeat and relentlessly driving. The first indication was with 1962's "You're for Me," and in '63 he came out with a monster: "Act Naturally." That song stayed at the top of the charts for a month and was a 1965 hit for the Beatles. Once "Act Naturally" hit, Buck started a run of #1 songs that lasted for two decades and included standards like "Love's Gonna Live Here," which stayed at #1 for sixteen weeks, "Tiger by the Tail," "Waitin' in Your Welfare Line," and many more. He was elected to the Country Music Hall of Fame in 1996, and still stands as one of our greatest artists.

One of the many times Buck and I got together was in 1988, and I remember three stories he related as being especially interesting. One was about a rocker, one about a honky-tonker, and one about a country music journalist. I'll start with the rocker. Years after "Act Naturally" was a hit, Buck and Ringo Starr brought it out again. Here's how Buck explained that event to me:

"I love good rock and roll music. I love music with that old-time rock beat. And the rockers always seemed to like my music. You know, Eddie Cochran used to come in to the Blackboard before he ever recorded 'Summertime Blues.' Anyway, I got a call a few years

back from the people in San Francisco who put on the Bammies, the Bay Area music awards. They wanted to know if I'd perform with Huey Lewis, John Fogerty, Neil Young, and Santana. I said, 'Sure.' Then a few days later they called back and asked if I'd sing 'Act Naturally' with Ringo Starr. That sounded like a lot of fun so I agreed. Well, I got to the awards, and Ringo didn't show up. But a thought occurred to me. I was going on tour in Europe, and maybe Ringo and I could cut it over there. So I called him up and said, 'Ringo, this is Buck Owens. You want to have some fun?' He said, 'Suuuuure!' We recorded it at the Abbey Road Studios. He was a great guy, a very amiable fellow. And I'll say this—Ringo was often thought of as the 'least' of the Beatles' talent. He has taken some unwarranted criticism for his drumming over the years, yet I know great drummers who say he is terrific. I think the image problem Ringo had was the fact that he didn't write songs. He sure had the best name."

That version of "Act Naturally" was released in '89 and made it to the 20s in *Billboard*. But that chart figure belies the publicity value the song had. Part of its visibility was due to the accompanying video, which Ringo was initially against.

"When I first brought up the idea of making a video, Ringo said, 'No, Buck, I'm only in for a record.'

"So I brought the song back, mastered it in Nashville, and sent it to Ringo. I wrote him a little note saying, 'Call me after you've heard this.' So one day the phone rang and when I answered it all I heard was Ringo Starr chuckling and laughing, with 'Act Naturally' playing in the background. He said he was thrilled with it, so I took that opportunity to ask him again if he'd do a video. He hesitated but then said, 'Yeah, I'd be in for that.' I think he'd been real suspicious of the whole video idea, and with good reason. I'm sure a lot of people wanted to get a piece of the Beatles over the years. After we got the details down, I sent him a fax and told him to bring his favorite boots, hat, and shirt."

Ringo and Buck shot the video at an old western town near Los Angeles. They didn't use scripts, and Buck says it was because things did come off "naturally." "Ringo is a natural for the camera," Buck explained. "Nothing seemed to bother him. He was very cooperative

and just a nice man in general. I think he genuinely had a good time and was very pleased with the results. Chartwise, our version of 'Act Naturally' only got into the 20s. But it went through the roof in sales and the video stayed in heavy rotation a long, long time."

Since we were talking about people close to Buck, I decided to ask him about Dwight Yoakam, a guy whose music I like but one I wasn't sure I ever understood. I admitted that I'd had a hard time liking Dwight. I grew up in Nashville. I went to school here, made a career here. I love the people and the music we make. But I always felt like Dwight Yoakam took a shot at us every chance he got. He always gave the impression that he felt Nashville had treated him badly. It seemed that every time I read an article about him, he was quoted as saying something bad about the town.

Buck nodded. "I might be able to shed a little light on this, Ralph," he said. "Dwight sees Nashville as the establishment, and that establishment didn't give him a record deal. I once told him, 'You know, you aren't the only person who ever came to town and didn't get a record deal. The business is fraught with them! I was turned down. *Hank Williams* was turned down.' But Dwight felt that way, and he's a guy who has opinions and he rambles about them. I have to tell you, I've run on with my own opinions at times! I think that for Dwight, the whole thing is about artistry. Pure artistry. He can be brilliant, but he sees things one way and he doesn't like to look at them from another.

"I made a deal with Dwight when we were set to go out on tour together. I told him I didn't want him going on and on to the press about Nashville and the people here. They are my friends, too, Ralph, so I felt the same as you. Well, I pick up the *Atlanta Journal-Constitution* and there's a big anti-Nashville article. Dwight was attacking Chet Atkins. Actually attacking him. I said 'Dwight, Chet has more friends than you'll ever have! And there are many reasons all those people love him. You need to shut up and sing!' Then I reminded him of our deal and said I was considering going home. That seemed to be the end of it. We finished the dates and Dwight respected my feelings. Not long ago I saw some article where people had been baiting Dwight about Nashville, trying to get him to say

something, and the subheadline of the article was Dwight's response to the fellow: 'I'm just gonna shut up and sing.' "

We laughed about Dwight's comeback to the heckler from the press, and that reminded Buck of an opposite sort of press guy—one of the great music writers both Buck and I knew, Bob Claypool, from the *Houston Post*. Bob wrote about people and music he loved, and would never stoop to any attempt to get an artist to put his foot in his mouth. A lot of music journalists and radio or television interviewers could learn a lesson from Bob Claypool: It's not a contest between you and the artist, so you don't need to lay traps. Bob knew a great deal about country music history. Some who cover the music scene don't. Bob did.

"Bob loved pure country and he loved your all-night show, Ralph," Buck said.

I had to smile at that comment, because I'd read a very complimentary column he wrote about me, and it meant more than I can say. Bob wrote the column during my *Nashville Now* days, just after *Cable Guide* magazine readers had voted me Best Host of a Talk/ Entertainment Show and Favorite Cable Personality, with Best Entertainment/Talk Show honors going to *Nashville Now*. I guess some of Bob's friends only knew me through television, and considered me little more than an affable host and a "company man." Bob wrote that, in his opinion, I should be remembered as "the best all-night deejay in country music. Bar none." When a journalist of Bob's caliber hangs that tag on you, you tend to take notice!

"He used to tell me he'd ride around Texas in a big old Lincoln with Dwight Yoakam, playing Buck Owens on the tape player," Buck said. "Bob and I had a fantasy we developed. We wanted to rent a honky-tonk in Houston, just a small place with maybe a couple hundred seats. Then we were going to hire Ray Price and George Jones and book them for two shows. We'd have Ray sing an hour and then bring George on for an hour. Now there was a catch to this. Bob Claypool and I were going to put it in the contract that we got to decide what Ray Price and George Jones songs we wanted them to sing. We also were insisting that Ray use the Cherokee-type band, since Bob and I didn't like it when Ray used the orchestra.

And we were going to invite our best friends to this event and provide every one of them with their own bottle of Jim Beam. Then we'd just sit back and hear country music at its best."

Bob Claypool passed away soon thereafter, so he and Buck didn't get to play out that pipe dream. But I love the idea of Bob rocketing around Texas with Dwight Yoakam playing Buck Owens tapes, and I especially love the thought of Buck Owens and Bob planning their idea of a night of the perfect country show. As I write, I hope Bob Claypool is sitting at his private table in a hillbilly heaven honkytonk with a bottle of Jim Beam. Of course, since we still have Ray and George here with us, we'll hope he's listening to Hank and Lefty.

And I hope he's got his Buck Owens tapes, too.

Roger Miller:

"By Monday

I'll Be a Drummer"

*O*THERS MAY HAVE SOLD more or written more or even had more hits, but I think one man exemplified the national spark that seemed to ignite the Golden Decade of Country Music. And when Arthur Schlesinger speculated that the '60s would be "...spirited, articulate, inventive, incoherent, turbulent, with energy shooting off wildly in all directions," he might just as well have been describing my friend Roger Miller, probably the single most creative mind I've ever run across.

He was born in 1935 in Fort Worth, Texas, but financial circumstances caused him to be sent to live with an uncle in Erick, Oklahoma, at the age of three. "The Dust Bowl is what put us in bad straits," Roger said. "Our family had all those *Grapes of Wrath*–type stories. Heartland stories."

I once asked Roger to tell me about Erick and he responded: "Erick's one of those towns where if you have a parade there's no one left to watch. Our school band was a trio."

Sheb "Purple People Eater" Wooley is also from Erick, Oklahoma, so I reminded Roger that when Sheb did my show he always

referred to him as "Little Roger." Roger said Sheb had played a major role in his life. "My dad never talked to me a lot," he said. "Sheb married my sister when I was about five years old, and he taught me how to swim, how to tie my shoes, how to drive a car. Of course I was twenty-three at the time. Seriously, Sheb talked to me a lot. We used to build fences together, pull cotton together."

Erick inspired at least one of Roger's biggest songs, "Chug-A-Lug." In 1972 he told me that the song was taken from segments of his childhood:

"I didn't realize that I'd used a real situation in those lyrics for a couple of years," Roger admitted. "But in my hometown there was a big fat boy who used to drink a beer in three seconds. He called it chug-a-lugging. There were also some twin boys, the Gibson twins, who, together with their friend Charlie Ralston, made some home-made wine and brought it to school in a mason jar. That's all part of the first verse. And the third verse is about a little old beer joint that's on the state line of Oklahoma and Texas, in Western Oklahoma on Highway 66. An uncle of mine sneaked me in once when I was about fourteen."

On the other hand, it's interesting to note that the man who wrote "Engine, Engine #9" and many other train songs had never been on a train in his life when he penned the tunes.

His childhood musical heroes were Bob Wills and Hank Williams, and Roger had dreams of a music career even as a young boy. But he had no opportunity to get started as so many stars did: on a local radio show. Roger once said: "We didn't have a radio station. We didn't even have a filling station. Well, maybe we did have a filling station." It was while in the army that he found he could actually earn money making music. Roger had been drafted during the Korean War, and was sent to Fort McPherson in Atlanta. There he was recruited as a fiddle player for a Special Services unit called the Circle A Wranglers. The Wranglers traveled around the country as a recruiting group for the Third Army, following in the footsteps of Faron Young, who by then was back in Nashville recording hits again. Roger told me that he felt great pride at being in Faron's old post. On the weekends that he was in town, Roger played with Pete

Drake's band in Atlanta. I once asked him how he liked the recruiting business, and Roger deadpanned: "I did it with all the sincerity that my heart could muster."

Roger came straight to Music City when he was discharged, and there are two misperceptions that linger about those first years in Nashville. The first has to do with his career as a bellhop, and the second is about his first band job. For some reason people talk about Roger's stint as a bellhop as though it lasted for years. Roger told me it lasted a month. He wasn't cut out to be a bellboy. And it's often been reported that Roger's first job was as a fiddle player in Minnie Pearl's band. I'd never heard that Minnie even had a band, so back in 1972 I asked him to clear up the misperception. "It was actually Judy Lynn's band," Roger said. "It was in 1957, my first job in the music business. Judy worked a lot of fairs with Minnie Pearl."

By then Roger had become friends with George Jones, who was on Starday Records. George took Roger to his producer, Pappy Daily, and he and Don Pierce recorded some sides that went nowhere. But Roger's songwriting certainly went places. He penned "Tall Tall Trees," which Jones released in '57, and while it didn't become a hit until Alan Jackson released it as a single in 1995, it did stir interest in Roger's writing and he signed with Buddy Killen at Tree Publishing in 1958. While playing in Ray Price's Cherokee Cowboy Band, Roger pitched Ray's "Invitation to the Blues" and scored his first hit.

Personal stardom was going to take a couple more years. Roger recorded a few more sides with Starday, then moved to Decca, meeting no success there, either. Then, in 1960, he signed with RCA and had his first chart singles with "You Don't Want My Love" and "When Two Worlds Collide."

Roger went to California and played the club scene there for a time. He told me about one introduction:

"I was still a struggling songwriter and I was playing this little club where they let me sing when people weren't fighting. I was wearing my big red rock 'n' roll coat and had my hair sprayed back. This guy got up and gave me a big, flowery introduction. 'Here he is, folks, straight from Nashville, Tennessee, where he's written some

big songs! Give a big welcome to Dave Rogers!' " Roger must have thought he was experiencing "déjà vu all over again" when, in 1966, after he was a worldwide star, he went back to Erick, Oklahoma, for a visit, and an old farmer asked him what he'd been doing since he got out of the army! Roger loved both of these self-deprecating stories and never tired of telling them. I once asked him what he'd said when the farmer inquired about his post-army days.

"Nothing," Roger deadpanned. "I slapped him."

"I guess it humbled you," I added.

"Brought me right down," he said. "I've never worn a tuxedo since."

But it wasn't long before he wrote a song that would help change everything. The idea of a "king of the road" type of song had been bouncing around in his mind, and when he was in Boise, Idaho—as he put it, ". . . the Boise Hotel, room 622"—he sat down and wrote it.

It was around this time that Faron Young stepped in to help Roger get on his feet. As Roger always said: "Faron's heart is as big as his mouth." Evidently Faron ran into Roger and thought he seemed a little down in the mouth.

"What's wrong with you?" Faron asked.

"Well, I'm out of work," Roger said. "I've got a wife and a baby and no money. Not only that, my car's broke down."

Faron thought a minute, then asked: "Do you play drums?"

"When do you need a drummer?" Roger asked.

"Monday," Faron said. It was Saturday then.

"By Monday I'll be a drummer," Roger said.

Faron went with Roger right then and bought a set of drums. Roger practiced all weekend and by Monday he was a drummer.

Roger's wit got him another recording contract after RCA finally dropped him. He'd appeared on several national shows, including the *Jimmy Dean Show* and the *Tonight Show*, and as luck would have it, a Smash Records exec saw him, thought he was very funny, and believed that somehow that humor could translate to hit records.

Translate it did. Roger's first Smash sessions produced "Dang Me," "Chug-A-Lug," "Do-Wacka-Do," and "King of the Road."

"Dang Me" topped the charts for six weeks and "King of the Road" took the top spot for five weeks. In 1964 "Dang Me" won the Grammy award for Best Country and Western Single and the album *Dang Me/Chug-A-Lug* took the Best Album Grammy. Roger got the Grammy for his performance of "Dang Me" and was also named Best New C&W Artist by NARAS. The following year "King of the Road" won the Grammy, and Best Album went to *The Return of Roger Miller*. Roger again picked up the Best Male Performance honor as well as Best Song, Single and Contemporary Single. Buck Owens beat him out for Top Male Vocalist at the West Coast Academy of Country Music Awards, but Roger was named Man of the Year and Songwriter of the Year.

As great a writer as Roger was, he often looked for outside songs to cut. And I guess if you were looking for a hit, you could have simplified things by looking at songs Roger found. He had the first cuts on "Me and Bobby McGee," "With Pen in Hand," and "Ruby, Don't Take Your Love to Town," songs later made famous by Janis Joplin, Johnny Darrell, and Kenny Rogers, respectively. I reminded him that when "Ruby" was first released in 1969 it had been somewhat controversial, yet by the time of our 1972 conversation it wasn't in any way a subject of controversy. Roger said he hoped country songs didn't get too out of hand, as had rock lyrics in the late '6os. Since Roger was anything but a censor, I asked him if there was anything in particular that he'd object to in songs. But Roger was too slippery. He immediately said: "I object to the fact that I don't have a hit right now."

Of course, whether he had a hit out or not, Roger was doing very well by 1972. He sure wasn't picking cotton with Sheb Wooley in Erick, Oklahoma. He was living in Hollywood two doors down from Steve Allen. Lou Rawls and Roger Williams both lived on that street. Julie London and Dick Clark were neighbors. Roger's songs had been very good to him.

Roger was on my radio and television shows many times over the years, and you never had any idea what might happen when he appeared. Television was made for Roger because so much of his wit

and charm had to do with his comic instincts: a gesture, a grimace, a funny walk. Often, to really "get" the joke, you had to watch him tell it. I once tried to steal a Roger Miller story and use it in a show in North Bay, Ontario. It didn't work. Here's the story as Roger told it:

"I had this dog when I was a kid. He was an awfully good dog, but my dad was cutting hay one summer and the dog got caught in the mowing machine and it cut off all four of his legs. I got him four wooden legs and the dog got all right. He really got around on those legs until the house burned down. I got him out but the wooden legs got left behind and burned up. Then I got him a wheelbarrow and I pushed him around. That worked okay until one day he got after a rabbit and like to run me half to death."

I reminded Roger of my bombing with the story in Canada and he said, "You should tell jokes sitting on a stool. It's hard to lay an egg sitting on a stool."

On March 7, 1966, he was on my *Opry Almanac* show. It was a day after he'd been announced as a nine-time Grammy nominee and he'd just been offered a prime-time variety show by NBC. I asked him to describe his reaction to the news.

"I hung up the phone and called to my wife, 'Come in here!' She yelled back: 'I'm diapering the baby!' So I said, 'You better bring the baby with you!' Then when she walked in the room all I could say was 'Monday nights. Eight-thirty. Starts in September.' "

Roger had been up all night, but he looked as fresh as if he'd just stepped out of a bandbox. He was in rare form. He mugged for the camera, stuck his head under the advertising cards I'd hold up—he even danced with his guitarist, the great Thumbs Carlisle, who showed up in a Batman shirt.

Like I said, a lot of Roger's comic genius was in his gestures and little bits. The great lines that people quoted were what he called "snappy patter." But one of my favorites was his phone-dialing bit, where he mimics all the phone sounds of a dial. It's one of those things you have to have heard, but picture a conversation where you might mention phoning someone, or ask if so-and-so had called lately. Suddenly Roger Miller is sounding like a dial tone, then the

numbers being dialed. It was just one of those nutty things he loved doing.

And another way Roger was funny was in the offhand answers he'd give you. For example, once when I asked him what he thought of Johnny Cash he said: "I think of him often from time to time." I took it a step farther and asked him to talk about the famous Cash charisma.

"He has an animal magnetism," Roger said. "In fact, he was undressing the other day and a dog bit him. . . ."

Some of the Roger Miller stories around Nashville were actually about other people. One time I heard that Roger was in a Hollywood restaurant and Frank Sinatra walked over to introduce himself. Supposedly Roger said, "Not now, Frank. I'm busy." Roger later told me that, in fact, it had been Don Rickles who did that bit. It was a gag he cooked up by asking Sinatra to stop by his table and meet his out-of-town guests. Then when Frank walked up, Don waved him away. Sinatra thought it was hysterical. When Roger was introduced to Frank Sinatra by his friend Vince Edwards, Frank told Roger he was a big fan. Roger said it was one of the greatest thrills of his life.

Bill Anderson was one of Roger's best friends, which makes this next story all the better. One night back in the early '60s Roger decided to go over to Bill's house. That was back when Bill was a bachelor and living alone. Roger couldn't seem to rouse him by banging on the door, so he broke in a window. Bill heard the sound of glass breaking and got his gun.

"Do you mean Bill Anderson almost shot Roger Miller?" I asked.

"Yes he did," Roger said. "We could have set country music back a bit that night."

During that same visit I asked if Roger remembered telling me once that he and Bill Anderson were getting sick of a new guy named Harlan Howard. "I do," Roger said. "We were getting sick of him staying up in Detroit or somewhere, working in a magazine bindery and getting all the cuts here in Nashville. We finally convinced him to move to Nashville where we could keep an eye on him."

And Harlan did move to town, where he was an immediate and welcome addition to the Tootsie's Orchid Lounge crowd: Roger,

Bill, Justin Tubb, Willie Nelson, Hank Cochran. Roger says they got money by selling each other their cars. When someone was flush, he'd buy another fellow's car for a hundred bucks. Than that person would sell it back the following week.

Willie Nelson also came to Nashville at Roger and Bill's urging. Roger once recalled how that came about: "Bill Anderson and I were playing a Cow Town Hoedown at the old Fox Theater in Fort Worth. The house band had a little red-headed guy named Willie Nelson who was writing some awfully good songs. When he finally got to town, he moved into a trailer on Dickerson Road and I loaned him my Buick. I was a two-car man by that time. I had a hundred-dollar Ford and a hundred-and-fifty-dollar Buick. That was from my 1958 'Billy Bayou' cut on Jim Reeves and Ray Price's 1959 *Invitation to the Blues*. Jimmy Dean was the very first person to record one of my songs, 'Happy Child.' George Jones was the next with 'Tall Tall Trees'—but I made the money on Reeves and Price. It worked out though, because Jimmy Dean later became the first person to put me on television when he was guest-hosting the *Tonight Show*."

In 1972 I asked Roger if he'd ever considered writing a Broadway musical. "No," he said. "I don't think I have the discipline." But by a 1987 interview, much had changed. By then Roger had written *Big River*, which won seven Tony Awards in 1985, including Best Musical of the Year. It was the story of Huckleberry Finn and Mark Twain, from the Twain novel. Roger told me how he came to work in a field he once felt too undisciplined for:

"In 1982 I was playing the Lone Star in New York and was approached by a producer, Rocco Landesman, who'd been to hear one of my shows in the '60s. He could recite the lyrics of all these songs I'd done, songs like 'Half a Mind' and 'Big Harlan Taylor.' I was impressed because I'd never met a scholar of my work before. He said he'd produced *Pump Boys and Dinettes* on Broadway and wanted to put on a show based on Mark Twain's writings. I said, 'Well, it's a little late. He's not here to defend himself.' He finally convinced me to do the show. He said if I'd write the songs, he'd clear the way. And you know what? As we went along, he did every single thing he said he'd do. A man of his word. And as I began to read Twain, I realized

that these were my people. I came from Oklahoma and my parents came from Arkansas, just south of Missouri. They talked the same language as me. I'd long been a fan of Mark Twain, as I was of Will Rogers. But I wasn't a scholar of their work, like I was of, say, Hank Williams's work. And it wasn't until we got started on the songs and the story adaptation that I truly understood the deep connection."

Roger even played Huck's "Pap" for a time, modeling the character after his own father. "My dad used to wave his hat at the clouds when it wouldn't rain," Roger recalled. "He'd shout, 'Why, you God-dang no-good soul-selling sons of . . .' And I could still see him doing that."

Roger considered *Big River* his crowning achievement, perhaps more so because in the beginning he didn't believe he had a musical in him, or one that he could get out, anyway. When asked his favorites among his great songs, he often pointed to "England Swings," which really was inspired by little red-cheeked children he saw once on a promotional trip to Great Britain.

By the time we spoke in 1987, Roger had made a great many changes in his life. He no longer took pills. He'd moved from Los Angeles to a little town in New Mexico. He was as happy as any man I'd ever met. Sadly, it would not be many years before he developed throat cancer, which ultimately caused his death in 1992.

So I'm glad that day I got around to asking Roger to give me some off-the-cuff thoughts on some of country music's legends. Here's my "Roger Miller Recalls":

"Willie Nelson?" I asked.

"I don't remember Willie," Roger joked. "Really, I knew him from the beginning, from Fort Worth. From when he moved to Nashville with his wife, Martha, and their two daughters and their son. Willie played bass in Ray Price's Cherokee Cowboys when I was fronting the band. I drove Willie out to Faron's house to take a tape of 'Hello Walls.' I must have been involved in all-things-Willie."

"Ray Price?"

"I worked for the fire department in Amarillo, Texas, for a couple of months in the summer of 1957. Ray Price came through to play a show and I went backstage to hang out a while. I was singing my

songs and pitching my songs. Van Howard, who sang duets with Ray, had quit around that time. Ray listened to me and said, 'You can sure sing high. Maybe you could come to work for me.' About a month later he called and I resigned from the fire department just in time to keep from being fired. I wasn't a very good fireman."

"Cousin Minnie Pearl?"

"When I first got out of the army, I got a bellhop job during the day at the Andrew Jackson Hotel. And every night I'd head over to WSM to hang out. One Friday evening at the Frolics, a guitar player on the Opry—Johnny Johnson—told me there was a tour of fairs being put together for Minnie and Mel Tillis and Judy Lynn. Mel Tillis told me they needed a fiddle player and I said: 'Here I am!' "

"Mel Tillis?"

"We've been friends ever since that tour. Mel had already written 'Honky Tonk' and 'I'm Tired' for Webb Pierce, but he still carried his guitar around in a tow sack."

"He couldn't afford a guitar case?" I asked.

"Either that or he couldn't talk enough to buy one. When we were on tour, he had to eat grilled cheese sandwiches all the time because he couldn't get out 'h-h-h-hamburger.' "

"Kris Kristofferson?"

"I was living in Los Angeles and had come back to record," Roger said. "Mickey Newbury was one of the new guys in town who was just setting everybody on fire. Newbury played me a song that I loved, then said: 'If you think this is good, you ought to hear this ole boy who's cleaning floors at the CBS studio.' So the next day he introduced me to Kris Kristofferson and the first thing I thought was that he should change his name. I ended up taking Kris and Mickey back to my place in L.A. for a week's visit. Kris would sit around and sing me these songs. One of them was 'Me and Bobby McGee.' I ran right back and recorded it. There was something so literate about most of Kristofferson's lines. He started writing sharper images than had been done before. The songs weren't simply heartbreak songs or honky-tonk songs. They had a sharper edge—'The Sunday smell of someone frying chicken.' There's something very literate in that line."

I mentioned that I used to ask Kris to visit my afternoon televi-

sion show, not for his singing ability, but to give the girls around the office a thrill.

"Oh, he's pretty," Roger cracked. "He used to sign my name when he signed autographs."

"But he can't sing," I responded.

"He sings like a duck," Roger agreed.

I asked about another person Roger knew: Johnny Carson.

"We know each other and we can talk," he said. "But we aren't really friends. I remember one night on his show I mentioned that I'd never once seen him away from the show. 'Let's keep it that way,' Carson said. I said, 'Okay.'"

Before Roger left I asked him to tell me what line he'd uttered when he first saw the Grand Canyon.

"Imagine what God could have done if he'd had money."

And that brings me to this: Imagine what Roger Miller could have done with more nerve. I'm kidding, of course. Roger Miller is the guy who, when staying at the White House, disassembled the antique clock in Lincoln's bedroom and repaired it.

Willie Nelson:

Just Waiting for

Everyone Else to

Catch Up

ROGER MILLER always said Willie Nelson was about five minutes ahead of his time. When Willie guest-hosted my radio show once back in the '70s, I mentioned that to him. Willie didn't crack a smile. He just shook his head and said, "You know, Ralph, I always thought Texas was right on time and just waiting for everybody else to catch up."

While Willie's songwriting is equal to anybody's in the business, it did take the general listening audience a while to catch on to his singing style. I think that's because when all is said and done, Willie's a jazz singer. Willie's early influences ran from the honky-tonk and jazz of Floyd Tillman to Bob Wills's western swing to the polka music he played when he first started playing in bands. Willie wrote songs from the time he was a little boy, and by the time he moved to Nashville in the early 1960s he'd already sold two of his biggest copyrights: "Family Bible" and "Night Life."

Willie was born in Fort Worth, Texas, and raised in the little town of Abbott. He and his sister, Bobbie, started playing music early, influenced in part by the musical grandparents who raised

them. After high school Willie joined the air force. Willie once told me how he viewed his short stint in the military:

"It was peacetime and I couldn't understand the need for all that marching and yelling," he said. "So I'd answer roll call, then go hide for the rest of the day. They put me in the military police for a while, until they figured out I was on the side of the guys they wanted me to arrest. Then they made me a medic. Luckily I got sick and ended up in the hospital. That was when they let me leave the air force for good."

I've always been a big fan of Willie's, and, in fact, he had his first #1 hit, "Mr. Record Man," in 1961 on my WSM show. It didn't chart nationally. Willie very nearly couldn't get arrested on country radio throughout the 1960s. But he was a force in this town, one of the songwriters who helped make Nashville Music City.

The truth is, "Mr. Record Man" had tied for the #1 spot on my show that week. Every Monday I had a listener countdown tallied from phone calls and letters about favorite songs. I can't remember which song had the same number of cards and letters as "Mr. Record Man" that week, but I was the one who always broke a tie vote and my vote went to Willie. I liked him, respected him, and really hoped his career would take off.

I don't know why it took so many years to chase Willie down and get him to be a guest host on my show, but it wasn't until 1975 that he sat in with me for a week. Willie quickly made up for lost time, and listening to those old tapes recently, I realize we sounded like a comedy team much of the time, trading off straight-man duties. A lot of the repartee wouldn't even translate well to print—it was just something you had to be there for. Willie's a lot like Roger Miller in that much of his humor is in the nuance. Of course, Willie understood radio work, since he'd had seven years of deejay experience. He'd started out as a deejay in Texas during the '50s. Like a lot of people, Willie exaggerated his job experience.

"I applied for a job working for Doc Parker in Pleasanton, Texas," Willie said. "When Doc asked me if I had any experience working the board, I lied and said yes. So he pointed down at this RCA board and asked if I was familiar with that one. Luckily I remembered that

I'd once seen a Gates board somewhere, so I said casually, 'No, Doc. I've always used a Gates. You better walk me through this RCA.' Doc trained me on the board, but it didn't take him long to figure out I didn't have any real experience. For one thing, it would take me over half an hour to read a fifteen-minute newscast."

The first board I learned on was a Gates, but I had an advantage over Willie—I came out of radio school and they had a board setup. But every time I changed jobs they had different boards, and you had to train all over again.

When I could get Willie to be serious, he told me about some of those great songs he brought to Nashville in the '60s. "Touch Me" was one of his first releases on Liberty Records, and it climbed up to #7 on the charts, one of the only two that made it into the top-10 during the '60s. The other was his Liberty debut, "Willingly," a duet with future wife Shirley Collie.

"I wrote both 'Touch Me' and 'The Party's Over' when I was on the road playing with Ray Price," Willie recalled that week in 1975. "We were all out there running up and down the road in Nudie suits—Ray had closets full of them. We had just pulled out of Beaumont in the bus on our way to play a show in Odessa. Jimmy Day was playing steel for Ray, and as I remember, he had the bottom bunk and I had the top. We were both writing songs, and every so often Jimmy would call up, 'Willie, what do you think of this?' Then he'd read me a line or two and I'd say, 'Jimmy, that's terrible. Write something else.' In between messing with Jimmy, I wrote 'Touch Me.'"

He wrote "Half a Man" after waking up in the middle of the night and wanting a cigarette. "I discovered I had one arm around a woman, and couldn't get it free without waking her up," Willie says. "So with the other hand I not only had to fumble around for the cigarettes, but I had to light one using a matchbook. That's not easy one-handed. I got to smoking that cigarette and thinking about what it would be like to be half a man."

We joked around during the show and it seems like one or the other of us was always commenting on the time. Then the other one would quip, "Funny how time slips away." Willie had written that song the same week he wrote "Crazy."

"When I first came to Nashville, I moved into a trailer out in Madison with my wife and our three kids," Willie explained. "Hank Cochran, who encouraged me to move here and signed me to Pamper Music, was just moving out of that trailer. As soon as he was out, we were in. Every day I made the drive in to the Pamper Music office in Nashville, and I wrote songs in my head all the way. One of those weeks I remember turning in three songs, and two of them were 'Crazy' and 'Funny How Time Slips Away.' Those two songs have been pretty good to me. 'Funny How Time Slips Away' is my most recorded song. That week stands out in my mind more for something else, though. I was real worried about how I was going to come up with twenty-five dollars for the oil bill.

"We had a little house out in back of Pamper, and one time Hank and I were out there getting ready to write. I was just about to tell him my idea for 'Hello Walls' when he got a phone call up at the main office. He went in to take the call and by the time he finished ten minutes later, the song was already written. That turned out to be an expensive phone call for Hank," Willie said, laughing.

I reminded Willie that I'd contributed to his coffers when I did the answer song, "Hello Fool," which made it to the top-5 in 1961. "Yeah, Ralph, you talk a good song," Willie deadpanned.

Aside from hanging out with Hank Cochran, Roger Miller, Faron Young, and Harlan Howard down at Tootsie's, Willie got into keeping a few farm animals and he liked to give them names. He was probably the only "farmer" in Tennessee with a chicken named Bill Dudley and pigs called Lester and Earl and the Foggy Mountain Hogs. "You know, some didn't get nicknames, Ralph," Willie told me. "Some got nick-numbers." The subject of chickens reminded Willie of a Roger Miller story.

"You know Roger Miller has been working on a chicken diet, don't you?" Willie asked me.

"No, I didn't," I said, then inadvertently played straight man into his line again. "Does it involve eating a lot of chicken?"

"Oh no," Willie said. "I mean a *chicken* diet. Where your face stays thin. Think about it. You ever see a chicken with a fat face?"

"Three Days" came about after Fred Lockwood, the fiddle player,

told Willie a joke. It seems a panhandler came up to a guy and asked him for some money. "I'm hungry," the panhandler said. "I haven't eaten for three days—yesterday, today, and tomorrow." Willie thought the joke was just okay, but the line was a great hook. He ran right home and wrote it.

"Bloody Mary Morning" was written as a result of Willie's appearance on the *Glen Campbell Goodtime Hour*, which was filmed out in Hollywood. "That show took all week to rehearse and then film," Willie said, shaking his head. "The night it was over we had quite a party. I don't know if everybody else got to sleep in, but I caught flight 50 from L.A. to Houston early the next morning and wrote the song from firsthand experience."

And "Pretty Paper" came directly from another firsthand experience. Willie told me that he used to frequently see a disabled fellow on a street corner in Fort Worth. The man didn't have any legs, so he rolled himself around on a little platform on wheels selling wrapping paper and pencils. Willie watched him through his years of playing in little Texas bands, then wrote "Pretty Paper."

"What Can You Do to Me Now" is one of those song stories that's almost too bizarre to believe. Yet it's all too true. "I'd got a divorce that year and totaled four cars and a pickup," Willie said. "Hank Cochran and I wrote that song one day and the next day my house burned down. If that wasn't bad enough, when the album came out, my manager opened his copy and RCA had mistakenly put a Waylon Jennings record inside."

Then Willie grinned. "There's no end to what they can do to you once they put their mind to it, Ralph."

Willie helped put Nashville on the songwriting map in the '60s, then helped put us on a whole different map in the 1970s and 1980s. As I mentioned, as an artist he made it to the country music top-10 only twice during the 1960s. Of course as a writer he scored with many big country hits, including "Crazy," "Hello Walls," and "Funny How Time Slips Away." And he had a kind of cult following, people who loved him onstage, loved his voice and his show. But on the national charts he faltered until 1975. Even songs that later became his trademark stalled. "Yesterday's Wine/Me and Paul" only made it

to #62 in 1971. "Shotgun Willie" topped out at #60 in 1973. "Stay All Night" seemed to reverse his downward trend, and made it to #22 in '73, and "Bloody Mary Morning" peaked at #17. Part of the problem was the fact that he was on RCA from 1970 to 1972, then moved to Atlantic in '73 and '74. Neither label really knew what to do with Willie. Luckily, Willie knew. In 1975 Willie moved to a new label, Columbia, and in July he released a Fred Rose song titled "Blue Eyes Crying in the Rain."

"I'd been singing that song in my show for years," Willie explained. "We recorded it in Garland, Texas, with my band. I'm playing guitar on the record. It became my first national number one release."

In December 1975, Willie Nelson and Waylon Jennings released a song they cowrote, "Good-Hearted Woman" on RCA. The song went to #1, stayed there three weeks, and went on to be the CMA Song of the Year. Chart success wasn't the only thing that was changing with Willie Nelson. His hair was long, he wore a bandanna around his forehead, and he fit right in with the '70s hippie population. People started calling him a Cosmic Cowboy. I asked him how he felt about that tag.

"I'm not into labels," Willie answered, then quickly quipped: "Does that mean I get 'higher'?" Like Merle Haggard, Willie made no secret of his fondness for pot smoking. I asked him what he thought, then, about the label "progressive country," which many were starting to use when they talked about certain recordings and artists. "I've heard it called a lot of things, including the 'Austin sound' and 'redneck rock,'" Willie said. "But I don't think it's as much artist driven as it is audience driven. If there is an 'Austin sound,' it's because Austin is one place where you can play live music to some of the most enthusiastic audiences in the world. It's an honest audience, and all they want from you is honest music. So I don't really think it's about recordings, just live music."

I then asked Willie if he was the leader of this live music phenomenon brewing in Texas.

"Oh, no," he said. "I just saw what was happening and joined in.

Jerry Jeff Walker was there before me. Same with Ray Wylie Hubbard, Kenneth Threadgill, Michael Murphey, Rusty Weir—a lot of guys. We're all examples of why this movement is really an audience movement. If an audience can sit and listen to a guy singing who has long hair and a beard, that's pretty progressive."

I asked Willie if he thought back when he was a young Turk, when Roger Miller was a young Turk, if they could have gotten away with the hair, the beards, the bandannas on the forehead. Willie thought that over.

"We probably wouldn't have got off scot-free. But I like to think we could have made it home without being killed." Then he grinned. "You know I call my band the Offenders." Willie was kidding around of course, and it's hard to think of him ever offending anybody. He is one of the most laid-back people I've ever met. The world doesn't seem to affect him like it does the rest of us. I remember calling Waylon during the time the IRS was auctioning off Willie's belongings. I was worried about Willie and inquired how he was doing.

"Willie's fine," Waylon answered. "He doesn't care."

Thinking Waylon was just making an offhand comment, I went on, and asked another of those but-how-is-he-*really* type of questions.

"You don't understand," Waylon said. "I mean he *really* doesn't care. Willie's things don't have much to do with him. That's not what he's about."

I believe Willie Nelson makes a concerted effort to keep the worry out of his life, and it's easier for him to do that because he is such a thinker. He sees things from a slightly different angle. One day we were talking about someone who was all broken up at a funeral and Willie said, "They're crying for their own loneliness, not for the person who died. It's all about the loneliness they see ahead without the other person."

After that interview in 1975, Willie went on to be the most popular man in country music—maybe in any kind of music—through the rest of the '70s and much of the '80s. Despite his later popularity,

I include Willie Nelson in the 1960s because of his enormous contribution as a songwriter. I begin the 1970s with the man who took control of his recordings in the '60s, quietly setting the tone for the '70s "outlaw" movement. That man is Bobby Bare, another incredibly laid-back artist. The only time I ever saw Bare get excited was once on my show, when Doyle Wilburn's dog, who was asleep under the desk, woke up and cold-nosed Bare's leg. That made him jump.

Many of the photographs that I have obtained over the years were sent to me by fans. Such is the case with this rare photo of Marty Robbins taken on Bougainville in the South Pacific in 1944. Marty drove a landing craft on many beaches while under fire. *(Photograph courtesy of Harold and Faye Gregory)*

This is a classic photograph of Tennessee Ernie Ford, a "clowning" Audrey Williams, and Hank himself. It was taken in May 1950 in Nashville. *(From the collection of Merle Kilgore)*

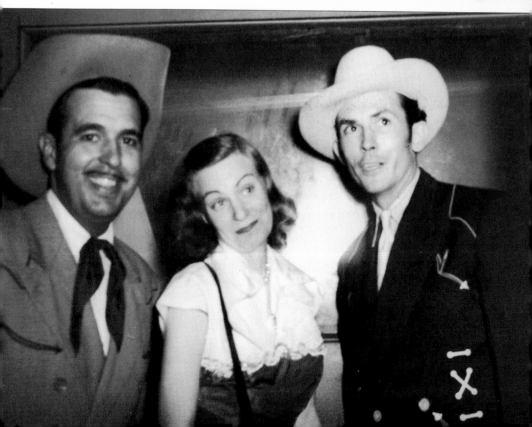

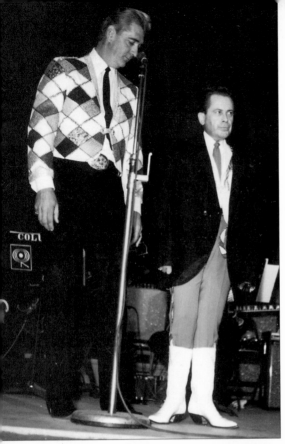

At the Grand Ole Opry in the early '50s, stars Carl Smith and Jimmy Dickens have exchanged jackets. Dickens is obviously modeling his. (*Photograph by Judy Mock*)

An early photograph of Kitty Wells in the '50s when she became the "Queen of Country Music" and opened a door for other female performers. She was dubbed "Queen" by the legendary Fred Rose. (*Photograph by Judy Mock*)

I interviewed Hank Thompson in Carthage, Texas, in 1999, when he was inducted into the Texas Country Music Hall of Fame. This photo was taken in the '50s at a show in New Jersey when Hank was one of the kings of western swing. (*Photograph by Judy Mock*)

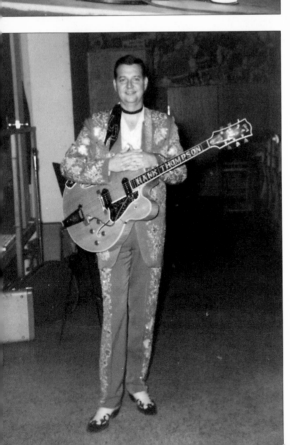

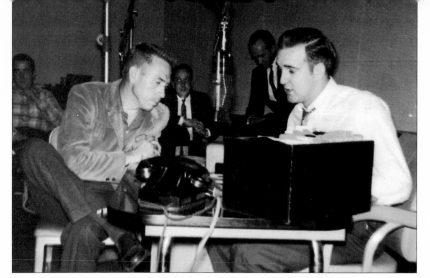

BUCK OWENS ON my all-night radio program in 1959, before he became a big star. His record at the time was probably "Under Your Spell Again" or "Above & Beyond." (*Photograph by Les Leverett*)

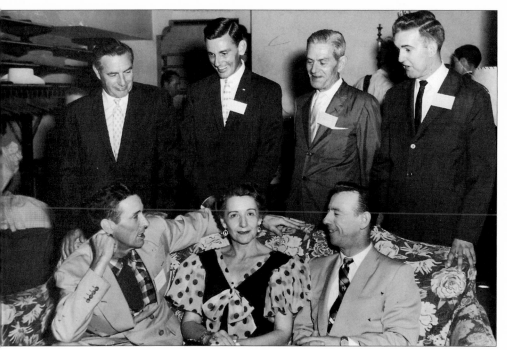

IN 1959, I was the emcee for a festival in Meridian, Mississippi, honoring the "Father of Country Music," Jimmie Rodgers. The local newspaper, *The Meridian Star,* referred to this photo as the million-dollar ensemble. On the couch are Ernest Tubb, Carrie (Mrs. Jimmie) Rodgers, and Hank Snow. Behind the couch are Ted Mack of the famous *Amateur Hour,* Charlie Walker, Harry Stone (then the first executive director of the Country Music Association), and yours truly. I remember riding to Meridian with Hank Snow, who loved to stop for ice cream. (*Photograph by Jim Sellers*)

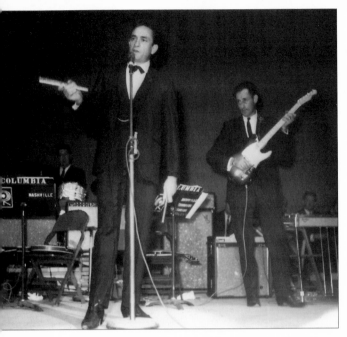

JOHNNY CASH IN the early '60s, holding in his hands cold rolled steel (two steel rods), which he used to dramatize the song "John Henry," striking one with the other. This made the sound of John Henry driving a spike into a rail cross tie. The drummer is W. S. "Fluke" Holland. The guitar player is Luther Perkins. (*Courtesy of the author*)

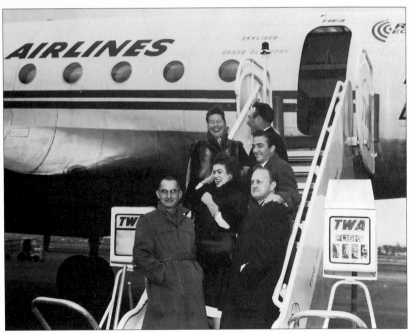

THIS IS A photograph of six members of the Opry cast who went to Carnegie Hall in November 1961. This photo fascinates me. Today they are all in the Country Music Hall of Fame and, unfortunately, deceased. The photo was taken as they descended the steps of the plane in New York. On the bottom step are Grandpa Jones and Bill Monroe. In the middle are Patsy Cline and Faron Young. At the top, Minnie Pearl shares a laugh with Jim Reeves. Marty Robbins took a different flight. (*Photograph by Les Leverett*)

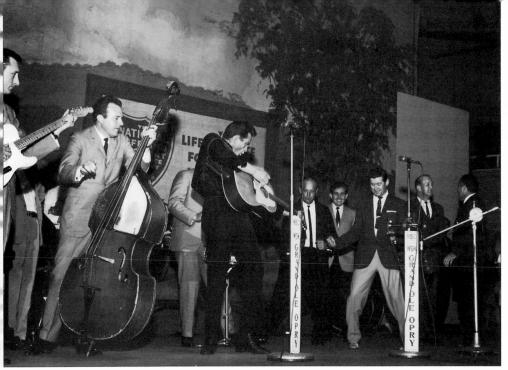

I CALL THIS photo "The Two Kings." It was March 23, 1963. Johnny Cash was performing at the Grand Ole Opry while Roy Acuff felt the music and started dancing. I think the photo is a classic. *(Photograph by Les Leverett)*

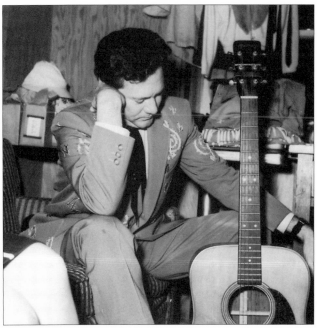

A MOMENT FROZEN in time. Hall of Fame country singer Lefty Frizzell had just been informed of the assassination of President John F. Kennedy on November 22, 1963. *(Photograph by Judy Mock)*

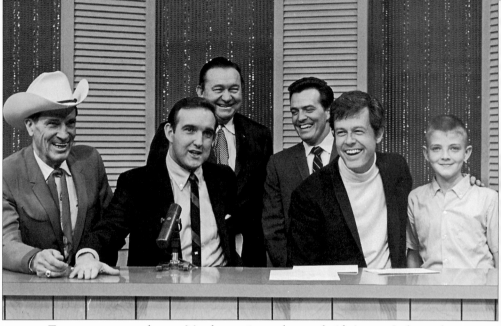

THIS PHOTO WAS taken on March 3, 1967, on the set of *16th Avenue*. Left to right are Ernest Tubb, your friendly host, Tex Ritter, singer Ronnie Dove, actor Robert Culp, and Tinker Tubb (Ernest's son). Note how thin my necktie was; it was the style. *(Photograph by Les Leverett)*

Rocky Marciano

undefeated heavyweight
champion of the world!

(AREA 713) 224-0681

EXECUTIVE OFFICES
806 MAIN STREET
TWENTIETH FLOOR
HOUSTON, TEXAS 77002

November 1, 1968

Mr. Ralph Emery
WSM RADIO-TV
P. O. Box 100
Nashville, Tennessee 37202

Dear Ralph:

Couldn't resist dropping you a note to tell you how
much I enjoyed meeting with you and to thank you for
the kind words you said about RAY FRUSHAY.

This was the first time I had ever attended a C and W
Convention, and I really enjoyed it; in fact, so much -
I'm looking forward to being back next year.

Again, Ralph, many thanks for all your courtesies, and
if I can ever be of any assistance to you, please don't
hesitate to contact me.

With all best wishes.

"Keep punching"

Rocky Marciano

RM:MJ

"Winners Never Quit, Quitters Never Win . . . Keep Punching"

<—◈—>

THIS IS A note from the unde-
feated heavyweight champion
of the world, Rocky Marciano
(his record was 49–0). Rocky
had attended the 1968 Disc
Jockey Convention in support
of country singer Ray Frushay,
whom he was sponsoring and
promoting. He had hoped
to attend the convention the
following year but died in a
plane crash on August 31,
1969. *(Courtesy of the author)*

MARTY ROBBINS AND me at the WSM Studios in 1969. (*Photograph by Les Leverett*)

FOR GLAMOUR, IT's hard to beat this quartet on an old *Hee Haw* show featuring George "Goober" Lindsey, Grandpa Jones, and Gailard Sartain along with me in my beautiful wig. (*Photograph by Jim Frey*)

MARTY STUART TELLS a wonderful story about guitar master Merle Travis. He mentions the fact that Merle was a cartoonist. In 1983, Merle came to *Nashville Now* when I had a beard and drew this cartoon about my giving him a hard time. Merle wrote the hit song "Sixteen Tons," which he referred to as "that old thing." He was also Chet Atkins's hero. (*Courtesy of Merle Travis*)

THE MAN WHO used to sing "Peace in the Valley," Red Foley. Red was the star of the *WLS National Barndance* in Chicago, the Grand Ole Opry, and in Springfield, Missouri, *The Ozark Jubilee* for ABC Television. Red was a major star of some of the biggest shows in country music history. (*Photograph by Judy Mock*)

DID YOU EVER see the other side of Minnie Pearl? This is Sarah Cannon, who is out of uniform—not wearing her Minnie Pearl costume. This photo is from 1971. (*Photograph by Judy Mock*)

THIS PHOTOGRAPH WAS taken on the fifth anniversary of *Nashville Now* in March 1988. Barbara Mandrell, Chet Atkins, and I celebrated with a cake. (*Photograph by Jim Hagans*)

GEORGE LINDSEY GAVE me this photo one day after a golf match. It blew me away because of its star power. It was taken October 23, 1988, and was a celebration of Grandpa Jones's sixty years in country music. Everyone has a funny story about Grandpa Jones, and we certainly told plenty that day. From left to right: Grandpa Jones, Fred Foster (the founder of Monument Records), and George "Goober" Lindsey. The pretty lady is Mrs. Grandpa Jones. Her name is Ramona (Grandpa called her "Rominey"). The next person is me, then Roy Acuff, *Hee Haw*'s Gordie Tapp, Roy Clark, Roger Miller, Tennessee Ernie Ford, and Ricky Scaggs. What a party! (*From the collection of George Lindsey*)

THIS IS LORETTA Lynn, one of America's favorite people, having fun with me on *Nashville Now*. (*Photograph by Jim Hagans*)

I'M PICTURED HERE with two musical giants. They are two of my favorite singer-songwriters, Willie Nelson and the man to whom this book is dedicated, the first superstar in country music, Eddy Arnold. (*Photograph by Judy Mock*)

AN AMERICAN TRADITION—Willie and Waylon. The photo was taken at the *Ryman Country Homecoming* in 1999. (*Photograph by Tim Campbell*)

"THE STORYTELLER" AND "The Tight-Ass," two of my closest friends, Tom T. Hall and Bobby Bare. You have to read the book to find out why I gave them their titles. Tom always looks like he has more teeth than a person should have. *(Photograph by Judy Mock)*

HERE I AM with Charley Pride, the newest member of the Country Music Hall of Fame. Charley is included in the chapter with Mel Tillis and Ronnie Milsap about three who overcame great odds to be successful. *(Photograph by Jim Hagans)*

GEORGE JONES AND Ray Price, two country music giants, are both in the Country Music Hall of Fame. These are the two guys who Buck Owens wanted to hire to sing for the perfect private party at which each guest would be given a bottle of Jim Beam. (*Photograph by Jim Hagans*)

A STUNNING PHOTO of two of my friends, Barbara Mandrell and Reba McEntire. (*Photograph by Jim Hagans*)

THE TWO MOST dynamic personalities whom I have met going down the road these past fifty years, Dolly Parton and Johnny Cash. *(Photograph by Judy Mock)*

THIS IS GARTH Brooks with his hero George Jones, whom he was very reluctant to meet, feeling that George might not measure up to his image of him. As it turned out, George was everything that Garth had imagined. *(Photograph by Judy Mock)*

Two BEAUTIFUL LADIES waiting for hair and makeup (they didn't need it) at the Opry House, Trisha Yearwood and Martina McBride. *(Photograph by Judy Mock)*

HAVE YOU EVER heard of a "guitar pulling"? People sit around, play guitar, and sing for the fun of it. In this case, Vince Gill, Mary Chapin Carpenter, and Kathy Mattea are having too much fun. *(Photograph by Jim Hagans)*

AT A GATHERING of some twenty country music stars called *Ralph Emery's Country Homecoming* in March 2000, for a televised special on TNN, I am joined by super-writer Kris Kristofferson, the beautiful Lorrie Morgan, and one of my favorite country music singers, Gene Watson. (*Photograph by Judy Mock*)

—◇—

A BEAUTIFUL LADY found in one of our final chapters. This photo was taken at the Nashville Network booth during Fan Fair 1998. I think one of her smartest moves was to change her name from Eileen Twain to Shania, which is an Ojibway Indian name meaning "on my way." (*Photograph by Tracy Montgomery*)

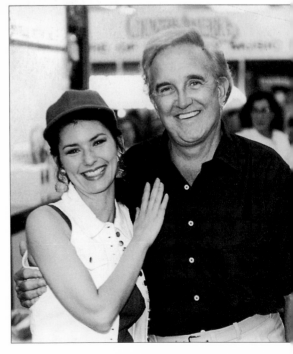

PART 4

*Broadening the Scope
in the 1970s*

‹◆›

Bobby Bare:
Ushering In a Time
of Contrasts

\mathcal{T}HE 1970S STARTED OUT as one of the most volatile
times in modern U.S. history. The country was being
pulled apart over the war and a number of other social issues, from
civil rights to the treatment of Native Americans. It was a time of
contrasts. The decidedly dark *Midnight Cowboy,* with its antihero
theme, won Best Picture at the Academy Awards, while America's
favorite stand-up guy, John Wayne, won Best Actor for *True Grit.*
"Aquarius," by the Fifth Dimension, was one of the year's biggest
hits. Still other pop chart-toppers included the lighter "Sugar Sugar"
from the Archies and "Dizzy" from Tommy Roe. On the country side
of things, Johnny Cash had the biggest song when "Daddy Sang
Bass" stayed at #1 for six weeks, followed by Jack Greene's "Until My
Dreams Come True" and Jerry Lee Lewis's "To Make Love Sweeter
for You." A new car would cost you about $2,500 and a new house
around $40,000. Gas was selling for 36 cents a gallon.

Country music was an established and honorable genre by the
beginning of the 1970s. Artists such as Bobby Bare charted pop as
well as country and brought new attention to Nashville. Waylon,

Willie, and Tompall Glaser were fighting for the same control over their recordings that Bare enjoyed. And Waylon and Willie were also on the brink of making country music as hip as any genre in the United States with their fired-up gritty songs and outlaw images.

We started off the decade with Sonny James, the Country Gentleman, holding the 1970 top chart spot for a grand total of fourteen weeks. Again, a country singer with pop leanings was holding the spotlight, bringing in new fans and enlarging the genre. Sonny had his first country hit in 1953, which illustrates the longevity of artists back then and why it's difficult to include artists in specific time periods.

Lynn Anderson's "Rose Garden" became a monster international pop-country hit that year and won Lynn the Grammy for Best Country Female Performance and ACM Female Vocalist of the Year. Another pop-flavored country artist, Anne Murray, debuted with "Snowbird." NARAS gave Best Country Male Performance to Ray Price's performance of "For the Good Times." The song also won the ACM's Song of the Year. Its writer was a rising star named Kris Kristofferson, who'd only recently quit his day job as a janitor at Columbia studios. The CMA Awards also proved good to the former janitor when Kris's "Sunday Morning Coming Down," performed by Johnny Cash, took home Song of the Year. And in 1971, Kris's "Help Me Make It Through the Night" helped young Sammi Smith bring home a Grammy for Best Country Vocal Performance, Female. Merle Haggard won Entertainer of the Year at both the CMA and ACM awards in 1970, while Marty Robbins won the Grammy Song of the Year award for "My Woman, My Woman, My Wife."

After several up-and-down chart years, Dolly Parton was ready to break wide open as the '70s began. Loretta Lynn, who had firmly established herself as one of country's premier writers in the '60s, became a superstar in the '70s. Chart-wise, Tammy Wynette just about owned the 1970s. Jerry Reed and Charley Pride were hot as fire. And to prove that country was open to comebacks, Freddie Hart, who'd been recording since 1953, made one last recording for Capitol Records, figuring he was as good as dropped, then saw "Easy Lovin' " become one of country's all-time biggest hits. Tanya Tucker and Donna Fargo both debuted in '72.

It's interesting to note that the two biggest media tags associated with the 1970s, the Outlaw Movement and the Urban Cowboy era that started with a 1979 *Esquire* article about Houston's Gilley's Club, were both more media- and marketing-driven than lasting musical directions.

THE CMA AWARDS had been inaugurated in 1967, with the first televised event coming the following year, when NBC-TV taped the show for broadcast on the Kraft Music Hall. Eddy Arnold took home the organization's first Entertainer of the Year award. The taped '68 show found Roy Rogers and Dale Evans hosting and awards going to "Honey" and "Harper Valley PTA." In 1969 Johnny Cash won five awards at the event's first live broadcast. And the first broadcast of the new decade found Merle Haggard the big winner.

In addition to revving up the CMA awards show as a country showcase, the industry got involved in the tourist trade with the beginning of Fan Fair in 1972. Irving Waugh told me that the event was his brainchild, an attempt to bring tourists to town in part for the Opry and the Opryland Theme Park. Irving got the industry involved, including the Johnson sisters, Loudilla, Loretta, and Kay, from Colorado, who ran—and continue to run—the International Fan Club Organization. The first year Fan Fair was held in April, and it was soon decided that June would be a better month because the nation's schools were out then and even more visitors might attend. I don't know why they miscalculated, except that they were trying to get another network television show six months from the October CMA Awards. I do remember how the record companies groaned when presented with this idea at the CMA board meeting. They were already spending a lot of money producing shows for the Deejay Convention, and they didn't want to fork over any more. And that Deejay Convention was another factor in the desire for a spring or summer event. Fans had started showing up in droves to the radio events, and it frequently got in the way of convention events. The CMA figured if they offered a weeklong festival honoring strictly country fans, it would ease that problem. That first year was difficult,

though. We had to offer Fort Campbell soldiers free tickets to fill up all the seats.

I hosted the first Fan Fair All Star Show in '72, and Irving told me if I could convince Marty Robbins to headline the show they'd name the WSM television studio after me. I got Marty, but not the studio name. That day is a good example of how loose the business was back then. Tom T. Hall happened to be signing autographs in the vicinity and stopped by. I asked him if he'd sing a song or two and he said, "Hell, yes!" He sang three or four songs, much to the delight of the audience. Now, of course, most shows are so tightly scripted that would be impossible.

We may, however, be edging back to those days when we have to round up an audience. Attendance has been down at Fan Fair, and country radio ratings have been dropping since 1994. I believe a big part of the problem is that we now have such a proliferation of new artists that fans don't have a chance to get "warm and fuzzy" feelings for a lot of artists—not like they did for a Conway or a Loretta or a Tammy. Some say it's because the music is now aimed at the pop, or "popular," market and is leaving the "real" country fans behind. As I mentioned earlier in this book, I once told Marty Robbins that there were three things you should never debate: politics, religion, and the definition of country music.

Few artists illustrate country music's large umbrella any better than Bobby Bare, definitely a country artist, but one who appreciated pop and country and charted pop early on. Bare belongs equally to the '60s and '70s. He was a vital part of country music's '60s success, but he was also a forerunner in the artist-directed '70s, when people like Waylon wanted the production helm. Bare had control of his productions long before the battle started. Chet Atkins had simply turned it over to him.

Bobby Bare was born in Lawrence County, Ohio, near Ironton, in 1935. Raised on a farm throughout childhood, he moved to Springfield as a teenager, and it was there that he started playing music. He played in bands around the area, and even pitched himself to some record labels in Cincinnati, yet he wouldn't give Nashville a try. "I was about seventeen or eighteen when I first hit Nashville,"

Bare recalls. "Bill Parsons and I came down to the Opry to see Carl Smith and Jimmy Dickens. But I didn't have the nerve to approach anyone in Nashville—that was where all my heroes lived. Los Angeles seemed easier to crack."

Bare was working at Stone's Grill in Portsmouth, Ohio, the year he turned eighteen and got his chance there to see what L.A. had to offer. "It was December and colder than hell," Bare told me in a recent interview. "There was this guy who had been coming in for about a week or so. He drove a beat-up red convertible, with plastic taped over the back window, and he wore a Nudie suit. He kept saying he could get us work in California—that he knew Jimmy Bryant and Speedy West and a lot of important people. The guy's name was Al Warwick. Big Al, we called him. 'I'm leaving tonight,' he told us finally. I collected my pay, about forty dollars, and was ready to head west.

"Bill Parsons was married, so he couldn't go. After Bob Gary, my steel player, paid his bar bill, he was broke, but he came along anyway. By the time we got to Missouri, it dawned on me that I'd bought all the gas we'd put in that convertible. Then it dawned on me why. Big Al was as broke as Bob Gary."

The little band of travelers stopped off in Texhoma and lucked into a gig playing for tips at a local ballroom. That got them enough money to get almost through Texas, and when that money ran out, they started playing honky-tonks in little oil-field towns. They soon found that the oil workers were hungry for country music and they tipped well to show their appreciation.

"By the time we got to California, we each had fifty or sixty bucks in our pockets," Bare recalled. "The only problem was that Big Al had failed to tell us you had to be twenty-one to play in a California club. It took me a while, but I finally found a place where they didn't care. In fact, the Hula Hut was a pretty good deal. I got paid a little salary, got a portion of the profits—which was nothing—and got a place to stay and food to eat. Actually the room and board wasn't part of the music deal. The club had an old lady named Gracie who ran the kitchen and she fed us and let us sleep in her garage. When you consider we'd come from a freezing December in Ohio to sunny

California—I thought I'd died and gone to heaven. A job playing music, a place to stay and food to eat, seventy-degree weather, and the prettiest girls I'd ever seen."

It was there that Bare ran into another young Turk who'd soon turn Nashville on its ear: Harlan Howard. "The Hula Hut was about a mile from a place called Sherry's Barn, where Wynn Stewart worked. I think Wynn and I were the only two guys in southern California who were playing Grand Ole Opry–style country music. California was Bob Wills crazy back then. Wynn was one of the great ones. I ended up staying at his house for a while, and so did Harlan Howard. Wynn's mom wanted to kick Harlan out. He always got up real early in the morning and spilled sugar all over the counter and the floor when he fixed his coffee. Carl Belew was also staying there."

In 1956 Bare got a shot to record for a major label. "Wynn was on Capitol and had two or three hits with Ralph Mooney on steel. Big Al with the red convertible had actually come through and introduced me to Speedy West when we first got out there, and Speedy had been promoting me to Ken Nelson at Capitol. So I had a couple of things going for me. The first thing I recorded was a Buck Owens cover, 'Down on the Corner of Love,' which he'd recorded for Pep Records. Pep was part of the L.A.-based Pamper Music, and Hank Cochran was their song plugger."

Bare also recorded briefly for Challenge, but Los Angeles wasn't where he would find his musical niche. That came about through a string of wrongly credited songs and mislabeled releases.

One night Wynn and Bare came home from honky-tonking and decided to write a song. "It was about the time 'Heartbreak Hotel' was big and we decided to write a rock and roll song," Bare says. "Carl had been working on a rock song that was basically a rip-off of 'Heartbreak Hotel' and Wynn and I didn't want to work on it. Harlan wasn't having anything to do with writing rock and roll, so he didn't want in on ours."

That night Bobby Bare and Wynn Stewart sat down and wrote "Lonely Street." The next day they went to Pasadena and cut the demo, with Carl singing. Wynn's band played on the recording. Bare played bass. All of a sudden it was being played on the radio with the

following people listed as writers: Carl Belew, Kenny Sowder, and W. S. Stevenson. I asked Bare if he and Wynn ever got credit for "Lonely Street."

"No," he said wryly. "But if you'll notice, I got the melody from 'Satisfied Mind.'"

The California scene was rife with talented writers and Bare got to know most of them. Tommy Collins was there, the guy Merle Haggard would later write "Leonard" about. He was famous in the industry for his suggestive songs like "You've Got to Have a License" and "You Better Do That." Bare often went to Town Hall Party to see Tommy perform his songs. He recalls the time he and Willie Nelson, both with no vehicles, had to walk to the Red Barn in Orange County to hear Roger Miller play.

"The first time I heard Willie sing I knew he was a star," Bare says. "Hank Cochran took me to a demo session that Pamper Music was doing on Willie and I fell in love with his music immediately. I thought he was the greatest thing I'd ever heard.

"A lot of my musical heroes were in Nashville, but L.A. had plenty of them, too, and I went to see them perform as much as possible: Lefty, Freddie Hart, Joe Maphis, Tex Ritter. It bothered me to see Lefty Frizzell playing those little joints out there. He should have had better."

In fact, Lefty's life had started downhill long before Bare started going to see him in L.A. in the mid-1950s. In 1951 Lefty was arrested after an Opry performance for contributing to the delinquency of a minor while on tour with Hank Williams in Arkansas. He wasn't prosecuted for the offense, but by 1953 Lefty was no longer having radio hits. He ended up in Los Angeles working as a regular on Town Hall Party. Los Angeles welcomed Lefty: He was presented with a star in the Hollywood Walk of Fame and became the first country artist to play a concert at the Hollywood Bowl. But the hits had dried up, and between '55 and '58 he had nothing in the charts and was playing the little honky-tonks where Bare and other performers gathered to offer him encouragement. Lefty did have a brief comeback in 1959 with "Long Black Veil" and another in 1964 with "Saginaw, Michigan."

Bare ended up with another name on his song "All American Boy," too. It was in 1958 and Bare had just been drafted. He was home in Ohio awaiting orders and hanging out with his old friend Bill Parsons, who was just out of the military.

"We got this old boy who owned a nightclub back in Wellston to pay for studio time, got a band from Dayton, and headed to Cincinnati to record. I'd been working on a talking blues song called 'All American Boy,' so I hopped up there, did four or five takes, and put it down at that same session. I told Bill if he got a record deal he ought to record it. After the session we went back to Dayton, where my sister lived, and hit the Bottoms Up beer joint. So while we're in Dayton drinking beer, the old boy who wrote the check for the studio time decided he needed another copy of the session, an acetate. The studio couldn't make one so he went over to Fraternity Records to see if Harry Carlson would make him a copy. Harry took one listen and loved the stuff.

" 'Who is that?' Harry asked.

" 'Bill Parsons,' the guy answered. Now of course that was true on the song 'Rubber Dolly'—but it was me on 'All American Boy.'

" 'I'll give you five hundred dollars to put that out,' Harry said.

"So our 'backer' ran to the phone and called Bill and me at the Bottoms Up.

" 'Fraternity Records will put this out and pay us five hundred dollars,' he said. I'd never heard of them, but I told him to take the money. Of course, before he could leave Cincinnati he had to take our money over to the studio and pay them for the time since the check he'd issued them was rubber. He got back to Dayton and gave us fifty bucks apiece. I went in the army and forgot all about it. Then, a few weeks later, 'All American Boy' was a smash! Bill called me up and said he was scared to death! They'd put it out under his name, without him knowing it, and now he was supposed to go out and promote the record!

" 'They want me to go on tour!' he said. 'They want me to do *Dick Clark!*'

" 'Well, you better do it,' I said. 'I can't get out of the army and do anything.'

Bobby Bare's talking-blues record credited to his friend Bill Parsons hit #2 nationally, and by the time Bobby had finished his army stint, everyone know who the real singer/songwriter was on "All American Boy." Bare had agreed to record some sides for Fraternity Records in Cincinnati, including a rock 'n' roll song he wrote titled "Book of Love" (not to be confused with the Monotones' release). The single got Bare a spot on the *Dick Clark Show*, and considerable attention in the industry. While he still didn't move to Nashville, Bare got publisher/song plugger Troy Martin to represent his songs in Music City. One day in 1962 Troy stopped by Chet Atkins's office. Chet, who had been running RCA since 1957, was impressed with the songs and the singer.

"Chet wants to meet you," Troy said in a phone call to Bare. Bare and Chet forged a long-term friendship at their very first meeting.

"Come back next week and we'll have the contracts waiting for you," Chet said.

Bare had some loose ends to tie up. For one thing, although he wasn't under contract, he was still recording for Fraternity Records and had become close friends with owners Harry and Louise Carlson. "I went to Cincinnati and talked to Harry," Bare recalls. "And he was supportive of my decision to record for RCA and happy that Chet would produce my records."

The first recording Bare made with Chet was a Bill Enis/Lawton Williams song titled "Shame on Me." The song had a recitation on it, and when Chet heard how strong Bare came across with a recitation, it set something of a trend. Not only did Chet and Bare look for recitations, and in at least one case, add them to a song, but songwriters began to tailor their material to suit Bare. Curly Putnam wrote "Green, Green Grass of Home" for Bobby, but since Bare had a three-week European tour coming up, he gave the song to his friend Johnny Darrell. (In 1965 Porter Wagoner would have a country #4 hit with "Green, Green Grass of Home," and in '67 Tom Jones would weigh in with a #11 pop hit.)

In 1962 "Shame on Me" made it to #16 in the *Billboard* country charts and #23 in the pop charts. It was followed by another song with a recitation, "Detroit City," which got to #6 in country and #16

in pop. In 1963 "500 Miles away from Home" was a #5 country hit and a top-10 in pop. "Miller's Cave," into which Bare himself inserted a recitation, became a #4 country record and a top-40 pop hit. Clearly, at a time when rock was so powerful and men like Chet Atkins and Owen Bradley had been given orders from New York to appeal to a broader audience, Bobby Bare was a gold mine. To illustrate the point, consider this: "Shame on Me" only made it to #16 in country, yet the pop airplay propelled sales to over a million. And with each release that charted pop, the sales grew. You could bet on it, and labels love those odds. Chet came to understand that Bare knew his music and his way around a studio to such an extent that Chet did the unthinkable in those days. He allowed Bare to produce his own records. That was the beginning of the so-called Outlaw Movement of the 1970s. There were no guns drawn and no shots fired. Just Chet Atkins putting his trust in Bobby Bare. The media just didn't know it.

Bare made the move to Nashville in late 1964. By that time he'd married Jeannie and they had decided they wanted to raise their family in Tennessee. But there was also the Music City magic factor. "The thing I remember about Nashville in the early '60s is the buzz you felt the minute you got off the plane," Bare says. "There was so much creative talent here that it felt electric. I sometimes think that once you move here you start to take that talent and energy for granted."

I don't think Bare ever took it for granted, though. Waylon calls him a "songhound," a man who can spot a hit song the first time he hears it. He can also spot genius. I asked him to elaborate on his initial thoughts about Willie's talent as well as some other country legends. I wondered if Bare could teach us all how to be "songhounds."

"I'm afraid it's something you can't describe," he admitted. "Every time I've heard a song that *really* turned my head around, it turned out to be a hit. I don't think I've ever felt really strong about a song but what something didn't happen to it."

I reminded him that he told me his first impression of Willie Nelson was that he was a star. A lot of people thought Willie was a great songwriter. But not everybody saw his star quality right away.

"In the case of an artist like Willie, it's a combination of everything. People aren't buying into Willie's songs alone, and not into the way he looks or the way he sings. It's the whole package. When they buy a record, they are buying Willie Nelson, the sum total. Then you look at songs that, for example, a Tom T. Hall writes. He writes about people I knew and know. People I grew up with. That honesty combined with his brilliance in putting the words together makes a whole song package. And of course, if he sings them himself, that's another part of the package. 'The Homecoming' is probably one of the finest songs ever written. 'The Ballad of Forty Dollars' is a classic, as is '(Margie's at) the Lincoln Park Inn.' Then of course you get to Shel Silverstein, who picked up where everybody else left off. He was a brilliant man in a different time zone. And a good, good friend. I won't live long enough to get over losing Shel."

Since Bare is credited with finding Waylon Jennings, I asked him to put Waylon in this mix.

"Waylon had already recorded 'Just to Satisfy You' and 'Four Strong Winds' on the fledgling A&M Records that Herb Alpert was trying to get off the ground. I brought it to Chet and we recorded both songs, then sat around talking about how great that singer was. Then I went to Phoenix for a show at McGoo's and Waylon got onstage and did 'Four Strong Winds' with me. We ended up going to dinner and we hung out some, and I stayed over to go to J.D.'s, where he played. It was a big place and he had a packed house.

"The show totally blew me away. Waylon had this little stripped-down band, just a bass, guitar, and drums. He was tall and skinny and good-looking and charismatic. And maybe just as important—he had an element of danger about him. Elvis had that same thing and so did Cash—they had a threatening sort of energy. I called Chet and told him I had a star for him and he ended up signing Waylon over the phone.

"Waylon came to visit me in Nashville, and to help pay for his plane tickets, he played on some sessions. In fact, that's Waylon on 'Streets of Baltimore.'

"Like Willie, with Waylon you get the whole package."

As Bare talked I was reminded of an interview I did with Waylon

in 1998, when his new autobiography was published. One of the things Waylon and I talked about was Buddy Holly, a man Waylon says was one of the most "happy" people he ever met. Of course, the story about how Waylon gave up a seat on that fated last flight when the Big Bopper was sick is well known. But many didn't know that Buddy was the person who first inspired the "outlaw" tendencies of Waylon that came to symbolize the '70s. "Buddy came to Nashville and hooked up with the wrong musicians and the wrong producer," Waylon mused, referring to Buddy's attempt to record with Nashville's A team and Owen Bradley. "It was nothing against those men, either. They were just wrong for what he was trying to do. It took me a long time to realize that his talking about finding his own sound had influenced me as much as it did."

Since this book started with lengthy chapters on Hank Williams, I feel compelled to share a story about a pair of boots Hank Jr. gave Waylon. It seems that Hank knew Waylon idolized Hank Sr. and wanted to give him something personal that had been his father's. So he presented Waylon with a pair of Hank's boots. The next time Hank Jr. saw Waylon he asked him if the boots fit.

"How'd you know I'd try them on?" Waylon asked.

Hank Jr. just smiled and asked again: "Did they fit?"

They did, as a matter of fact, but Waylon eventually thought twice about wearing them. "I'd started putting them on every so often," he recalled. "And one rainy night I wore them to the recording studio. Suddenly someone ran in and said, 'Waylon! You got to go look at your new Cadillac!' I ran out in the rain and there was a huge tree lying on my car! I wondered if someone was trying to tell me I didn't fit the boots just yet, especially when we finally got the tree pulled off. There wasn't a scratch on the car."

I don't know if Hank Williams had anything to do with that tree falling on Waylon's Cadillac, but I do know that Waylon Jennings could wear almost anyone's boots. I admire his independence, his candor, and his music. And while I admire his courage in kicking the drug habit that could have killed him, it's possible that I admire his courage in going back to school and getting his GED even more. He's spoken about it often, how he realized the importance of having

a high school diploma, and the importance of making his action public as an example for kids who either quit school or were contemplating doing it. I don't know if Waylon knows this, but one of the people he inspired is another country star of legend, Miss Tanya Tucker. When she heard about Waylon and his GED, she began thinking seriously about doing the same thing. In fact, since she's been helping her daughter Presley with homework, she says she just might try to graduate from high school with her in a few years.

Waylon told me he questioned the concept of "the outlaws" for two reasons. First, he felt the music might get confused with the rock group by that name, and second, he was gun-shy about tags and labels. But, he laughed, ". . . it worked."

I guess the question is: How could it not work, with a couple of guys like Waylon Jennings and Willie Nelson at its helm? As Bare said, they represent the whole package.

Since we were talking about star power, I decided to ask Bare what he thought of the business today, what of the new, young stars and the new music. It's easy and tempting for people who've been around a while to simply dismiss today's music and today's stars as less than those of country's Golden Age. I was interested in what a man like Bobby Bare would say. Bare smiled when I asked the question.

"We can piss and moan and whine all we want to, you know? Those of us who are artists in our sixties now can sit around and say it's all going to hell in a handbasket. But that's the way it's always been. Younger people have always controlled the market, because they've got the energy. And that's the way it should be. I'm sure when I was coming up in my twenties, Ernest Tubb and Roy Acuff were saying, 'Damn! That ain't country! What's he doing putting horns and strings in there?' I know for a fact that kind of thing was going on. The only thing that worries me these days is that I don't hear easily identifiable voices on the radio. That could change, though. I blame it on record labels because they get a call from New York or Los Angeles and tell Nashville to get them another so-and-so. If something is working, try to duplicate it. That's been a problem in the industry for a long time though. They were out there scouring

the streets for another Johnny Cash, too. Every time you start to criticize the way things are today you have to look back and see if it's really anything new.

"I'm reminded of a conversation I had with Shel Silverstein one time. I said, 'Shel, there ain't nothing these days but these guys with tight asses.' Shel said: 'Stop whining, Bare. When you were in your twenties, you all had tight asses.' "

Kudos to Kris

WILLIAM BLAKE IS one of Kris Kristofferson's favorite literary figures, and it's interesting that one of Blake's most famous lines is "to see a world in a grain of sand." One could almost relate that concept to Kris's songwriting, because his lyrics certainly contain microcosms of the realities in this world. Yet Kris would tell you he doesn't like to analyze his or anyone else's songs.

"I think it's a little artificial," he told me during a 1972 interview. "It's like when college reporters ask me what I *really* meant in 'Help Me Make It Through the Night.' They seem to think it's about drugs or religion. To me the meaning is pretty obvious. It's exactly what it sounds like."

There's another thing Kris doesn't really care to dwell on and that is his amazing life story, especially his history as a Rhodes scholar. "A lot of interviewers want to talk about my time at Oxford," Kris reflected. "In fact, it seems to make people dwell on the past more than the present or the future."

Still, even Kris's best friends were in awe of his knowledge and education. Mickey Newbury, one of country music's finest writers, had this to say about Kris back in the early '70s: "Kris is an exception. You can't put him into any category. For one thing, he's a

highly educated man. You don't just jump out and get to be a Rhodes scholar! It takes work and it takes smarts."

I speculated that possibly those people found it ironic that a Rhodes scholar gave up a career at West Point to move to Nashville, place himself in poverty conditions, and write country songs. Most country artists and writers came from the opposite circumstances. Kris thought that one over and answered: "I was listening to country music long before I was a Rhodes scholar."

He was certainly born in the right place to listen to country music: Brownsville, Texas. And while his childhood hero was fighter Rocky Graziano, he had a second love: Hank Williams singing "Lovesick Blues" on the Grand Ole Opry. Kris once told me that one of the biggest disappointments of his early life was that he never could learn to yodel. His father was a career military man, a three-star general, so the family moved around a great deal, and by the time Kris was ready to start college he was in California. He enrolled in Pomona College in Clairmont, California, studied creative writing, and was a standout in both academics and football. That record helped him win the prestigious Rhodes scholarship, founded with a trust from financier/statesman Cecil Rhodes and based on both athletics and grades. Back then Kris hoped to be a novelist.

Out of college and at loose ends in the early 1960s, Kris signed up for the military and went through ranger school, parachute jump school, and pilot training. He became an expert helicopter pilot, a skill that would one day keep his rent paid in Nashville and allow him to make one of the more spectacular song pitches in country music history by landing a chopper in Johnny Cash's yard to give him "Sunday Morning Coming Down." According to Kris, his time in the military wasn't particularly happy even though by most standards he was very successful. He drank heavily, crashed motorcycles, and, according to him, never got in a very positive frame of mind. Perhaps that's why, even though he was considering a career as an English literature teacher at West Point, he was playing in a country band and trying to get his songs to Nashville.

"I knew a guy who was related to songwriter Marijohn Wilkin," Kris reflected. "I gave the guy a tape and he sent it to her in

Nashville. I waited and waited to hear what she thought of my songs. It seemed like it took forever and I had about given up. Then right before I left the army, she wrote to this guy. Down at the very bottom of the letter it said, 'If Kris ever gets to Nashville, tell him to call me or drop by.' That was all it took. As soon as I got out of the army in 1965 I was on my way to Nashville."

Once here, Kris moved into a fifty-dollar-a-month apartment and made the rounds without much luck. Marijohn thought he had potential, but nothing happened for him right away. He took the janitor job that writer/artist Billy Swan was just leaving at Columbia Records Studios, hoping to make more contacts in the business. As Kris says, the job didn't directly result in any cuts, but it certainly helped him become known among artists and musicians.

He took a second job working at the Tally Ho Tavern on Record Row. "Sixty dollars a week and all the beer and barbecue I wanted," Kris says, laughing. There were some people who knew Kris was a great writer from the first time they ever heard one of his songs. One was Roger Miller and another was Bobby Bare. But like most new writers in town, Kris took a lot of criticism for his songs and had negative input from a number of others. Instead of letting it beat him, it prompted him to write "To Beat the Devil." In the song he talks about the feelings so many songwriters have: ". . . with a stomnach full of empty and a pocket full of dreams."

But Kris added a little twist to this tune when in the lyrics he speaks of beating the devil, and stealing his song. I asked him what that meant. "The 'devil' is anybody who makes you doubt yourself and your abilities," he said. "And the way to beat him is to take whatever he's saying that's negative and make it work for you instead of against you." Those are good thoughts to remember for any new writer in town. And "To Beat the Devil" is one of the songs I always point to as an example of Kris's talent, the genius found in songs that never were big commercial hits but are classics anyway.

I know from personal experience that Marijohn tried to help Kris, because she attempted to pitch one of his songs to me. She phoned and left a message asking me to call her back, but as usual I was busy at the time doing two or three things and put it off for two

or three days. When I finally got around to it, Marijohn said she'd found what she thought would be a good song for me. It was a recitation called "Vietnam Blues" by a young guy named Kris Kristofferson. I was too late, though. Marijohn had already given it to a deejay friend of mine named Jack Sanders. He had a great radio career going in Louisville during the '50s and '60s, then he moved to Nashville and did some recitation recording from time to time. Jack's version never did get into the national charts, but it caught the attention of Dave Dudley, who took it to #2 in 1966.

"Vietnam Blues" was one of the few songs Kris wrote throughout the '60s and '70s that could be considered a current events song. "I don't usually like them," he told me in 1972. "The events that made it current are awfully fleeting." He later wrote more political material, in the 1980s with his Mercury album *Repossessed*. But early on, "Vietnam Blues" was one of his rare ventures into the front pages.

"That was the first song I got recorded," Kris recalled in an interview with me in 1980. "I wrote it when I was getting out of the army in '65 and flying space available. I got bumped in Washington, D.C., and there was a rally of some kind going on in the terminal. The war hadn't really escalated like it would in the next few years, but I had some friends on their way over to fly helicopters, and I was worried about them. One guy came up to me and asked if I'd sign a petition sending encouragement. I almost signed it, thinking it was for the servicemen. But then this guy said it was to send to Ho Chi Minh. I was shocked. I'd heard about the widows of some pilots getting harassed, and I hated it. It had nothing to do with how I felt about the war. It had to do with the fact that I'd spent four years with these men and I was concerned about them coming back alive. I wrote 'Vietnam Blues' that day."

I did record one of Kris's songs, though. It was a song titled "Late Night Morning Sidewalk," and I've always felt like it was the precursor to "Sunday Morning Coming Down." I cut the song when I was on ABC Paramount recording with Fred Carter Jr. We even did a photo shoot that portrayed me in a trench coat on an empty, lonely street. Later, when Kris wrote "Sunday Morning Coming Down," it brought to mind for me Record Row on a Christmas morning. What

would be lonelier than to be a songwriter, too broke to go home, walking along Record Row on a deserted Christmas morning?

Kris did know what it meant to be lonely here in Music City. His parents didn't support his decision to come here. They hated the thought of their college-educated, Rhodes scholar son writing hillbilly songs and associating with people in this business. As Kris told me, they hadn't a clue what Nashville was all about. When they finally did meet people like Johnny Cash and June Carter, they realized how wrong they had been. It probably didn't hurt when Kris was featured on the cover of *Look* magazine in 1971 with the headline reading: "Hillbilly No More: Country Music Sweeps the U.S.A."

Kris addressed the misperceptions about country music in that issue of *Look*. "I can remember when 'country' was a dirty word. It was raw, honest emotion and that was too strong for people. But now they're looking for honest expressions. They identify with country because it's up front and no bull."

Ultimately, Kris received a letter from his father apologizing and admitting what a mistake he'd made. "No one could have kept me from being a pilot," Kris's father wrote. But in those early days, Kris had very little outside support.

Fred Foster at Monument Records finally heard Kris's songs and signed him to a writing and recording contract. Most country music fans have heard the story of how, in 1969, Fred gave Kris the idea for "Me and Bobbie McGee." The name, of course, was really Bobbie McKee, a secretary in the building. The story went that Kris misunderstood Fred's pronunciation. In 1972 Kris told me that he'd had a lot of women write him letters and ask if she was the Bobbie in the song, including one Bobbie McGee who said Kris had ruined her life! "People come out of the woodwork to ask me about that song and they want to know when I was out hitching rides with Kris Kristofferson!" she complained. The reason Kris misunderstood the name is that he was dead drunk when Fred called.

Kris told me that when we talked in 1980. He was in town to film a tribute to Hank Williams with Brenda Lee, Jerry Lee Lewis, and Ray Price. At that time he'd been on the wagon for three years. "*A Star Is Born* was a prophetic movie for me," Kris said. "Drinking got

to be a big problem. I couldn't go onstage without a lot of whiskey. At the time I quit, I'd finish a bottle of Jack Daniel's before I even walked on a stage. And I was drinking a lot while we made that movie, too. They had my dressing room stocked with tequila." I asked Kris what changed the tide for him and he didn't hesitate. "My daughter Casey," he said. "I wanted to watch my little girl grow up. Plus, I watched an interview I did with Geraldo. I was very drunk and I was embarrassed by it."

I know that a lot of stars use liquor to fight stage fright, and I asked Kris if he was ever fearful before he walked out onstage. "Aren't you?" he asked, eyes widening. "I'm still scared. But I watched Johnny Cash once and realized he was nervous just before he went onstage. I thought, 'Well, if Cash never got over it, nobody's gonna.' I am more afraid of walking on stage than I am of anything, you name it—snakes, heights, death."

Since Kris had mentioned A Star Is Born, I decided to ask him a question I'm sure he got all the time: What was working with Barbra Streisand like? Kris hesitated.

"She's tough and she's a perfectionist," he said. "We had some tense times. But I owe her a great debt because I learned so much about acting in that film. And there were times when Barbra came through like a trooper. During one scene she was supposed to roll around in the mud, which she did. But when she got up she had a funny look on her face and yelled at the director, 'Frank! This mud smells like dogshit!' And it did. It smelled like a bucket of manure. They told her it was just some chemical they had to add to it, but that didn't make it any more bearable and she started to complain again. Frank put his hand up and said, 'I don't even want to know about it.' All of a sudden she started laughing and she couldn't stop. She could have easily thrown a tantrum and walked off the set.

"There was another time she showed what a professional she is, and it had to do with me. I was supposed to walk in and sit down with her at the piano, then stand up smoothly with her in my arms and carry her over to a pile of cushions. Have you ever tried to stand up and lift someone off a piano bench at the same time? I picked her up, staggered a little, swung her around, and her feet knocked every-

thing off the top of the piano. Then when I took a step, I got caught in the lighting cables. Nobody yelled 'Cut' so I kept going. I could hear light after light falling behind me, popping as they hit the floor, one right after the other. Finally I got to the cushions and just dropped her in a heap. It was then that I realized the director was laughing so hard he couldn't say 'Cut.' And Barbra was down on the cushions laughing, too. She was a good sport about the whole thing."

The movies made Kris a larger-than-life star and brought more recognition to country music. But on a personal note, Kris has, on a couple of levels, never been quite comfortable with his fame. The first and biggest problem is a lack of privacy.

"After *A Star Is Born* was out, I went to hear Billy Joe Shaver play a show. I hadn't heard him in years and he's a favorite. But after the first song I couldn't hear anything because people were grabbing me and asking for autographs. One woman jerked on my beard and asked me if it was real! I'd never been through anything like it. I'll tell you the truth, Ralph, I felt like a public toilet where people were writing on the walls. I just can't shine it on like Willie can. Willie and Muhammad Ali are two naturals when it comes to crowds. They can stand and sign autographs and talk to strangers all day long. It puts me under the table."

Then there was a misperception about his career direction: People saw him in movies and figured he had abandoned music. "I play music whenever I'm not making movies," he told me. "Sometimes on the weekends when I *am* filming. And I'm still writing songs."

I asked Kris if he had any favorite cuts of his songs. "I'm still enough of a Nashville songwriter that it knocks me out that anybody cut my songs in the first place," he said.

I pressed him a bit and he gave what I thought was a perfect and well-thought-out answer. "There are a lot of specific cuts that I could call favorites for a variety of reasons," he said. "Johnny Cash's recording of 'Sunday Morning Coming Down' was a big award winner and changed a lot of things for me. But Ray Stevens's version is special, too, because he went to so much trouble in the studio to make the music perfect. I don't think anybody has ever put that much of an effort into one of my songs. Then you have Jerry Lee

Lewis's cut of 'Once More with Feeling.' That was a huge surprise to me. He took a song that I thought was just 'all right' and made it into a hit recording. I don't think I understood before how an artist could do that. And Waylon made 'The Taker' better than it started out when he took it from three/four time to four/four time. I had no idea 'For the Good Times' was a hit until I heard Ray Price sing it. George Jones singing 'Why Me' knocks me out. I could probably go on all day if I started thinking about it."

When Bobby Bare and I gathered some of the great stars of country music together in 1999 to talk about this wonderful music's history, Kris talked about his song "Why Me." I thought it was a powerful story, especially since it's not like Kris to talk about his personal struggles.

"Connie Smith and I had played a benefit for Dottie West's high school band in Cookeville, Tennessee, and Connie invited me to attend Jimmy Snow's church the next day," Kris said. "I didn't often attend church in those days. But I sat there listening to Larry Gatlin singing 'Help Me' and something powerful came over me. The song had a profound effect. A little later Reverend Snow had everyone kneel and he said 'Anyone who is lost, please raise your hand.' That was something that would be out of the question for me! I would never raise my hand in front of all those people. But all of a sudden I felt my hand raising in spite of myself. I hoped no one was looking, because I couldn't seem to pull my hand down. Then Reverend Snow said: 'All who are ready to accept Christ as their savior, come to the front of the church.' That, too, was out of the question. But I felt myself standing up and walking to the front of the church. I honestly don't remember much of what happened then, as far as what Reverend Snow said or anything like that. All I remember was that a great feeling of peace and forgiveness came over me. I felt forgiveness I didn't even know I needed! I went home and wrote 'Why Me.' "

I asked Kris if he had any idea that song would be one of his biggest. "No," he answered. "I went in to record the album *Jesus Was a Capricorn* and we recorded 'Why Me.' Larry Gatlin came in and

sang on it. I didn't even know it would be a single." It not only was a single, it was Kris's first #1 and a pop hit as well.

As I mentioned before, during that earlier interview Kris was in town to film a tribute to Hank Williams. But while he was here in Nashville he also went over to Pete Drake's studio and recorded with Ernest Tubb. Kris told me he still couldn't get over it, the idea that he was standing there in a studio with Ernest Tubb. For all the accolades, the songwriting royalties, the respect of men like Roger Miller, Bobby Bare, Willie Nelson, and Johnny Cash, Kris Kristofferson still doesn't get it. "I still have the feeling that one day someone will shake me awake and tell me the floors at the Columbia studio need cleaning and the ashtrays are full," he said.

The Storyteller:
Tom T. Hall

*L*IKE KRIS, Tom T. Hall greatly expanded the possibilities of country songwriting, making the concept of a song being a "three-minute movie" into a reality. If there is a better example of the art of the song meeting the art of the short story, I don't know about it.

There is something that sets Tom apart from much of Nashville. Maybe it's his lack of interest in all that is "celebrity" or maybe it's his perceptive nature. It's always interested me that Tanya Tucker says Tom was her idea of a "real star" when she toured with him in the early 1970s. He impressed her with his stature, his lack of pretension, and his formidable intelligence. She says she instinctively knew that she could learn from this man. Many people have felt that same impact over the years, for Tom is a thoughtful man and one of the most intensely creative people I know. In addition to being one of the most *interesting* guys I know, he's also one of the most *interested*. He's vitally absorbed in furthering his education, expanding his knowledge. Each year he takes some time off and hires a tutor in some subject: history, a foreign language, literature. In recent years

Tom has taken correspondence school classes to become a recording engineer. He's built a fine studio at his farm and has begun recording his own as well as others' music. He told me that learning about new recording techniques had taught him one important thing: You can now make a perfect record. "The problem with that," Tom said, "is that people who make bad records can now make perfect bad records. You used to be able to tell the difference."

A lot of Nashville songwriters and artists will tell you they ran into more than a few sharks once they hit town. But Tom T. Hall has a story that will best them—he was discovered by a crook. Not just a run-of-the-mill Record Row shark or weasel, either, but a real wanted-by-the-FBI crook.

Tom was working as a deejay at WRON in Ronceverte, West Virginia, in the mid-1960s, and trying his hand at songwriting. Here's how Tom tells it:

"I was writing radio copy when this fellow came in and said he was promoting Stonewall Jackson's 'Don't Be Angry.' I told him the song was already a hit, so I didn't know why he was promoting it. 'I wrote the song,' he replied. Then he noticed my guitar propped against the desk and asked me if I wrote songs. At his request I sang a few of them. He seemed impressed and told me if I'd put them on tape he'd take them to Nashville to Jimmy Key. Jimmy was a publisher and an agent and I knew he could help me, so I recorded some guitar/vocals and gave them to the man. It wasn't long before I got a call from Jimmy Key, who asked: 'Did this fellow help you write these songs?' I'd written them alone and told Jimmy so.

" 'I didn't think he had anything to do with them,' Jimmy said, then added, 'Now that we've cleared that up, you might want to stay away from this guy because he's wanted by the FBI.'

" 'Really? What'd he do?'

" 'Well, for one thing, he's been cashing the royalty checks for "Don't Be Angry," which is an Acuff-Rose song written by Wade Jackson.'

"I didn't know how he was managing this, but I did know it would involve fraud charges. I didn't want anything to do with the whole mess. Jimmy told me he'd send me some contracts for the

songs he'd heard, and asked me to send him some more. So I was busy writing songs and making demo tapes for Jimmy Key when the FBI showed up one day. The agent gave me a card and told me to call him the minute this Wade Jackson impersonator showed up. I probably shouldn't tell the next part because I don't know how long the statute of limitations lasts for not reporting a crook's whereabouts to the FBI, but the next time the guy came through I tipped him off. I didn't know exactly what was going on, and didn't want anyone's arrest on my head. He left and they caught up with him without my help. And that's a roundabout way of telling you that I was discovered by a fugitive from the feds."

Tom was still sending his songs to Jimmy Key when he decided to attend Roanoke College to study literature and writing.

"My life's ambition had been to write," Tom says. "I wanted to be a journalist, or write the Great American Novel. I loved songwriting, but I never set out to do that for a living, and I certainly didn't set out to be an entertainer."

It took years for Tom to see the error of his thinking. After he'd had great success as a songwriter, Tom started writing books. In his home Tom has a book royalty check framed. The check is for one penny, and underneath it he has written a reminder to himself: "It's the music, stupid." Still, when guys from the 1960s and 1970s look at today's business, they are shocked at the difference in financial rewards. Tom told me that 1974 was his single biggest year money-wise, yet he happened to notice the concert grosses in *Billboard* last year and realized that Reba McEntire took in more at one concert than he'd made in his most lucrative twelve-month period!

Tom moved to Nashville in 1964, married Dixie Dean, a songwriter and then-editor of *Music City News*. Tom tells a particularly funny story about the first time he ever saw Dixie. "We met at the BMI Awards, where Miss Dixie was getting an award for 'Truck-Driving Son of a Gun,' and I was getting an award for something. My version of what happened is this: I saw this charming lady with a British accent, a talented songwriter and journalist, who also happened to be wearing a load of diamonds and furs. I thought, 'Now

here is a well-to-do Englishwoman with great writing skills! The woman of my dreams.' Then about a year later I married her and learned that she'd borrowed all that stuff from her friend June Carter! We got married and found out that we were both broke. That was a little over thirty years ago."

Dave Dudley and some others had recorded Tom's songs, but Tom hadn't yet had his big breakthrough with "Harper Valley P.T.A.," or started his own recording career. One day the head guy at Mercury Records, producer and legendary guitarist Jerry Kennedy, came to Tom and said, "I love your songs but I've been pitching them to a lot of people and they don't want to record them because they seem too personal. They say they're good, but they are stories. *Your* stories."

"There was a time in Nashville when artists did things with a certain projection, in a certain style," Tom reflects. "The audience heard it and believed it was a part of them. You heard Marty Robbins do those cowboy songs, and Marty became a cowboy. Others might not have got away with some of the songs he recorded. They wouldn't have been believable. Many of my songs were difficult to fit with anyone else's image. Not all of course, but some.

"I wasn't writing what we used to call 'Little Darlin' ' songs— '. . . you broke my heart and left me all alone' songs. I just wasn't very good at that. Oh, I could write 'em, but they didn't sound real to me. Mine were more autobiographical. That, I believe, was left over from my prose writing and my love for Hemingway, Flannery O'Connor, and the other great short story writers. When Kennedy asked me if I wanted to record some of them myself, I hesitated. I really didn't see myself as an entertainer, and I was starting to make a little money with the songs that were being cut. But then Kennedy said something that changed everything. 'Well, Tom, if you don't record some of these, they are never going to be heard.' I went in the studio with Jerry and recorded. What I never counted on was that it would be anything but a songwriter album. I never pictured Mercury releasing a single. But one day I got a call from a guy in Louisiana who said 'I Wash My Face in the Morning Dew' was a hit down there and would I come play a thirty-minute show for five hundred dollars.

236 OF MY COUNTRY

I liked the sound of that, so I got in my car and drove to Louisiana to play my first show. The backup band was six children playing little plastic Roy Rogers and Gene Autry guitars. We might have been the first punk country band."

Tom played the songs from his album, plus some of the songs he'd recorded by Dave Dudley and Jimmy C. Newman, so there was enough to make an interesting half-hour show. And the five hundred dollars seemed like easy money, so Tom hired a bass player and a guitar picker to go out and play some more dates. They started out with a Cadillac and a U-Haul. That ended abruptly when Tom heard a Texas deejay announce on the radio: "Here's a song by Tom T. Hall and the U-Hauls." He went out and bought Loretta Lynn's bus, which promptly broke down. "Mooney Lynn didn't want to pay for having it repaired," Tom said, laughing. "But Loretta made him do it."

Tom's breakthrough came when Mercury released "The Ballad of Forty Dollars" in November 1968, and it went to #4. "Homecoming," released in August 1969, hit #5, and in 1970, "A Week in a County Jail" became his first #1. As I mentioned earlier, Bobby Bare told me he thinks "Homecoming" is Tom's greatest song, and that includes a long list of great songs. Tom says it takes him back to when he started out, and his father couldn't quite grasp this show business concept. He simply could not understand that people made a living writing songs. Tom said: "We were a very practical family. One brother was a civil engineer, another was an engineer at the telephone company, and another was a schoolteacher. My father lived long enough to see my success, and he finally understood what I did for a living. But it took him a while to grasp it."

Jimmy Key is the fellow who gave Tom the "T" initial in his name—just like he put the "C" in Jeannie C. Riley. In Jeannie's case, she did have a middle name, Carolyn, but in Tom's case, the "T" was pulled out of a hat because he had no middle name. And speaking of Jeannie, while Tom was trying to heat up his own record career, Shelby Singleton, over at Plantation Records, was setting Tom's songwriting career on fire. In August 1968 Shelby cut Tom's "Harper Valley P.T.A." on a young woman named Jeannie Carolyn

Riley. Jeannie changed the gender of the song when she sang "the day *my* mama socked it to the Harper Valley P.T.A." Tom never meant it to be anything but third person.

Shelby was so convinced that "Harper Valley" was a monster record he released it immediately. And he was right. It shot to the tops of the pop and country charts, won a Grammy and CMA Single of the Year. And Tom T. Hall was one of Nashville's elite songwriters about the same time he was becoming one of its favorite performers. This also changed Tom's finances.

"When I first came here it was hard to make a living as a songwriter unless you were also an artist, like Roger Miller and Willie Nelson. There were only two hundred radio stations that played country music, and some of those only played it during the farm hour. We used to get around fifteen thousand dollars for a number one hit, and that money didn't start coming in right away. Now it might be close to a half-million dollars if you were the sole writer."

The music historian Charles Wolfe likes to say Tom is the only liberal in country music. He was a big supporter of Jimmy Carter, and his politics remain liberal Democratic. He says he's into politics more as a spectator these days, though. Tom met Jimmy Carter early on in the election process and came to like and respect him. Rosalyn and Jimmy came to see Tom when he played in Nashville, and Amy Carter even clogged at the Opry one night! Tom's best stories about the Carter family have to do with one trip to New Hampshire and meeting the matriarch, Miss Lillian.

"I was helping Carter campaign in New Hampshire, and Miss Lillian was there. I'd already embarrassed myself once that day. I walked up to a young woman sitting in a café and introduced myself, then told her I was there saying nice things about my friend Jimmy Carter. The young woman smiled and said, 'Well, let me introduce myself. I'm Maureen Reagan and I'm here saying nice things about my father.' So I said, 'Well, it's nice to meet you and I'm going to move right along.' The Miss Lillian story is this: I was playing a show there in New Hampshire. Miss Lillian and I were staying at the same motel, so I stopped by her room and the minute she saw me she said,

'You must be Tom T. Hall.' I said, 'And you must be Miss Lillian.' Miss Lillian took stock of me and said, 'Yes, I am. They're trying to get me to come over and hear you sing. I don't know anything about your singing, and I'm not going to pay twelve dollars to find out.' I said, 'Why, Miss Lillian, you don't have to pay twelve dollars. You'll be my guest. And you come on over and find out about my singing because I'm gonna break your heart.' We were sweethearts after that. Miss Lillian thought I was as cute as a button. After that we went to Plains a lot, and got close to the whole family. I got to stay at the White House and I flew on Air Force One."

I reminded Tom that he'd sent me a note from Air Force One, and that reminded him of a White House story.

"We spent a couple of nights in the White House. One morning the president and Mrs. Carter were taking off for Camp David very early, so they told us to just take our time, relax, and make ourselves at home until we got ready to leave. This was about the most awesome feeling I've ever had. We were on our own in the White House. I felt like we were kind of in charge and I wanted to share that with someone. So I picked up the phone that morning and said to the operator, 'Get me Darrell Royal at the University of Texas.'

" 'Yes, sir,' the operator said. He didn't have any idea who I was, but since the call was coming from the private quarters, I guess he thought I must be *somebody*. The amazing thing was that you didn't have to know phone numbers. You just picked up a phone and gave them a name and a city and they found the person. I even called my sister and a few golfing buddies."

I told Tom that I remembered when Jimmy Dean was out on his yacht once and President Bush found him. No one even knew he was on that boat—but the president found him.

Tom told me about a night when he stayed in the Lincoln bedroom. "There was a refrigerator down the hall and they told me to just go there if I wanted a sandwich or anything. It was well stocked. So I got a beer out of the refrigerator and went back and sat on Lincoln's bed drinking it. Jimmy Carter had been out jogging. He stopped by the room, just plopped down in a chair and asked if I was having a good time. I said, 'Mr. President, this is a great day in the

life of a country boy.' And President Carter looked at me and asked, 'Are you talking about me?' "

Then I speculated to Tom that it must have remained an "awesome experience," being such a close friend to a president, close enough to be left "in charge" of the private quarters and make phone calls on the White House phone just for the hell of it. Tom thought about that a moment.

"I'll tell you the truth, Ralph. His celebrity got in the way. I've never liked being around celebrities. Nobody in the business ever says this, but I will and it's the truth: Famous people are a pain in the ass. A lot of them don't mean to be, but all the attention they get distracts from what they are. In the case of a politician, the Secret Service people and the FBI entourage and all that make you crazy. It's hard to get back to the real life of the individual."

Then Tom started talking about the days when he searched the country for songs, and it took us right back to his celebrity as pain-in-the-ass theory.

"I always thought one of my best albums was *In Search of a Song*, and the title ought to tell you what I was up to. I used to go get in the car and drive to some intersection on the interstate, see which way the wind was blowing and drive in that direction. I'd get off the highway and take the back roads. I'd eat in little mom-and-pop cafés and stay in little motels. I'd sit around in the local taverns, drinking a beer and eavesdropping on people's conversations. Or I'd strike up a conversation with some fellow. You learn a lot about people and the stories that make up this country when you do that. And what better way for a writer to stay in touch with the world? Unfortunately, once I made a lot of records and my picture started getting out there in magazines and on television, I couldn't do that. I really hated losing my anonymity. I remember one time when I'd checked into some motel and I was sitting in the bar relaxing when someone approached me and asked, 'Aren't you Tom T. Hall?'

" 'Yes, I am,' I answered.

" 'What are you doing out this way?' the fellow went on.

" 'I'm out looking for songs,' I answered.

"We talked a little while, but I was tired from the drive and soon

went to my room to get some sleep. The next morning there were about twenty-five songwriters standing in the lobby with tapes of their songs."

Tom thought a moment and finally added: "My celebrity had become a pain in the ass."

Against the Odds:
Tillis, Pride, and Milsap

*N*ow I'D LIKE to talk about three men who overcame seemingly insurmountable odds in their lives to become dominant figures in country music. These three are Ronnie Milsap, Mel Tillis, and Charley Pride. Like most of the stars in this book, they cross from one era to another, being important figures in more than one decade.

Mel Tillis figured prominently in what I call country's Golden Decade, the '60s, when he took off as a prominent Nashville writer, but his solo career was a '70s phenomenon. Mel moved to Nashville and signed with Cedarwood Publishing in 1957. It was actually Buddy Killen over at Tree who gave him his first break, but somehow Jim Denny entered the picture and convinced Mel to join forces. According to Buddy, it was because Mel found a like-minded carouser in Denny's partner, Webb Pierce.

Jim Denny started out paying Mel $50 a week to keep him afloat while he wrote songs, and Mel thinks Jim resented the money. "Mr. Denny got me a job playing rhythm guitar with Minnie Pearl for eighteen dollars a day," Mel told me in 1995. "Then she told me she

needed a fiddle player. Well, I'd met a bellhop down at the Andrew Jackson Hotel. He claimed to be a fiddle player, so I ran right down to the coffee shop where he hung out and asked him if he was good enough to play in a band.

" 'Sure. Who's the job with?' he asked.

" 'Minnie Pearl,' I said.

" 'Well, any port in a storm!' he said laughing, then headed for the door.

" 'Wait a minute,' I yelled. 'Where're you headed?'

" 'I'm gonna go give the Andrew Jackson my two-minute notice,' he said."

I didn't even have to ask Mel who that fiddle player had been. It was Roger Miller. And the band was really Judy Lynn's.

Minnie Pearl is the person who persuaded Mel to start speaking onstage. That stammer *made* people listen to him. He'd actually played some dates earlier with the Opry's Duke of Paducah, but those jobs didn't require that he open his mouth. Minnie had Mel singing some numbers and she insisted he introduce each one. "I c-c-can't," Mel said. "Yes, you can," she said. "And if the audience laughs at your stammer, understand they are laughing with you, not at you." Mel started talking onstage, and when he heard the laughter, it was just as Minnie had predicted—happy, friendly laughter. He found he liked the laughs just as much as the applause.

Mel started recording for Columbia in 1957. He didn't make much of a splash as a recording artist, charting in the mid-20s even with a 1963 Decca duet with Webb. Make no mistake, though, Mel was a force in Nashville even while he struggled to find his place as an artist. In 1960 alone he had songs recorded by Webb Pierce ("No Love Have I"), Stonewall Jackson ("Mary Don't You Weep"), and Ray Price ("One More Time"). In '64 Ray Price had a monster hit with Mel's "Burning Memories" and Wanda Jackson released "The Violet and the Rose." And while it didn't chart nationally, Charley Pride's RCA debut with the Mel-written "Snakes Crawl at Night" established Pride as a black contender in a white-dominated music genre. In 1969 Kenny Rogers and the First Edition had an international hit with "Ruby, Don't Take Your Love to Town."

"Ruby" was written several years earlier during a Nashville rush-hour traffic jam. Mel was driving home from his office at Cedarwood one day and found himself in a line of cars traveling at a crawl. He was listening to the radio and when Johnny Cash came on the airwaves singing the line "don't take your guns to town," Mel suddenly thought of another line: "Ruby, don't take your love to town." It reflected a real-life situation Mel knew about when he was a child growing up in Pahokee, Florida. Out behind his house sat three apartments facing what the neighbors called "Cat Alley." A World War II veteran lived in one apartment with his wife, a British nurse he'd met while convalescing during the war. He traveled to Lantana once for a treatment that left him paralyzed for a period of time, and while bedridden he loudly accused his wife of running around on him. According to Mel's mother, the accusations were unfounded—at first. Finally, Mel says, the man's wife got so sick of being denounced as a fallen woman, she took to the streets. The sorry ending to the story is that this fellow divorced the nurse and married two more times. He shot his third wife, then turned the gun on himself, proving that in this case at least, the third time wasn't the charm at all.

I asked Mel if the people around Pahokee ever knew he wrote "Ruby" about the Cat Alley couple and he said: "Not till I told 'em!"

Mel had "Ruby" finished by the time he made it home to Donelson. He rushed in, played it for his wife, and was informed it was "the awfulist song" she ever heard. His confidence in the tune sagged until Johnny Darrell had a 1967 top-10 hit with it. Darrell wasn't the only act who cut it, though. There was a band calling themselves the Almond Joys who also recorded the song. They didn't hit with it, but maybe they would have once they changed their name to the Allman Brothers. Two years later Mickey Newbury played "Ruby" for Kenny Rogers, who recorded it with the First Edition. Never intended as a single, the song started to get hot when a Cleveland deejay started playing it in heavy rotation. Mel thinks the times were what made "Ruby" a big pop hit.

"By 1969 Vietnam was in the news, the students were protesting, we'd had Kent State—that's what made 'Ruby' so big," Mel says. "It

sold twenty-two million records, and I believe it was due in part to the times. Johnny Darrell came out with it two years too soon."

Mel recorded for Kapp and MGM, but it wasn't until 1972, when MGM released the #1 "I Ain't Never," that Tillis hit big. Though it would become his all-time biggest hit, the success of "I Ain't Never" didn't last, and it took his signing with MCA in 1976 to put him in the superstar category. Mel's MCA debut, "Love Revival," made it to #11. Then, in October 1976, he released what would be his second #1 and second all-time biggest release, "Good Woman Blues," kick-starting a long string of hits. In 1979 Mel had his third-biggest hit with the chart-topping "Coca-Cola Cowboy," which was featured in Clint Eastwood's *Every Which Way But Loose.* "I Believe in You" ('78) and "Southern Rains" ('80) clock in at his fourth- and fifth-biggest releases.

In 1975 Mel made his second movie, *W.W. and the Dixie Dance-kings,* starring Burt Reynolds and Jerry Reed. He was voted into the Songwriters Hall of Fame the following year and won the CMA's Entertainer of the Year award.

Mel almost set his coat on fire during those award ceremonies. He sat in the audience doing something I've never seen before or since at a televised award show: He smoked a pipe! When he was announced the winner, he simply stuck the pipe in his pocket. It smoldered through the acceptance speech until Mel could get back-stage and grab it out! That wasn't the worst case of smoking nearly ruining a television show, though. That would have to be when Waylon was playing a scene with Big Bird and between takes dropped a hot ash on his feathers. Waylon told me that story, then grinned, saying, "Ralph, did you know Big Bird's feathers cost three dollars each?"

One of the questions Mel Tillis is most frequently asked is this: "Do you really stutter?" Yes, he does, and it is something that helped him be a comic (winning the Music City News Comedian of the Year award seven times) but stopped him from one thing he'd have liked: a dramatic acting career. I remember when he first started coming on my show, my program director, Ott Devine, told me I'd better be careful that Mel and I didn't offend "real stutterers." I said,

"But you don't understand—Mel *is* a real stutterer!" In fact, Mel has had to prove to television producers that he stutters. The producers of the *Glen Campbell Goodtime Hour* brought in a doctor from UCLA to examine him for authenticity.

I always wondered why Mel doesn't stutter when he sings, and in 1995 he told me it's because of two things. First, he knows the words to the songs so well he doesn't have to think about them, and second, there's a rhythm to the words that isn't usually there while he talks.

Mel thinks his stuttering is genetic, even though a case of childhood malaria may have contributed to it. His father stammered some, and Mel didn't even know he stuttered until he started school. His neighborhood pals never noticed, or if they did they never said anything. But on his first day at school, the kids noticed and pointed and laughed. Mel says he promptly messed his pants and had to be taken home where his mother washed him off under a very cold outdoor water pump! One teacher even held him back a year, not because his grades were bad but because of his speech patterns. Mel says she never did "cure" him and later in life he was glad she hadn't.

Those kinds of experiences could have held Mel back, destroyed his confidence for good—but they didn't. Even though his family moved a great deal looking for work, putting him with new classmates nearly every year of his young life, Mel survived. I remember him telling me about going out by the lake near Pahokee and looking out over the water while he practiced speaking. It sounded like a lonely time to me, but true to form, when I asked Mel about it he turned it into a joke. He mentioned the statesman Demosthenes, considered the greatest orator in history, and how he practiced speaking with a mouth full of pebbles. "That never helped me, but I did swallow some and have kidney stones," Mel quipped. Then he added: "You know that Moses-s-s-s, uh, couldn't talk good. His brother Aaron talked for him most of the time. If I was ol' Aaron, I'd be mad 'cause Moses got the credit for everything!"

The way Mel fought those early insecurities was with sports, music, and humor. By the time he graduated from high school, he was a top football player, even being scouted by several Florida col-

leges, and was known as a good singer and a very funny guy, a guy people wanted to be around. He was voted class wit and one of his classmates predicted he'd wind up being one of the highest paid hill-billy singers in Hollywood.

Another part of Mel's upbringing that interested me was that he often attended what is called "strawberry school," where Florida kids back then attended classes in the summer so they could pick straw-berries with their parents in the winter. Mel told me you got paid two cents a quart for the berries, and when he said, "I was fast and could make eighty cents a day," he said it with as much pride as when he spoke of being named Entertainer of the Year. Another farm-related job led to Mel's interest in music. His family didn't have a radio for years, so the first time he was aware of country music over the airwaves was when he and his family had a job shelling peas for two dollars a day. "We'd sit there shelling peas while these big speak-ers broadcast people like Eddy Arnold and Bob Wills. One family would sing and then another family. That was what started it all."

WHAT STARTED IT all for Charley Pride was a Philco radio his dad kept tuned to the Grand Ole Opry. Charley had always been exposed to blues and gospel sung by other black workers picking cot-ton in the fields around his hometown of Sledge, Mississippi. But when his father bought the Philco and insisted they listen only to the Opry, young Charley was hooked on Roy Acuff, Ernest Tubb, and Hank Williams. In fact, that radio is the reason that years later, in 1969, Charley's release of a live version of "Kaw-Liga" contained a few wrong lyrics. "I never had a record of Hank's, so all I knew was what I'd learned from the radio shows. Either Hank missed some words or I remembered them wrong," Charley said, laughing, recall-ing the mistake in a 1972 talk with me.

Charley's father, Mack, was such a fan of the Opry that he used to write to the Opry and collect photos of the stars. Charley studied those pictures so that as he listened to the voices every Saturday night, he could picture the people standing onstage. After he started singing the songs himself, his sister Bessie asked a question that some

fans and deejays would ask much later: "Charley, why are you singing white folks' music?" Charley answered then as he would later: "I don't know. It just comes natural."

Charley did face a big race obstacle when it came to country music. With the exception of DeFord Bailey, most of the black faces associated with the genre were painted on for a comedy show, like Jam Up and Honey. Charley proved that talent could win over bigotry, even in the civil rights–era South.

In 1954 Charley started playing baseball for the Negro American League, pitching against greats including Willie Mays and Hank Aaron when the major leagues sent their teams barnstorming through the South. Willie got some home runs off Charley, but Hank never got a hit. Charley detoured from baseball to serve in the military in 1956. In 1958 he returned to baseball for a short time until an injury sidelined him. He then moved to Helena, Montana, to play in the Pioneer League. During the off-seasons, Charley and many of the players worked at the Anaconda Mining Zinc Smelting Plant.

In 1961 Charley went to training camp with the California Angels, who ended up sending him back to Helena with nothing more than an orange and a sandwich to eat on the long ride home. ("I already had a bus ticket," Charley laughingly told me in '72. "I'd gotten a round-trip ticket to California just in case.") He tried out for the Mets, too, sending a letter of introduction to the legendary Casey Stengal and a case of bats engraved with his name to the Mets clubhouse. He was let go there, too, despite the fact that many considered him an ace ballplayer. It seemed there were just too many players with talent. Charley was a bit different from many of them, though. He had another talent. He could sing country songs, and when he returned to Helena, he did just that.

In 1963 Red Sovine and Webb Pierce were scheduled to play a concert in Helena and the promoter asked Charley to sing during the second show. A local deejay named Tiny Stokes promised Charley he'd arrange a private audition with Webb Pierce. As it turned out Webb had been replaced by Red Foley. But Red Sovine was impressed by Charley's singing and he encouraged him to come to Nashville.

"You come to Cedarwood Publishing and I'll get someone to listen to you," Red promised.

Well, the man who'd sent the Mets a case of bats was obviously not one to let an opportunity slip by him. He arrived at Cedarwood and the first person walking down the hall was the one and only Webb Pierce.

"Isn't that Webb Pierce?" Charley asked the receptionist.

"Yes, it is," she replied.

"Could I talk to him?" Charley asked.

She motioned him back, and Charley walked into Webb's office and introduced himself. Webb nodded, sitting there looking sharp in a blue Western-style suit.

"Do you know Tiny Stokes?" Charley inquired.

"No," Webb said.

"Oh. Well, do you remember that show in Montana when Red Foley filled in for you?"

"Yes."

"Tiny said he had it set up for me to sing for you," Charley explained.

Webb sat there with a frown on his face. He scratched his chin. Finally he said: "I usually do my own singing."

Charley hastened to correct the error. "I mean audition for you."

Webb smiled. "Oh! All right." Then he yelled to the outer office: "Somebody get this man a guitar!"

Ironically, Cedarwood's PR exec, Jack Johnson, heard Charley singing and was knocked out by his voice. And like Sam Phillips had once looked for a white singer who sounded black, Jack Johnson was looking for a black man who could sing country. Jack Johnson took the helm of Charley's career and stayed with him for many years. Jack Johnson took Charley to Jack Clement, who'd started out at Sun with Sam Phillips and later moved to Nashville. Clement was a rebel and just the kind of person who'd love the challenge of breaking a black into country music. They cut some sides and Jack took them to Chet Atkins at RCA.

In 1966 RCA started promoting their new act, minus any photos, as Country Charley Pride. The first song they released, "Snakes

Crawl at Night," didn't chart nationally. Many deejays didn't even know he was a black man. When one of them threatened to take Charley's record off the air, Faron Young—who'd become a great friend to Charley—threatened to burn down their station.

Faron was the main person Jack Johnson had warned Charley about when his career was just getting started. Faron was considered a cocky, outspoken redneck who just might call a black man anything right to his face. Yet, as Jack told Charley, Faron was one of the most important people they needed on their side, especially when it came to booking Charley with some of the established stars. The rumor was around that Faron had said he wouldn't dream of taking that "goddamn jig" on tour and jeopardizing his career.

Charley says he thought of Faron's attitude as separatism more than racism. And those attitudes didn't come as any surprise. In many ways, Charley Pride had been in training for Faron Young for years. So one night he tracked Faron down at a bar. He introduced himself, and even though the Sheriff seemed apprehensive, they ended up singing some songs together. Finally Faron said, "I can't believe I'm singing with a jig and don't mind it." He stood back and waited for a reaction.

Charley looked him square in the eye. "I was waiting for you to call me worse," he said. "And if you did, I was ready to call you a pucker-mouthed banty rooster son of a peckerwood."

"Well, I'll be damned," Faron said.

One of country music's great friendships had just been forged. And the best news I've had so far in 2000 is that this year's Hall of Fame inductees will be those two old pals, Charley and Faron.

"Just Between You and Me" was the second release, and it made it to #9. Next he released a Clement-penned song, "I Know One," and it got to #6. Charley's next five releases, including the live version of "Kaw-Liga," all hit top-5. Charley debuted on the Opry in '67, introduced by Ernest Tubb, and in 1969 he had his first #1 with "All I Have to Offer You Is Me."

There was often the question of race when it came to booking and promoting Charley. No one seemed to know exactly what to

say. I was hired to announce a show in Detroit and Charley was on the bill. It was an interesting show because of the problem of picking a house band. Back then the newer artists usually used someone else's band, since they couldn't afford one of their own. If there wasn't a house band, someone's road band usually got tapped. That day the question was this: Will it be the Buckaroos or the Strangers? Well, Buck Owens was the bigger of the two, so he declined on behalf of the Buckaroos. Merle said: "Well, I guess that's what happens when you're a 'little star.' "

I knew that very few people knew Charley Pride was black. So I walked out and said: "How many of you people have roots in the South?"

A lot of folks cheered, confirming my suspicion that a large number of first- and second-generation Southerners worked up in Detroit. That also told me that these people came to hear good country music. We opened with the great fiddle player Curley Fox. The crowd went wild for his show. They were just crazy with applause. Next up was Charley Pride.

"Ladies and gentlemen, we've got an old boy coming up now who is from the South—from Sledge, Mississippi. He's a new fellow on RCA and he's had two singles out, 'Snakes Crawl at Night' and 'Atlantic Coastal Line.' Give a big Detroit welcome to Charley Pride!"

Charley walked out with his guitar strapped across his back, and the applause quickly died down to nothing. I will always remember how he handled it. He flipped his guitar sideways and placed his arms on it, like he was resting them on a desk. "I realize I've got this permanent tan," he said with a smile. "But I want to entertain you if you'll let me." No one booed, not one person that I heard. Charley sang about six songs, and when he finished, that crowd applauded. Not like they had with Curley Fox, but it was a warm response. Charley Pride had changed their minds that day.

Charley and Jack liked the simplicity of my introduction, and soon after that they asked Horace Logan to use the same introduc-

tion at a show. I don't know why, but Horace felt he had to go out and say: "Here's a fellow on RCA. He's colored and he's had three singles out."

There were other, subtler situations that Charley faced. Webb Pierce once mentioned that he thought Charley was good for "our" music. You have to give credit to Charley, who quickly answered: "It's my music, too, Webb." And while it wasn't coming from a racist point of view, I know that Mel Tillis was surprised to learn that Charley knew more about Roy Acuff and Hank Williams than he did about Brook Benton and Sam Cooke.

I was thinking about race and records one day when I interviewed Charley. He'd mentioned that back when he started out he was referred to as "colored" or as a "Negro," and that by the mid-1970s he was called a "black." I asked him if he thought the South was as racist as it had been portrayed in the days when he started out, or if we'd had a bad rap. He hesitated, then said that he believed racism was more situational than personal, that attitudes and actions evolved because of wrong systems, not wrong people. In Nashville he was treated well—after all, he was a star, with the support of powerful people like Chet Atkins. But Charley told me that his decision in 1969 to move to Dallas instead of Nashville was based in part on race considerations.

"I seldom felt outright prejudice here, certainly not in the business," he said. "But I'd raised my children in Helena, Montana, and when my career got hot and I needed to move, I wasn't sure about the South. Nashville might treat me well, but what of my children? They'd be in school and they weren't used to hearing words or ideas I feared they might hear. I thought about Denver or Phoenix; then I met a fellow who suggested I consider Dallas. After I checked out the Dallas schools, I never even went to Denver or Phoenix. Dallas felt like home."

There was one other consideration about the move to Nashville, and I understand how an entertainer might feel this way. Charley feared that familiarity might breed contempt. "I met a lot of people in Nashville while I was getting started. And I saw that when a star

lives there, he is pitched ideas, songs, and even tour possibilities all the time. It's very hard for me to say no to people, but I knew I'd have to do it. So I was afraid I might offend someone or that people would say I'd changed. Living in Dallas seemed to solve that problem before it ever came up."

One thing many people may not know is that Charley is something of a philosopher. He loves to talk about astrology, and says he's used some of his studies on the subject to help reverse what he considers bad traits. "I'm like many Pisces," he once told me. "I'm overly sensitive at times. When a fan gave me a book about astrology and I saw some things about my sign that I recognized in my personality, it helped me try and either change them or at least have some control over them."

Being a Pisces myself, I understood just what he meant. And I certainly understand trying to better yourself. Charley and I both tried to do that by smoothing out our intense Southern accents. Charley didn't have any problem with the way blacks in Mississippi spoke, except he said it was so slow it would take all day to say all he wanted to say in just one conversation. Charley sounds more like a Texan now and less like a slow-talking Mississippi fellow, and my old drawl has been gone for years. Joe Tex's drummer once sat listening to Charley talk about Jim Reeves. Finally he leaned forward and said, "You really do talk this way!" Charley said that yes, he did. The drummer said, "I always thought you just did it to make a dollar."

One interesting story Charley told me was about prejudice of a different sort: the dislike of country music. He happened to be playing a show in Canada right after Nixon's surcharge went into effect. Charley says he thinks the journalist in question not only disliked country music, but due to the surcharge he disliked our entire country that particular night. "I'd received five standing ovations during the show," Charley said. "And the next morning I read a review that said 'Pride gets four ovations and gives nothing.' He went on to say he didn't like Nashville or country music anyway because it all sounded the same. He said that better songs, like 'Bobbie McGee,' were the only reason I got any ovations. I guess he didn't know about

the song's Nashville connection!" In that one review Charley felt the stigma of being considered a hillbilly just like many of us had felt all those years.

THE THIRD STAR who I believe overcame the most to get to the top is Ronnie Milsap, who, like Mel Tillis and Charley Pride, had a barrier to overcome. In Mel's case it was a speech problem that might have caused him to give up hopes of an entertainment career. In Charley's case it was prejudice against a black man singing "white man's music." In Ronnie's case it was blindness, which might have caused him to give up trying at all.

Yet Ronnie Milsap became one of country music's larger-than-life superstars. His country career took off in the '70s and remained red-hot through the '80s and into the '90s. He is still a dominant figure in music, crossing any boundaries and capable of bringing an audience to its feet, with a new album out for the new millennium.

Ronnie was born in Robbinsville, North Carolina, raised by his grandparents after his parents separated, and sent to the Governor Moorhead School for the Blind in Raleigh as a child of six. There he studied classical music, often getting into trouble for forays into rock 'n' roll. When Buddy Holly died, Ronnie held a wake in his honor, playing Holly tunes for the other students. When a music teacher discovered the group, Ronnie was suspended from all music programs. Unfortunately for the school and fortunately for young Ronnie, the void he left could not be filled and he was reinstated the following year. He played completely by ear, obviously, and it's amazing to realize he committed the music of Mozart, Bach, Beethoven, Brahms, and other classical composers to memory.

Ronnie attended college, studying music and pre-law, then turned down a scholarship to law school to pursue a music career. Many were against that move, but by that time he'd married Joyce Reeves, who backed his decision completely. Ronnie will tell you that marrying Joyce was the smartest thing he ever did.

Ronnie worked with blues rocker J. J. Cale, then formed his own

band, ultimately signing with Sceptor Records as a blues artist. He moved to Memphis, where he worked with Chips Moman and played on some Elvis Presley sessions, including "Kentucky Rain." Elvis discovered Ronnie long before Nashville did. The King even hired Ronnie to perform for two of his New Year's Eve bashes. Ronnie laughingly tells about his faux pas at the 1969 party. "I asked Elvis if he wanted to get up and sing a number," Ronnie recalled. "He politely declined, saying he just wanted to hang out and have a good time. I never made that mistake again."

Once, while on a tour promoting a blues release, Ronnie played a club in California and had an unexpected guest: country star Charley Pride. Since Charley was in the audience, Ronnie sang a couple of country numbers he remembered from listening to WSM. Charley came backstage and said, "Don't ever sing anything but country music!"

When Ronnie got a job offer at the King of the Road club in Nashville, he quickly became a favorite of the industry. And once again, my old friend Faron Young enters the picture. Jack Johnson told Ronnie if he wanted to make it in Nashville he needed the support of two people: Ralph Emery and Faron Young.

"I used to get Faron's goat when he came to the club," Ronnie says, laughing. "A band member would tell me Faron was in the audience and what he was wearing. So I'd stop playing and say, 'Faron Young! That's a nice tie you're wearing. It goes well with the blue suit.' Faron would yell, 'Ronnie Milsap's a fake! He's not blind!' One of Faron's favorite comments to me was 'Ronnie, I don't feel a bit sorry for you because you're blind. Now if you sang like Webb Pierce, then I'd feel sorry for you.' I obviously passed the Faron Young test."

Ronnie certainly passed the Ralph Emery test, if there was such a thing. But I'll tell you about that later.

In 1973 Ronnie joined Charley Pride on the RCA roster. Produced by Tom Collins, Ronnie hit #1 on his third release, "Pure Love." He went on to have thirty-one chart-toppers, attracting pop attention as well. He became one of the biggest stars of the next two decades, winning six Grammy Awards, three CMA Male Vocalist

nods, an Entertainer of the Year award, and countless gold and plat-
inum records. But Ronnie's well-documented superstar status isn't
what I want to leave you with in this chapter. What I want to tell
you about is not his highest moments, but his lowest, and how he
began the climb out of it.

Only once did Ronnie Milsap let his blindness get in the way of
his dreams. When I spoke to Ronnie in the early spring of 2000, he
recounted a story that chilled me. The story was prompted because I
asked him a question so many people throughout the years have
asked me about this country superstar: Was he always totally blind?
Or could he see at one time?

"Yes, sir, I was able to see a little at one time," he answered. "I
had a small amount of vision in my left eye early on. I had no vision
in my right eye due to congenital glaucoma, which—that is what I
hear—was the cause of my particular blindness. I could see color,
some amount of distance, lights and darks, faces up close to some
extent. To a blind person that small amount of vision seems miracu-
lous. Still, I had such limited vision that I couldn't attend public
school and was sent to the Governor Moorhead School for the Blind
in Raleigh at age six.

"It was a very strict school—and times were different back in
1949, when I started school. It was okay to slap a child or whip him.
And the learning was intensive. We learned Braille in three to four
days—it's amazing how fast a child can learn."

It's also amazing how quickly what little light in a small child's
life can be extinguished. Ronnie told me that while his teachers
were strict, he believed the people fair and credits them with mak-
ing him the independent, self-sufficient man he is today. In fact,
Ronnie is the world's biggest supporter of that school. But the
houseparents could be another matter. And one day the housefa-
ther in Ronnie's quarters slapped a boy, sending his glasses clatter-
ing to the floor.

"You didn't have to slap him!" fourteen-year-old Ronnie shouted.

The blow seemed to come from nowhere and knocked Ronnie
from his chair to the floor. The pain in his head intensified with each
second, terrifying the young teen. The next morning all Ronnie

could see was a red blur. Ronnie ran to the housefather's room, nearly hysterical that his limited vision was disappearing. He screamed at the housefather, "I can't see anything!"

And here's what the man said: "We can't be crying over spilt milk."

It turned out that Ronnie's good eye had almost been knocked out of his head, the vein that was the organ's "life support" torn so badly that the eye began deteriorating. At the school's medical facility, Ronnie was told he had a blood clot right behind the eye. Doctors attempted to dissolve the clot before it did permanent damage, but to no avail. The pain was so bad they gave the fourteen-year-old boy codeine until he became addicted to the drug. Doctors shook their heads over the incident, yet nothing was done to the housefather. They advised Ronnie that his eye would probably have to be cut out. The normally positive, upbeat Ronnie sank into such a deep depression he lost twenty pounds in two months. Nearly a year later Ronnie remained in pain, dependent on codeine and still going to doctors who tried to break up the blood clot. By this time he was in total darkness.

In February 1958 doctors removed the eye and replaced it with a $15 glass one. The darkness he felt extended to every part of his life. Music, which had been a big part of Ronnie's life, held little fascination. His study habits were abandoned. That small amount of sight Ronnie Milsap had experienced was gone, and with it, all hope.

"I could no longer see the point of going on," Ronnie admitted to me. "The depression was complete and debilitating."

"How did you pull out of it?" I asked, reminding Ronnie that when I met him years later he brimmed with confidence and enthusiasm. I'll never forget his answer.

"In that complete darkness, I finally began to construct a world of light within my head," he said. "My teachers helped. My music helped. My faith helped. And I learned that the world is beautiful, whether you can physically see it or whether you build one in your mind. I built a new world, and it brought me back out of the darkness."

Ronnie sat in quiet thought for a moment, then added something else I'll not forget:

"I remember well when I first met you, Ralph, and it wasn't the day you first met me. I first 'met' you one night when I was in school in Raleigh. I was twisting the radio dial and found you on WSM. We all started tuning to your show, even though we were supposed to be paying attention to classical music—never rock or country. And over time, as I listened, I felt like I made a friend. Not just any friend, but someone with the inside track to the music business. I trusted you. So when we finally met all those years later I immediately felt I had a friend in Nashville."

Nothing he could have said would have pleased me more, to think that someone in my listening audience considered me their personal friend in Nashville.

Mr. and Mrs. Country Music: George Jones and Tammy Wynette

*B*ACK IN THE 1970S, fans fell in love with an idea, Mr. and Mrs. Country Music. I'd like to reflect back just a bit on those days, on why this couple so charmed the public, and why it hit their fans so hard when they broke up.

George Jones was already a legend and Tammy Wynette was well on her way to becoming one when the two wed in 1969. George had been a star ever since his 1955 #4 debut on Starday, "Why Baby Why?" His first chart-topper had come in 1959, with "White Lightning" (penned by J. P. "Big Bopper" Richardson), a single that stayed at #1 for more than a month. And although that edgy tune took him to the top, his career was founded on heart-and-sorrow songs, big hits such as 1960's "The Window Up Above," 1962's "She Thinks I Still Care," and 1967's "Walk Through This World with Me." George didn't always make it into *Billboard*'s upper realms. He had as many misses as he had hits. It seemed as if his label, Mercury, was recording him at top speed and throwing out as many singles as possible, with lackadaisical song selection.

There was a reason that Mercury had all those songs ready to release. Starday and Mercury had a release deal similar to the Four Star/Decca arrangement. And Starday's Pappy Daily had cut a deal to help George's finances. Any time Jones ran short of money, he could come to Nashville and get a hundred dollars a song to record. I remember one time George breezed into town and cut twenty-five sides. He left town with $2,500 in his pocket.

He certainly couldn't match Tammy's hit list. With the thoughtful guidance of Billy Sherrill over at Epic, Tammy had racked up a whopping seven #1 singles between her 1967 debut, "Apartment #9" (written by Johnny Paycheck), and 1969's "The Way to Love a Man." That list included one of the biggest songs in country music history, also released in 1969, "Stand by Your Man." This song came to define Tammy, even though she happened to be divorcing husband number two, Don Chappell.

Tammy had the hits, but George was the bigger star when they married. Whether he hit the top of the chart or not, he was *George Jones*. One of the first things that happened after the Tammy-and-George union involved a label change for George. I'm sure that Billy Sherrill knew that the duet potential with this couple was boundless, and if George was also on Epic, it would be relatively painless. Negotiating duets between labels has always been a problem. Waylon once said that every time he and Willie recorded a duet, a record executive somehow lost his gig, since Willie was on Columbia and Waylon was on RCA. The negotiations must have been fierce at times.

When George Jones signed with Epic in 1971, there was no stopping the George-and-Tammy recording train. Unless, of course, the marriage train-wrecked along the way. And even if that happened, the label could stockpile enough songs to keep releasing duets for several years, which is just what Epic did. Some of the legendary duets were 1973's #1 "We're Gonna Hold On," 1976's "Golden Ring," and 1976–77's "Near You."

Their voices rang true together. There was the road-weary soul of Jones mixed in with the heartbreaking tears-in-her-voice vocals of Tammy. Yet there seemed to be something hopeful in the performances, something listeners could hang on to, could rely on. These

are truly some of the great duets in our history. And they are part of the reason that while Tammy Wynette and George Jones were married only seven years, their tag as Mr. and Mrs. Country Music will probably last forever.

Both Tammy and George have written autobiographies detailing the rocky marriage, the fighting, the drinking, and the 1975 split. I really believe these two loved each other deeply and would have made it if either had made just a little effort. I invited them on my television show, *Pop Goes the Country*, some months after the divorce and asked them if they'd consider getting back together. Just to be safe, I sat in the middle with the former Mr. and Mrs. Country Music on either side.

"Are you going to quit drinking?" Tammy said, leaning across me to address George directly.

"Are you going to quit nagging?" George shot back.

A lot of fans' hopes were dashed when this couple divorced. People loved them both as solo artists and they *really* loved them as a couple. I think the fans felt as if they were somehow a part of that marriage. It was something like the way so many identified with Hank Williams. They were let in on the lives of these stars through their music. In George and Tammy's case, it went even deeper because those two were often interviewed about married life, inviting the listening public right into their living room. Of course, they generally didn't mention the knock-down-drag-out fights they'd later talk about in their memoirs. As with so many marriages, the truth emerged later.

I interviewed George and Tammy separately and as a couple many times during their marriage, and I believe I know what chord they struck with the public. It was their seeming normalcy. Tammy and George may have been singing about not being a power couple, as in 1974's "(We're Not) the Jet Set," but in truth they were. They hobnobbed with the biggest stars in the world and were invited to the most elegant events. The public certainly knew this, but in some way, I think they saw George and Tammy as their representatives in the world of money and celebrity.

I remember one interview when George was talking about the

fact that Tammy always cut and styled his hair. "I'm one of those guys who takes his hair stylist along with him," George said, laughing. "Luckily, I married the finest hairdresser in the world. Actually, I married the finest cook in the world, too. She makes me biscuits from scratch every morning! And I also married the finest singer. Don't forget that." George turned serious, looking at Tammy with admiration. "I married the finest person in the world. I guess that's what it comes down to."

That's the kind of statement that grabs the public right in the heart. Another radio interview that comes to mind when I think about what it was that caused the public to fall in love with Tammy and George was a 1974 talk with Tammy. I'd asked George to come along, but this interview interfered with one of George Jones's greatest loves: football.

"You can't get in the way of George's football watching," Tammy explained. "He'd watch football fifteen straight hours on three televisions if he could. When we go on the road he's up raring to go at six in the morning so we can be at a motel and watch a game that afternoon! The next time you want him on the show, try a Wednesday night. I think that might be one of the few times he can't find a game."

Tammy and I started talking about something she'd showed me when I went to Lakeland, Florida, for the opening of the music park. George showed me through their house, and when he took me in the master bedroom I saw a huge plaque hanging above the bed. The story about it so moved me that I asked Tammy to tell the listeners about it.

"When Georgette was born in 1970 George wanted to do something to commemorate it," she explained. "He wanted to give me a present that we'd always have to remind us of how special our daughter is and how much we love each other. He was initially disappointed over the idea because he wanted the plaque hanging over the bed when I brought Georgette home from the hospital. But since he needed a photo of the baby, it took longer than he expected. But it meant the world to me when I finally saw it. It really says a lot about George Jones."

I asked Tammy to tell the listeners in detail what is on that plaque.

"Well, it's very big," she began. "I guess it's about four feet long and two and a half feet high. On one side is a picture of me. Underneath it is a verse George wrote: 'This bedroom holds lots of old memories./There are good ones and bad ones, I fear./But from now on there'll be only sweet ones,/'Cause my darling Tammy sleeps here.' Then, on the other side is a picture of George, and underneath it he put one of his favorite sayings: 'When my hair has turned to silver and affection no longer flows, it is this I ask of you, darling. Will you love me when I am old?' In the center is a picture of Georgette. George put these words under the picture: 'When young love is in bloom and she's happy, I hope he loves her as I love her mom.'

"You know, Ralph, George adores Georgette. He loves nothing more than to put her on his lap and drive around our property on the golf cart in the early morning. Sometimes he takes her on the riding mower when he mows the lawn."

I think the message on that plaque is beautiful. And I love the idea of George Jones carefully planning what he wanted to say, negotiating the logistics of getting it done, running a picture of the new baby to the people making the plaque, and even feeling a little dejected that it wasn't done as soon as he hoped. I also love the idea of George driving his little daughter around the property on a golf cart or a lawn tractor. The only stories we heard later were the ones about his trying to get to a liquor store on that tractor. Back then, the public saw Mr. and Mrs. Country Music in terms of loving messages and scratch biscuits.

I think that's why it broke people's hearts when it all fell apart.

The Eighties:
Contemporary Country
Meets Back to Basics

❖

TNN: Country's
Coast-to-Coast Party

*A*T 8:00 P.M. ON MARCH 7, 1983, I stood in front of the television cameras and said: "Welcome to the Nashville Network. It's a coast-to-coast party and we've invited twenty million people to join us."

Looking back on that launch night makes me think of a line from "I Wish I Was Eighteen Again," the song that George Burns hit with in 1980, and that the legendary Ray Price reprised in the year 2000. Lately I've been listening a lot to Ray's new CD, which includes "Eighteen Again," and I am struck by that song as well as by Ray's still-formidable talent throughout. The line that took me back to the launch of the Nashville Network was this: ". . . going places that I've never been." That's how we all felt, and in an excited way. It was like we were teenagers just starting out on one of life's big adventures.

Bill Anderson said country music fans would recall the date in the same way they remembered November 25, 1925, the day the Grand Ole Opry went on the air. "A hundred years from now they'll still be talking about us," Bill concluded. ·

The Nashville Network (TNN) was a joint venture of WSM and Group W Satellite Communications in Stamford, Connecticut. The cable network enjoyed a record-setting subscriber base of nearly 7 million homes and an estimated 21 million viewers.

I want to talk a little here about the launching of TNN, about its effect on the business through the 1980s, and about its diversity. Many fans were saddened as the 1990s came to a close and country music was all but forgotten in the TNN lineup. I'm sorry about it, too, but instead of lamenting its demise, I'd like to pay tribute to the network by revisiting that first night, by going back to the concept. And what a concept it was.

We'd kicked things off that afternoon with a nationwide news conference from the Opryland studios. And true to form, the country music lovers who happened to be visiting Opryland or who had televisions tuned to the event that day got right down to basics, offering their ideas on who and what the new network should offer.

"This is a blessing out of the sky," said a transplanted Alabama man calling from Washington State. "Keep up the good work."

One man wanted confirmation that TNN would include gospel acts.

An Oklahoma man wanted rodeo coverage.

A North Carolina man called to make sure TNN included his favorite star, John Anderson, on its new shows: "He doesn't get enough exposure."

And to my mind, that was a lot of what TNN was about: exposure for country music. I would bet that if you put up two graphs detailing the growth of country music and the growth of TNN in the '80s, they'd be almost identical. We were able to introduce the new acts as well as rejuvenate older ones. Johnny Russell told me his bookings doubled and tripled from his *Nashville Now* and other TNN appearances. Johnny told me about a show he was scheduled to play in Pennsylvania during the *Nashville Now* years. The promoter was fearful that he couldn't fill the park and nearly canceled. Only when he learned that Johnny had booked another date en route to Pennsylvania and would be in terrible financial trouble did the promoter go ahead with the concert. Johnny arrived via the backstage area, so

he didn't have any idea if he'd drawn 30 or 300 to the outdoor venue capable of holding around 3,000 people. When he walked onstage he saw a standing-room-only crowd. Later, he sold a pile of merchandise, then spoke to the promoter.

"What's a Ralph Emery?" the promoter asked.

Johnny said he had to laugh. That was what people said when they'd seen him on *Nashville Now*: "I saw you on Ralph Emery." And that was what the ticket buyers had mentioned as they streamed in the park that day. Johnny told me his price went from $1,200 or $1,500 a date to $5,000.

In fact, I tried to keep a balance throughout my tenure at *Nashville Now*: a new, unsigned, or emerging artist, an established star, and an older artist, perhaps an Opry member on each show. It wasn't always possible, because booking a nightly variety show is one of the most difficult situations television producers face. But that was our goal.

WSM and Group W referred to the channel as an eighteen-hour per day, seven-day-a-week network built around the city of Nashville and the music that made it famous. And while there were events like tractor pulls and swamp-buggy races, the network promised that the focus would be on Opry stars like Roy Acuff and Loretta Lynn, as well as pop country hit-makers like Crystal Gayle and Rosanne Cash.

In addition to my *Nashville Now* nightly variety show there were *Bobby Bare and Friends*, focused on songwriters; *I–40 Paradise*, a sitcom set at a roadside diner; *Dancin' USA*, a "countrified" *American Bandstand* with choreographer Melanie (Mrs. Lee) Greenwood; *Fandango*, a game show featuring country trivia; *Yesteryear in Nashville*, a music history show something like today's *Time and Again* on MSNBC; and *Country Sportsman*, fishing with the stars; plans called for special productions as well. A half hour of TNN programming might cost $20,000 as compared to the $200,000 a network spent for half an hour.

Dancin' USA, with Jacky Ward as host, was taped a year in advance, with music under the direction of Jerry Whitehurst and a group that would become my *Nashville Now* band. I'm still proud of that bunch of guys—they were among the best in the business as far

as I'm concerned. The inimitable Archie Campbell hosted *Yesteryear in Nashville*. One night they invited me as the guest, and after they taped that I got to turn the tables on Archie and do one of those *This Is Your Life*–type shows on him.

As we got the five-hour premiere special started, I introduced the stars hosting from various locations throughout the country. Bill Monroe and Emmylou Harris were in Austin on the set of *Austin City Limits*, Lynn Anderson and George Lindsay were in Denver, Tanya Tucker and Hoyt Axton hosted from the Palomino Club in L.A., and Tammy Wynette and Don Williams checked in from Chicago. The first person to sing on the *Nashville Now* set that night was Con Hunley, a blue-eyed singer that all the girls loved. Everytime I see Con, I remind him that he was the show's first guest.

When you consider the styles represented by this diverse group— from Bill Monroe's bluegrass to Lynn Anderson's soaring pop to Tanya's edgy soul to Tammy's stone country—I think you can see why I'm proud of the network as an all-around showcase. Nobody said, "Well, *that* ain't country" or "That's *too* country." It all fit under the TNN umbrella.

We had a second Nashville location, the Opry House, which was packed with stars. Even if some were unsure what this new network was all about or if it would work, they came out: Roy Acuff, Patti Page, the Gatlins, Chet Atkins, Ray Stevens, Brenda Lee, Ronnie Robbins, John Conlee, Jeannie Seely, Jeanne Pruett, John Hartford, Ferlin Husky, and the Oak Ridge Boys were all there.

At the time I thought that five hours was a little unwieldy. I had so much more prepared than I could use that I often felt everything was getting away from us. I previewed footage from some young stars-to-be: George Strait in the recording studio; Lionel Cartwright as a regular on the TNN sitcom, *I-40 Paradise*.

I introduced Bobby Bare, who was almost as laid back as Don Williams as he talked about the importance of songwriters to Music City, USA. And Bare's show was a classic, part of an important legacy to Nashville history. These shows ought to be available to the public.

We had some solid advertisers and pitchmen on the debut show:

Tennessee Ernie Ford touted Martha White biscuits and muffins, Fran Tarkington extolled the virtues of National Life and Accident. Kraft was in from the beginning, as was Stroh's beer. As I looked at the old footage nearly twenty years later, I realized what a feat the producer, the father of TNN, my friend Elmer Alley, with help from Buddy Reagan, had pulled off. Even with all the switching of locations, the sound remained pretty good.

Perhaps the greatest thing that happened that night was this: We showed America all that country music was and could be. We showcased the personalities, the diverse talents and artists running from current superstars to newcomers to Opry acts who, though they might not have been in the upper realms of the charts for a few years, were still vital to the business. So as you read through my indulgence, stop and notice the rich and varied medley we offered.

The very first act? Host Roy Acuff, balancing his fiddle on his chin, from the Opry House. Then he introduced the very contemporary near-perfect harmonies of Larry Gatlin and the Gatlin Brothers, who sang three songs: "Sure Feels Like Love," "Almost Called Her Baby," and "All the Gold in California." Next Roy introduced a legend: Chet Atkins, who was backed by an orchestra. Chet chose three starkly different tunes to pick that night—"The Battle of New Orleans," the standard "If I Should Lose You," and one of his favorites, "Dance with Me." For viewers who hadn't seen Chet perform, he stood as a gentlemanly and soft-spoken record producer and label executive, as well as one of the world's greatest guitarists, the likes of which we seldom see. Chet recalled that he'd started out on a 5,000-watt station and now he stood being beamed from a satellite. Then he said something prophetic:

"As strange as it seems standing here in 1983, we'll one day look back on these times as the good old days of country music."

We had some taped portions: Minnie Pearl saluted TNN and Waylon said, "It's about time we had our own network."

Ray Stevens's portion of the show included everything from jazz ballads to comedy. At one point he announced a "punk country" tune: "I'm Gonna Whup Your Car." Then he sang his monster pop and country hit: "Everything Is Beautiful." Cohost Patti Page intro-

duced the "Tennessee Waltz" by saying, "I've sung this song all over the world, but it's most special tonight because the writers are coming up here to sing it with me." She called Pee Wee King and Redd Stewart up, then the Gatlins, then Roy Acuff and Chet Atkins. It was a stirring moment in the night's offerings.

Some other highlights included Emmylou Harris and Bill Monroe live from Austin, Texas. Emmylou's set was another example of country's diverse styles: "Movin' On," "Hickory Wind," and "Born to Run." Rosanne Cash checked in from New York with her stellar band: Vince Gill on lead guitar; Rosanne's then-husband/producer, Rodney Crowell, on guitar; ace musician/producer Emery Gordy Jr. on guitar; Elvis's piano player and now one of Nashville's most important producer/label heads, Tony Brown on keys; Hank DeVito on steel. Every individual in that band has contributed greatly to our music through the years.

Porter "Slick Nickel" Wagoner did a version of "This Cowboy's Hat," today a mainstay of rodeo cowboy and country rocker Chris LeDoux's show. Tanya Tucker and Hoyt Axton were live from the Palomino in L.A. Tanya was just starting on what others—but not her—called her "comeback." Tanya always told me she never went away in the first place. Watching Hoyt—with that larger-than-life personality—makes it all the more difficult to realize that both he and Mama Mae Axton are gone from us.

TNN did a lot for country music through the 1980s and 1990s. As I mentioned, the channel rejuvenated many careers even as it was helping get a lot of careers off the ground. It took a couple of years for us to really make an impact, but we did just that. I debuted a Nashville Palace dishwasher named Randy Traywick on *Nashville Now*, before he was Randy Travis on Warner Bros. Records. I remember first hearing Ricky Van Shelton sing on my show and saying I thought CBS Records had found their George Strait. CBS had a phenomenal response from his appearance, too. In fact, a lot of industry people told me that *Nashville Now* resulted in more record sales and bookings than the *Tonight Show*. Of course it did—we had a target market.

At a recent country radio seminar, a pollster lamented the fact

that the general public only recognizes the names and faces of country's biggest superstars: Garth Brooks, Shania Twain, Faith Hill. That should come as no surprise because the newcomers have few places to go for visibility.

Celebrities from film and television also called for bookings. Mickey Rooney came on the show to help promote his wife's country career. Chuck Conners once phoned and asked if he could come on the show with his songwriter son, who was having a hard time getting started in Nashville. "Nobody wants to give him a break," Chuck told me. Naturally I said yes. I remember that the Nitty Gritty Dirt Band was the first act to give us a gold record and acknowledge the help we'd been in their achievement. In fact, they believed TNN was responsible for breaking "Dance Little Jean" for them. The channel was great because we had so much more flexibility as to the artists we played. Back when the Byrds had come to WSM and trashed me for not playing their record, it was because we simply didn't have cross-genre records. I'd had to tell Buddy Holly the same thing: We didn't have his records either. But unlike the Byrds, Buddy realized I was just the on-air personality and didn't make station policy.

Some artists were skeptical at first, and the labels cared only if we could break a record for them or add to an act's visibility. I had to remind the artists and managers who were trying to help a new single along that my audience expected more than just a new song— they wanted something familiar, too. That's why people attend concerts, after all, to hear the hits. I was happy to help promote the new music, but sometimes I had to ask them to throw me a bone!

Some artists were supportive from the beginning. Barbara Mandrell, Merle Haggard, and Tom T. Hall come to mind as being supportive from the day we started talking about TNN. All three had hot careers going and none of them ever turned me down when I needed them. I remember well calling Tom one afternoon and saying, "Tom, I'm on my way to the hospital to have surgery and you better get over to *Nashville Now* because I'm counting on you to fill in for me!" He did, too.

I don't remember the exact phone call from Elmer Alley, the one

where he asked me to host *Nashville Now*. I do know that he'd been unsuccessfully pressured to hire a hotshot from Los Angeles. Since Elmer knew this guy had neither interest in nor knowledge of country music, he stuck with me as his choice. As he said, I had television experience and I knew the music. I'd spent two years at WTBS doing a weekly prime-time show that was really the precursor to *Nashville Now*. WTBS had planned a series of live shows starting with "Nashville Alive" and "Atlantic City Alive," moving to "Las Vegas Alive" and "Hawaii Alive." Those plans were scrapped when TNN went on the air. In fact, I was on WTBS in reruns for months after *Nashville Now* started. For a while I was everywhere on cable!

The first actual meeting I had about *Nashville Now* with Elmer took place at a restaurant called Michael's on Murphreesboro Road. He got right down to brass tacks: "Ralph, you've got ninety minutes. What are you going to do with it?"

I told him I didn't want a tight format. "I've been flying by the seat of my pants for a long time," I said. "I might as well keep right on doing it."

We kept right on operating by the seat of our pants, and I think that during the years *Nashville Now* was on the air that was a great part of our charm. It was quite an adventure. *Nashville Now* did a world of good for my career and certainly for my ego. I had no idea how much power television held until I started being recognized on trips all over the country and even in Europe. I should have remembered what Mel Tillis told me once. I asked him if his repeat appearances on the *Glen Campbell Goodtime Hour* had changed his life. Mel said: "Oh, yeah. They even know me in Australia, hoss."

Looking back, it would be hard to say who my favorite guests were. I'd probably start with a list that would read Dolly Parton, Barbara Mandrell, Reba McEntire, Johnny Cash, Jimmy Dickens, Bobby Bare, Faron Young, Minnie Pearl, Grandpa Jones, Kathy Mattea, and Tennessee Ernie Ford. That wouldn't even begin to cover the great guest list, though. The show allowed me to meet so many people I might not have met: Jimmy Stewart, then president George Bush, and Mickey Rooney, who said as he left: "Ralph, if you're ever in Hollywood, look me up. I'm the short guy." I'm a big fan of instru-

mentalists, and it was a thrill to have people like Bela Fleck and Sam Bush on the show.

One favorite show involved a visit from Grandpa Jones. Now what you need to know about Grandpa during the mid-1980s is that he was losing his hearing and he was a little forgetful. So one afternoon he rehearsed "Are You from Dixie" with my house band, then walked straight out onstage that night and swung into "Night Train to Memphis." The band recovered quickly and played right along. All of a sudden Grandpa realized what he'd done. He turned and spoke to bandleader Jerry Whitehurst in that loud voice a lot of hard-of-hearing people use: "Weeelll, I changed it!" Then he went right on with "Night Train to Memphis."

Having Roy Acuff live right behind the *Nashville Now* studio was something else. Acuff moved to Opryland after Stringbean was killed. It frightened Roy that intruders had waited for String and his wife to arrive home after the Opry. Roy confessed his fears about living alone to Bud Wendell at Gaylord, and Bud offered to build him a house right on the grounds. Roy watched the show every night, and if he saw something that interested him, he ran over. One night during our audience segment, we introduced a woman to her pen pal of over thirty years. The women's husbands had contacted us about the idea and we loved it. I often had to fight for the audience segment, but it was one of our most popular. On that night, Acuff sat watching the women talking about their thirty years of letter writing and it fascinated him. He was soon banging on the back door, exclaiming, "I want to meet them women!" And Roy loved Shotgun Red as if he were a real person, not a puppet! All of us got to thinking of Shotgun as real, truth be known.

I think a lot of the industry mourns the loss of TNN as a country showcase like they mourn the passing of a friend or a relative. It sure was a good place to introduce an act or to get "up close and personal" with a star. The loss distances the artists from their audiences, especially now that deejays seldom introduce a song by naming the singer.

Still, I can't say I was taken by surprise when TNN lost the country format. I remember that when CBS bought both CMT and

TNN, I told Joy that they'd get rid of one of them. Few companies would keep two country channels. Now with Viacom buying CBS, CMT has the MTV and VH-1 clout, and it's a big hammer. Maybe the three music channels will be offered to systems as a package and it will strengthen CMT. I look for TNN to move out of town. If the channel isn't about country music why house it at the Opry complex? And I do hold out a glimmer of hope for all the viewers who tell me they believe we'll be back one day. I look for Gaylord to consider reentering the country music television market once their non-compete is over in 2001. They've got the facilities, and this is, after all, Music City.

The future has yet to be written, though. And I was reflecting about country music in the 1980s.

Urban Cowboy and Beyond—
All Hat, No Cattle?

\mathcal{T}HE 1980S BEGAN with a magazine article that inspired a movie that inspired a new country craze—cowboy hats and the two-step. The often-criticized Urban Cowboy trend was kick-started by a 1979 *Esquire* magazine article about the crowds flocking to Gilley's honky-tonk in Pasadena, Texas. The Urban Cowboy fad lasted only a couple of years, and at times I think it is overrated as a lasting factor in country trends. Like the "outlaw" days, this seemed as much a media-driven phenomenon as anything. It did result in country dance clubs opening up all over the nation.

The influence it had on radio was both bad and good. The downside was that, as happens any time country gets a boost, radio stations looking for a new format jump on the bandwagon. Then, as soon as the current trend cools, they jump somewhere else. The good side of that situation is that some of the stations who jump on the bandwagon stay on it.

One of the best comebacks I've ever heard to the "death of country music" talk happened at Alabama's June Jam in 1985, which I was emceeing. I was standing backstage with Keith Fowler,

Alabama's booking agent, when a writer from the *New York Times* approached us. This guy was at the Jam to research a story on county music. He obviously had an agenda, because instead of mentioning the 65,000 cheering fans in that audience, he said, "Mr. Fowler, would you care to comment on the demise of country music?" Keith immediately responded:

"Have you looked out front? There are sixty-five thousand people out there. The Yankees didn't draw that well when they had DiMaggio."

I never did see what the fellow finally wrote, but I suspect he didn't use that quote.

I guess the Urban Cowboy phenomenon might be compared to the anticipation when a hurricane is about to hit the Florida coast. I remember when we in the business got wind that John Travolta had made a country music–oriented move at Mickey Gilley's nightclub in Texas. Tension rose until all of a sudden, with a great "whoosh," we saw the movie sweep through the box offices of America. Suddenly even New Yorkers were wearing cowboy hats and boots. Then, when the wind died down, when the hurricane sailed on out of town, talk and fashion trends turned to something else.

If anything influenced the record business, it was the huge sales of the *Urban Cowboy* soundtrack. In retrospect, there is one thing about that soundtrack that keeps getting ignored in the blanket blasts: *Urban Cowboy* was an eclectic offering. This was no bland pop country record, not with Bonnie Raitt and Joe Walsh included. If not for a couple of cuts, it wasn't a country album at all, and in many ways didn't reflect the tone of the movie. The movie was weighted heavily toward country dancing.

It might be interesting to reflect here on just what *was* on the album. It kicked off with Jimmy Buffett's "Hello Texas," followed by Joe Walsh's "All Night Long," Dan Fogelberg's "Times Like These," and Bob Seger's "Nine Tonight." Then, five songs into it, we have Mickey Gilley singing "Stand by Me," Johnny Lee singing "Cherokee Fiddle," and Anne Murray with "Could I Have This Dance." The Eagles' "Lyin' Eyes" followed, and then the Johnny Lee song that came to mean "Urban Cowboy"—"Lookin' for Love." (That

song, by the way, was pitched to Johnny by Irving Azoff, then the Eagles' manager. It was written by a couple of Mississippi school-teachers named Wanda Mallette and Patti Ryan, who'd never had a cut before.)

Right after "Lookin for Love" we heard Bonnie Raitt on "Don't It Make Ya Wanna Dance," followed by Charlie Daniels's "Devil Went Down to Georgia" and Mickey Gilley on "Here Comes the Hurt Again." Gilley's band played "Orange Blossom Special" and Kenny Rogers offered "Love the World Away." The last four cuts were: Charlie Daniels's "Falling in Love for the Night," Bonnie Raitt's "Darlin'," Boz Scaggs's "Look What You've Done to Me," and Linda Ronstadt's "Hearts Against the Wind."

The lesson this album might have taught was that cross-genre records get a cross-genre audience, hence more potential sales, especially when you have a hit movie to back them up. The soundtrack shows how country, pop, and rock can interact wonderfully. And behind it all was Gilley's, a club that, while it was country oriented, featured blues, rockabilly, Cajun, zydeco, TexMex, and even a polka band from time to time.

There was even a follow-up album release, *Urban Cowboy II*, which didn't even have any songs from the film, thereby losing credibility as far as I'm concerned.

Of course, country's popularity seems to grow when other music trends sour. When singles-driven pop in the mid-1970s died down, the outlaw trend was of interest to a new bunch of fans. Urban Cowboy came along when disco and new wave rock were faltering. There's another theory connected to the Urban Cowboy days, and it's a theory a lot of writers drag out every time country gains in popularity. Ronald Reagan took the White House in 1980. Country music became big news again. So, determined some writers, once again "hillbilly" music surfaces every time the country turns more politically conservative. Mom and apple pie. Family values. Then there's the theory that country becomes more popular in hard times, which leaves one wondering about the huge popularity country enjoyed through much of the 1990s with its booming economy.

The 1980s have too often been portrayed as "all hat, no cattle,"

but that decade brought us a great variety of music. I'll talk about some specific artists in this portion of the book. The '80s witnessed Dolly's coming into full flower and the Rise of Reba, as well as the back-to-basics music of Ricky Skaggs, George Strait, and Randy Travis. It doesn't sound like such a bad time to me.

I don't get on crusades against so-called outside influences in this music. I'm not a country purist. I can appreciate hearing Ray Price singing "Heartaches by the Number" back to back with Ronnie Milsap's "Lost in the Fifties." And I know that if a singer wants to sell masses of records, he has to reach masses of people. Eddy Arnold could never have outsold RCA's pop artists without the middle-of-the-road buyer. I don't look down on crossover records, and I can't think of any artist who would turn one down. I remember back when Wilma Lee and Stoney Cooper had "Johnny, My Love" out, with that great guitar passage provided by Hank Garland. They got a little pop airplay and were excited as hell. Another thing that annoys me is when country artists want pop play for themselves, but disapprove of pop artists crossing into our territory.

When all is said and done, our music constantly changes. It is all personal taste, too. Some prefer Skaggs, some Shania. And if the hip critics have a problem with country records being too "middle-of-the-road," I ask, "Who appointed them country music's arbiters of taste?" I think that's the audience's job. I hate it when critics trash an artist because he or she doesn't fit their view of what country music is or isn't. Moreover, I really hate it when people read that tripe and think it's the last word. The public will have the last word.

And in the 1980s, the public liked many facets of country music.

In 1980 the soundtrack of *Coal Miner's Daughter* won Album of the Year at the CMA's and Sissy Spacek won an Oscar for her portrayal of Loretta Lynn. Barbara Mandrell won the Country Music Association's Entertainer of the Year, Emmylou Harris took home Female Vocalist, George Jones won Male Vocalist, and "He Stopped Loving Her Today" won Single and Song of the Year. That song, penned by Bobby Braddock and Curly Putnam, swept the awards shows in 1980 and 1981, and Barbara repeated her Entertainer of the Year win in '81 as well. Anne Murray took home a Grammy for

"Could I Have This Dance," and Willie Nelson won one for Song of the Year with "On the Road Again."

In addition to the smash success of "He Stopped Loving Her Today," the big records of 1980 show a wide diversity: Johnny Lee's *Urban Cowboy* hit "Lookin' for Love," Kenny Rogers's "Coward of the County," Don Williams's "I Believe in You," Willie's "My Heroes Have Always Been Cowboys" and "On the Road Again," Waylon's "Ain't Living Long Like This," Dolly's "9 to 5," and Terri Gibbs's "Somebody's Knockin'." Willie had a huge year in '80 with several albums attaining gold and platinum status: *Willie Nelson Sings Kristofferson, Willie & Family Live,* and *Honeysuckle Rose* (a soundtrack). Waylon, too, remained a major force, with RIAA certifications for albums including *Theme from the Dukes of Hazzard* and *What Goes Around. Wanted: The Outlaws* went double platinum, the first in country music history. But the most gold and platinum went to Kenny Rogers that year: *Coward of the County, Gideon, Greatest Hits, Kenny,* and *Lady.*

Just a couple of facts to take you back to that time: In pop music, the decade of the '80s was dominated by Michael Jackson and Madonna. Prince became R&B's biggest-selling star. In '82, Spielberg's *E.T., the Extra-Terrestrial* started a trend in sci-fi flicks such as *Star Wars, The Empire Strikes Back,* and *The Return of the Jedi.* Television offered *Cheers, Dallas, Dynasty,* and *Hill Street Blues.* In 1980 a house typically cost $87,000 and the average income was just under $12,000 a year. And on Music Row, there was a changing of the guard.

IN THE LATE '70s and early '80s some men came to Nashville who would ultimately take the reins of the country music business. Two who arrived in '77 came from very different backgrounds: Jimmy Bowen was a Texas native who'd been a deejay, a teen idol of sorts, a Los Angeles record producer, a label owner, and an A&R executive. Joe Galante was an East Coast graduate of Fordham with a degree in finance and no A&R experience whatsoever. Yet both men ended up contributing greatly to Nashville music. Three other men hit

town in 1980 and they, too, have become integral to the business: Jim Ed Norman, Tony Brown, and James Stroud. It's interesting to note how the paths of these men all cross in Music City.

Bowen was a teenage deejay in Texas when his friend Buddy Knox got him involved in the recording side of the business. They had a successful double-sided single with "Party Doll," performed by Buddy and backed by "I'm Stickin' with You" by Bowen on the flip side. Bowen laughs and says he stayed in the teen-idol business until the girls stopped screaming long enough to realize he couldn't sing. Bowen went to Los Angeles and his production skills ended up providing him with a brilliant pop career, producing acts including Frank Sinatra, Dean Martin, and Sammy Davis Jr. He founded A.M.O.S. Records, recording artists like Kenny Rogers, Don Henley, and Glenn Frey. In the mid-1970s Bowen tired of L.A. and took some time driving the back roads of Arkansas and Texas, checking out the country music scene. He was no fan of "twang," but he did hear something he liked and in 1977 he moved to Nashville. Here he immediately hooked up with Tompall and the Glaser Brothers at "Hillbilly Central" on 19th Avenue South, where outlaw music was thriving. He started producing, beginning with Mel Tillis, and soon parlayed his A&R savvy and West Coast connections into a series of label-head jobs at Warner Elektra, MCA, Universal, and Capitol. People both respected and feared him, because his modus operandi involved months of rumors of a takeover followed by a "sudden death day" when he swept into the building and fired the entire staff, no questions asked or answered. Of course, many corporate guys have learned the hard way that keeping a staff loyal to the previous CEO can be dangerous, so who knows if Bowen's way was the right way or not. Bowen changed the way Nashville recorded, demanding the switch to digital recording and considerably upping the costs of making an album. He once joked: "I taught the hillbillies how to make a forty-thousand-dollar record for a hundred and fifty thousand." Actually, Bowen made the first digital recordings in any music genre.

The one thing Bowen guarded jealously was Nashville's autonomy. For that reason, he changed the name Capitol Nashville to

Liberty, and he wrested away much of the New York and Los Angeles strangehold on our music. He was smart and he was tough. We won't see the likes of Jimmy Bowen anytime soon.

Joe Galante was a finance and marketing guy who started out in Nashville the same year as Bowen. But while Bowen was hanging out with Tompall Glaser, Galante was working as director of Nashville operations for RCA. His mentors were Jerry Bradley and Chet Atkins. Galante moved up through the ranks and in 1982 took the helm of RCA from Jerry Bradley. Joe appeared to make few mistakes, because RCA owned the '80s as far as sales went. It was the biggest-selling label for eleven straight years and sold 750 million units. Galante signed the Judds, Keith Whitley, Lorrie Morgan, Clint Black, and many other big sellers to the label. From 1990 to 1994, Joe went back to New York as president of RCA's U.S. operations. But when the label's sales started to flag and MCA became the power label, Galante came back to Music City.

You really have to hand it to Galante. A lot of record executives might have shied away from signing the forty-something K. T. Oslin. She was sexy but no sex symbol. She was an outspoken woman in a town very likely to put her in the "pushy broad" category.

I cohosted the first TNN awards show back in the mid-1980s. Sharing my emcee duties were Willie Nelson, the Oak Ridge Boys, and K. T. Oslin. The show opened with a song from the Oaks and our first big special effect: smoke from which the Oaks would magically appear. As the machines were turned on and the stage started to fill up with smoke, K. T. turned to me and whispered, "I guess this is where we start to blow smoke up our own asses." You gotta love her.

K. T. is such a great talent. Her songs are at times powerful, fun, poignant, and, always, meaningful. Good for producer Harold Shedd for bringing her to Joe and good for Joe for inking the contract.

MCA's success can really be traced to the man *L.A.* magazine called the King of Nashville in 1996, one Tony Brown, piano man. Tony was born in North Carolina and started performing with his family at regional church events at a young age. After he graduated from high school, Tony started playing piano for the renowned gospel group J. D. Sumner & The Stamps. He went on to work with

the Oak Ridge Boys, Voice, and the Sweet Inspirations, who opened for Elvis. In 1975, when Glen Hardin left Elvis's band, Tony got the gig and kept it until 1977, when Elvis died. Former Elvis piano player David Briggs told Tony he should talk to Emmylou Harris about a job in the Hot Band, since, ironically, her piano player, Glen Hardin, was leaving.

The next year Tony took a job with Free Flight Records, a pop label under the RCA umbrella. When that closed, he was sent to RCA Nashville, where he discovered a band that would have quite an impact on the '80s and beyond: Alabama. Tony missed playing music, though, and he joined Rosanne Cash's Cherry Bombs. By 1983 he had signed on to work for RCA once again, and this time he brought a new act with him, Vince Gill. To the detriment of Vince's immediate career, Tony was soon offered the job of vice president of A&R at MCA, where Bowen had just cleaned house. After some years languishing at RCA, Vince hooked back up with Tony and took the '90s by storm. Meanwhile, Tony proved to be an A&R executive who saw potential in many nontraditional acts, signing Joe Ely, the Mavericks, Steve Earle, and Nanci Griffith in addition to traditional artists like Patty Loveless and Mark Chesnutt.

A word about Chesnutt: After listening to records on the radio for so many years, I've learned that those with "presence" don't come along every day. I'm not talking about great vocals, or great production or great songs. I'm talking about a combination of the three, plus the perfect technology for the specific recording. It's when a record absolutely climbs out of your radio and becomes a living, breathing presence where you sit. They are very special recordings and very rare. Back in the 1960s, Owen Bradley and Patsy Cline made records with presence. Ray Charles's *Modern Sounds of Country and Western* contained songs with presence. And in the 1990s I will tip my hat to Mark Chesnutt. His records have presence. It's all there in a Mark Chesnutt album: the vocal styling, the songs, and the production.

The thing Tony brought to Nashville was a solid grasp of the many sides of country music and an understanding of a variety of talents. He seems to bring out the best in anyone he works with.

Florida native Jim Ed Norman is credited with helping the traditionalist movement greatly by his signing of Randy Travis and Dwight Yoakam to Warner Bros. Records, and later forming the Warner Western label, which focuses on western and cowboy songs as well as cowboy poetry. Like his MCA counterpart Tony Brown, Jim Ed first made a name in music as a piano player. He was attending college at North Texas State when another student, Don Henley, asked him to join a band he was putting together. Jim Ed accepted and went with the group, Shiloh, to L.A., where they signed with Jimmy Bowen's A.M.O.S. Records. Produced by Kenny Rogers, the band made a few records before disbanding. Henley then joined with Glenn Frey to found the Eagles, and Jim Ed came aboard as an arranger and sometime session player. That job garnered him the recognition he needed to get arranging jobs with artists including Linda Ronstadt and Bob Seger, and to produce the 1977 monster pop hit "Right Time of the Night" with Jennifer Warnes. Jim Ed was soon working with country artist Anne Murray, on (among others) her award-winning "A Little Good News." Jim Ed was introduced to Music City when he opened a publishing company with offices in L.A. and Nashville, and as he began making more frequent trips South, he picked up more production jobs, including Crystal Gayle, Hank Williams Jr., Johnny Lee, Mickey Gilley, and Michael Martin Murphey. In 1983 he was offered the job of vice president of A&R at Warner/Reprise, and in 1984, when label head Jimmy Bowen moved to MCA, Jim Ed became president of the company.

Another man who got here in 1980 is James Stroud, a blues drummer from Mississippi who'd made a name at Malaco Records in Jackson. When Nashville producer David Malloy heard the trademark Stroud sound on those recordings, he decided it was a perfect match for a couple of records he was getting ready to produce with Eddie Rabbitt: "I Love a Rainy Night" and "Drivin' My Life Away." Stroud came to Nashville and was soon one of the most sought-after drummers in town. He was also quick to start producing records, and Jimmy Bowen was quick to notice his A&R talents. And so, as if all roads once again led to Bowen, Stroud went to work for the Texas

maverick executive at both MCA and Capitol. Stroud left Capitol to open Giant Records, which has a tie to another label head, Jim Ed Norman. The man who funded Giant was Irving Azoff, who managed the Eagles. Giant's first million-seller was the Stroud-produced Eagles tribute, featuring nearly every big name in Nashville. He also signed Clay Walker and took him to gold status before leaving to accept the helm of Dreamworks.

Many people played major roles in '80s country, and I don't mean to slight any of them. But as I've said, *50 Years Down a Country Road* is made up of stories about a few of the artists with whom I've crossed paths through the years.

Here are some of the people who I believe made the '80s great:

When the Judds debuted in 1983 with "Had a Dream (for the Heart)," they started one of the longest and most successful duet careers in Nashville's history. Naomi, who was always a great promoter of the act, used to talk a lot about her "homespun" life on my morning television show. She had a wringer washer and a recipe for lye soap. Not long after she started talking about the lye soap, people started writing in and asking for the recipe. So Naomi wrote it out and we sent it to anyone who requested it. One morning I was distracted, and when it came time to introduce "Naomi and Wynonna" I couldn't for the life of me remember those names. So I welcomed the "Soap Sisters," and I continued to do so once in a while even after they were big stars.

When Florida rocker John Anderson switched to country music in the '70s, he brought the genre one of its great voices. Another '80s mainstay, John broke through in 1980 with "1959," following it with a Billy Joe Shaver song, "I'm Just an Old Chunk of Coal (But I'm Gonna Be a Diamond Someday)." Another rocker turned country contributed much to the '80s, Rosanne Cash. In just that one decade she racked up eleven #1 songs, including "Seven Year Ache," "My Baby Thinks He's a Train," "The Way We Mend a Broken Heart," and a remake of her dad Johnny's hit "Tennessee Flat Top Box." Dwight Yoakam stirred things up in the late '80s with his Buck/Bakersfield Sound and K. T. Oslin burst on the scene with her "'80s Ladies" anthem, proving that a middle-aged singer/songwriter really

could stage a breakthrough in country. And then there was k.d. lang, about whom Roy Acuff said: "She looks like a girl, dresses like a boy, and sings like an angel."

The Oak Ridge Boys were certainly a major force in the '80s, adding some classics to country's repertoire: "Trying to Love Two Women," "I Guess It Never Hurts to Hurt Sometimes," and the crossover smash hits "Elvira," "Fancy Free," and "Bobbie Sue." The Oaks had been making music, both gospel and country, for a long time when they took the '80s by storm. Another long-lasting group was the Statlers, who had their first #1 with the country/pop crossover "Flowers on the Wall" in 1965, then had their biggest chart decade in the 1980s with #1 releases including "Elizabeth," "My Only Love," and "Too Much on My Heart." And of course there is the case of Keith Whitley, one of the great country vocalists whose career was shut down all too soon. Who knows what a legacy he might have left us if he'd not died in 1989, a mere five years after he debuted with 1984's "Turn Me to Love," featuring another great country vocalist, Patty Loveless, on harmonies. I never saw Keith drunk. When I was around him, he was always a soft-spoken, serious young man with two great loves: country music and his wife, Lorrie Morgan. Musically, Lorrie came into her own in the years after Keith died of an alcohol overload. She was a mainstay on TNN and *Nashville Now*, then became a major star in the 1990s.

Hank Williams Jr. had been making records since 1964, when as a teenager he released "Long Gone Lonesome Blues." He struggled for his identity for almost twenty years before putting together his definitive Southern rock and country sound in the late '70s and early '80s. He started with 1979's "Family Tradition," and had chart-toppers with "Texas Woman," "Dixie on My Mind," "All My Rowdy Friends Have Settled Down," "Honky Tonkin'," "I'm for Love," and "Ain't Misbehavin'." Once Hank had established a solid identity separate from that of Hank Sr., he could easily cover one of his father's hits, "Mind Your Own Business," and make it work. The record included guests spots from Willie Nelson, Reba McEntire, the Reverend Ike, and Tom Petty. Another point might be made here. Like his father before him, Hank Jr. has the ability to make the audi-

ence feel they are living a part of his life when they listen to his music. That is a rare talent.

In the '80s Alabama became the landmark band of the decade with a pop country, edge-of-Southern-rock style that captured a whole new youth market. Anne Murray and Kenny Rogers became superstars.

All these people deserve chapters—books—about their careers. But to keep from writing a thousand-page tome, I've narrowed the '80s down to reflections on several acts. I want to discuss the tragedy that stopped Barbara Mandrell's career just as it was at its height in 1984. Even though Dolly Parton's defining years were in the '70s, she had more hits and international exposure in the '80s. I want to talk a bit about why she branched out in the 1980s and about the early experiences that gave her the confidence to make those ultimate career moves. And of course no discussion about '80s country can omit Reba McEntire. Like with Dolly, I want to talk about Reba's childhood, where her strength was forged, and to show some of the personal side of this superstar.

Dolly and Reba both sang traditional and pop country and made it work. Then I want to talk about three traditionalists who certainly made this a top decade for country fans: Ricky Skaggs, George Strait, and Randy Travis.

Barbara Mandrell:
My Little Blond Buddy

*W*HEN SHE WAS a child prodigy musician (steel guitar, banjo, saxophone, accordion, bass, and mandolin), veteran musicians dubbed Barbara Mandrell the Princess of Steel. After her chart success (which started in the early '70s, then peaked between 1978 and 1984), music journalists started calling her the Queen of Blue-eyed Soul.

Barbara was born on Christmas Day 1948. Her parents, Irby and Mary Mandrell, raised her and her sisters, Louise and Irlene, in southern California where they played in the family band, often entertaining troops at nearby military bases. When guitarist Joe Maphis heard young Barbara play, he convinced her musician/music-store-owner father to let him take the youthful steel player on his Vegas tour. By 1961 she was touring with Patsy Cline. After attending the Grand Ole Opry in 1968, Barbara decided she should settle in Music City. Here she started playing Printers Alley, and before long several labels got interested, with Columbia offering a contract in 1969. Her first top-10 was a 1970 duet with David Houston, "After Closing Time," followed by a string of singles, the most notable being 1971's

#17 release, "Do Right Woman, Do Right Man," which led to her band's name, the Do-Rites. Barbara's breakthrough chart hit was also a breakthrough for female artists, 1973's #7 "The Midnight Oil," with sexually charged lyrics previously unheard of from a woman on the national charts. In 1975 Barbara moved to ABC-Dot. Amid more so-so charting releases, she had top-5 hits with 1975's "Standing Room Only," 1977's "Woman to Woman," and 1978's "Tonight."

Then, on September 9, 1978, Dot released what would become her first #1 song, "Sleeping Single in a Double Bed." She released one more chart-topper on Dot, "(If Loving You Is Wrong) I Don't Want to Be Right" in 1979. That year she signed with MCA and had another big run of hits including 1979's "Years," 1980's "Crackers" and "The Best of Strangers," 1981's duet with George Jones, "I Was Country When Country Wasn't Cool," 1982's "Till You're Gone," 1983's "In Times Like These," and 1984's "One of a Kind, a Pair of Fools."

Those hits and Barbara's blue-eyed soul and high-energy performances are part of what kick-started the decade. She was the ACM and CMA Entertainer of the Year in 1980; repeating the CMA win in '81; CMA, ACM, and Music City News Female Vocalist of the Year in 1981; won two Grammy Awards in '82; and debuted the amazingly successful *Barbara Mandrell and the Mandrell Sisters* television show in November of '80.

Barbara combined several crucial qualities. She was soulful, progressive yet traditional in her sound, a top stylist with the ability to spot hit songs and one of the genre's all-time best entertainers. If not for one tragic night in 1984, I believe Barbara Mandrell might well have been the undisputed Queen of Country Music through the 1980s.

I want to talk about that accident in this chapter, because I believe it was one of those fateful events that changed the course of music history in addition to the career of Barbara Mandrell. I think the potential for an amazing body of work was lost because of what happened on September 11, 1984.

Barbara and her children had been shopping in the antique malls of Madison, Tennessee, that afternoon, looking for items with which to furnish a log home Barbara and her husband, Ken Dudney, were building for his grandmother. Barbara is one of those people who hates to be told she *has* to do something. She hates interference from what she considers meddlesome laws and unnecessary governmental controls. Barbara Mandrell considered seat-belt laws meddlesome. But something happened as she got ready to leave the mall in Madison. Barbara was horrified to see a station wagon pulling out of a parking space with the tailgate down and young children playing in the back. She buckled up and told Matt and Jamie to do the same.

That is the last thing Barbara remembers until two weeks later when she opened her eyes and saw Dr. David Jones sitting beside her explaining about medication levels. What she knows now she learned from others: how young Mark White, home from the University of Tennessee, crossed over the middle line and hit her car; how a passerby who stopped told daughter Jamie that Barbara looked dead; how Barbara's leg, ankle, knee, and tailbone were badly broken, nearly crushed; how she had a serious head injury; how at the accident scene the emergency crew asked Barbara if she knew who she was and she replied, "Of course, Santa Claus." There were many things that Barbara didn't know during the weeks and months that followed. Wichita, Kansas, radio station KFDI put up a billboard outside her hospital room with thousands of signatures from fans. Even though she was shown the tribute, Barbara knows about it only because people told her.

The public didn't know everything, either, and that includes me. What we didn't know was that Barbara had suffered a terrible head injury. I sent a book to her as a way to pass the time as she convalesced. I knew she'd been considering writing an autobiography, so I got her a book about the Supremes, hoping she'd pick up some pointers. Unfortunately, no one had told me that for months she couldn't assimilate or remember what she read. And the public certainly didn't know that sweet Barbara was cussing like a trooper at everyone who looked at her in that hospital!

"The anger was always there," Barbara recalls now. "It was intense, stayed for a long time, and was most often directed at my husband. Like they say, you always hurt the one you love. The thing I learned, though, is that I can't imagine myself without Ken. Before the accident I'd thought of myself as so independent and self-reliant that I could go on alone easily. I learned I couldn't."

Barbara left the hospital a completely different person at the end of September. "I spoke of myself in the third person," she says. "When I heard my recordings, I had no idea who was singing. They had nothing to do with me. I never wanted to go onstage again. That was *her*, not me. Before the accident I loved to see the tour buses stop by our gates, and I often went down to say hello. After the accident I got upset every time I saw the buses. 'How dare they come here?' I would say to Ken. That was a dramatic change for me. I thought I was losing my mind."

On October 8, 1984, Barbara's fans breathed a sigh of relief. There she was, telecast live from her home, telling the CMA awards show audience she was doing just fine. She was anything but fine. She had to be given a powerful shot of novocaine in her tailbone to be able to sit on the couch long enough to deliver the short message. She had to read cue cards because without them she stuttered.

"Dad and Ken thought it was best to show people I was okay," she later told me. "In reality, I was a nut."

The accident didn't do her career any damage, though. It left physical and psychological damage, but it was Tennessee law that dealt a near-fatal blow to the career of Barbara Mandrell. There is a little-known and misunderstood law in Tennessee that makes it impossible to collect from your own insurance company unless you have a court judgment absolving you of responsibility for the accident. And while Barbara tried to walk without a limp, while she tried to talk without a stutter, her lawyers filed what to them seemed a routine lawsuit against the estate of Mark White. Keep in mind, no money would ever transfer hands between the Whites and Barbara. It was just a formality. Or so it seemed.

When the newspapers got hold of the story, it appeared that

wealthy and powerful Barbara Mandrell was sticking it to the poor parents of a dead college student. Worse yet, when Barbara realized the perception was wrong, her attorneys would not allow her to comment.

"I would have reacted the exact same way many of my fans did," Barbara told me. "When I hear 'no comment,' I think 'guilty'!"

What a fiasco. Before the case could even be heard, Barbara's insurance company—the company into which she and Ken had faithfully paid for years—filed for bankruptcy. And Barbara's reputation was in tatters. I am sorry to report that once again, no one told me that much of the smearing had been kept from Barbara, the daily papers hidden by Ken and Barbara's father, Irby. Years later I interviewed Barbara and read her a couple of letters protesting her actions and Barbara's eyes filled with tears. She hadn't known just how ugly the perception of her was. I wished I could have taken it back, but once the subject was on the table, Barbara pulled herself together and told me a related story.

"My housekeeper went to her son's Little League game and during a casual conversation with another mother mentioned she worked for me. The woman was irate and said, 'You couldn't pay me enough money to work for that greedy woman!' I was devastated."

So was her career. The woman who had been the hottest female entertainer in the business in 1984 watched her bookings dry up and her album sales plunge. Ticket sales are a quick gauge of what is happening with a career because they are based on popularity as well as hit recordings. I also believe that the lawsuit effectively killed her on radio, because she never again had a #1 release. Ironically, at the time she cared more about people's personal perceptions than her career because she never planned to work again. Then her father came to her and said, "Don't let an accident make that decision. Do one more show. Then you make the decision about quitting."

And so on February 28, 1986, I hosted Barbara's "comeback" at the Universal Amphitheatre in Los Angeles. Barbara was scared to death. She was sick to her stomach and crying. She had to have cue cards for every line of every song. She watched as her friend Dolly

Parton, the other woman who ruled the mid-1980s and who opened for no one, opened the show. Then Barbara gathered her band and family in a circle and prayed for courage.

"When I walked onstage I felt at peace," Barbara said. "I still didn't feel like myself. But I felt at peace."

Barbara didn't really feel like herself until she began the healing process of writing her autobiography. It was a wrenching, soul-searching experience, and it helped her put things in perspective. But even though she has now come to terms with the accident, you will never hear Barbara make the empty statement you so often hear about tragedy: "It was for the best."

"Nothing good came out of it," Barbara says. "I didn't turn into some sainted, glowing person because of a scrape with death. The lessons are to buckle up, drive defensively, and be glad you have a safe trip every time you leave home!"

I believe Barbara would have torn up the '80s on country radio. I believe she'd have made more television shows, starred in more movies, and become one of the biggest "divas" in any form of music. Remember, she didn't leave her television series because of ratings—the show was on top. She left because she wanted the time and the energy to continue her monumental recording and touring career.

Barbara made more records for MCA, then moved to Capitol. But she never regained the momentum she had in 1984. A great part of the blame for that can be laid at the feet of Tennessee law, which not only left a wrong impression about a great lady, but kept her muzzled except for this: "No comment." What a shame.

Dolly Parton: A Brain
Beneath the Wigs, a Heart
Beneath the Boobs

*D*OLLY PARTON, the superstar who stood by Barbara's side that night in 1986, is not only one of the most talented, but she is one of the strongest women I've ever met. If there's a way to keep her down, I can't envision it. Dolly could have fit into several sections of this book. She signed a songwriting contract back in 1960 when she was just fourteen years old. And even though her songs didn't hit for some years, that and her subsequent work through the decade would qualify her as a part of Music City's Golden Age of Songwriting. Her defining years came in the 1970s, and I'm sure some would put her in that time frame. But I want to talk about Dolly as a businesswoman, a star, and a decision-maker. I want to talk about Dolly when she rescripted her career, and took some heat for "selling out" her country roots. And I want to tell you about the strong side of Dolly Parton, the side that has powered her through all these decades of change.

First of all, that line in the title is how Dolly says she wants to be remembered. It was around 1977 when Dolly Parton, already a major

star, took stock. She was an important figure in Nashville, a beloved star with legions of fans. She'd had huge hits like 1970's "Joshua," 1973's "Jolene," 1974's "I Will Always Love You," and 1974's "Love Is Like a Butterfly." All these songs went to #1 on the country charts. Yet Dolly often had a hard time paying the bills to keep her show on the road. Sure, she was making money, but it wasn't enough to support all the people she had on salary. She'd cut most ties with Porter Wagoner in 1974, although he produced her records until 1977. But she realized more changes were necessary. She got down to business and started her own publishing company, stepped up the PR machine, and started looking to Hollywood for film roles and for songs with crossover potential.

The year 1977 saw the release of a song Dolly wrote for Porter, and I don't mean "I Will Always Love You." That was, of course, an earlier hit. No, the song I'm talking about is "Light of a Clear Blue Morning," which Dolly wrote just after tying up all the loose ends of the Porter Wagoner business dealings. She told me that while she loved the freedom it gave her, it was a sad kind of freedom, one that made her wish for better spirits. One rainy, gloomy day in Nashville she started writing down how she felt: "It's been a long dark night and I've been waiting for the morning. . . ." Finally she came to the hook, "I can see the light of a clear blue morning." According to Dolly, at that precise moment the rain let up and the sun came out. Then Dolly knew she was on her way.

I won't go into all the details of Dolly's multifaceted career. But I'd like to recall some of the events that were pivotal in the "making of Dolly."

I think it's crucial that children feel that they are each special in some way, and in a family of twelve, it might have been very difficult for little Dolly to experience that. She's told me a couple of stories that make me understand how she gained that early confidence and spirit.

Dolly's mother was a very wise woman. She knew that with twelve children, attention and "special moments" might be hard to find. So she employed the old fable about "stone soup" every few days. She'd tell the children she needed a special stone to make soup,

and that stone would be the perfect ingredient to make the perfect dinner for the family. The children all ran to the river, where, Dolly says, they knew all the most special stones were. When they returned, Mrs. Parton picked one and with that she started the soup that would include many ingredients, but that was started with one stone.

"Mama always seemed to know which one of us was in need of a little special attention," Dolly says. "And that is the person who had miraculously picked the perfect stone."

And of course that is the same woman who made Dolly her famous coat of many colors, the subject of her 1971 top-5 hit. From Avie, Dolly learned that money and things didn't make a child special, it was someone else showing that they were indeed extraordinary.

The other story is a favorite of mine and involves "Aunt Marth," the elderly woman who owned the land Dolly's parents share-cropped. Dolly loves to recall visiting Aunt Marth, who always had some gingerbread or a treat of some sort for the Parton children. But most of all, she remembers a little song Aunt Marth used to sing when Dolly bounced in the door. "The song went 'Tiptoe, tiptoe, little Dolly Parton. Tiptoe, tiptoe, she's so fine,' " Dolly explains. "I couldn't believe there was a song about me, that it said I was 'so fine,' and that Aunt Marth knew it!"

So when you see Miss Dolly on television, funny, spiritual, playful—and as she puts it, "full of it"—remember Mama Avie's stone soup and Aunt Marth's song and you'll understand how Dolly came to be what Burt Reynolds once described as "human sunshine."

The whole Parton family was musical, especially the women. And some of them were doing something professional with their talents. Aunt Dorothy was a gospel songwriter; uncles Bill, Robert, and Louis Owens sang in regional bands; and Grandpa Jake was a talent as well. But it was Uncle Bill Owens who bought Dolly her first guitar and who eventually brought her to Nashville.

Dolly showed extraordinary talent as far as Bill was concerned, and he took her to audition for the *Cas Walker Show* in Knoxville. In addition to getting paid for her appearances, Dolly was allowed to

put some of her self-penned songs down on tape at the television stu-
dio. This turned out to be both a blessing and a curse, because
Dolly's schoolmates teased her mercilessly about being a "star" once
she began appearing on the weekly program. Once they even locked
her in the darkened coatroom. "The one thing I am afraid of is the
dark," Dolly confided to me. "And I honestly thought I'd die in
there." Still, Dolly seems to hold no malice toward any of her school-
mates, shrugging it off even now by saying, "Kids will be kids and
they can be cruel without understanding why."

Her association with Cas was where I first heard of her, as a mat-
ter of fact. Carl and Pearl Butler started talking about this little girl
who sang on the show and in 1965 they brought her to my television
show. A lot has been written about Dolly's Cas Walker days, so I'm
just going to share one story, another favorite of mine. I call it "Dolly
and the Great Greased Pole Caper." Cas Walker owned a string of
supermarkets and he used the television show to promote them. But
as Dolly recalled, the show wasn't his only way of promoting the
stores.

"The Pines Theater ran movies on Saturday afternoon, then had
a live show at night, and Cas would take us all there for appearances.
But it wasn't just the music he used as a promotion tool. He had a
bag full of ideas, including the greasy pole contest. He put up a big
metal pole, greased it, tied a little sack of money at the top, and each
Saturday before our show people tried to shinny up it for the cash. If
nobody could do it, they added to the money prize. One night the
money was up to two hundred and fifty dollars and I decided that
money was mine. I wet myself down and wallowed like an old hog in
the dirt until my whole body was gritty. Then I scooted right up that
pole and grabbed the money. Now some of the folks said it was
rigged because I sang with the show. But Cas walked out there and
said, 'I don't know how in hell you could rig a greasy pole. Dolly won
that money fair and square.' "

That not only brings real meaning to the saying "get a little dirt
on your hands," but it shows Dolly was full of true grit even back
then. The money did present a problem. The Partons didn't have a
television, so Dolly bought one for the family. Unfortunately, the

whole town showed up every night to watch the shows and they wouldn't leave. As Dolly says, they'd watch the test pattern and the "late snow" on that little television. Finally Dolly's father made her sell it so he could get some sleep! That may have been Dolly's introduction to what Tom T. Hall calls "the pain-in-the-ass side of celebrity."

At ten Dolly made a record titled "Puppy Love" on a little Louisiana label, and that got her a spot on the Grand Ole Opry. Soon afterward she played some of the demo tapes she'd made at the *Cas Walker Show* for Buddy Killen at Tree, and he believed in her enough to sign her as a writer. Then, when she was sixteen, Dolly made a second recording, this time for Mercury Records, "(It May Not Kill Me But) It's Sure Gonna Hurt." In 1963 Dolly did an album for marketing to supermarkets. She cut some Kitty Wells songs, and a girl named Faye Tucker cut some Patsy Cline songs, and the album was titled *Hits Made Famous by Country Queens.*

So that was where Dolly stood in 1964 when she graduated from high school. Certainly no beginner, but no real success, either. That's when she hopped a bus for Nashville with her clothes in a little cardboard suitcase. Carl and Pearl Butler became her fairy godparents here, and Uncle Bill Owens started pitching songs they'd written together. Dolly took part-time jobs, including some singing on the Eddie Hill show. Then Carl and Pearl brought her to me. Dolly was still putting that Brenda Lee–rockabilly spin on everything back then, and she used a lot of vibrato. I always thought it sounded contrived and was very happy when she cut down on it. That day she sang George Jones's "You Gotta Be My Baby" with such energy and personality that my audience took to her immediately. I wanted her to come back, but as it turned out she didn't have a car. As I often did with singers and writers without wheels, I offered to pick her up on the days she was a guest. And this brings me to Dolly's husband, Carl Dean.

I have read where Dolly is supposed to have met Carl at the Wishy Washy the very day she got to Nashville. That's not what happened. I know because I was there. One of the days she sang on my show she brought her washing along in a little box and asked me

to drop her off at a Laundromat instead of at her room. I did, and that's the day she met Carl Dean. As Dolly once joked to me, "Ralph, what a day! I got dropped off by you and picked up by Carl!"

Dolly liked Carl immediately. She liked his honesty, his sense of humor (he's a real comedian when he's around people he knows), and his forthrightness. Carl liked Dolly, too. But as everyone knows, he didn't take to show business. "All it took was one BMI dinner and Carl resigned as a showbiz husband," she jokes.

By this time Dolly was signed to Fred Foster, who ran Combine Publishing and Monument Records, but she hadn't put out any records. So when Dolly came to him and said she wanted to marry Carl, Fred discouraged it. "I was getting my flashy image pretty well down by then," Dolly says, laughing. "And Fred didn't think a husband fit the bill!" So Dolly and Carl ended up eloping to Ringold, Georgia. Dolly's wedding actually required three trips to Ringold. Avie Parton came along to witness her daughter's wedding, so Dolly, Carl, and Avie traveled to Ringold on one afternoon but couldn't find a church for the ceremony. Dolly insisted on a church. "It might sound silly, but I wouldn't have felt married," she told me later. They made a reservation at a little Baptist church, drove back to Nashville, then returned for the wedding. The ceremony was performed on May 30, 1966, and Mr. and Mrs. Carl Dean and Mrs. Avie Parton drove back to Nashville once again. But as Dolly tells it, they had forgotten something vital at the church. "Mama had left her purse there," Dolly says, laughing. "She might not have ever noticed it except her snuff was in that purse!" Back they went.

The next morning Dolly was on my television show and confided to me that she was a newlywed. (It must have been a short wedding night.) "Don't you tell Fred, though," Dolly said. The secret was safe with me. I didn't say a word to anyone until a year later when Dolly announced it to everyone.

In 1967 Porter Wagoner asked Dolly to replace Norma Jean on his television show. It seemed like the fairy-tale opportunity of a lifetime, and although the story didn't have a happily-ever-after finish, it did a world of good for both Porter and Dolly. Here is

another character-defining moment for Dolly: Some audiences booed her when she was introduced as Norma Jean's replacement. Dolly understood that country audiences are loyal and that they saw her as an interloper. She just smiled, sang her heart out, and won them over.

Porter arranged for Dolly to record with him at RCA. Fred Foster hated to see her go because he correctly believed that she could be one of the biggest stars in entertainment history. They'd put out two singles, "Dumb Blonde," which made it to #24, and "Something Fishy," which made it to #17. But Fred never held any of his acts back if they had a shot with the big labels, and he was fair with Dolly. Chet Atkins told me he's still embarrassed when he sees Fred after stealing Dolly Parton away from him.

RCA had success with the Porter and Dolly duets, like top-10 releases "The Last Thing on My Mind," "Holding on to Nothin'," "We'll Get Ahead Someday," "Yours Love," and "Just Someone I Used to Know." Dolly's first RCA solo effort was a gutsy pro-woman song called "Just Because I'm a Woman," but it only made it up to #17, no higher than her last Monument release. Her first big success was the #3 "Muleskinner Blues," and Chet says he kept telling people at the label it would have been a #1 if she'd just gotten rid of those wigs. "That shows you how smart I was," he laughs now.

In 1970 Dolly finally got that chart-topper with "Joshua." In 1973 she embarked on a string of #1 hits including "Jolene," "I Will Always Love You," "Please Don't Stop Loving Me" with Porter, "Love Is a Butterfly," and "The Seeker." By 1974 Dolly knew she had to leave Porter to make her own way. As she once told me, "We fought like cats and dogs for a couple of years. I guess you could call it dueling dreams." In the two years she struggled to sever ties, Dolly had no #1 singles. Then, in 1977, she hit with "Here You Come Again." The song sat at the top of the country charts for five weeks and made it to #3 in pop.

Dolly's career through the 1980s was all over the place. She was one of country's biggest award winners, a platinum-selling album artist, a hit singles artist, and a movie star. She launched Dollywood.

She appeared on every television show you could name. Suffice it to say, once Dolly took charge, she could make her tour bus payments.

Some feared Dolly might be spreading herself too thin, that her music might suffer. But while she was making all the other career moves, she racked up more #1 hits between 1980 and 1989 than she had the previous decade: "Starting Over Again," "Old Flames (Can't Hole a Candle to You)," "9 to 5," "But You Know I Love You," "I Will Always Love You," "Islands in the Stream" (with Kenny Rogers), "Tennessee Homesick Blues," "Real Love" (with Kenny Rogers), "Think About Love," "To Know Him Is to Love Him" (with Linda Ronstadt and Emmylou Harris), "Why'd You Come in Here Looking Like That," and "Yellow Roses."

Dolly had the strength and the will to create her future. That is what the 1980s meant to this bundle of human sunshine: reinventing herself. I'll share a little story that an old friend told me about Dolly. It has to do with the early days, before she was a known songwriter and a recording artist, and certainly before she was the larger-than-life persona that Tex Ritter used to call a "real whamdoodler." At least she wasn't a whamdoodler that we knew of.

One day a friend of mine from the 1960s stopped by my office and we got to talking about Dolly. He told me that back when she was trying to get a foothold in Nashville, a fellow cheated her in a business deal. This was pre-Porter, so don't start penciling him into this story. In fact, this story is not connected to anyone in this chapter, so if someone was named here, it's not the person in question.

Anyway, Dolly was a young, struggling writer and someone did her dirty. When Dolly realized what had happened, she talked the incident over with the fellow who sat in my office telling the story. He told her in no uncertain terms that she had the basis for a lawsuit. Did she wish to pursue it? If so, he'd help her. Dolly Parton sat in the chair across from my friend and thought just a minute. "No," she said slowly, thoughtfully, "but I want you to let him know that I know what he did."

That says worlds about Dolly. It says she understood that a newcomer has to be careful about drowning if they rock the boat

too hard. It says she understood that a big brouhaha might do her more harm in the long run than a quick financial settlement would help in the short. It says she knew she'd be around to get the last laugh.

Did she ever.

Reba Nell

\mathscr{H}OPEFULLY THERE'S A GUY out there still walking around who helped a little girl one night in front of the Ryman Auditorium. And hopefully he'll hear this story. It would have happened in the summer of 1961, and this fellow had no doubt stepped out for a smoke. I suspect he was a Nashville native, because if he was a tourist paying his hard-earned dollars to go to the Grand Ole Opry he probably couldn't have been pried out of his seat. I can picture him standing out there on the Opry steps, surprised when a little redheaded, freckle-faced girl came running out and promptly threw up all over herself and the steps. She looked up, embarrassed and a mess. The gentleman went over to her immediately and handed her his handkerchief. She wiped the throw-up off her face and handed the hanky back.

"Oh, that's all right, honey," he said. "You can keep it."

If there's a good Samaritan out there somewhere who remembers helping this little girl, know that Reba Nell McEntire remembers you very well. And says thanks.

According to Reba—who often jokingly refers to herself as "Ruby Macintosh" when she talks to me—the trip to the Opry was one of the very few "real" vacations her family took. Usually the McEntires

spent their summers on the rodeo circuit. "We traveled to all parts of the country to rodeo, and when we had extra time we'd take in all the sights," she recalls. "During that one trip everyone had been sick to their stomach on the drive. Everyone except me. I waited until the night we went to the Opry to start throwing up! We had the cheapest seats you could get, the ones under the balcony. Now, if anyone hasn't ever been in the old Ryman, under that balcony, they won't know that you get 'leaked on' a lot! People sitting upstairs will dump their Cokes over and all of a sudden you realize that something is dripping on your head. Well, I had started feeling bad, but I thought maybe I could hold out until the show was over. But people kept dripping colas and orange sodas and lemonade on me and I finally couldn't stand it. I whispered: 'Mama, I think I'm going to throw up.' Mama loved the Opry so much—and she had seen so many sick kids in the past few days—she didn't even glance down. She said: 'Well, run to the bathroom.' So I got up and went out in the lobby to ask an usher. But by the time I found someone and they were trying to give me directions, I couldn't hold it anymore. I ran straight for the door."

That's when she encountered the gentleman with the hanky.

There's another great story Reba tells about a couple in Nashville. This was an incident that happened during Fan Fair, about the third one she attended as a Mercury/PolyGram artist. "I had zilch success for the first couple of years," Reba recalls. "And when people saw me sitting at the Mercury booth at Fan Fair they'd look at me as if they were trying to figure out if I was 'anybody'— then see the name on the sign next to me and realize I wasn't! It was really awful. I'd sit here with my mama, all those Sharpee pens lined up ready to use and that little stack of pictures. Well, one day a couple took a look at me and made a beeline for the booth. Mama said, 'Look! Here comes somebody!' I grabbed a photo and a Sharpee and was ready for 'em. So up the couple walked. And they asked me for directions to the bathroom!"

Reba laughs at herself easily. And while she takes her music very seriously, she is the first one to point out her personal foibles. That's just one of the reasons she is among my favorite people in this busi-

ness. Once when I complimented her on her recent movie successes and referred to her as a movie star, she winked and said, "I'm probably more of a movie twinkle, Ralph." Then she launched into a long story about wearing her boots on the wrong feet at one of her shows.

She has a tendency to switch the topic from her own superstardom to others in her life. And Reba would rather talk about her son, Shelby, than awards or hit records.

There are two stories from when Shelby was very small that I especially like. The first one involves prayers and dogs. Red Steagall bought Shelby a little dog the family named Chockie, after Reba's hometown. As bad luck would have it, Chockie found his way to the highway out at Reba's place. Reba's husband, Narvel, got Shelby another dog, Freckles, but it, too, escaped and made an ill-fated trip to the highway. Reba tried to soothe Shelby by telling him the dogs had gone to live with Jesus and by remembering Chockie and Freckles in their nightly prayers. "I'd start the prayer and try to include everyone we ever knew," Reba says. " 'Thank you, Jesus, for Grandma and Grandpa, for our friends, for flowers and trees, for Chockie and Freckles.' We went on and on. Then at the end we'd say, 'Thank you, Jesus, you live in our hearts.' One day I thought I'd show Narvel's son Brandon how smart Shelby was, so I said, 'Shelby, tell Brandon where Chockie is.' And Shelby took his blanket out of his mouth and said, 'He's with Jesus.' So then I said, 'Shelby, tell Brandon where Freckles is.' Shelby took his blanket out of his mouth and said, 'He's with Jesus.' Then I thought I'd really show off how sensitive Shelby was, so I said, 'Shelby, where does Jesus live?' And Shelby took his blanket out of his mouth and asked, 'Florida?' "

The second story is just great. Reba and Narvel had been potty-training Shelby. He was cooperating and would run up to Reba and say, "Pee, pee, Mama!" They'd run to the toilet and when he went, Reba would make a big deal over him, exclaiming, "Good boy, Shelby!" Then one time on a trip Narvel was in the hotel bathroom where he shaved and used the toilet. Suddenly from beside him Shelby piped up: "Good boy, Daddy! Good boy!"

I think Reba was raised to be a star. Not in the way you might think—her parents didn't push her. But she was raised to sing, to

work hard, to face down trouble head-on, and to see some humor in everything. She was also a tomboy and proud of it.

Since Reba is now known for her gorgeous stage costumes, I once asked her if she'd worn dresses much as a kid. She thought hard and finally said, "Just at church." Then she got a glint in her eye. The conversation had reminded her of something that just may have played a role in her desire to be a star, standing on the stage in all her feminine glory. "Once when I was in grade school, I was supposed to sing 'My Sweet Little Alice Blue Gown' at a school event," she recalled. "My teacher had a daughter who was the little bittiest thing you ever saw, and with a little work we were able to make her prom gown fit me. I walked out onstage with that chiffon gown and plastic shoes with rhinestone decorations. The lights overhead changed from white to red to blue. I could barely breathe because I felt like Cinderella. In fact, it was better than that. I felt like Dolly Parton."

The McEntire kids all worked hard. When it came time to look for cattle, even the small ones got thrown up on a saddle and pointed toward the brush where strays might be found. Reba says her grandfather looked out for them, calling across the prairie to each child on horseback. Reba would hear him and call back to let him know she heard and could find her way back. I once asked her if she felt like she'd lost part of her childhood doing that sort of work.

"Oh, no," she said. "We played a lot, but it usually had to do with riding and roping. Except for my sister Susie—she liked dolls. But I wanted to ride horses and play rodeo."

"No little-girl toys?" I asked.

"Yes—I did like to play with pots and pans," she said. "And canned goods. Don't ask me why! But my familiarity with the canned goods ended up saving me from being the cook eventually."

"How in the world did that happen?" I asked.

"Well, Daddy sent me to the house one day to fix lunch. I went to the house and got a tin of biscuits out and in the oven. Then I looked in the cupboard and saw a can of green beans. I loved green beans, so I opened it and started heating it up. Then I saw a can of pork and beans and I loved them, too. So I heated them up. Now I started looking for something else, and sure enough, another

favorite—a can of lima beans. Daddy came in and there was his lunch: a biscuit and three kinds of beans. That was the last time I got sent home to cook."

That's just fine. Because Reba was born to sing.

She was born to Clark and Jackie McEntire on March 28, 1954, in Chockie, Oklahoma. Clark was a champion calf roper, and according to Reba, her idea of the all-American hero. "Some kids looked at Roy Rogers and saw their hero," she says. "I looked to my father." Jackie was a singer, and she played a big role in Reba's high school having a music program. "We had a tiny little high school," Reba says. "There were only eighteen in my graduating class. We didn't have a music program or a marching band or anything like that. So mother asked the help of one of the teachers in putting together some classes, which just happened to end up being country and western classes! Our books were Merle Haggard or Glen Campbell songbooks and our homework was learning new songs or guitar chords! We started singing around at 4-H fairs, school events, anywhere we could."

The McEntire kids also formed a band, the Singing McEntires, and in 1971 they even wrote a tribute to their grandfather and released it regionally on a record: "The Ballad of John McEntire." Three years later Reba sang the national anthem at the National Rodeo finals in Oklahoma City. Most stories you read oversimplify what happened next by simply saying that the National Finals was where Red Steagall heard her sing and offered to pay for a demo session. What happened is this: Red was introduced to Reba on one of the nights she performed, then later heard her sing "Joshua" a cappella at the Justin Boots suite at the nearby Hilton. Red asked Jackie McEntire if Reba was serious about her music. "All three of the kids are," Jackie said. "Reba, Pake, and Susie. Could you help them get anything going?" Red frowned. "I don't see how, Jackie. It's all I can do to keep my own head above water in the music business."

So Reba headed back to college and Red headed back to his career. Then one day, out of the blue, he called Jackie. "I don't see any way I can help the three kids right now," Red said. "But let's start by doing some demo tapes with Reba."

Red took the tapes all over Nashville, and as Reba says, "Nobody wanted another girl singer."

One guy who believed in Reba early on was my friend Bill Carter. When Bill signed on to manage Reba, he'd never managed anyone. Bill was an attorney who'd worked with the Rolling Stones when he came to Nashville, and Reba was his first signed client. Not a bad start in Music City. I credit Bill with making Reba a star.

Another fellow who believed in Reba was Glen Keener at Mercury. When Mercury executives told him he had the go-ahead to sign one "girl singer," Glen already had Reba's tape ready to hand them. That's a moment I'd love to have witnessed, when Glen handed over Reba McEntire's demo. But even after she signed with Mercury, things were slow in happening. If the mid- to late 1970s had been as artist-disposable a time as we see now, Reba might never have had the full shot. In fact, on her first Opry appearance the gate-keeper didn't recognize Reba and wouldn't let her and her parents backstage. Her booking agent soon cleared it up, and Reba remembers standing backstage with her father, waiting to go on. He leaned over and said, "Do you know that exactly thirty years ago I won the Pendelton All-Around Cowboy award! It was September 17, 1947." Reba felt great about singing for her cowboy hero that night, but she certainly didn't feel good about the act she had to follow. Dolly Parton made a surprise appearance that night.

"When they told me Dolly had stopped by to sing a song, my knees started to shake," Reba says, laughing. "Then I saw her come down the hall with that blond hair and perfect skin and dressed in black chiffon. I listened to her sing and when it came my turn, the Four Guys almost had to carry me on that stage."

It took four releases to get out of *Billboard*'s lower numbers. In 1978 she made it to the top-20 with "Three Sheets to the Wind" with Jacky Ward, then released five more singles that didn't chart well. The bright spot in those years was her top-20 stirring rendition of the Don Gibson classic, "Sweet Dreams." If anyone was paying attention, they'd have realized that this was a world-class vocalist. Finally, in 1980, Reba got to the top-10 with "(You Lift Me) Up to Heaven." In '82 she had a #3 with "I'm Not That Lonely Yet," and

followed it with her first #1: "Can't Even Get the Blues." Another #1 came with the release of "You're the First Time I've Thought About Leaving," and Reba was off to the races.

About this time MCA Records saw the handwriting on the wall and came calling. Mercury simply didn't have the marketing muscle to take Reba to the next stage. And as much as Reba had come to love her Mercury home and appreciate the shot they'd given her, she also recognized that, marketing-wise, something had to change. MCA offered that change. Her first #1 on MCA was "How Blue," and it made her a national star of major proportions. She had many more chart-toppers in the '80s, but one in particular she believes was pivotal.

" 'Whoever's in New England' opened up the whole Eastern market for me," Reba says. "We filmed the video in Boston, and we saw response from those northeastern states. A response that we hadn't known existed."

Reba racked up eight more #1 singles in the 1980s, and she won an astonishing number of awards. She was named the Academy of Country Music Female Vocalist seven times, the Country Music Association Female Vocalist four times, one of *People* magazine's top three Female Vocalists (1988), and in 1985 she took home a *Rolling Stone* Critics Choice award. She's won both the CMA and ACM Entertainer of the Year. Another change Reba started thinking about in the late '80s was business expansion and the opening of their company, Starstruck Entertainment. Like Dolly, Reba began looking at publishing, management, and production facilities as a way to give her a stronger financial base. She also made the move to booking and concert promotion. Today, Starstruck, with its huge Music Row facility, oversees Reba's publicity, publishing, fan club, management, production, and business interests.

Although talk of the "new traditionalist" movement usually concentrates on the male side of things, it should be mentioned that Reba's country sound was a factor in that era, too. She was country to the core throughout the 1980s, and while she moved toward the pop side of country in the '90s, her contribution to traditional country can't be ignored.

The '90s began with one of her biggest songs, "You Lie," and she never slowed down. Chart-wise, Reba, Alabama, and George Strait appear to have more longevity than any of the early '80s artists. I suspect anyone who counts her out anytime soon will be in for a surprise, because Reba Nell came to town to be a star and stay a star.

THE LAST WORD on Reba: I want to mention something here that's bothered me for a few years. A fellow came to town four or five years ago, spent some time at Fan Fair talking to a few folks, then went back home and wrote a book about his experiences. I won't mention the name of the book, because to tell you the truth, I don't want to be the cause of anyone going out and paying money for it. This guy came to town to write a salacious book and that's what he did. He trashed Reba for not signing an autograph for every fan standing in line to meet her out at the fairgrounds, saying she was "insensitive" to her fans. This guy knew that just by hanging at one autograph signing at one year's Fan Fair. And he never mentioned that Reba had announced that she had a road date that would cut her time shorter than she'd have liked.

The year prior to the one he mentioned, Reba threw an extravaganza at the Municipal Auditorium for her fan club. She provided the food and the entertainment—and, unlike some artists, she didn't ask for a "donation" to help offset the costs. Reba invited me, my agent at William Morris, Mel Berger, and Tom Carter, the guy who wrote my first two books with me. The food was spectacular. The entertainment was spectacular. Reba started signing autographs at around 4:00 P.M. After what seemed like forever, Mel and Tom and I cut out. The next morning I called to make my apologies. Reba was sleeping in. She'd stayed there at the Municipal Auditorium signing autographs and chatting with her fans until the very last one was gone at 4:00 A.M., twelve hours after she'd started. That, my friends, is not a woman who is "insensitive" to her fans.

Back to Basics:

Skaggs, Strait, and Travis

R ICKY SKAGGS IS sometimes overlooked these days as one of the most vital figures of the '8os and the revival of tra- ditional music. I'll bet some of the brand-new country fans only think of him as a bluegrass guy, if they are familiar with him at all. That's too bad, because he made some of the best music of the '8os. He was born to Dorothy and Hobert Skaggs in rural eastern Ken- tucky in 1954 and was singing in church with his mother by the time he was three. Hobert gave his son a mandolin when the boy was five years old, and Ricky taught himself to play well enough to perform at local fairs and festivals. It's difficult to comprehend a five-year-old getting a big career break, but Ricky got his in 1959 when Bill Mon- roe played a show in Martha, Kentucky, and at the urging of the audience, asked the boy to come onstage and perform the Osborne Brothers' song "Ruby." Ricky stepped onstage and wowed Monroe, picking the legend's own vintage Gibson mandolin. The song would work well for Ricky a couple of years later, too, when he played it again, this time for money ($52.50) on Flatt & Scruggs's national television show.

I know Ricky is usually referred to as a Bill Monroe protégé, but I always thought I heard a lot of Flatt & Scruggs in his music.

Ricky hooked up with fellow Kentucky native Keith Whitley in 1969, formed the East Kentucky Mountain Boys, and made quite a regional reputation. The two were so good at imitating the Stanley Brothers that the brothers hired them to go on the road with them. There they stayed through 1974, working their bluegrass style into a perfect sound. Ricky joined up with J. D. Crowe, then formed another band, Boone Creek, with Jerry Douglas. Ricky recorded both with Boone Creek and as a solo artist for independent labels like Rounder, Sugar Hill, and Rebel during this time, and one of his Sugar Hill solo efforts, "I'll Take the Blame," caught the public's attention enough to get some national chart movement in 1980. Meanwhile, since 1977, Ricky had been playing in Emmylou's Hot Band. "I was a 'Hot Bandette,'" Ricky joked back in '83. "That was my first experience with an electric band, and I learned so much from it. It also helped my name get out there, because I'd always played in regional bands until going with Emmylou. All of a sudden, people knew the name 'Ricky Skaggs.'" I asked Ricky what it was like to work for Emmylou Harris, and he likened her to "one of the guys."

"Emmylou is *always* nice," Ricky went on. "You can always talk to her about anything, sound problems, music—you name it. I don't believe I ever saw Emmylou act 'starlike' once in the time we worked together. That means a lot to a picker."

Ricky married Buck White's daughter, Sharon, and produced many of the Whites' records in the '80s. Sharon and Ricky were on my show, and I asked about their two-career marriage. They discounted any problems with the dual careers, but Ricky was quick to point out one big difference between the two:

"I'm a real pig!" he said. Sharon kind of frowned and shook her head, so Ricky backtracked a little.

"Well, I shouldn't say I'm actually a *pig*. But I'm not as neat around the house as I should be. I don't help pick up like I should. I don't do much but music. I don't even have a hobby." By this time Sharon was almost laughing, knowing Ricky was digging himself into a hole. Then his face brightened. "Actually, I do help around

the house. I'm a handyman and a drain-fixer. We had a drain that kept getting slower and slower, and I finally told Sharon, 'I hate that drain!' And Sharon said, 'Well, that drain hates you, too.' So I tore it apart and fixed it."

"He takes out the trash, too," Sharon said with a grin.

"Yes, I do!" Ricky exclaimed. "I'm the drain-fixer and the trash man."

Since Ricky mentioned he had no hobbies, I asked him what he did for fun. He puzzled over that. "I guess it's play music onstage," he said. "I love that."

"What about recording?" I asked.

"No, I don't love that," he said quickly. "There's always a deadline hanging over you and it truly feels like a noose around your neck. I can always count on getting sick during the session. Being onstage is a completely different feeling. There it's about a show and not about a record."

Of course, in the studio Ricky is known to be a perfectionist. "Picky Ricky" is a name he freely admits to as an honest assessment. So I'm sure the freewheeling stage show is a breather for him!

Ricky's likes and dislikes are about as country as it gets, with one exception. For example, he loves catfish, bean soup, corn bread, and the out-of-doors. The exception? He dislikes coleslaw. He also dislikes conceited people and greedy people.

"Do you fish or hunt?" I asked, knowing that was how most guys in country music spent their spare time.

"I fish a little and I used to hunt," he said. "But I don't like hunting anymore." He didn't elaborate on that, and I had to assume that he meant he didn't see the purpose. I've known several former hunters who've said the same.

"You know what Ricky loves to do when he's on the road?" Sharon asked me. "He loves to shop! Ricky is a serious shopper. He haunts antiques malls."

"And vintage clothing shops," Ricky added. "I love the old clothes. Almost as much as I love the old music."

❖ ❖ ❖

RICKY'S LOVE OF the "old music" helped him create a commercially viable sound. After signing with Epic Records, Ricky reevaluated his style and put together a sound that combined contemporary country and old-time bluegrass in a radio-friendly way—no small feat in the middle of the Urban Cowboy marketplace. He did it by removing the banjos, adding drums and electric bass, and relying on smooth, high harmonies that stopped just short of harking back to the Appalachian high lonesome sound. The public loved it. *Waitin' for the Sun to Shine* was one of 1981's finest albums, with singles like "Don't Get Above Your Raisin'," "You May See Me Walkin'," his first #1, "Cryin' My Heart Out Over You," and the follow-up #1, "I Don't Care." For the next five or so years Ricky remained hot, making landmark albums including 1982's *Highways & Heartaches*, 1983's *Don't Cheat in Our Hometown*, and 1984's *Country Boy*.

Three of my favorite Ricky Skaggs songs are "Heartbroke," "Highway 40 Blues," and "Country Boy." Those songs display some of the finest musicianship of the era.

Ricky's tip of the hat to bluegrass helped revive interest in that genre, too. Even though he never tried to pass his new material off as "bluegrass," many people began listening for the instrumentation and found they liked it.

Ricky produced all his own albums as well as Emmylou's brilliant 1980 release, *Roses in the Snow* and Dolly's 1990 *White Limozeen*. He's been named the CMA Entertainer of the Year, *Radio & Records's* Best New Artist, *Billboard's* Artist of the Year, and one of *Musician Magazine's* top 100. He's also taken home four Grammy Awards.

Just as happened with Randy Travis, Ricky's label seemed to lose interest at some point. He changed labels, tried out some indies, then made a big decision. In the mid-1990s Ricky decided to start his own label, Skaggs Family Records. This allows him to make his own music, be it country or bluegrass or a combination of the two. He's counting on the new Americana format for airplay, and he's able to break even pretty fast on his recordings. One thing about it, Ricky Skaggs earned his place in country history and his name carries weight, so hopefully fans won't care what label his music is on.

Ricky has always said he'd rather have talent than name value. Luckily, he has both.

When George Jones asked, "Who's Gonna Fill Their Shoes," one answer would have been Ricky Skaggs, and that reminds me of a story: When Ricky first signed with Epic Records, he showed up at the label's Fan Fair show even though he wasn't performing. "I wasn't invited to perform," Ricky told me. "George Jones was the main act, and he couldn't have been hotter. But I wanted to meet the artists who were coming and hopefully talk to some of the visiting press and disc jockeys after the show. You might say I was hoping to cash in on their good mood after Jones warmed them up!"

Epic had asked me to emcee that show, held at the Opry House. I was happy to do it.

But something happened that night, something that wasn't unusual in the Possum's career. He was a no-show and we were left with a big hole in the lineup.

For his part, newcomer Ricky Skaggs was "just proud to be there." He'd had the opportunity to meet a few stars, and hobnob with some record executives and he was looking forward to doing some "shake and howdy" with the press and deejays. Then someone walked over and dropped the bomb: "Ricky, George Jones isn't here. Can you fill in?"

"I almost fell down," Ricky told me. "I was literally shaking. I figured I had three very big strikes against me. First, the audience had been sitting there waiting for the one and only George Jones. Second, I was such an unknown quantity that CBS hadn't even asked me to be on the show. And third, I was asked suddenly and didn't know if I could pull it off."

Ricky Skaggs proved his mettle that night. There was no house band, and luckily Ricky had a guitar with him. He walked out, performed an acoustic set, and brought the house down. By the time Ricky finished, the audience was on its feet in a standing ovation. His performance impressed me, too, as much as almost any performance I'd attended, whether I was a part of the show or not. And country music welcomed the first of what would be known as the "new traditionalists" into its fold.

❖ ❖ ❖

IT'S IRONIC THAT the man who has become the most lasting sym-
bol for country's traditionalist movement in the '80s started out a
rocker. George Strait wasn't even a country fan in his youth, prefer-
ring British rock and garage bands to honky-tonk and western swing.
George was born on May 18, 1952, in Poteet, Texas, and raised in
Pearsall, just about a hundred miles from the Texas border.

George's parents divorced when he was a child and the boy was
raised by his father, John, a math teacher. Soon after his high school
graduation, he started dating Norma, who had been a year behind
him in school. They wed after she graduated, and George headed to
the army, where, in the 1970s, he first began seriously listening to
the music of Hank Williams, Merle Haggard, and George Jones. One
album in particular changed his musical tastes for good: Merle Hag-
gard's homage to Bob Wills titled *Tribute to the Best Damn Fiddle
Player in the World*. From the moment he heard it, George Strait was
in love with western swing.

"I was too young to remember the Bob Wills days in Texas,"
George told me in 1986. "Once I heard Bob on a record, though, I
was hooked. I started buying up every Wills record I could get my
hands on. At one time, after the Ace in the Hole Band was playing
shows, we could have played a two-and-a-half-hour set of Bob Wills
music."

George spent most of his army life in Hawaii. I reminded him
that a lot of people pay to go to the islands on their honeymoons.
"Norma and I thought about that," he answered with a grin. "We
had a nice long Hawaiian honeymoon. Of course, if you are in the
military, it's not exactly a bed of roses!"

George attended finance school and worked for some time in the
paymaster's office, then moved to playing music. When a new gen-
eral was assigned to George's post, it was decided that the army
needed more live music. The general set about forming four bands:
soul, country, rock, and Hawaiian. George was chosen to sing in the
country band, Ramblin' Country, and by the time he left the army
it was a full-time gig. "It was a great job," he says. "You have two

responsibilities: to perform and to practice! Plus, we got to play clubs in the area on our off time to earn some extra money."

George has some thoughts on this time that some of the new generation of singers looking for deals might learn from. He says the time spent honing his skills was invaluable. "Playing music in the army, and then back in college, gave me experience I badly needed," he told me. "If I'd been offered a recording contract before I put that time in, I'd have jumped at it. And I'd have jumped too soon. I just wasn't ready."

After serving his time in the army, George returned to Texas, where he majored in agriculture at Southwest Texas State. George studied agriculture education, though he had no serious plans to be a teacher. But teaching was part of his family's history, and his grandmother, who, along with assistance from the GI Bill, was paying for his education, was adamant he finish school and have something to fall back on.

George first hooked up with the Ace in the Hole Band at Southwest Texas State. A lot of people know the band's tight sound, but many don't realize that it was already in existence when George Strait came aboard, joining Mike Daily on steel, Terry Hale on bass, Tommy Foote on drums, and Ron Cable on lead guitar. He found the band members much like college students have found roommates throughout time—the band placed a notice on a campus bulletin board advertising for a lead singer. Mike Daily was George's first contact with the "real" music industry, the road that could lead from Texas to Nashville. Mike was the grandson of the legendary Texas producer Pappy Daily, who owned D Records and who produced the first George Jones records. If you listen closely, on one version of "White Lightnin'" Jones sings, "down in Houston, Texas, where my Pappy Daily lives."

George remained in school, but it was becoming clear that he considered music his career, while the study of agriculture was a sideline. The band became a favorite of the college students, with coeds often showing up at gigs carrying Ace in the Hole posters and placards. The band recorded a single on D Records that got some airplay in Texas, and tried to expand their club circuit to include venues throughout the state. "We'd play anywhere," George once said, laughing. "Honky-tonks, bars, VFW halls, and weddings. If there was

room to set up, we'd do it." They started opening for acts like Moe Bandy, Johnny Rodriguez, and John Anderson. George started making the trek to Nashville to do spec recordings, starting with six songs penned by his friend Darrell Stattler. Even back then George had specific things he looked for in a song, starting with a strong melody that didn't sound like a rip-off of anything else he'd heard. If he loved the melody and felt it stood on its own, then he started listening to the lyrics. What songs would he turn down because of content? The only thing he told me he hated the thought of doing was serious cursing in a song. Anything else—drinkin', cheatin', fightin', and even songs that were "sensuous" in nature—wouldn't be ruled out.

One thing might be noted here. A lot of people, me included, advise artists to never pay for these initial demo sessions, saying that if you are good, a label will pay for them. There are a lot of sharks in Nashville only too willing to take your money and give you a mediocre demo in return. On the other hand, there are some honest people helping new artists as well. The truth is, if people like George Strait had to cough up some cash to record, anyone might. Every label in town turned down the Strait sessions, even though one of Stattler's songs, "A Fire I Can't Put Out," would later become a big hit for George.

But George Strait had attracted the attention of a man named Erv Woolsey, who had a club in San Marcos. Erv liked what he heard, and believed George and the band could expand far beyond Texas if given the chance. And so, when Erv Woolsey took a job with MCA Records, he brought George to Nashville and got him a recording contract. Erv put George together with producer Blake Mevis, and this time there was a song on the session that would become a big single, "Unwound."

I first met George Strait at the Fan Fair of '81. His debut MCA single, "Unwound," had just been released but it wasn't making any noise yet. I was at the Municipal Auditorium, since it was before they moved everything to the Tennessee State Fairgrounds. I was set up as a "roving reporter" for WSM, and my old friend Chick Dougherty from MCA brought George over for an interview. The fresh-faced Strait had been signing some autographs, his good looks attracting fans even if they had never heard "Unwound." We talked

for a few minutes and I put him on the air. George has never forgotten that, and brought it up for years to come.

"Unwound" got to #6 in the *Billboard* charts, "Down and Out" to #16, and the third release, "If You're Thinking You Want a Stranger" hit #3. I always kid George about that song because most deejays want to say the title is "If You Think You Want a Stranger." Of course the word "think" doesn't sing nearly so well as "thinkin'," but most deejays aren't singing their intros!

Then MCA released one of my all-time favorites, "Fool Hearted Memory," the Texan's first chart-topper and the beginning of a long run of big hits that continued through the '80s, the '90s, and into the year 2000. I once asked George if the recitation in "You Look So Good in Love" was something he enjoyed doing. Many artists like the effect, others don't particularly care for it. George falls into the latter category. "I sure wouldn't have set out to do a recitation, Ralph," he told me. "But I did and it worked."

"Would you ever do a song that was entirely the spoken word?" I asked.

George just laughed. "No! Don't look for any CB records from me!"

Of course he was referring to all the trucker CB songs like "Convoy," which made me wonder if he had a CB radio, and if so, what was his CB "handle"?

"I have one on the bus, but that's all," he said. "And I'm the Poker Chip."

To see George in his starched Wranglers, you might think Poker Chip was an off-the-wall handle for such a "strait" guy. I asked him about that image one day when he confessed on the air that he was a little fuzzy from the night before. "George!" I exclaimed. "Don't tell me you roar!" George looked up sheepishly and said, "Oh, I'd say I half-roar."

George has had one of country's biggest careers, and he's stayed close to his traditional music. According to the RIAA he is the third-biggest-selling country artist, with nearly 43 million units sold, behind only Garth Brooks at more than 100 million and Kenny Rogers at 80 million. One thing should be noted: RIAA figures are for domestic album sales. Back in earlier times we counted singles, so

that is how, for example, as far back as 1974, MCA Records could report that Webb Pierce had 49 million in sales.

George Strait remains one of the most untouched by fame of all stars. He ranches and lives the life of a rancher when he's not on tour. He hunts and rodeos, is a dedicated family man who spends great amounts of time with his son, George Jr. His son, by the way, has become a strong contender on the rodeo circuit, calf-roping and team-roping. After watching the toll stardom can take on stars, it's reassuring and refreshing to watch one such as George Strait keep everything in perspective.

THE SAME YEAR George Strait brought his Strait country to the airwaves, another traditionalist moved to Nashville. Randy Traywick was born in Marshville, North Carolina, on May 4, 1959. His father, Harold, was a great country music fan, a guitar player who loved Hank and Lefty and encouraged his sons, Randy and Ricky, to play music. Harold ran a construction business, raised turkeys, and bred horses, and he passed along a love of horsemanship to his son Randy. Make no mistake about it—Randy Travis not only knows horses, he loves them. And most love him in return. He once told me he had an Appaloosa that followed him around the yard like a pet dog. And when he was a boy, his father decided to punish him for some infraction of the rules and took his pony, Buckshot, saying that the horse had been sold at auction. Randy was heartbroken for weeks. Finally, when Harold thought he'd learned his lesson, he drove Randy to the pasture where he'd hidden Buckshot. Randy couldn't believe his eyes. He jumped out of the pickup and started running. Buckshot looked up and saw Randy and he, too, started running. When they met in the middle of the field, once again a horse of Randy's reacted like a big lovable dog, and began licking his master's face. That's what makes the end of this next story so unlikely.

Years after Randy became a star he told me about a very special horse given to him by one of his heroes. It seems that Randy and his wife/manager, Lib, were seated next to Roy Rogers and Dale Evans at a CMA Awards ceremony. When Randy went on stage to present one

of the awards, Lib reminded Roy that when she and her husband had last visited the Roy Rogers Museum in Apple Valley, California, Randy had fallen in love with a colt he'd seen, a descendant of Roy's great horse Trigger. Randy loves palominos, and has been trying to breed one with all four white stockings. This colt had two stockings and Randy thought it had great potential as a breeding horse. So Lib sat there and convinced Roy to sell her the colt so she could present it to Randy for a Christmas gift. Now we'll let Randy pick up the story:

"I came offstage and sat down," he said. "Suddenly Roy leaned across Lib and said, 'Your wife talked me into selling you that colt you like.' Lib's mouth dropped open and she said in a big stage whisper: 'Roy! That was supposed to be a surprise!' Roy just grinned. But I did learn that Roy could be sensitive about horses he sold. Some time later, after that palomino had bit me and charged another horse, I mentioned to Roy that he was a little mean. Roy got real serious and more than a little uncomfortable and said, 'Well, Randy, he *is* from California.'"

Randy and his brother, Ricky, played in clubs around Marshville through their teens. And while people loved his music, many worried that young Randy Traywick was self-destructing. He started drinking heavily and doing drugs. Luckily, Randy often played the Country Club in Charlotte, where owner Lib Hatcher saw not only great talent, but a genuinely nice guy who just needed a break. At one point, when he was about to be busted, she talked the police into letting her take charge. In fact, "busted" is a mild word for what Randy faced. The judge he faced that day was fed up with Randy Traywick. When he released him to Lib Hatcher, he said:

"Boy, if you ever come back to my courtroom you'd better bring your toothbrush. You'll be staying."

Randy continued to work the Country Palace, recorded with country star Joe Stampley in 1979, making it to #91 in *Billboard* with "She's My Woman." In 1981 Randy and Lib moved to Nashville, where Lib started managing the Nashville Palace. Randy changed his name to Randy Ray in Nashville and did everything from dishes to stage work. Still, like most stars, he was turned down many times before he got that deal with Warner Bros. I booked him on *Nashville Now*, and industry people started paying a little attention. Still, it

wasn't enough, nor was his live album, *Randy Ray—Live from the Nashville Palace*, recorded in 1983.

I remember having Randy on my morning show before he came to *Nashville Now*. Sometimes I look back on things I have said to artists and wonder what I was thinking. This was one of those times. Randy walked out to sing and I was sitting there chomping on a cigar.

"Are you any good, boy?" I asked.

Randy looked a little startled, and finally choked out: "Yes, sir."

"Good," I said, still chomping on the cigar. "From now on when someone asks you that, you should answer, 'You're dang right I am.' "

One of Warner's promotion guys says he was at the Palace one night and stopped back in the kitchen to inquire as to the whereabouts of the great country singer who'd been onstage earlier. He asked a guy bending over a steaming hot sink of dishwater. The guy looked up and said, "Oh, that's me."

Finally, in 1986, Randy recorded what has now become a country classic, *Storms of Life*, which featured "Forever and Ever Amen," one of the biggest and best songs of the decade. The brilliance of that album lies in Randy's uncompromising presentation, his power styling, and the stone country production. Of all the "new traditionalists," I think Randy Travis had the most impact, reigning as the new King of Country through the second half of the 1980s. Randy isn't the kind of guy who likes to sit around analyzing music or the business. He'll just tell you he sings the kind of music he grew up listening to—the music of George Jones and Merle Haggard. It's gritty and hard-hitting, full of realism and sorrow. Just like you could hear a tear in Tammy's voice, you can hear hard times in Randy's.

It's possible that Roger Miller was thinking of Randy when he accepted his Pioneer award at the ACM Awards in 1988. Roger made a comment that was immediately taken as political, but wasn't meant to be. Roger said country music was the kind of sound that could make you know how hot the bomb was when it was dropped. Roger had to explain himself many times to many overzealous journalists looking for an antinuclear message. What he meant was that country music is out-and-out reality, not a made-for-TV version of life.

One person I want to offer a tip of the hat to in the Randy Travis

story is a woman named Martha Sharp, then an A&R executive at Warner Bros. Without her support Randy might have been washing dishes at the Palace for a while longer, and he might not have found those songs that defined him in the early years. Martha not only "heard" and "got" Randy Travis, she had an ear for a good country song, too. When she retired some years later, Nashville lost one of its secret weapons.

One thing that happened in the mid-1990s involving Randy is a puzzler. Warner Bros. stopped asking his opinion about single releases, and according to Randy, put him on the back burner when it came to promotion. I don't know, maybe he sounded too country. But Randy went over to Dreamworks, one of the new indie labels, and continued to release his true grit country. Last year someone at Warner made the comment that they'd signed a guy who was the "new Randy Travis."

I don't know what was wrong with the old one.

As the '80s wound up, many established acts remained strong: Randy Travis, Alabama, Ronnie Milsap, Ricky Van Shelton, George Strait, Hank Jr., Reba McEntire, Tanya Tucker, and others. And some new guys stepped up to the plate. Georgia's Travis Tritt scored big in '89 with his Warner Bros. debut, "Country Club." That same year RCA's Clint Black had the first of a string of chart-toppers with two #1 releases: "A Better Man" and "Killin' Time." Capitol's Garth Brooks didn't make quite as much noise as Clint, but his first two releases certainly grabbed some industry attention: "Much Too Young (to Feel This Damn Old)" and "If Tomorrow Never Comes." Billy Ray Cyrus was waiting in the wings and would take country radio and video outlets by storm with '92's "Achy Breaky Heart." Alan Jackson debuted in 1989 with "Blue Blooded Woman," then hit with "Here in the Real World" the following year. After struggling on the charts for almost the entire decade of the '80s, Vince Gill hit in 1990 with "When I Call Your Name." Every one of these guys made their mark, and the '90s also witnessed a brave new world for women artists: Mary Chapin Carpenter, Lorrie Morgan, Trisha Yearwood, Shania Twain, Faith Hill, and more. But one artist dominated the decade, and that artist was Garth Brooks.

PART 6

The Nineties: Country Explodes

The Garth Factor

*I*N MY SECOND BOOK, 1993's *More Memories*, I predicted that Garth Brooks would have staying power that outlasted many of the acts that broke in 1989. The reason? It wasn't his extravaganza stage show or his marketing abilities but the fact that he seemed willing to continue to dip into Nashville's songwriting well for songs. A lot of artists appear to ignore the fact that Music City was built on songs and remains the songwriting capital of the world. They want to write their own tunes, and that's fine as long as they can compete with the vast talent of the writing community. And while Garth has certainly written a lot of his own songs, he appears still to look to Nashville publishers for new material. And he's helped open doors for a lot of writers who hadn't had many major cuts, too. It doesn't seem to matter to Garth and his producer, Allen Reynolds, whether the writers are among the "in crowd" or not. I've heard that between Garth, Allen, and the management and productions team, they go through over three thousand songs a year preparing for recording sessions.

Here, I think, is the reason Garth became the big winner in a "Hat Act Battle" the media seemed determined to stir up between Garth and Clint Black. Clint's debut on RCA, *Killin' Time*, burst on

the airwaves with four straight *Billboard* chart-toppers: "A Better Man," "Killin' Time," "Nobody's Home," and "Walkin' Away." The press took a look at the two artists and decided to turn it into a horse race. Keep in mind, Alan Jackson's first single, "Blue Blooded Woman," sent to radio on October 21, 1989, went only to #45. His next three singles, "Here in the Real World," "Wanted," and "Chasin' That Neon Rainbow" (all 1990 releases) were top-5 records. But the sex appeal of the dueling Black/Brooks albums seemed to catch on. I believe that by the end of the 1990s it is Alan Jackson who has emerged as the premier traditional country vocalist. But back then he was running a distant third as far as the press was concerned.

Several magazines even suggested that Garth and Clint pose together for articles about the perceived competition. Garth flatly refused, disgusted at the whole idea of turning it into a contest. Once "Friends in Low Places" hit, the "horse race" was over and Garth had crossed the finish line first. Clint, while he has remained a vital artist in country music, has not become the superstar many were predicting he'd be. I think two things came into play. First, Clint should have followed Garth's example and dipped into that legendary Nashville songwriting well. Too many of his songs, cowritten by Clint and his band member Hayden Nicholas, sounded similar. The other problem may be that Clint moved to L.A. and his energies weren't always clearly focused on his music. Even Randy Travis, surely one of the biggest stars in country, wasn't able to pull that off. When he moved out of town and started thinking "movie star," his recording career suffered. In 1999 Garth, too, seemed to have a case of film fever, having opened a film production company in Hollywood several years earlier. As we all know, he released his Chris Gaines album as a way to promote the company's first film, the story of a doomed rock star. Critics panned the album, and the film is on hold for now, although people in Garth's camp say it will be made. But whatever long-range effect this end-of-the-decade move will have, Garth Brooks redefined country music's possibilities in the '90s.

He showed country that it could sell bigger than rock and pop and that a country star could be as big as any rocker out there. It's

appropriate that *50 Years Down a Country Road* use these two men as "bookend" acts: Eddy Arnold and Garth Brooks. The two artists have so much in common. They both love all kinds of music, although their first love is country. They have smooth, accessible voices. They both found audiences far afield from the honky-tonks while keeping a country fan base intact. Both were criticized for what some considered a straying from traditionalism. Both are astute businessmen. Even at their pinnacle, both are comfortable driving themselves around Nashville while some lesser artists hail limousines. There have been other larger-than-life stars: Johnny Cash, Willie Nelson, Kenny Rogers, to name a few. And of course Elvis was not merely a music legend, he became a worldwide icon. But if Garth Brooks reminds me of another superstar, it is Eddy. And as I said when I started this book, don't ever underestimate what a monumental figure Eddy was in this entire industry, not just in country.

There is a difference in how the industry reacted, though. No one seemed to expect every act to be a repeat of Eddy Arnold or Johnny Cash in either sales or style, but we seem to have jumped on the clone bandwagon after Garth. And executives wanted those mega sales. They wanted another Garth Brooks. Sometimes Garth takes the heat for this trend, although many in the industry agree that's shortsighted. Emmylou Harris recently noted that in no way could Garth be blamed for the fact that record companies were trying to duplicate him and his success.

I should note that the man who signed him to his recording contract, Lynn Shults, died in '99. Lynn was the A&R guy who heard Garth sing at the Bluebird Café and convinced Capitol label head Jim Foglesong that the kid from Oklahoma had potential. Garth's debut album was just hitting the streets when music mogul Jimmy Bowen took charge of Capitol and fired the whole staff, including Foglesong and Shults. Lynn went on to work for a couple of publishing companies, Atlantic Records, and *Billboard,* and he'd just taken a job out of the music industry when he died of a sudden heart attack. He was only in his mid-fifties. Lynn was a good guy with an ear for hit songs and hit artists. It was a loss to the industry.

When Garth recorded his first album for Capitol Records in 1989

(*Garth Brooks*), he says he was scared to death, hoping to do nothing more than make the people back in Yukon, Oklahoma, proud. That he did. After the debut single, "Much Too Young (to Feel This Damn Old)," made it to the top-10, the album contained three #1 hits: "If Tomorrow Never Comes," "Not Counting You," and "The Dance." Garth told me that "If Tomorrow Never Comes" quickly became his signature song and "The Dance" his most requested.

Those singles were quite a beginning. I thought "Much Too Young" was a dynamite radio record. The follow-up, "If Tomorrow Never Comes," completely switched styles, from rowdy to poignant, and it touched a lot of people. And "The Dance," with a well-thought-out video, made him a major star.

Garth Brooks became the biggest-selling country album of the '80s, selling 9 million units over the next decade. From the beginning, Garth worked with Allen Reynolds, who had come to Nashville with Sun Records' Jack Clement (Jerry Lee Lewis, Johnny Cash, Charley Pride). Reynolds had done some great work with Don Williams, Crystal Gayle, and Kathy Mattea. But he was by no means the producer du jour in Music City. He was a laid-back person who seemed more intent on finding the right project than on padding his bank account. In Reynolds, Brooks found a safe home—a mentor who would be a major factor in keeping the trappings of stardom from consuming him.

Garth said that by the time he recorded *No Fences*, he was no longer scared. "I was confident and calm," he reflected. "It was like stepping up to the plate and knowing that you can hit the ball." The first single, "Friends in Low Places," quickly became the hottest song in the country and a college anthem, with students lined up outside campus bars singing the "Low Places" chorus while waiting for the doors to open. Three more hits followed, including the controversial "The Thunder Rolls," which was accompanied by a video depicting domestic violence and was banned by TNN. The move cut Garth to the quick. He got the news a day after sweeping the Academy of Country Music Awards, where he won Song and Video of the Year ("The Dance"), Single of the Year ("Friends in Low Places"), Album of the Year (*No Fences*), Male Vocalist of the Year, and Entertainer of the Year.

No one seemed able to say which was objectionable: the violence or the idea of a woman shooting the drunken, violent husband—played by Brooks in disguise.

Garth was asked to record a disclaimer on the end of the video, one that pointed women to domestic shelters rather than take the law into their own hands. He went to TNN, taped an announcement, but called later and put a halt to the whole idea. To add this, Garth felt, was to try to get a video played on the backs of hundreds of thousands of abused women. Instead, Capitol's PR firm, Gurley & Co., started a phone bank, hooked into shelters and counseling services throughout the nation, which with little fanfare became a kind of information clearinghouse. In my second book, *More Memories*, I took Garth to task for this. Maybe I was wrong. Women around Music Row reported that for months conversations focused on abuse, with women confessing they'd been victims to friends they'd previously kept in the dark. The video and the surrounding furor focused much-needed attention on one of society's dark little secrets.

"The Thunder Rolls" took the heat for like videos to come, most notable Martina McBride's "Independence Day" and the Dixie Chicks' "Goodbye Earl."

Garth's feelings about the matter were no doubt assuaged when he got word that *No Fences* was on its way to being the biggest-selling country album of all time, unseated only recently by Shania Twain's *Come on Over*. *No Fences* sits at 16-plus million and *Come on Over* at 17 million, Twain's effort outdistancing Alanis Morissette's *Jagged Little Pill* and making it the bestselling album ever released by a female artist in any genre. But Garth should feel all right, because about the same time *No Fences* lost its top spot, his *Double Live* was certified at 13 million, matching the record previously set by Bruce Springsteen & the E Street Band's *Live*. And Garth's label, Capitol, is probably feeling just fine, since they not only have the Beatles catalog of 113-plus million albums sold, but Brooks's 100-plus million sold, and Kenny Rogers's 80-million in sales. Garth's sales change so rapidly that by the time you read this the numbers will probably be much larger.

In 1991 Garth released *Ropin' the Wind*, an experience he likened

to a car race: "You're right behind the lead vehicle—which was *No Fences*—and there's a calm space created for you. In a race, the two cars actually help each other, and I think that's what happened with *Ropin' the Wind* and *No Fences*."

Spurred by five big hits, including a cover of Billy Joel's "Shameless," *Ropin' the Wind* made *Billboard* history on September 28, 1991, as the first album to enter the *Billboard* top 200 chart and the *Billboard* Country Chart at #1 simultaneously. It has since sold some 14 million albums. The interesting thing about *Ropin'* is the diverse music, which ranged from rockin' rodeo to crooner-style balladeering to pop to honky-tonk.

In '92 Brooks released two albums, *Beyond the Season*, a Christmas album, and *The Chase*. There were rumors starting in Nashville about a conflict between Bowen and Brooks by now. For one thing, Brooks announced he was donating a portion of the proceeds of *Beyond the Season* to a children's charity. Bowen then upped the price of the CD by a dollar, a move Brooks reportedly hated. And *The Chase*, an intensely personal album with songs like "We Shall Be Free," which denounced prejudice against gays and others, did not receive the marketing budget the earlier albums had received. This remains one of Garth's favorite albums, so it is not surprising that cutting his marketing budget rankled him. Especially considering the fact that Bowen was on a signing spree, spending Garth-earned label dollars for one new project after another. Add to that the fact that Bowen, for no apparent reason, fired Garth's biggest ally at the label, marketing VP Joe Mansfield, and you've got a big trust gap getting bigger.

Word on the street was that Bowen wanted to fire Allen Reynolds and step in as producer. Brooks would have nothing to do with it. He renegotiated his contract and got complete control over his recordings. In many ways Bowen was the immovable object and Brooks the irresistible force.

The public couldn't seem to get enough of Garth Brooks. He appeared on the cover of every magazine in the country including *Forbes*, which declared "Country Conquers Rock." Finally he

declined more magazine photo shoots, saying, "Even *I* am getting sick of seeing my face on magazine covers."

In 1992 Garth added *Billboard*'s Top Pop Album Artist to his long list of achievements. *In Pieces* was released in '93, with *Rolling Stone* putting Garth on the cover and saying, "If Garth's sales have propelled country music into the mainstream, he has achieved them by exploding country stereotypes."

It's funny, isn't it? That's what is always said about those huge country stars like Eddy Arnold, Johnny Cash, Marty Robbins, Willie Nelson, and Dolly Parton. It's as if the writers don't understand that this has been going on for a while. And it isn't country music artists or industry types perpetuating narrow stereotypes.

During the early 1990s I could always count on country fans asking me this question: "What kind of a guy is Garth Brooks?" I once mentioned that to Garth, and he grinned and said, "Well, that's a coincidence. A lot of fans ask me what sort of a guy Ralph Emery is, too."

A lot of singers are tough interviews. It's pretty hard to get Don Gibson to open up about things, and Don Williams is a quiet guy. But Garth Brooks is an easy talker. He's also always seemed to be a gentleman, a caring guy who has a lot of empathy for other people. Back in 1991, when Garth was basking in the glory of *No Fences* and "Friends in Low Places," I asked him how he handled this newfound fame. I'd seen fans mobbed around, hoping for autographs that time wouldn't permit. Did that bother the personable young man?

"There was a time, and it wasn't that long ago, that I had time for everyone," Garth reflected. "I always remember that show in Aniston, Alabama, where nine people showed up at a club designed for twenty-five hundred. It was a show arranged as a part of Capitol's tour support, and it was right after my first single, 'Much Too Young (to Feel This Damn Old),' was released. The security Capitol hired involved more people than those who attended the show!"

I asked Garth what he did—did he beg off or play the show? "Oh, sure, I played the show," he quickly responded. "And once I started playing, it was as if there were nine thousand people there."

Then Garth got very serious.

"It wasn't long after that that I was lucky enough to be opening a show for George Strait. Of course, since it was George, we were playing to a huge crowd—maybe seventeen thousand people. After I did my opening act, one of the security guys brought me a note that read, 'Garth—We're proud of you! From one of the Aniston 9.' I ran straight to the gate opening onto the crowd area and asked the guy there if he could see the person who'd brought it. He said it had been a young woman who simply handed him the note and vanished into the crowd. I stood here looking out at the people cheering for George, clutching that note, and I'd have given anything for that girl to come back so I could tell her how amazing it was to know I'd made one of that Aniston audience proud. That was quite a night. Because I not only made a fan proud but I got to open for one of my heroes."

"And now some of your heroes must be opening for you," I suggested. That's how it works in this business. The legends have careers that cool, and, legend or not, if they want to work, they often open for the "next big thing." I asked Garth to talk about some of his recent opening acts. He was clearly uncomfortable with the concept and ducked the question.

"I feel silly that some of these people are opening for me. It's a sacrilege. I have so much respect for these stars, and when it comes to talent, they outdistance me. So what is happening is that because of a few years' difference in age or career length I am now going on after them? It's just not logical."

I suggested that the music business worked that way, and Garth got very quiet. "Yes I know. And when you start to see it firsthand, it makes you feel lousy."

I knew he wasn't going to be specific about any of the opening acts, so I asked him about a man I knew to be one of his heroes, a man who was at that time having some problems getting his singles up the charts. George Jones hadn't had a solo hit since 1987's "The Right Left Hand." His 1990 hit had been a duet with hot traditionalist Randy Travis, "A Few Ole Country Boys."

"Garth, the first time I ever talked with you, you said meeting George Jones was a frightening prospect. Have you now met him?"

"Yes," Garth said with a sheepish grin. "The first time we talked, I'd played three shows with George Jones, and I'd ducked him every time."

Ducked him?

Garth nodded. "George Jones is a god in this business. I felt like meeting him would somehow make him mortal, and I liked him right up where he was. Then one day when I was doing a TNN *Viewers' Choice* show with Lorrie Morgan, Shelby Lynn, Clint Black, and George Jones, I finally spoke with him. But it wasn't because I didn't try to duck out first! I finished one of the rehearsals and was easing out the side door to the bus when I heard that unforgettable voice: 'Mr. Brooks.' Can you believe that? George Jones was calling me Mr. Brooks. I felt a shiver right down my spine. So I turned around, and he stood there, hand out. We shook hands, and I was amazed at how big and powerful his hands are, what a big, firm handshake he has. And at the risk of sounding hokey, I looked in his eyes and saw the soul of country music—the pain, heartache, hard living, hard times, and the joy and humor, too. He looked in my eyes and saw tears welling up. I think it embarrassed him, because all he said was 'Hi, I'm George Jones' and walked off. I felt like I'd been struck by lightning. There's an aura about George Jones. It's the same with Loretta Lynn. When she walks in the room, she absolutely commands attention. But what happened next will tell you a lot about George Jones. He started coming up to me during the rest of the rehearsals, kidding around, whispering a joke in my ear—anything to put me at ease. It worked, because by the end of the day I could—almost—carry on a conversation with him."

Garth thought a minute, then added, "So many times you hear about people meeting their heroes and they aren't what they've appeared to be. George Jones was all I could have dreamed of and more."

I asked Garth what he'd do if Jones called him up and wanted to sing a duet with him. "Oh, I guess I'd find his house by the time he could hang up." Garth laughed.

I then brought up the other Garth Brooks hero, George Strait. What is it that drew Garth to these two singers? Here was a guy who admitted to listening to KISS more than country during college. Why those two?

"It's the honesty," he said. "George Jones and George Strait have stayed true to themselves no matter what. Probably the biggest temptation in this business is to try to change to meet everyone's needs. You just can't do it, because you'll end up being a here-today-gone-tomorrow fad. If you change, it has to be because that's how you feel, not because someone else is demanding it. These two men answer to no one but themselves. You have to respect that."

I think that's pretty much what Garth was asking for, to have no one to answer to except himself when it came to his career. It's not that different from what Bobby Bare wanted, what Waylon and the rest of the "outlaws" wanted. It's too bad Bowen and Brooks couldn't solidify their relationship. They are surely two of Music Row's great minds when it comes to making and promoting music.

In 1995 Bowen had a cancer scare, came through the surgery and treatments completely cured, and then retired. EMI then hired Brooks & Dunn producer Scott Hendricks to succeed Bowen. Since Hendricks was also an Oklahoma boy, you'd have thought he and Garth might have enough in common for the new regime to work. But reports at the time indicated that Scott did little to assure Garth that, as the artist paying top management's salaries, he would receive his well-deserved due when it came to the marketing efforts. In fact, Scott walked on to Garth's bus and introduced him to Trace Adkins, calling the newly signed artist "the next Garth Brooks." Not the sort of offhand comment a star wants to hear when looking for reassurance. It probably made Trace uncomfortable, too. There was another problem, too. One executive was known to down more than his share of drinks at a local watering hole, then hold court, often speaking disparagingly of Garth and other Capitol artists.

When things came to a head, Garth backed Pat Quigley, the New York marketing guy who'd supported him the most once marketing guru Joe Mansfield had been fired. None of the real problems made it to the front pages. It simply looked as if Garth was throwing his weight around. And in retrospect, Quigley may not have been a wise choice. He was under fire from the day he came, whether it was for his belief that Patsy Cline was alive and available for duets with Capitol artists, his seeming disdain for stone country music, or his

favorite joke: "What do you call a New Yorker in Nashville?" Answer: "Boss."

And now, in 2000, Quigley is gone from the label. As of this writing, no one knows what will happen at Capitol. Corporate buyouts are rampant and have left all of Nashville wondering where the next paycheck is coming from.

Garth Live from Central Park, which drew some of he biggest crowds in New York's history and became HBO's most successful live event, proved that Garth remains one of music's most important figures. And the hoopla over the fact that his later sales haven't matched *No Fences* and *Ropin' the Wind* says more about the business than about Garth Brooks. The downside of a monster-selling album or a huge debut is that wags will always say you're slipping if you don't repeat it every time.

I've never seen Garth as a great vocalist, good, but not great. He is certainly a great entertainer, and he most assuredly has a personal charisma that made him universally accepted. Yet I still hear criticisms that make little sense. Kinky Friedman, for example, loves to quote himself calling Garth the "anti-Hank." I'm not sure what that means. Hank certainly thought in commercial terms. He was highly competitive, and he wanted those hit records. "Ole Hank" also referred to himself in the third person, as Garth often does. In fact, I could see Hank turning in a helluva performance on "Friends in Low Places." And you can't try to compare people and personalities from such different cultures, anyway.

When all is said and done, I am reminded of something Asleep at the Wheel's Ray Benson once told Huey Lewis, who was at his peak and taking critical hits: "Everybody's gonna try to tackle the guy carrying the ball."

Shania and Nashville:
Never the Twain Shall Meet?

WITHOUT A DOUBT, Shania Twain is the most visible woman in country music. Although it looks as if Faith Hill is gearing up to give her a run for the money, as things stand now, Shania dominates when it comes to sales and media coverage. She's won nearly every award country music has to offer and has been on the cover of everything from *Rolling Stone* to *Esquire*. Still, her success was accompanied by a downside that has now become more of a story than her music.

Shania didn't make much news until she teamed up with pop writer/producer Mutt Lange, who became her husband about the same time he became her producer. Her debut on PolyGram had only two charting singles, and they both stiffed at #55. They did, however, have videos that caught Mutt's eye, and he called the singer asking for an autograph. Shania says she'd never even heard of Mutt or his work with acts like Def Leppard or Bryan Adams. "I think I misspelled his name on the autographed photo," she said later, laughing.

Mutt invited Shania to Europe, where the two traveled together,

wrote songs, fell in love, and ultimately were wed in Paris. The next thing Nashville knew, there was a single on the radio called "Whose Bed Have Your Boots Been Under," a sexy video, and a new star rising. The song made it to #11, and the follow-up, "The Woman in Me," got to #14. But the third time was the charm for this album, and "You Win My Love" hit #1, as did release #4, "No One Needs to Know."

Around this time some folks in Nashville began theorizing. Who was Mutt Lange anyway? Was Shania the studio creation of her pop-producer husband? She announced she had no plans to tour in support of the album. No tour, no talent, some speculated. Some were put off by Shania's midriff-baring videos. The artist said she couldn't understand all the fuss about a video, and the naysayers called her strictly a video star. Her label head, Luke Lewis, admitted that he'd known all along she'd be a video star and that her break would come from the visuals. Still others grumbled that Shania was all about looks and not about music. And weren't some of those guitar riffs borrowed directly from Def Leppard tracks?

She's now broken all the records for female vocalists. She's crossed over into pop territory and is being called a pop diva. Interestingly, the doubting Thomas stories from Nashville have now become a part of her own publicity machine. If you watch *Behind the Music*, the VH1 special on her, you'll see an entire video profile based on the alleged shunning of Shania.

I'm not sure the bashing was ever quite as bad as the press or Shania or Mercury/PolyGram president Luke Lewis now sees it. "The trouble with Shania" wasn't the daily gossip that revisionist history would have it. I remember very few lunch conversations with industry people about Shania's music. There was some head-shaking and eyebrow-raising, but there were also kudos coming from producers who appreciated Mutt's studio work.

Her story was assuredly that of a country song, full of pathos and, ultimately, triumph over tragedy. As we know, the native of Timmons, Ontario, Canada, lost her parents in a car wreck when she was twenty-one years old. She was forced to move back home from Toronto, where she was pursuing a music career, and take on the

raising of her brothers. And she knew it was not going to be an easy task. Shania admits she felt like bolting for deepest Africa, where no one would ever see or hear from her again. Luckily, a friend of Shania's mother's, Canadian singer Mary Bailey, stepped in. Mary found Shania a job singing at a resort in Hunstville, Ontario. Shania moved to Huntsville with her siblings, into the only house they could afford. It lacked running water. "We bathed in the river," she recalls.

For the next three years Shania—or Eileen, as she was then known—appeared nightly in a variety show, singing show tunes and dancing. While she didn't care much for the gig, it kept her family fed and clothed. "For years I sang anything that paid the bills," she now reflects.

When Shania's youngest brother graduated from high school, Shania felt almost like a mother with empty nest syndrome. Only twenty-five, she says she felt forty. Once again Mary Bailey came to her aid. She invited music attorney Dick Frank to Huntsville to hear her protégée, and he was sufficiently impressed to move Shania to Nashville. Noted record producer Norro Wilson cut four sides on Shania, and within months of the move she had a record deal with Mercury/PolyGram.

There was just one problem. At the time she was still Eileen Twain, and the record company didn't think the name had a good ring to it. When they suggested dropping "Twain," she balked. It was Shania's stepfather's name, and she had always seen him as her true father. Instead, she took the Ojibway Indian name "Shania," meaning "on my way." That move came back to haunt her when the tabloids pointed out that she wasn't a "true" Indian, just the stepdaughter of one. Shania was furious and, worse, hurt. Jerry Twain had been the only father she really knew, and he had raised all the children to respect his Ojibway heritage. "There were times we wouldn't have eaten if my father's friends from the reservation hadn't brought us meat they trapped," she said.

The name change turned out fine. But the label wanted other concessions less attractive to Shania. For example, she now says she hated the Nashville habit of insisting that new artists seek cowriting

opportunities with established writers. "I hated the nine-to-five concept of writing," she says. "And even after I wrote with the locals, only one of my songs got on the first album."

Norro Wilson says that her songs were given the same consideration as any pitched to him during the sessions. "It was just as it always is with a new artist," he explained. "If the songs hold up, they make the album."

Between country critics and the tabloids questioning her loyalties to the Ojibway, Shania understandably became resentful. But Nashville bashing is easy to do, and the press loves spinning criticisms into an even bigger story than warranted. Certainly there was some skepticism, questions about the lack of a tour, about her singing prowess and her sexy image. But she ultimately toured, and it was one of the most successful in country history. And her bare midriff is just one of many these days. Also, the tabloid stories did not originate in Nashville.

I think there was another factor in this story, and it is one that still exists.

Why didn't Shania have the industry supporters and cheerleaders around Music Row? The ones who on any given day could be found singing Trisha Yearwood's praises or Faith Hill's or Martina McBride's? Shania doesn't have publishers up and down the street who have a vested interest in her career. Her songs are Twain/Lange tunes, and the money stays strictly with them and not in Nashville. I think that if Shania's songs, with those huge radio and mechanical royalties, had been scattered around town, you'd have found a Shania supporter on every street corner.

And I think this: We in this business should applaud every success. We should stand up and cheer the people who bring in new audiences. Whether they are our personal favorites is not the issue. If they have added to country music in some way, let's give them their due. To paraphrase something President John F. Kennedy once said: "A rising tide raises all boats."

Trisha: She's in Love
with the Music . . .

*F*EW VOCALISTS OF the 1990s or any other decade are any better than Trisha Yearwood.

"She's in Love with the Boy" had been pitched around Nashville for quite a while when Garth Fundis played it for his newest "find," twenty-three-year-old Trisha, then working as a receptionist at MTM Records. "A lot of people thought it was too corny," Trisha explained to me. "It talked about chickens pecking on the ground and had folksy phrases like 'you ain't worth a lick, when it comes to brains you got the short end of the stick.' But it seemed to hit a nerve. I had so many young women say it was exactly like their situations."

Trisha's 1991 debut single on MCA Records soared to #1 and stayed for two straight weeks. A formidable beginning, and a tough act to follow for a newcomer. But Trisha has repeatedly released platinum-selling albums and chart-topping singles. She never suffered from the dreaded sophomore slump, and she never lost her focus when it came to finding great tunes.

I first met her when we traveled to Travis Air Force Base in California to entertain returning Desert Storm troops. We did the show

in a giant hangar, since Travis AFB is one of the nation's key transport bases. Trisha's voice impressed me then, and it still does.

Trisha grew up in Monticello, Georgia, the daughter of a banker father and schoolteacher mother. She loved Elvis, Linda Ronstadt, and the Beatles.

"I always wanted to sing professionally," she told me. "That's why I transferred from junior college in Georgia to Belmont in Nashville—to be close to the place they made the music. I got an internship in publicity at MTM, Mary Tyler Moore's company, then after graduation they hired me as a receptionist. Being that close to the people making music set me on fire. I couldn't bear to be so close and not be singing."

A lot of singers have started out working in Music Row offices. Jeannie C. Riley was a secretary, as was '80s star Sylvia. As a receptionist, Trisha began the all-important networking that would lead to getting work as a session singer. Demo singers have an inside track to record labels. The song demos go to producers and publishers, who the singers hope will one day say, "The song's okay, but that singer is great!" Many session singers of that era moved on to label deals: Joe Diffie, Pam Tillis, Billy Dean, and Linda Davis, to name a few. And it was through demo work that Trisha met two men, both named Garth, who would play important roles in her ultimate success.

Producer Garth Fundis was a Jack Clement protégé, a second engineer at the Sound Emporium on Belmont Boulevard in 1971. Between '71 and '78 he worked on Don Williams recordings, engineering and often adding harmony vocals. Ultimately, Fundis produced some of Don's biggest hits: "Tulsa Time," "I Believe in You," "Good Ole Boys Like Me," and "Lord, I Hope This Day Is Good." He produced Keith Whitley's "Don't Close Your Eyes," "When You Say Nothing at All," and "I'm No Stranger to the Rain." Then in 1990 he heard demo singer Trisha Yearwood sing at a Nashville club and decided she deserved a break.

When Trisha played a showcase, where Fundis invited label heads and A&R execs out to hear her sing, MCA's Tony Brown stepped up to the plate. As any country fan knows, Trisha is a tall woman who could never be described as anorexic. She's not fat, just

not one of the size 6 singers we see so often these days. At the time of Trisha's showcase, a songwriter in attendance reported that the only person considering signing her who did *not* mention putting her on a diet was Tony Brown. He was strictly concerned with the talent, which just adds to the reasons to admire this guy. With the advent of music videos, we've seen image become more important than ever before. One wonders what luck Patsy Cline might have had in this market. Trisha has thankfully avoided the temptation to starve herself into a size 6, but she freely admits the pressure is always there. Just this year, with 13 million albums sold and awards too numerous to name, she told *Country Music* magazine's Tamara Saviano that, "there's so much pressure to be tiny and perky and young. I really aspire to be a strong, independent woman." At thirty-five, Trisha is a strikingly handsome, statuesque woman with no apologies to make about her looks.

The "other" Garth in Trisha's life, Garth Brooks, was just experiencing some success with his self-titled debut on Capitol when Garth Fundis was showcasing Trisha. Brooks had been impressed with Trisha's vocal prowess as well and had promised to help her if he was ever in the position to do so. That time was coming faster than anyone knew.

Trisha had but one song on the charts when her old friend Garth Brooks, by now a superstar, hired her to open his stage show. It scared her to death. "I figured no one would show up for the opening act," she remembered, laughing. "And I made all my mistakes in front of crowds of over ten thousand people."

"What mistakes did you make?" I asked.

"I didn't get my record deal because of playing live. It came through session work," she explained. "I didn't have a show together. I bet it was three or four shows into the tour before I did anything except stand out there and sing. And I didn't talk much, either."

I asked her if she had any snappy repartee down yet.

"Not really," she said. "I still sing more than I talk."

Were there any other problems being on tour with Garth?

"Yes," she admitted. "Some people started saying I couldn't have

'made it' without his help. And as important as he was to my early career, I promise you that Garth Brooks can't make radio play a Trisha Yearwood song."

I asked her what pluses, besides the exposure, her professional relationship with Garth had brought about.

"If I learned one thing from Garth Brooks, it is to put everything I have into a song. He never goes into the studio and gives anything less than a hundred and fifty percent. He completely immerses himself in the performance. People see him do it onstage, but that intensity is also there in the studio. I think it is key to what has made him such a big star."

Trisha's self-titled debut album was released on July 20, 1991, just a little under a year since "Friends in Low Places" had become the college and club anthem of the decade. Trisha had four huge hits on that album: "She's in Love with the Boy," "The Woman Before Me," "That's What I Like About You," and "Like We Never Had a Broken Heart."

Interestingly, some were skeptical about two of those songs because they didn't seem appropriate for a "girl singer." But Trisha was always independent. "Like We Never Had a Broken Heart" (written by Brooks and Pat Alger) alluded to a one-night stand. "People were afraid for me to sing it," Trisha told me. "It was like they didn't think women did things like drink too much or cheat or have any of the human failings."

"That's What I Like About You" was written for a man to sing about a woman, with lines asking for a woman who won't walk in his shadow yet will cry on his shoulder. Trisha thought that sounded like the sort of man she'd like to meet, one strong enough to walk his own path yet sensitive enough to lean on her when he needed support. Still, some questioned her judgment. The public didn't question it. Both songs were top-5 *Billboard* hits.

Along about the time that Trisha's debut came out, she made the comment that she didn't like "wimpy songs." And, as she told me, that came back to bite her. People didn't know if it meant she hated feminine tunes or liked man-bashing songs or what. It seemed pretty

simple. She liked songs that portrayed women as capable, strong people. Of course they'd have vulnerabilities, but the unguarded parts of their personalities needn't define them.

Primarily, Trisha likes songs that actually say something. Take, for example, her 1993 hit, the Hugh Prestwood–penned "The Song Remembers When."

"That is one of the most beautifully written songs I've ever heard," she told me. "It is a poetic reminder that music has amazing power. Think how many times you've heard a song from the past and were transported back in time or to another place. It is amazing when you really think of it."

Trisha's music has taken her many places. She's a multi-award-winning vocalist with nods from the Grammys, the Country Music Association, and the Academy of Country Music. She's sold in the millions. She coproduces her albums with Tony Brown. And just to show you how music-filled her life is, in one week she traveled to Italy to sing with Pavarotti, flew back to New York to sing with Don Henley, and then went on to L.A. to sing with Garth Brooks.

Of all the songs Trisha has recorded, she says "Wrong Side of Memphis" is the most autobiographical. "That's a song about packing up your car and heading out after your dreams," she told me. "It's about wanting to see yourself on the Opry. If I were to give artists one bit of advice, it's this: Go where the music is made. You just can't phone it in." Then she grinned. "But make sure it's your decision. Because if it doesn't work, I don't want someone saying, 'Gee, Trisha Yearwood said this was all it takes!' "

The New Mr. and Mrs.
Country Music?

I'M OFTEN ASKED if Faith Hill and Tim McGraw are the new Mr. and Mrs. Country Music, Tammy and George being the originals. I always say this: It's possible that popularity-wise they could be considered country's favorite couple, but until they've recorded some classic duets as husband and wife, you can't put them in Tammy and George territory. And they'll need to do a lot of interviews together, like George and Tammy did. However, considering that Tammy and George didn't last as a couple may cause Faith and Tim to want to think twice about it.

I should have suspected that something was going on with Faith and Tim when they were first touring together. At that time I wanted to do an *On the Record* with two of country's new stars: Faith Hill and John Michael Montgomery. Faith was interested but kept balking, saying she'd rather do the special with her touring partner, Tim McGraw. She was adamant about it.

Faith is another success story I predicted the day I first met her. She had that elusive something called star power, and she was beautiful. Looks have always been a boon in show business, but at no time

in our history have they been more important than right now in this video age. Like Trisha Yearwood, Faith worked in the business for some years before she got a break, and that experience was crucial. It helped her get a backstage view of how things worked—and when and why they didn't. The first lesson she learned was when to talk about your dreams and when to stay quiet. Audrey Faith Perry moved to Nashville when she was nineteen.

"My dad moved me here," Faith told me in '93, right after her first single, "Wild One," from *Faith Hill: Take Me as I Am* was released on Warner Bros. Records. I started making the rounds, meeting people and trying to both get a foot in the door and get work. But I could not seem to find a job anywhere. Finally it dawned on me that people do not want to hire aspiring artists. There's a lot of reasons they don't, too. For one thing, if you work up front in a Music Row office, they don't want you trying to slip tapes to producers or A&R people who stop by. And they want you to concentrate on your job, not what you hope to be doing as soon as you can get a break. But at first I didn't know that, and I'd truthfully tell every potential employer that I wanted to be a singer. Bad answer! They'd wish me luck and show me the door. I finally answered an ad in the newspaper for a job selling T-shirts at Fan Fair, and that became my first paycheck in Nashville.

"Then I got an interview with Gary Morris Music, and on my way to the office I decided I'd keep my career plans to myself. I said only that I loved the music business and wanted to work in it. And I was hired on the spot."

Faith worked at the front desk, and as Gary realized what a responsible and hard worker she was, he gradually increased her duties. Before long she was helping out with publicity, some of management's detail work, and had publishing duties as well. People who knew and worked with her at the time tell me they had no idea she wanted to sing, just that she was a good, responsible employee. She kept quiet for a year and a half, attending writers' nights, showcases, and other learning events as a representative of Gary's office. Only a handful of people knew she sang.

"I was a closet singer," Faith said, laughing. "Then I finally did

some demos, and they wound up in Gary's hands. He called me in and said, 'Young lady!' I about died, not knowing what he was going to say. Then he smiled. 'Young lady, you need to get out from behind that desk and get busy on this career!' That was just the kick in the butt I needed. I didn't have to sneak around to play the Bluebird or sing demos anymore. I will always be grateful to Gary for that encouragement."

There's another artist who guided Faith, not so much by what she said but by the example she set. "After I worked for Gary, I worked for about a year at Starstruck, Reba's company. That was an opportunity I couldn't turn down, because Reba was one of my biggest influences growing up. I worked in her fan club office, taking and filling orders for her merchandise. Reba knows absolutely everything that goes on with anything pertaining to her career. That was a good lesson for me to learn, because if you don't watch out for your own business, you can get tripped up quickly. Another thing I learned from Reba is that your fans are who keep you in business. Reba treats her fans great. She appreciates them and lets them know it."

After getting to know Faith, I admire her ambition and her holding Reba up as an inspirational businesswoman. But I hope she has good people around her, because I don't see Faith as the tough businesswoman I know Reba to be. Reba's got that killer instinct about business, as does Barbara Mandrell. Many a businessman has thought he might bamboozle those two, and he's been wrong.

One night when Faith was singing harmony for a friend, the illustrious writer/artist Gary Burr, Warner Bros. A&R VP Martha Sharpe was in the audience. You may remember that she is the woman who signed Randy Travis to the label. Now, I don't know if record labels ever check back to see just how much money a specific A&R person has actually brought the company coffers, but I'll bet Martha's balance sheet would look pretty good. Martha asked Faith for a tape and soon signed her to a development deal. It would be two and a half years before Faith saw her face on a CD cover.

"I had no idea how Nashville worked," she remembered. "I really did believe I'd hit town, dazzle someone, and be on television in a month! I certainly didn't realize that even when you 'get discovered'

it might take years for anything to happen. We had to find the right management, the right producer, the right songs, the right sound."

Of course, Scott Hendricks, who later took the helm at Capitol, turned out to be the producer who found Faith's sound. And as everyone soon knew, the two found each other as well. Both divorced their respective spouses and became quite an item around town. (Faith was then married to Nashville publisher Daniel Hill.) It was several years later, when Faith signed on to the Tim McGraw tour that the Hill/Hendricks relationship fell apart and the Faith & Tim Show started. Tim and Faith made no apologies. As Tim said, "You can't help who you fall in love with."

Just as Faith learned not to talk about her career plan, Tim learned not to listen to negative people. When his first album on Curb stiffed, there were plenty of folks telling him to go home and forget it. Curb released three singles from the debut, and the best anything charted was "Welcome to the Club," which crawled up to #47. By the time "Two Steppin' Mind" was released, the radio interest was so poor it stayed in the charts a scant two weeks and died at #71. Tim obviously just didn't have the makings of a star, according to some.

Fortunately, he believed in himself and in a song he'd road-tested titled "Indian Outlaw." It's interesting that "Indian Outlaw" got only to #8, because it seemed to play everywhere and all the time. And it made Tim a star. When he released the follow-up, "Don't Take the Girl," he got his first chart-topper. The name of that second album was *Not a Moment Too Soon*, and I suspect that's how Tim felt about it. The record sold over 5 million copies and stayed in the charts twenty-six weeks.

My favorite of Tim's songs was "I Like It, I Love It," from his 1995 release, *All I Want*. That single stayed at #1 for five weeks, and I understand it's still a crowd favorite.

Tim has now sold over 13 million albums and 4 million singles and scored enough award wins to fill a room. Just more reasons to ignore people who count you out because of a failure or two.

One thing I like about Tim and Faith is that they say their family comes first in their lives. They've got a special bus to accommodate

their daughters, Gracie and Maggie. Most people are aware that Tim didn't know his real father for years—baseball pro Tug McGraw—and that Faith is adopted. But one conversation I had with Faith about her family, and her adoption, told me worlds about her childhood, which she describes as downright enchanted. I asked her at what age her parents told her she was adopted.

"I don't ever remember not knowing," she said. "You see, my parents already had my two older brothers. The boys were their birth children, but they wanted a baby girl. They called the adoption agency and were told they'd be on a very long waiting list. But they both said later that they never lost faith that they would get a baby girl, and that it would be sooner rather than later. Just a couple of days later they got the call to come and get me! That's why they named me Faith. And my other name is Audrey. My brothers were in love with Linda Evans, Audra on *Big Valley*. So they picked it.

"I always felt special, because my parents picked me. They made me feel that way, and so did my brothers. To me, that is the special story in my life. Down the road, if I do become a star, if anyone asks me to tell my 'story'—I will first think of the day my parents got the call that I was waiting for them."

In the years since "Wild One," Faith has reinvented herself. Her music leans to pop, and her look is that of a breathtakingly beautiful diva. Maybe Faith and Tim are not yet Mr. and Mrs. Country Music, but they are certainly country's supercouple. In 2000 they embarked on Soul 2 Soul, a lengthy tour their fans had been clamoring for and the press is eating up.

The children, Gracie and Maggie, will be with them throughout. Tim has been an integral part of their life right up to and including 2:00 A.M. feedings and diaper changing. A personal aside. When Gracie was born I went to the Hall of Fame archives and got a copy of the old "Ain't It Amazing, Gracie" for Tim. The girls are already showing an interest in music. The only thing they love more than watching their parents perform is running out and dancing onstage. Their favorite of Faith's songs is "This Kiss." And of Dad's tunes? It's the same as mine: "I Like It, I Love It." But what country act is featured on the poster hanging by Gracie's bus bunk? The Dixie Chicks.

Dixie Chicks "Fly" High

THE DIXIE CHICKS, who took country music by storm the past couple of years, kept the fiddle and steel but made the sound contemporary and drew in a lot of new listeners in the process. They took a big chance by insisting on the instrumentation, especially since the word was that Sony put them on the newly revived Monument imprint because they were considered an alternative country act, therefore not surefire hit-makers.

I don't know what Sony really thought, but whatever it was, they soon learned that the public was hungering for something unique. The Chicks' first CD, *Wide Open Spaces*, became the biggest-selling album ever by a country group or duo with 6 million sold. The follow-up, *Fly*, looks as if it will be even bigger.

They brought in a new young crowd without crossing very far into pop territory. And their brash attitude caused *Rolling Stone* to call them the "badass queens of country music." That label sounds like *Rolling Stone* jargon to me. But they do seem to be having a helluva good time, and they don't appear to care if they are less than ladylike doing it. Patsy Cline was that way. Dolly Parton has been known to say outrageous things, too. And the fans love her for it.

What I want to make note of is that in the last days of the 1990s

here is one of the biggest breakthrough acts, and it has deep country roots. Other acts have not. They've been equally good, just rootless at times. Like my friend Barbara Mandrell, the two original Chicks, Martie and Emily Erwin, mastered a variety of instruments early on. Martie placed second at the 1987 Old Time Fiddlers Convention, and won third place in 1989's National Fiddle Championship. Emily can pick with the best. On record and onstage, Martie plays fiddle and viola, while Emily plays banjo, dobro, lap steel, and acoustic guitar. The third member, lead vocalist Natalie Maines, hooked up with Martie and Emily after her father, Texas pedal steel great Lloyd Maines, played on some of the early Chicks recordings. Lloyd, by the way, lists as his hero and primary influence steel guru Jimmy Day, who played on everything from "Crazy Arms" to "Don't Do It Darlin'."

Lloyd Maines has played on CDs by everyone from Joe Ely to Guy Clark to Uncle Tupelo to Radney Foster to Wilco, and that roster may be a key to his influence on the Chicks. Those are the sort of acts that say, "Don't limit yourself, don't copy others, and make your own kind of music." Lloyd is also part of the Maines Brothers (with brothers Kenny, Donnie, and Steve), and the act has made eight albums, including one on Mercury/PolyGram. Add to that the fact that two of Nashville's best and most uncompromising producers, Paul Worley and Blake Chancey, are at the production helm of the Chicks' recordings and you'll start to get the picture of how yesterday and today came together in this group.

In mentioning the traditional aspects of the Dixie Chicks, I want to mention song selection. They are fearless. They sing about sex, murder and mayhem, and rowdiness in general, in addition to what Tom T. Hall calls the "Little Darlin' "–style love songs. Remember, Loretta sang about the Pill and was chastised from many a pulpit for doing so. And Dolly and Reba sang songs about prostitutes. Yet some still question the Chicks about a song in which a woman murders her abusive husband. Those folks ought to check back through the songs at the Hall of Fame. Country music has always had death and destruction among its main themes.

Lastly, I want to mention that old bugaboo the "Nashville

machine," so roundly decried by many. When the Chicks came to Nashville, I'm told that many Texas fans were afraid Music City would get its "clutches" into the girls and water down their music. Well, that didn't happen, for the reasons I listed and one more very important one: The girls had a vision and they stuck with it. I think it's a lesson to be learned by all who come. If you don't know what you're about, somebody is likely to tell you. If you do know, they'll probably let you "Fly."

Marty Stuart:
The Keeper of the Flame

I'VE HEARD Marty Stuart described as country music's biggest fan. That may be true, but I like to call him the "Keeper of the Country Flame." He is also one great musician and entertainer. Marty, who serves on the board of the Country Music Foundation, has one of the biggest collections of country music memorabilia in the world and is very good about loaning it to the Hall of Fame. In fact, when I was researching Hank Williams for this book, I utilized a lot of the information that Marty provided.

A lot of people think Marty started out on the road for the first time at age thirteen with Lester Flatt, but he'd already been picking with gospel singers Tammy and Jerry Sullivan for a year before Lester heard him play the mandolin. I asked Marty how he got signed to go on a tour with Lester Flatt at such a young age.

"People often ask me how to go about breaking in the business, and I tell them that if you're a picker and singer, the thing to do is go to bluegrass festivals," Marty said. "Bluegrass is still a homespun atmosphere. The stars and pickers are accessible. In country music the big stars have tight schedules, and if you wait around near the

backstage area hoping to show them your guitar or mandolin playing, what you may see is a glimpse of their taillights driving off to the interstate.

"My daddy took me to Beanblossom, Indiana, to Bill Monroe's big festival. It was huge—thirty thousand people came to it. Lester Flatt was a guest artist on the show. Flatt and Scruggs had played with Bill in earlier years. The great thing about these outdoor festivals is that there's a lot of waiting time for the pickers. So they have time to visit with people. There was a fellow in the band named Roland White, a mandolin player. I met him and got to talking to him during one of those 'downtimes.' Roland was very kind. I played a little mandolin for him, and he showed me some things on the instrument. We got to be friends that day, and I wrote him some fan letters. Then I heard that Lester Flatt and his band were coming to my hometown—Philadelphia, Mississippi—for the Choctaw Indian Fair. I was playing that whole summer with Tammy and Jerry Sullivan. I couldn't get there for the show, but I called home and gave my mom and dad some 'instructions.' I said, 'When Lester Flatt gets to town, I wish you'd go out to the motel and look up Roland White and ask if anybody wants to come over to our house for a home-cooked meal.' Roland and a few of the band members were happy for the offer and stopped by the house for dinner. Roland told my parents they'd love to have me come along on the bus, just for the ride.

"When I got back for the school term, it was quite a shock. You see, what I learned on the road was that if you played music, you got applause, you got paid, and girls liked you. You could cut up and laugh and have a good time. I'm talking about good clean fun here, of course—this was a gospel show, and I was a kid. But going back to school didn't turn out to be an appealing thing. One day they sent me to the principal's office because my hair was too long, and instead of going to the office, I walked out the door and home, where I called Roland White. 'Could I take that trip to Nashville now?' I asked. Roland had to clear it with his boss, because I hadn't actually met Lester Flatt yet. Then I had to clear it with Mom and Dad. They finally let me go just for the weekend.

"When Lester heard me picking mandolin with Roland, he asked

me if I wanted to make a guest appearance on the show, and I jumped at it. The crowds loved it, and Lester asked me if I wanted to stick around and play the Martha White Show on WSM. That meant selling Mom and Dad once more. They agreed to that and said they'd drive to Alabama the following week to pick me up. Once they got to Alabama, it was Lester Flatt doing the selling. He promised that he and his wife, Gladys, would watch out for me, see to my schooling with correspondence courses and keep me in line. Well, I'd been kicked out of school in Philadelphia by then, so it seemed like a good deal! At least I'd be taking those correspondence courses."

And so Marty Stuart, age thirteen, headed out on the road. He did take the correspondence classes and, as he put it, "got a world of information, knowledge, and advice from the geniuses on the bus." Whatever those guys did must have worked, because Marty is a knowledgeable and highly intelligent guy.

He stayed with Lester six years and played electric guitar with Vassar Clements's "Hillbilly Jazz" and acoustic guitar with Doc and Merle Watson. He's played on tour with Bob Dylan and Johnny Cash as well, and the Man in Black calls Marty his favorite electric guitar player. When he was still a teenager, Marty also toured with Bob Dylan, and his perceptions of that experience are interesting.

"I think I was just wanting to try my heels elsewhere," he admitted. "After Lester Flatt died, I felt a little burned out, and I also wanted some of that fast rock 'n' roll money. It didn't take me long to learn that rock 'n' roll money is just rock 'n' roll money. I learned how much I loved country music and country music fans during that road run. Country was where my heart and soul were, and that's where I decided I wanted to be. Lucky for me, the job with Johnny Cash came around right after the Dylan tour ended."

I asked Marty if he could describe the difference between a country fan and a rock fan.

"I'll give you a good example," he said. "The first weekend I worked with Lester Flatt was Labor Day weekend in 1972. A lady and her husband came by the bus and brought Lester a birthday cake to show their appreciation for his music. It wasn't his birthday at all.

But they told him even though it was belated, they wanted to say happy birthday and thank him for all the years of music. You see, Ralph, those people had been coming out to hear Lester since Flatt and Scruggs were playing in Bill Monroe's band in 1945. They didn't always stay for an autograph, just came to hear the music. And this was their way of saying thanks. I think most country stars will tell you they have fans that are loyal to them for years, for decades. I'm not sure rock fans have the same endurance."

Marty released a couple of albums on bluegrass labels, then signed with Columbia Records in 1986. That deal didn't work out despite a great self-titled album, with one song that many considered a new rockabilly classic, "Arlene." Marty told me a great story about the aftermath of a deal gone sour. It contains some important advice from Merle Travis, the man Chet Atkins called the world's greatest guitarist and the man who wrote "Sixteen Tons" and "Nine Pound Hammer."

"That was one of the lowest points in my life," Marty said. "I was going through a divorce, and my label deal was falling apart. But one night I was looking through an old journal—I've kept one since I was thirteen—and ran across something. Through working with Johnny Cash, I got close to Merle. Merle was the kind of guy who'd draw you a cartoon, write a good article, take a good photograph, write a classic song, and play perfect guitar. He was also a kind of country philosopher who'd hand you some advice anytime he saw you in need of it. We were in Memphis playing cards one night, and I was down to ten bucks. Merle won the hand and took the ten-spot. Then he said, 'Marty, I'm going to tell you what you get for this ten dollars. You are going to get some advice. I heard you want to be a hillbilly singer.'

" 'Yes, sir,' I said. 'I just signed a deal with Columbia Records. I'm real excited.'

" 'Well, you're gonna have a lot of ups and downs as a hillbilly singer,' he said. 'I'll tell you what to do when you run into that first streak of bad luck. You go out and buy a Cadillac. It doesn't have to be new, and it doesn't matter what color it is. But you buy that Caddy and then go buy yourself a Nudie suit. Then I want you to

think of a favorite hillbilly song and drive around singing it. Oh, and find a good-looking woman and have her ride with you.'

"Well, Ralph, when Columbia dropped me, I did exactly what Merle suggested, and it got me a new record deal. I went out and bought a '77 Cadillac with a hundred thousand miles on it. I shined it up and even put a car phone in it. Then I went over to Manuel's shop and bought a flashy suit. I got me a girlfriend and rode around town singing the old Johnny Cash song, 'Cry, Cry, Cry.' "

"How did it get you a record deal?" I asked.

"It took about a year to get out of the deal with CBS, and I was sitting around in limbo going crazy," Marty said. "So I called Tony Brown at MCA and told him I wanted to make some tapes with him. 'You got any songs?' he asked. When I told him I wanted to record 'Cry, Cry, Cry,' he said he thought it had been done right the first time. I told him I agreed, but I wanted to throw it at him one more time. That song ended up being the first single off the album, and while it didn't tear up the charts, it turned out to be a good way to break the ice at radio."

"Cry, Cry, Cry" went to #32, and the follow-up, "Don't Leave Her Lonely Too Long" died at #42. But the next single, "Hillbilly Rock," established Marty as a force. He had more hits through his years at MCA, including "Little Things," "Tempted," and 1991's "The Whiskey Ain't Workin' " duet with Travis Tritt on Warner Bros. The release won a CMA Vocal Event of the Year and a Grammy. Travis and Marty turned out to be magic onstage together, and they put together one of '92's most acclaimed tours, the No Hats Tour. They did a couple more tunes that captured the attention of both radio and the fans, 1992's "This One's Gonna Hurt You" and 1996's "Honky Tonkin's What I Do Best."

Marty's latest offering was 1999's concept album, *The Pilgrim*. It didn't do well commercially despite a lot of critical acclaim, and Marty moved on from his MCA deal. He published a book of photography, complete with fascinating annotations from his career. He's now married to Connie Smith, the woman Dolly Parton says is the finest vocalist in the business. I don't think Marty's chart history quite tells the story of what he is all about. I think you could proba-

bly consider him in Merle Travis territory as far as talent goes: He's an award-winning songwriter, a brilliant instrumentalist, a journalist, a photographer, and a part-time philosopher. He's also a great storyteller.

He told me another Merle Travis tale that touched me. He said that once when walking along Oklahoma's Tahlequah River near Merle's home, Merle said this to a friend: "Every feller finds his rainbow, and every feller finds his rainbow's end. Old Travis has found his rainbow's end right here at this river. This is where I want it all to come."

Merle died that very day, and from what Marty learned, Merle may have known it was coming.

"When Merle went back to the house, he emptied out his pants pockets," Marty said. "In them were a buckeye, his guitar pick, a pocket knife, and thirty-five cents. He laid it on the counter and went into the bathroom, where he suffered a fatal heart attack. I was standing at the funeral, thinking about Merle and what his friendship had meant to me, when his wife walked over to me. She pressed some things into my hand and said she believed Merle would have wanted me to have them. They were the buckeye, the guitar pick, the pocket knife, and the thirty-five cents."

Since Marty was so close to Johnny Cash, I asked him about John, prefacing everything by saying that when we were all dead and gone, the world would remember Johnny Cash.

Marty grinned. "You know, I was with Johnny at a McDonald's in Budapest, Hungary, one time when we were playing concerts in Europe. All of a sudden there's this big commotion, and people are crowded around John thrusting papers at him for autographs. I said, 'John, there you go causing trouble again.'"

I asked him what it was like to work with Johnny in the studio. "Marty, Ricky Skaggs says he almost hates to record because he's such a perfectionist. Is Johnny Cash a perfectionist?"

"Not at all. Well, maybe in his own way. But when you hear Ricky Skaggs records, they are perfect. And I love that about them—that perfect musicianship is amazing. But you are going to hear a little trash on a Johnny Cash record. He's going for the spirit and the

soul, and he doesn't mind if it's got some trash along with it. That's part of the charm and character of a lot of John's recordings, especially the Nashville sessions of the 1960s."

Then Marty turned very serious. "I believe that in three thousand years if a student pushes a button somewhere to find the definition of integrity in country music, the name Johnny Cash will come up."

Because Marty had seen so much for such a young man—he was thirty-one years old when we had that talk—I asked him if he still kept that journal he'd mentioned.

"Yes I do," he said. "I have a lot of colorful friends, a lot of dear friends, a lot of famous friends, and a lot of not-famous friends. I have a lot of friends who are local legends that mean as much to me as the ones who have their pictures on all the magazines. When any of those people tell me something meaningful, I'm quick to take it down."

That chronicler side of Marty, along with his respect for the history of this industry and its people, is why I call him the Keeper of the Flame. One day I hope that journal is published. And then put in its rightful place in the Country Music Hall of Fame.

Postscript:
Some Things I've Learned
Along the Road

About Music . . .

I HEARD STEVE ALLEN deliver a great comment about music on an old television show, and I'd like to steal it from him to start this final section of *50 Years Down a Country Road*. It goes like this: Music is one of the few pleasures in life that is legal, nontaxable, low in calories, and can be enjoyed by either sex—or instead.

"Tennessee Waltz"

I THOUGHT IT MIGHT be interesting to reflect a moment about Patti Page's "Tennessee Waltz," which she released in 1950, essentially the same year this book begins. The record sold over 6 million copies and is considered the first "mega-selling" single, quite an accomplishment for a country song in 1950. It's now second only to "White Christmas" in overall single sales. Interestingly, the version

of the song that Jerry Wexler (who helped build Atlantic Records) pitched to Patti's manager, Jack Rael, was by R&B recording artist Erskine Hawkins. When I was reading this information from Mercury Records, I learned something else I always wondered about: Exactly what was the first record to use double-tracking? I'd thought it might have been a Les Paul and Mary Ford record, but according to Mercury, Patti Page had pioneered double-tracking with a Patti Page/Patti Page duet of "Confess" in 1947, a couple of months ahead of Les Paul.

"She Thinks I Still Care"

DICKEY LEE AND his wife, Katie, are two of the closest friends my wife, Joy, and I have. Dickey wrote one of my favorite songs, "She Thinks I Still Care," and when he sings the hit, he usually introduces it like this: "I've been really lucky with this song. I wrote it about the first girl I ever fell in love with. She really messed up my life. Of course, so did the second girl I fell in love with. And the third. But 'She Thinks I Still Care' was written about the first. Then George Jones had a number-one hit with it. And Anne Murray had a number-one hit with it. Elvis had a number-one hit with it. Finally I made enough money to hire a hit man and send him out looking for that girl."

Dickey was joking, of course, but the song was a true story dating back to his college days at Memphis State. He was attending school and writing songs for producer/songwriter/publisher Jack Clement. When Dickey wrote the song, he didn't think of it as being a hit, just a way to work through the breakup. Jack Clement thought different. "Jack told me he liked it and wanted to demo it," Dickey recalled. "Then all of a sudden I got a call from Jack's partner, Bill Hall, and he said George Jones had recorded it! I didn't know Jack had pitched it to anyone, let alone George Jones. It was on the flip side of a song titled 'Sometimes You Just Can't Win.' I thought that was the better of the two songs."

"Sometimes You Just Can't Win" was written by a deejay named Smokey Stover, who was just inducted into the Disc Jockey Hall of

Fame this year. And I well remember playing that song time and again in honor of the Vanderbilt football team. Vandy has a lot of things going for it as an institution of higher learning. But it's not much of a football school.

George Jones has been quoted as saying 1962's "She Thinks I Still Care" is his favorite song among all his hits. I can see how it might not only be his favorite but one of the most crucial to his career. It was his third chart-topper, and he didn't have another for five years when 1967's "Walk Through This World with Me" hit #1. The next huge-impact record was 1980's "He Stopped Loving Her Today."

Over ten years ago Dickey Lee was told that over four hundred people had recorded "She Thinks I Still Care." Merle Haggard cut it, and Dickey didn't even hear about the session until it started showing up on his royalty statements. It was included on Elvis's last album, *Moody Blue*, in 1976. It was Anne Murray's first #1 record. James Taylor recorded it just a couple of years ago.

And while Dickey has written many, many hits, including George Strait's "Let's Fall to Pieces Together" with Johnny Russell, "I Saw Linda Yesterday" with Allen Reynolds, and "The Door Is Always Open" with Bob McDill, the Jones cut of "She Thinks I Still Care" is his sentimental favorite. Dickey's multiple careers—as a hit songwriter, a country star with hits such as "Never Ending Song of Love," and a pop star with hits such as "I Saw Linda Yesterday" and "Patches"—have put him in an enviable position. He can pursue his first love, songwriting, here in Nashville, and he can go on the road with rock package shows when he likes. As I write this, Dickey is set to head out with Mitch Ryder ("Devil with the Blue Dress"), Tommy Roe ("Sheila" and "Sweet Pea"), Gary Lewis and the Playboys ("This Diamond Ring"), and Brian Hyland ("Yellow Polka Dot Bikini").

"The Wind Beneath My Wings"

LARRY HENLEY AND Jeff Silbar had started writing a song called "Wind Beneath My Wings" when Larry went down to the Gulf of

Mexico to relax on a friend's boat. Larry had written down the title years earlier, thinking of his wife, a woman he says inspired him in many ways. "I remember when we'd leave the house with lists of things to do, and her list would be three times longer than mine. When we got back, she'd not only accomplished everything on her list but half the things on mine!" But by the time Larry and Jeff began working on the song, Larry and his wife—the woman he called the wind beneath his wings—were divorcing after thirteen years of marriage. "I guess I wrote it as an apology to her," Larry told me. "I wanted to let her know that I really did appreciate what she did, even when I didn't appear to do so. I used to think of her as my hero."

The song was pitched in an unusual way, via a mass mailing to every artist the publisher could think of. They were going for a Kenny Rogers cut, but Roger Whittaker was the first to record it, followed by Willie Nelson, B. J. Thomas, Lee Greenwood, and Gary Morris. Lee had actually recorded it prior to Gary's session, so it upset him when Gary jumped out with the first single and ended up with a country smash in 1983. In retaliation, Lee quickly released his version in Europe and had the hit there. That irritated Gary. It's since been recorded by over a thousand people. But in 1989 Bette Midler eclipsed all other recordings, and her version became the biggest song of the year, including all genres of music.

I asked Larry what his ex-wife thought about her song when she finally heard it. He hesitated, then said, "Not much."

"I Believe in Music"

I THINK the song "I Believe in Music" is the definitive song for people who sing for a living. That belief will keep them going through some awfully hard times. I once asked Mac Davis how he came to write it.

"I was in England on tour in 1969," he said. "I got invited to a party at the pop singer Lulu's house. Lots of musicians were there. In fact, I met Ringo Starr and didn't even know who he was! I was introduced to a guy named Richard Starkey right when I walked in

the house. I said hello and moved on. Somebody grabbed me and said, 'Wow, what did Ringo say?' I said I didn't know, the only person I'd met was a fellow named Richard Starkey. The guy said, 'That *is* Ringo!' Well, this was at the height of the hippie movement, and all of a sudden somebody comes up with the idea of having a séance. I had no interest in that. I mean, what were they gonna do, put their hands on a table and try to lift it off the floor? So I grabbed a guitar belonging to Maurice Gibb and sat in the corner strumming it. A little time went by, and some guy walks up and says, 'What's the matter with you? Don't you believe in ESP?'

" 'Nope,' I said.

" 'Well, what do you believe in?' the guy asked.

" 'I believe in music,' I answered.

"He wandered off, and I sat there strumming Maurice's guitar, repeating that line.

" 'I believe in music. I believe in music. I believe in music.'

"Finally I put down the guitar, went back to my room at the Dorchester Hotel, picked up my own guitar, and started singing, 'I believe in music!' I finished it that night.

"I still have the hotel stationery that I wrote the words down on," Mac said. "And I cherish it."

"I Ain't Never"

MEL TILLIS WAS an unsigned writer working with Buddy Killen at Tree Publishing when he decided that Cedarwood Publishing, owned by Webb Pierce and Jim Denny, was more to his liking. Buddy speculated that since those were Mel's rowdy days, he liked to party a little more than was usual over at Tree. At any rate, Mel Tillis and Webb Pierce started hanging out together. One day Mel walked into Cedarwood and noticed that Webb had a pair of new custom-made boots. "Those boots were the fanciest things I'd ever seen," Mel says. "I loved 'em and said so."

As it turned out, Mel had just written a new song titled "I Ain't Never," and when he played it for the folks at Cedarwood, Webb

had an idea. "How about I trade you these boots for half of the song?" It was just another song to Mel, and those boots were one of a kind. So he struck the deal.

Webb recorded it in 1959, and the song got to #2. Mel cut it and got a #1 in 1972. It's also been out by artists including Delbert McClinton, the Four Preps, and John Fogerty.

"You know what?" Mel said at the Ralph Emery Country Homecoming. "The last time I checked, those boots cost me around eight hundred thousand dollars."

Knock It Off!

IF YOU ASK Tom T. Hall whether he believes in ESP or not, he'll say "not." If you ask him *why* not, he'll most likely say, "If you believe in anything like that, you have to believe in everything like that. And there's too much coming down the road that I wouldn't want to run into for me to believe in it all."

Still, Tom T. Hall has a ghost story, and it goes like this: "I used to have a friend who was a carpenter," he says. "I am the world's biggest fan when it comes to carpenters, to people who build things with their hands. So when he worked on my house, I'd sit with him and we'd talk about his craft all day long. Well, I am sorry to report that he died. And I am even sorrier to report that after he did, things started happening in the room he worked on. There were noises day and night and things mysteriously moving from one location to another. My wife, Miss Dixie was upset. Our housekeeper was even more upset.

"Finally one night I went in that room and confronted him. I said, 'You are upsetting Miss Dixie. You are upsetting the housekeeper. You're just causing too much trouble. Furthermore, you built this place! Why are you trying to tear it down? Just knock it off!'

"That was the end of it all."

"Well, Tom," I said, "I don't know how you had the nerve to confront a ghost!"

Tom shrugged. "I figured we were good friends in life and there shouldn't be any reason for it to have changed."

The Story of a Hee Haw Fan

EDDIE RABBITT HAD a friend who had a monkey named Jo-Jo. The friend traveled a lot and finally decided he'd have to give the monkey to a pet shop. Eddie thought about Jo-Jo in a cramped cage in some pet shop and didn't like it a bit. This was while Eddie was still writing songs for others, before he started his own recording career and set out on the road. So Eddie had a huge cage built, complete with a swing, furnished with toys and blankets, and brought Jo-Jo home to his place on 17th Avenue in Nashville. It was Eddie's opinion that Jo-Jo was a smart monkey and one who deserved to be entertained. And so he pulled an old television out of the attic and left it on beside Jo-Jo's cage. Jo-Jo took to TV right away, especially certain things.

"He really loved the blonde who advertised Pearl Drops toothpaste," Eddie said. "But even more than her, he liked *Hee Haw*. *Hee Haw* was featured on Nashville's Channel Five every Saturday at five P.M. I started noticing an odd thing one weekend. About ten minutes until five on Saturday evening, Jo-Jo started rearranging his cage. He got all his blankets over in a pile on the television side of the cage. He brought his grapes and bananas and lettuce scraps over and piled them in front of the blankets. He brought a few of his toys over. Then he sat down. In a minute that banjo intro to *Hee Haw* started up, and Jo-Jo went nuts. He danced around the cage and clapped and rattled the bars. Then he sat down to watch the show. Over the next few months I made a point of being around every Saturday to watch this. And sure enough, he repeated his actions every week. Somehow he knew when that show was coming on."

I asked Eddie if he thought Jo-Jo liked the laugh tracks, thinking maybe the sound reminded him of a lot of monkeys!

"No," Eddie said. "He liked the banjo music, and he liked certain people. Buck Owens, Roy Clark, and Archie Campbell were his favorites."

"Do you still have Jo-Jo?" I asked.

"No," Eddie admitted. "When I got my own career started, I

found a monkey sanctuary and took him there. It was a wonderful place, actually."

"Were you afraid you'd be gone too much?"

"Not really. There was a little problem. By that time I'd met my future wife, Janine. Jo-Jo was awfully jealous of her, and I couldn't leave her there alone to deal with it."

"So you took him to the sanctuary. Did he hate to see you walk away?"

"Oh, no," Eddie said. "The sanctuary was filled with girl monkeys. Jo-Jo took one look at them and never looked back."

Yeah, but did he miss the banjos?

Send Me the Pillow

ONCE, when Vince Gill was a little boy, he and his mother were driving along with the car radio on. Jerene Gill wasn't really paying attention to what was on the radio and was surprised when Vince suddenly said, "I want one of those."

"One of what?" she asked.

"One of those," he said, pointing to the radio. "A pillow to dream on."

The song playing was, of course, Hank Locklin's "Send Me the Pillow You Dream On." I thought it was a fascinating take on the song, too. A little boy saw it as a real pillow that brought you dreams. Fast-forward to Christmas 1999, after Vince's every dream came true. He sent his mother a beautiful pillow with a note that read, "Here is a pillow for you to dream on."

And when Hank Locklin rerecorded all his hits, guess what country superstar he asked to come and sing on "Send Me the Pillow You Dream On"?

Willie's Guitar

WILLIE NELSON IS the least pretentious star I know. He has a famous guitar that has been signed by most of the big stars of music. He's played that guitar so much that he's even picked a hole

in it. When we filmed the Ryman Country Homecoming in 1999, I was looking at the names and wondered how he determined who signed it.

"How do you qualify to get your name on that guitar, Willie?" I asked.

"You gotta have a pencil," Willie answered.

"Keep Punching"

I LOVE TO collect many kinds of memorabilia—bits of history, first-edition books, signed photos, drawings, and autographs. One of the items I am most proud of is a letter from boxing great Rocky Marciano, dated November 1, 1968. You might picture Rocky getting into a variety of businesses after he retired, but could you picture him promoting a country singer? That's what he was doing when he visited the Deejay Convention in Nashville that year. Rocky had invested in a singer named Ray Frushay and was hoping to get the attention of somebody of power here in Music City. As I recall, Ray could sing, and he was a handsome young guy. Unfortunately, Rocky's efforts didn't pay off. Ray never did get a deal that I know of, although I had him on the radio show and helped open a couple of doors. Rocky dropped me a note of thanks and said he'd enjoyed the convention so much that he was planning on coming back the following year. It occurred to me recently that he never did come back, so I checked some background material to see what I could find out. Sadly, the reason was evident. Rocky Marciano died in a plane crash at Newton, Iowa, the following August 31, 1969. His business slogan, printed on the bottom of his stationery, is good advice for anyone, and especially anyone trying to break into the music business:

WINNERS NEVER QUIT, QUITTERS NEVER WIN. KEEP PUNCHING.

Packin' Heat at the Opry House

BOBBY AND SONNY OSBORNE opened the country show at the White House back in 1973, when President Nixon invited country stars including Merle Haggard to perform on St. Patrick's Day,

which happened to be Pat Nixon's birthday. The following year the president came to Nashville on March 16 to help open the new Opry House. Security was tight, though not as tight as it would be nearly twenty years later when George Bush came to *Nashville Now* and we all had to pass through a metal detector. In 1974 it seemed that the main security was in the number of Secret Service guys running all over the Opry House. Now, Sonny Osborne carried a pistol with him everywhere he went. He'd got in the habit because the Osborne Brothers carried their cash collected from promoters on the road, and most people could have easily figured that out. Sonny knew that the president was coming to the Opry that night, but it was second nature for him to stick that gun in his pocket. He was already past security and inside the Opry House when he realized just what a bad move he'd made. "That gun felt like it was growing inside my pocket," Sonny later told me. He decided his only "out" was to stay as far away from the president as possible.

President Nixon went onstage and did his thing, yo-yo-ing with Roy Acuff and leading the entire house in singing "Happy Birthday" to the first lady. Meanwhile, Sonny Osborne is skulking around the back hall, staying low-key. After the president finished onstage, he and his entourage started down the hall to the "intersection" where one hall led to the exit. When the president got to the place to turn for the exit door, he noticed Sonny down at the end of the other hall.

"You! Osborne!" the president called.

Sonny froze.

"Come over here," President Nixon said.

Sonny eased a little closer, scared as hell.

"You're one of the Osborne Brothers!" Nixon said. "You played at the White House last year."

Sonny tried to smile and offer a little polite small talk, picturing a Secret Service man screaming, "He's got a gun!" Then shooting him in the head.

The president chatted just a moment, then left the Opry, while Sonny stood there feeling faint. The truth is, everyone was thrilled to see the president come to the Opry, but nobody was as thrilled as Sonny Osborne when he left.

Acuff and the Great Göring Caper

MOST EVERYONE has heard about the Nazi's ripping off art collections throughout Europe during their infamous reign. But how many of you know that Roy Acuff ripped off Hermann Göring? I will let Mr. Acuff tell you this in his own words:

"I'm a great collector. I collect anything that has some historical value or that I think is of interest to people, myself included. In fact, if I see something interesting, I'll buy, beg, borrow, or—at least in one instance—steal it. It happened when I was in Germany one year on tour. The U.S. government wanted us to extend the tour for a couple of weeks, and I was to meet with them about it. Since we were in Nuremburg, I was sent down to the U.S. office at the Court of Justice to discuss the proposition. I looked around the building, and it dawned on me that this was the place where they'd held the war-criminal trials. So I asked if I might see the actual courtroom. They balked at first but finally located a German guide who said he'd take me in. He explained that the court had never been opened to the public before. We walked through the area, and he showed me how the prisoners had been led through chutes from the prison so they couldn't be seen or escape. And then he showed me where everyone sat. He pointed out Hermann Göring's place and noted that Göring's glass hadn't even been removed. Well, when he turned away to show me something else, that glass somehow ended up in my coat pocket. Then at the American counsel's table I noticed a little ashtray. I asked the fellow if he'd mind if I took it to display in the U.S. with my other collections. He said he'd just turn away and if I took it, he wouldn't know about it. So I slipped that in the other pocket. It was a fifty-fifty deal. I stole the glass but asked for the ashtray."

To Russia with Love

HERE ARE A COUPLE of stories about country music traveling to the Soviet Union. The first is told by Tennessee Ernie Ford:

"I got a call from Washington one day," Ernie told me. "The cul-

tural attachés from the Soviet Union and the United States had been meeting, and the Soviets had asked about this thing called 'country music.' It seems they thought our music would be a good thing to use in some of their arts exchanges. They'd picked out a group of young singers including some of the Opryland dancers and singers, and I guess they finally realized the troupe would need a 'daddy.' That was where I came in. We did twenty-seven concerts across Russia, for many different peoples—Armenians, Georgians, Russians. We got along fine because we were well briefed in the do's and don'ts before we ever left. In fact, the biggest 'don't' concerned religion. We were told to leave our Bibles at home, along with any other religious symbols like St. Christopher medals, that sort of thing. The State Department made it very clear that our luggage would be searched at every stop, and if we had Bibles, we'd be suspected of being on a preaching mission.

"We got along fine, though, and were told later that those twenty-seven shows were better than any five summit meetings. The great thing was the way we were introduced. The emcee would come out and say, 'Ladies and gentlemen, here are our friends from across the ocean singing the music of men who work on the railroad—the American cowboy!' "

ROY CLARK TOOK a tour over in 1976, right at the height of the Cold War. He, too, was instructed that there was to be no mention of Jesus or the gospel. Well, you tell an old country boy he can't do something, that's what he's gonna do. One of the acts on that tour was the Oak Ridge Boys, who were just making the transition from gospel to country. One night a fellow connected with the Oaks was having a birthday, and the group went to a restaurant to celebrate. They sang "Happy Birthday," and the harmonies were so fine they started singing more songs. Well, with the Oaks leading it off, you can bet the songs were gospel. I asked Roy if the people in the restaurant were upset.

"Oh, not at all," he said. "In fact, they joined in!"

Roy told of another event that wasn't quite in the gospel cate-

gory. It seems they had an interpreter who loved to translate American slang into Russian slang. Roy took delight in trying to trip him up, and he often did. And the Russian man loved showing Roy the wonders of the Soviet Union. One night in a restaurant he told Roy he would show him how Soviet men drank. He filled a glass full of vodka, took a deep breath, and drank it down in one gulp.

"There, you see?" the interpreter said.

"Man! That's something," Roy said, his eyes wide. "Bill—Bill Golden! Get over here and see this."

Bill Golden of the Oaks walked over, and once again the man took a deep breath and downed a large glass of vodka.

"Duane!" Roy shouted to the Oaks' Duane Allen. "You are not going to believe this! Come on over here!"

And so it went. One American country singer after another watched the guy drink vodka in honor of Soviet manhood.

"We had to put him to bed that night," Roy remembered, laughing. "Poor guy, he never suspected he'd been had."

Freddie Hart's Gender-Bending Birth Certificate

FREDDIE HART IS a big, strong, amazingly tough country star. Imagine his surprise at what happened when he needed to apply for a passport and sent away for his birth certificate. The certificate was his, all right. But it listed him as a baby girl. "I had to laugh," Freddie said. "My mother had all her children at home. The doctor would just make the rounds, sometimes arriving on time and sometimes not. Then he'd wait and fill out the paperwork for several weeks at a time all at once, when he got around to it. I guess he just forgot who was who. It was an honest mistake."

"Not if he could see you now, Freddie," I felt obligated to say.

George Gilley?

I ONCE ASKED Mickey Gilley if his given name was Michael or Mickey.

"Mickey Leroy," he said, hesitatingly. "Actually, it was George on my birth certificate."

"George Gilley?" I asked, surprised I'd never heard that before.

"Well, I was born in a charity hospital in Natchez, Mississippi," Mickey said. "When my mother took me home, she hadn't picked out a name. The doctor couldn't submit the birth record without a name, so he picked 'George.' I had to go to court to get my name legalized."

"You didn't like George?" I asked. "It's done all right by George Jones."

"Oh, I liked it fine," Mickey said. "But changing George to Mickey in the court was easier than changing Mickey to George on my driver's license, my Social Security card, my credit cards, my marriage license . . ."

Second Billing

EVER WONDER what it would be like to be a singer if your brother was the biggest star on the road? Tommy Cash could tell you about the time he played a show at the Edison Hotel in Toronto. He took a flight to Toronto and caught a cab to his hotel. "I was riding along, and all of a sudden I saw this huge billboard," Tommy told me. "There in three-feet-high letters were the words JOHNNY CASH. As he got closer, he saw that the sign actually read JOHNNY CASH'S BROTHER. And in letters about three inches high— TOMMY CASH."

Tommy immediately went to the club and confronted the manager. "This is not fair to me, and it's not fair to my brother," he said. Still, the sign didn't get changed until Tommy's manager, Bob Neal, put in a call to the hotel. It's bad enough when you take second billing, but second billing to a man who's not even there?

More on Roger Miller

AS I MENTIONED earlier in this book, Roger once repaired a clock in the Lincoln Bedroom at the White House. According to his wife, Mary, it wasn't unusual for Roger to tear something apart to see how it worked. And he was an avid clock collector and repaired every nonworking one he bought. In fact, Mary says Roger was also an

inventor. She has an entire book of his inventions, including a new way to build guitars so restringing was a snap. He studied subjects like perpetual motion, energy—you'd have to say he had the mind of an engineer. He also had a mind full of mischief. Mary told me the two attended a gathering at the New Mexico governor's mansion hosted by then-governor Bruce King and his wife, Alice. They were staunch Southern Baptists and great charity workers. Mary said that Roger ran into some friends of his early on, and they started drinking Jack Daniel's. Now, Roger Miller was an admitted pill-popper, but he was not a drinker. As the evening wore on, Mary realized that her husband was very drunk. So you can imagine how fearful she was when she noticed him bending the ear of the very straight first lady of the state. Mary eased over in time to hear Alice King finish up a spiel about the many camps and other charities her husband supported. Mary had just started to breathe a sign of relief when Roger opened his mouth:

"Hmm," he said. "Maybe he should open a halfway house for girls who won't go all the way."

Mary grabbed Roger's arm and hauled him off.

Did Mrs. King say anything?

"No," Mary said. "Either she didn't get it or wouldn't admit she had."

Nicknames of the '60s

BACK IN THE 1960s a bunch of us had nicknames for each other. It all started at Justin Tubb's house, where he and Dottie West collaborated on songs. Justin started calling Dottie "Beulah," a name she heartily disliked, so he kept it up. Then it spread to Linebaugh's restaurant on Broadway, where the crowd used to gather to play Rook. There's no rhyme or reason for these names, except that at one point or another someone decided the name suited. Here's the list:

Ralph Emery: Moncrief
Skeeter Davis: Justerini

Red Lane (songwriter): Schmedley

Glen Campbell: Humbolt

Lee Hazelwood (songwriter and producer of Nancy Sinatra and
others): Chitwood

Steve Sholes (RCA executive who was Chet Atkins's mentor):
Faircloth

Joyce Gray (Jim Reeves's longtime secretary): Gladys

Cousin Jody: Cromwell

Hank Cochran: Goodacre

Dottie West: Beulah

Bill West (Dottie's husband): Orville

Charlie Dick (Patsy Cline's husband): Spaulding or Moby

Carl Perkins: Claridge

Rusty Kershaw: Wharton

Justin Tubb: Lovelace

Ben Dorsey (called the Greatest Roadie in the World, having worked
for Ferlin Huskey, Ray Price, Faron Young, Willie Nelson, and
Waylon Jennings): Poot

Tommy Hill (Starday Records president): Arbuckle

Chet Atkins: Prentiss

Billy Grammer: Cameron

Ray Price: Guthrie

Willie Nelson: Osgood

Shirley Nelson (Willie's second wife): Edna

Joe Allison (songwriter/deejay): Ballard

Tommy Alsup: Nesbett

Roger Miller: Sweeney

Wayne Walker (songwriter): Whitney

Mel Tillis: Doolittle

Billy Walker: Tugwell

Buddy Killen: Childress

Bobby Skyes (sang harmony for Marty Robbins): Rutledge

Bobby Bare: Andwrite

Bobby Lord: Rigsby

Jeannie Seely: Dabney

Jerry Shook (guitar player): Wooten

Pete Drake: Rose (Note: Pete's second wife was named Rose, as it turned out.)

Ellen Wood (BMI): Eunice

Kelso Hurston (Capitol A&R chief): Sport

Pickle Puss Jones

SPEAKING OF NICKNAMES, did you know that George Jones once called himself Pickle Puss Jones when he worked as a deejay in Texas? He wasn't exactly right for the job, though. He was reading some advertising copy and mentioned a local "aunty-Q" sale. The program director hastened to correct him on his pronunciation of "antique." Jones figured he'd do better as The Possum, singing in honky-tonks, than as Pickle Puss hawking "aunty-Q's." And he was right.

Instrumental Trivia

INSTRUMENTALS HAVE ALWAYS had a hard time getting airplay. "Down Yonder" went #5 in '51. Ten years later "Last Date" went to #11. Chet Atkins's "Yakety Axe" came out in the summer of '65 and went to #4. Buck Owens and the Buckaroos had the only #1 country instrumental in 1965, with "Buckaroo." I can't find another one that topped the country charts.

Enjoy Yourself?

FEW PEOPLE KNEW about this, but back in 1958, Marty Robbins got fired from the Opry. It all started because Marty ran overtime on his part of the show, a definite no-no. Bob Cooper was the WSM general manager, and he was very upset about it. He marched over to Marty as he came offstage and asked, "Did you enjoy yourself out there?"

"I sure did," Marty said.

"Well, it's the last time you'll be on that stage," Cooper said, and fired him.

Back then they had photos of all the Opry stars on the walls of WSM, and some clown started hanging black crepe on Marty's. But Marty wasn't finished with the Opry or Bob Cooper. He wisely went to Grand Ole Opry announcer T. Tommy Cutrer, who went to Roy Acuff, who took Marty's case to Mr. E. W. Craig, the chairman of National Life, which owned WSM. Marty was reinstated.

The behind-the-scenes part of this story is that Bob Cooper was known to drink heavily both on and off the job. When I think of him, I am always reminded of one night when he called my radio show, very much under the influence. He called to comment on one of Sheb Wooley's "Ben Colder" records. Ben Colder (as in "been colder"), of course, was Shep's "drunken alter ego" when he sang song parodies like the one I'd just played. Suddenly the studio hot line lit up. I grabbed the phone and there was Bob Cooper.

"Did you like that record?" he demanded to know.

"Yeah, Bob, I thought it was pretty funny," I answered.

"The guy sounded a little drunk to me," Bob Cooper slurred.

He didn't get it.

Junior Samples Figures It Out

FOR A WHILE in 1966 the Arab-Israeli War dominated the news. Junior Samples visited my show early one morning—at 1:00 A.M., to be exact. A recap of the conflict had just been on the radio. I asked Junior if he understood what all was going on in that part of the world. "Well, it looks simple to me," Junior said. "All these big countries jumped on this little bitty country, and this little bitty country beat the hell out of 'em."

Trivia

WHAT WAS country's first album? A ten-inch LP on Columbia, *Gene Autry's Western Classics, Vol. I*. So while RCA "invented" the 45, it was Columbia at the fore with an LP.

The Lovin' Spoonful and Stringbean Get Down

BACK IN 1967, right after "Nashville Cats" was a big hit for the Lovin' Spoonful, the group came through Music City. I had them on my television show on the day that Stringbean appeared, and I decided it would be fun to see if the group could and would sing with String. "Sure," they said. It turned out that both the group and String loved "Little Liza Jane," so that's what they performed. During the song, String leaned over toward the hot group and said, "Stick with me boys, and you'll go places." I later picked up an album the Lovin' Spoonful recorded after they'd been to Nashville and they listed some of the favorite things they'd done in the past year. High on the list was "singing with Stringbean in Nashville."

Looking Back at the '90s

THE 1990s SAW country explode with album sales we never dreamed possible. At the beginning of the decade country sales were about 500 million dollars a year, and by 1995 we were a 2-billion-dollar-a-year industry. As I mentioned in the Garth Brooks chapter, many mistakes were made because record companies failed to remove Garth from the equation. We saw too many signings and expectations of quick returns. A lot of good people lost record deals because they "only" sold gold.

Soundscan played a big role in how people viewed country music. Prior to this actual scanning and reporting of sales, record-store employees were often polled about what was selling, so Country got shortchanged over the years. If actual sales were really known, I think we'd see that the country boom started long ago.

We did see women making great strides. If there was ever a decade that accepted a variety of styles from female performers, the 1990s was it. We saw the folk-oriented country music of Mary Chapin Carpenter, Kathy Mattea, and Suzy Bogguss catch on right along with the more traditional music of Patty Loveless and Tanya Tucker. We saw great new vocalists like Trisha Yearwood, Martina McBride, and LeAnn Rimes record albums that went all the way

from stone country to pop. I have to give a nod here to the torch vocals of Lorrie Morgan, too. She's made some great records, and I consider *Merry Christmas from Lorrie*, featuring the New World Philharmonic, one of the best Christmas albums ever made. When people ask me who the next big female star will be, I say Jo Dee Messina, not because I have a crystal ball, but because people expect an answer. She's released strong records and seems to have the charisma required to make a lasting impression. The same goes for my male choice for stardom: Brad Paisley.

Pop music was dominated by women, too: Madonna, Whitney Houston, Celine Dion, Mariah Carey, and Janet Jackson outdistanced most of their male counterparts. Of course, Elton John's tribute to Princess Diana, "Candle in the Wind, 1997," sold 32 million singles, overtaking "White Christmas."

The biggest singles of the decade came from many stalwarts and some newcomers. Some artists who had top radio records at each year's end: George Strait, Alabama, Randy Travis, Garth Brooks, Clint Black, Alan Jackson, Mark Chesnutt, Brooks & Dunn, Billy Ray Cyrus, Wynonna, Reba McEntire, Lorrie Morgan, Vince Gill, Faith Hill, Tim McGraw, John Michael Montgomery, Trisha Yearwood, and Lonestar. Lonestar wrapped up the decade with one of country's all-time biggest singles, "Amazed." But RCA ran up against a problem: Even when Lonestar's single had been at number one for two months, the label ran into brick walls trying for major talk-show appearances. Of course, bands have always had problems getting booked on those shows. Nobody wants to go "four-on-one" for an interview. But clearly something had changed since the early '90s. Only when "Amazed" crossed into the pop charts did the talk shows respond.

Our society saw a great paradox during the 1990s. On the one hand we had economic stability. On the other we had twenty-four-hour news shows that featured hourly reports on political scandals, sex scandals, high-profile crimes, and overnight celebrities. It seems that Andy Warhol's "fifteen minutes of fame" theory is here, and unfortunately those fifteen minutes seem to be stretching out. The line between being famous and being infamous has blurred.

The '90s have been defined by corporate consolidation in all

industries, and the record business was no exception. Radio owner-ship, too, has become smaller as a result of deregulation. Country radio peaked in 1994 when it had 14 percent of America's listeners. It is now down to about 8 percent.

The Internet, with its free downloading of music, is causing major labels to reconsider how and where they sell music. And it's making a lot of songwriters nervous. The press has concentrated on how it affects established rock bands and unknown artists who want exposure and are willing to give away a certain amount of their music for that purpose. In Nashville, we worry about how it will affect the songwriter down the street who's trying to pay the rent. The Nashville Network is history.

It's too soon to know exactly what all this bodes for country music. But there's one thing that remains the same: People are still questioning the so-called dilution of Country music. One of the most heated meetings at this year's Country Radio Seminar was titled "Too Pop? Too Country?" Labels blamed radio for what some people were calling "watered-down" pop, and radio blamed Nashville for giving them cloned records.

Looking Ahead: The Hall of Fame

WEBB PIERCE WAS the second artist I ever interviewed. I was just getting started at WAGG in Franklin and learning that the estab-lished jocks got the name acts. The Carter Family came out to the station when I'd worked at WTPR in Paris, Tennessee, and one of the senior on-air personalities got the interview. So I was thrilled when Opry star Del Wood visited me in 1953, a couple of years after she'd had her instrumental hit with "Down Yonder." But that thrill was nothing compared to the day Webb Pierce showed up. It was still 1953, and Webb was the hottest new act out there. From Janu-ary 1, 1952, to July 4, 1953, he racked up ten top-5 hits, with four #1 songs staying at the top of the charts a total of nineteen weeks.

I was talking to Webb in 1974 and mentioned that day to him. He remembered it but hadn't realized what a career boost he'd given me.

"I'd like to thank you for that day twenty years ago, Webb," I said.

Webb drew back with a mock frown and boomed, "Well, you sure took your time telling me."

That was Webb. He might loan you twenty bucks or tell you to go to hell. But even when he wanted to kill me one time—and he probably would have, except he'd have gone to jail for murder—he treated me all right. The time I'm talking about happened in 1964, when a promoter put together a package show for Madison Square Garden. We were on a tight schedule. Because of the unions in New York, if we ran over even a few minutes, we'd be in big trouble. In fact, Buck Owens was to close the show and be offstage by 11:30 P.M. The management at Madison Square Garden told us that one minute over and we'd be fined $5,000.

Each star was allotted two songs. You can imagine how nervous I was as I announced first one and then another. I'd get on the stage and announce someone, then go down into the orchestra pit, where managers and front men were trying to sort out what time their acts went on. There were actually three stages. The center one had a house band assembled for any act that didn't bring its own band. It was quite a house band, too, led by the great Leon McAuliffe, who for years played with Bob Wills. Then on either side there was a stage so bands could be setting up while the various acts performed on a different stage.

Somehow when Webb came on, I got confused. He sang one song, and I jumped out of the pit and announced Ferlin Husky, who was waiting down at the other stage. All of a sudden I was looking up into the face of a very unhappy Webb Pierce, who was a big man. He looked like a hulk leaning down into the pit.

"I thought I was supposed to do two songs," Webb snarled.

"You did!" I sputtered.

"No, I didn't!" he snapped. A couple of the band members figured out that Webb was right. When I understood what I'd done, I tried to ease the "pain" a little.

"Webb, you'll get more out of this now. I'll go introduce you again and tell everyone I screwed up."

After I confessed and reintroduced Webb, he walked out onstage, smiled at the audience, and said, "Well, I guess that's why people put erasers on pencils."

That was one of those mess-ups I'll never forget. Webb never forgot either. But he didn't hold a grudge. And even with the mess-up, we finished on time, barely. As I said, Buck Owens had to be off the stage at exactly 11:30. He ran out at 11:26 and did two two-minute songs. The second he finished the last note, I jumped out and said, "That's it. Good night!" That was just before the clock went from 11:30 to 11:31.

As I was researching this book and listening to old tapes, I got to thinking about Webb and the Country Music Hall of Fame. I was so thrilled a year ago when my old friend Conway went into the Hall of Fame. And this year it's been announced that Charley Pride and Faron Young are the inductees. Those choices thrilled me as well. But where is the biggest-selling, biggest-charting artist of the decade of the '50s? The man who'd sold 49 million records, singles, and albums by 1974. Why isn't Webb in the Hall of Fame?

At a recent meeting I mentioned the fact that Webb Pierce was not yet inducted and said I thought it was a shame. One fellow spoke up immediately.

"Oh, well, I saw Webb drunk at a bunch of shows."

Now, that stumps me. Can it be that Webb Pierce is being kept from his rightful place in the Hall of Fame because he turned up at some shows drunk? It makes me wonder how Ernest Tubb made it past the censors. Or Hank Williams. Lefty Frizzell. Faron Young. George Jones. Hell, it makes me wonder how Acuff sneaked in there. And we haven't even started talking about the pill-takers.

Some say it might be due to Webb's abrasive personality. Well, I said before that liquor turned Ernest Tubb from one of the most lovable characters in the world into one of the ugliest personalities. Faron could offend people at the drop of a hat. The same goes for many others.

Webb formed Cedarwood Publishing with Jim Denny and left the Opry when Denny was accused of a conflict of interest. Webb put his name on a lot of songs that he didn't write, and there's cer-

tainly been criticism for that. But it wasn't particularly unusual for a writer to share credit with a star in order to get a cut.

The truth is, the artist-as-writer scam is almost more common now. It's just that the methodology has changed. Now publishing companies set up brand-new acts to write with established writers. Sometimes it's warranted and sometimes not. I'm certainly not saying that some of the newer acts can't write and shouldn't be hooked up with the stars of the publishing industry. But there have been a lot of young kids sitting around twiddling their thumbs at a writing session, then walking away with their name on a tune. They tell of one well-known writer who was told by his publishing company that he had to write with a kid who just signed a label contract.

"Is he a good writer?" the guy asked.

The publisher shrugged. He had no idea. But it meant a cut.

So this writer shows up at the session, throws the kid a tape with both their names on it, and says, "Here's our song."

Then there's the old grumbling that Webb couldn't sing. And it's true that he was notoriously off-key. He was no Marty Robbins. No Vince Gill or Ronnie Dunn. But Webb had something that drew people into his songs. He was a stylist of the first order. Just listen to "There Stands the Glass."

Of course, many felt that Webb was simply outrageous. He built the guitar-shaped pool and invited tour buses to pull up right in the same neighborhood where the governor lived. On Saturdays Webb would come out and sign autographs. One neighbor, my old friend Ray Stevens, particularly hated it. Webb's response? "Ray should have known better than to move across the street from a star." I once asked Webb about his neighbors, and he mentioned Minnie Pearl, the governor, Ray Stevens, and the newest, Jerry Reed.

"Quite a neighborhood, Webb," I said.

"Oh, yeah, Ralph," he said. "They're closin' in on me."

"Does that bother you?" I asked, laughing.

"Nah. I *am* mayor of the hillbillies, after all," he said, only half in jest.

If you go to the Hall of Fame in Nashville, you can see Webb's prize promotion—his Pontiac Bonneville, the Silver Dollar car. It

was designed by Nudie, with inlaid silver dollars, pistols for door handles, silver horses' heads for knobs, and, of course, those great big horns on the hood. Webb said he used to book the car for $500 a day, which was more money that a lot of newer artists could make!

Webb once told me that the people who influenced him most were Hank Williams, Jimmie Rodgers, and Gene Autry. "Gene was my idol," he said. "I went to the movies every Saturday afternoon I could to watch him show me what a hero was all about. And my mother had just about every Jimmie Rodgers record in existence, so I played them a lot." But it was seeing Hank Williams sing that made Webb determined to become a performer. He went on one of Hank's last tours, in 1952. That was a time when Hank was in pretty bad shape, and reports of his conduct and poor performances continually got back to town. But not from Webb Pierce. I asked Webb if he was still impressed with Hank after that run.

"Hank Williams *always* impressed me," he said.

Webb's mother hated the idea of his being a performer. "You should get a job," she told him once he started getting some work playing music. "I knew I didn't want to work like I had as a kid," he told me. "Raising and picking cotton, growing corn and potatoes and peas. Farming is hard work. The one positive thing about it is that you usually have good food. No money, just good food."

It was the farming, though, not his music, that allowed him to earn enough money by age fifteen to buy a Model A Ford. "I got it from a guy named A. P. Mathis," he reflected once. "It only cost fifty dollars, but growing and selling fifty dollars' worth of vegetables represented quite a bit of work back then."

Webb started his music career at station KMLB in Monroe, Louisiana, when he was sixteen years old and then, after serving in the military, took a job with KWKH in Shreveport. Once he got his foot in the door, Webb became a mainstay at the *Louisiana Hayride*. One of the first people he helped along was a young kid named Faron Young. I'd often heard Faron tell how Webb advanced his career, so one time I asked Webb to tell me his version. He didn't stretch the truth. The stories were virtually identical.

"Faron was still a teenager when he started coming around pitch-

ing me songs he'd written," Webb said. "I had just signed with Decca, and I didn't have a hit yet. I'd listen to him sing them but never heard much I liked. Finally one day I said, 'Faron, you ought to try singing for a living. You are a lot better singer than you are a writer.'

" 'I'd need a job,' Faron said.

"I thought that over for a few minutes and decided I could use him. I really did like his voice a lot. So I told him he could come to work for me. I was playing the Skyway Club in Shreveport, and it was about to kill me. I needed a relief singer. That's how our working relationship started—me singing for thirty minutes and Faron singing for thirty minutes. I paid everyone fifty dollars a night, and I kept the rest of the money for car expenses, trailer expenses, and any business dealings we had to pay for."

After Capitol's Ken Nelson heard Faron singing on Webb's KWKH radio show, he gave him a contract with Capitol. Webb had the first hit of the two, 1952's "Wondering," and it was so big that Jimmy Dickens and Faron used to pose this question:

"If you go to darkest Africa and find a radio station, what do you think you'll hear?"

Answer: "Webb Pierce singing 'Wondering, wondering . . .' "

I was surprised when Webb told me that it was Faron who first made it to the Opry.

"Hubert Long got it set up," Webb said. "Faron had a contract with me, so he asked me what I thought about his going to the Opry. He didn't ask out of the contract—just wanted to know what I thought. Of course I told him he should go. I handed him his contract back and said, 'Faron, I think you're on your way.' Faron has one of the best voices in this business."

Webb also loaned Faron the money to get to Nashville for his Opry debut.

"Did you always think he'd be a star?" I asked.

"Of course I did! Why would I have put up with him if I didn't?"

And maybe that makes the best point. Some artists are harder to put up with than others. But you do it because of that something extra that's made them a star. Like Hank and Faron and Lefty

and at times Ernest, Webb was a real pain in the behind. But he was a star.

The people of this country must have danced millions of miles to his music. His hits became classics: "There Stands the Glass," "Slowly," "Even Tho'," "More and More," "In the Jailhouse Now," "I Don't Care," "Why Baby Why" with Red Sovine, and so many more. Four of his songs won *Billboard* Triple Crown awards, which meant they hit #1 in all three of *Billboard*'s charts at once: Jukebox, Best-Seller, and Deejay. It didn't work if you hit them at different times either. The Triple Crown was like a slot machine—all had to hit simultaneously. Webb had 13 #1 singles, 52 top-10s, and he stayed at the top of the charts a total of 101 weeks between 1952 and 1955. He should be in the Hall of Fame.

"I Wish I Was Eighteen Again"

LATELY I'VE BEEN listening to Ray Price's new CD, *Prisoner of Love*. Ray is seventy-four years old, an age when many singers have lost a great deal of vocal quality. Ray Price hasn't lost his chops a bit. This is a wonderful CD, and I'd recommend it to anyone. One of the songs on this CD particularly struck me. It's a tune I first heard George Burns sing, Sonny Throckmorton's "I Wish I Was Eighteen Again."

I was eighteen when I started out in this business, and country music has treated me well. I've met some wonderful people on the road these past fifty years. Sometimes it seems like yesterday that I first headed down to the Grand Ole Opry with my buddies to hear Lazy Jim Day. Other times I know those fifty years have all gone by. Those are the times when you feel an ache or a pain you didn't have a few years earlier, or when you realize you take more pills to stay healthy than you used to. Or the times when you've overdone it on the exercise bike.

But those aren't the times I wish I was eighteen again. The times that kind of thought enters my head come around when I've listened to a tape of the all-night radio show I did with Tex Ritter or watched a tape of Roger Miller and me goofing around on morning television.

I wish I could turn back the clock and talk to Minnie Pearl again. The same goes for so many: Conway Twitty, Faron Young, Tennessee Ernie Ford, Grandpa Jones. It was all a great adventure, and I'd like once again to go running off into the wind, go places where I've never been. I think we all love to reflect on our adventurous times, our salad days. But since none of us can turn back time, I'd like to share these sentiments with you from that beautiful recording by Ray Price:

> *I'll never again turn the young ladies' heads,*
> *Or go running off into the wind.*
> *I'm three-quarters home from the start to the end,*
> *And I wish I was eighteen again.*
> *Oh I wish I was eighteen again*
> *And going where I've never been.*
> *Now old folks and old oaks standing tall just pretend*
> *I wish I was eighteen again.*

The Impact Charts:
A Measurement of the Best
of the Fifty Years
1950–2000

WHAT KIND OF IMPACT did these performers from 1950 to 2000 have on the public?

To answer that question, I decided to do an analysis of country music for this time period. It is based on a number of factors. If it were only based on record sales, then the champs would be Garth Brooks and Shania Twain, who led the sales explosion of the '90s. The problem with that is that they only represent one decade out of five.

Much of what you are about to read is based on the record charts of each time period plus—and this is very important—longevity in the five decades. The first factor that I considered was how long an entertainer made a major impact on the public. Other factors taken into account were whether they hosted television shows, appeared in movies, and won major awards such as Entertainer of the Year from the CMA and the ACM as well as the Male or Female Vocalist of the Year or Outstanding Duo or Vocal Group. And yes, sales.

These impact charts reflect the most outstanding performers for each five-year period between 1950 and 2000. Some outstanding performers fell just short of making these charts, but the competition was fierce. Therefore, I want to recognize people like Bobby Bare, Ronnie Milsap, Charlie Rich, Sonny James, and Anne Murray who had great careers.

1950–1954

MEN	WOMEN	GROUP
Hank Williams	Kitty Wells	Johnnie and Jack
Eddy Arnold	Jean Shepard	Davis Sisters
Webb Pierce	Goldie Hill	Delmore Brothers
Hank Snow	Anita Carter	Flatt & Scruggs
Carl Smith/Lefty Frizzell		Carter Family

1955–1959

Johnny Cash	Kitty Wells	Everly Brothers
Webb Pierce	Jean Shepard	Browns
Elvis Presley	Rose Maddox	Johnnie and Jack
Ray Price		Louvin Brothers
Marty Robbins		Wilburn Brothers

1960–1964

Buck Owens	Patsy Cline	Browns
George Jones	Kitty Wells	Wilburn Brothers
Marty Robbins	Skeeter Davis	Everly Brothers
Johnny Cash	Loretta Lynn	Louvin Brothers
Jim Reeves	Rose Maddox	Flatt & Scruggs

1965–1969

Merle Haggard	Tammy Wynette	Statler Brothers
Johnny Cash	Loretta Lynn	Osborne Brothers

George Jones	Connie Smith	Wilburn Brothers
Buck Owens	Dolly Parton	Browns
Eddy Arnold/	Lynn Anderson	Flatt & Scruggs
Glen Campbell		

1970–1974

Merle Haggard	Loretta Lynn	Statler Brothers
Conway Twitty	Tammy Wynette	Osborne Brothers
Charley Pride	Lynn Anderson	Glaser Brothers
Johnny Cash	Dolly Parton	
Tom T. Hall	Tanya Tucker	

1975–1979

Conway Twitty	Crystal Gayle	Statler Brothers
Kenny Rogers	Dolly Parton	Oak Ridge Boys
Willie Nelson	Loretta Lynn	Gatlin Brothers
Merle Haggard	Anne Murray	
Waylon Jennings/	Emmylou Harris	
Glen Campbell		

1980–1984

Willie Nelson	Barbara Mandrell	Alabama
George Jones	Dolly Parton	Oak Ridge Boys
Merle Haggard	Janie Fricks	Gatlin Brothers
Conway Twitty	Reba McEntire	Statler Brothers
Lee Greenwood	Crystal Gayle	The Judds

1985–1989

Randy Travis	Reba McEntire	The Judds
George Strait	K. T. Oslin	Alabama
Hank Williams Jr.	Dolly Parton	Gatlin Brothers

| Willie Nelson | Kathy Mattea | Forrester Sisters |
| Steve Wariner | Roseanne Cash | Restless Heart |

1990–1994

Garth Brooks	Reba McEntire	Brooks & Dunn
Vince Gill	Tanya Tucker	Diamond Rio
Alan Jackson	Mary Chapin	Alabama
George Strait	Carpenter	Kentucky
Clint Black	Wynonna	Headhunters
	Kathy Mattea	Sawyer Brown

1995–2000

George Strait	Shania Twain	Brooks & Dunn
Alan Jackson	Reba McEntire	Dixie Chicks
Garth Brooks	Faith Hill	Mavericks
Tim McGraw	Martina McBride	Diamond Rio
Clint Black	Trisha Yearwood	Sawyer Brown

IMPACT CHART
The Top Ten Acts from 1950–2000

MEN	WOMEN	GROUP
Johnny Cash	Dolly Parton	Alabama
Merle Haggard	Reba McEntire	Statler Brothers
George Jones	Loretta Lynn	Brooks & Dunn
Willie Nelson	Kitty Wells	Oak Ridge Boys
George Strait	Tammy Wynette	The Judds
Garth Brooks	Patsy Cline	Browns
Conway Twitty	Crystal Gayle	Everly Brothers
Buck Owens	Tanya Tucker	Gatlin Brothers
Eddy Arnold	Shania Twain	Diamond Rio
Hank Williams	Barbara Mandrell	Johnnie and Jack

INDEX